SEEING
THROUGH
CLOTHES

A·N·N·E H·O·L·L·A·N·D·E·R

SEEING THROUGH CLOTHES

THE VIKING PRESS NEW YORK

Copyright © Anne L. Hollander, 1975, 1976, 1978
All rights reserved
First published in 1978 by The Viking Press
625 Madison Avenue, New York, N.Y. 10022
Published simultaneously in Canada by
Penguin Books Canada Limited

LIBRARY OF CONGRESS CATALOGING IN PUBLICATION DATA
Hollander, Anne.
Seeing through clothes.
Bibliography: p.
Includes index.
1. Costume in art. 2. Human figure in art.
3. Art—Psychology. I. Title.
N8217.C63 704.94′2 78-15598
ISBN 0-670-63174-4

Chapters 1 and 11 appeared in *The Georgia Review* in
somewhat different form.
Printed in the United States of America
Set in CRT Garamond

To Martha and Elizabeth

CONTENTS

ACKNOWLEDGMENTS

The ideas and observations expressed in this book have been taking shape in one form or another since my earliest experience of clothes and art. Making articulate sense of them has required a lengthy education, not only as a formal student of art history and a private student of costume history but as a friend, acquaintance, and informal student of many different scholars and writers. Those by whom I have felt most fruitfully encouraged, advised, and enlightened have been Julius Held, John Hollander, Michael Hollander, Stephen Orgel, Irving Lavin, Marilyn Lavin, Donald Cheney, Iris Cheney, Angus Fletcher, Thomas Nagel, Meyer Schapiro, Roy Strong, John Walsh, Marshall Cohen, Richard Poirier, Harry Ford, and Harold Bloom.

The manuscript was in large part completed while I held a Guggenheim Fellowship in 1975-76, and I am grateful to The John Simon Guggenheim Foundation for timely support.

The first two chapters appeared in slightly different form in *The Georgia Review* under the titles "The Fabric of Vision: The Role of Drapery in Art" (Summer 1975), and "Fashion in Nudity" (Fall 1976).

I am very grateful to Elisabeth Sifton and Victoria Stein of The Viking Press for all their valuable attentions, both pictorial and editorial, to the manuscript and its illustrations.

This book is concerned with how clothes in works of art have been connected with clothes in real life, during the two and a half thousand years of Western history in which the aim of art has been to represent the visible world with conviction. Each of these chapters explores the idea that in civilized Western life the clothed figure looks more persuasive and comprehensible in art than it does in reality. Since this is so, the way clothes strike the eye comes to be mediated by current visual assumptions made in pictures of dressed people. Changes of style in clothing are consequently inextricable from changes in the medium of art in which the human figure usually appears, and the clothed body looks most natural when it is perceived in terms of its naturalistic image.

In the twentieth century, photography and cinematography are the commonest media for figurative art, and other, older popular pictorial modes now copy their effects. But for centuries before the camera, all kinds of prints and engravings were conveying the human image to Western eyes. Not only were famous paintings engraved, published, and sold, but thousands of cheap prints of actresses, criminals, statesmen, and other celebrities were sold in streets and shops, along with prints showing important current events, recent or remote historical moments, amazing occurrences, and horrible crimes. There were biblical illustrations,

illustrations of fiction, pictures of extraordinary foreign peoples, pictures of everything—produced to fill the same visual need we all still feel: the need to see the human world, both known and imagined, in the form of lifelike images. The medium and conventional style of these images change through time, but at each moment they are seen to look natural. Movies in 1918 looked natural then, as movies in 1978 look natural now; paintings on Greek vases and carvings on medieval cathedrals offered the same natural vision long before cameras or printing.

Looking at a range of works of art with figures in them, from painted vases and frescoes to magazine illustrations and movie stills, one can see at once how the construction of clothing itself has changed over time and differed among people at one time. But the obviousness of such historical differences in clothes themselves perhaps obscures another important fact: that the formal properties of the work of art itself do not mask but, rather, illuminate the basic evidence about what people used to wear. These formal properties offer different but even more important evidence about changing assumptions and habits of actual seeing, and so of visual self-awareness. Such formal elements demonstrate not how clothes were made but how they and the bodies in them were supposed and believed to look. Even actual garments themselves, old or new, offer only technical evidence and not perceptual knowledge.

In a picture-making civilization, the ongoing pictorial conventions demonstrate what is natural in human looks; and it is only in measuring up to them that the inner eye feels satisfaction and the clothed self achieves comfort and beauty. In the Western world people see themselves taking their places inside the accustomed frame of how things look—something most commonly learned nowadays from camera art. Only when they are safe inside that visual matrix do they then measure themselves against other persons inside the same frame and feel that they look different or similar, natural or strange. Learning exactly how clothing was *made* in the past does not yield much knowledge about how it looked or felt. These qualities would have depended on how clothes were inwardly believed to look at the time when they looked outwardly natural; and at any such time, while the ordinary body was dressed, it would feel itself to appear in harmony with the contemporary style of art in which nature was made to look real. This correspondence is what would produce a sense of natural looks.

It is tempting to believe that people always feel physically the same and that they look different only because the cut of their garments changes—to subscribe to the notion of a universal, unadorned mankind that is universally naturally behaved when naked. But art proves that nakedness is

not universally experienced and perceived any more than clothes are. At any time, the unadorned self has more kinship with its own usual *dressed* aspect than it has with any undressed human selves in other times and places, who have learned a different visual sense of the clothed body. It can be shown that the rendering of the nude in art usually derives from the current form in which the clothed figure is conceived. This correlation in turn demonstrates that both the perception and the self-perception of nudity are dependent on a sense of clothing—and of clothing understood through the medium of a visual convention.

The works of art of Greek antiquity serve as a fountainhead of styles for figures in Western art. Their influence shows through their direct modifications in Roman, Early Christian, and Byzantine art, and later in many different deliberate imitations and revivals and allusions. In the course of their artistic development the ancient Greeks produced a flexible and enduring model for realistically portraying all kinds of bodies in some convincingly harmonious relation to their clothing, whether they were wholly covered or virtually bare. They did this by conventionalizing, with more variety than had ever appeared before in art, the random action of cloth itself, combined with an equally stylized range of seemingly random bodily movements and gestures. From the storehouse of Greek prototypes comes the Western awareness of the scope of beauty possible to the clothed body when its "natural" look is created and exalted by art. Those ideal, rhetorical, but always apparently casual arrangements of limbs, torsos, and folds set a standard, not just for later artistic practitioners but for perceiving eyes of later centuries.

As a consequence, in the later history of Western art it is drapery and nudity, both together and separately, that most easily show the effect of convention on perception. The nude body and draped cloth became essential elements of idealized vision; they came to seem correct for conveying the most valid truths of life, entirely through the persuasive force of their appearance in works of art rather than through any original significance attached to them in real life. The "natural" beauty of cloth and the "natural" beauty of bodies have been taught to the eye by art, and the same has been the case with the natural beauty of clothes. The tight-laced waist, the periwigged head, and the neck collared in a millstone ruff, along with flattened breasts and blue-jeaned legs, have all been comfortable, beautiful, and natural in their time, more by the alchemy of visual representation than by the force of social change.

To consider the aesthetics of dress entirely from the point of view of economic or political history, or of the history of technology, or even of social custom, with which it is so closely allied, may be very illuminating

on the question of how such matters affect symbolic invention in clothing. But to do only this is to limit dress to the status of an elevated craft, as if it had the same aesthetic scope as pottery, tapestry, or furnishings. Clothing might be thought to claim the more serious kind of attention given to architecture, if its materials had comparable permanence and the size of its examples more command over the eye. It may be quite correct to consider a garment as an aesthetic but useful artifact similar to a house, a car, or a teapot, something extruded onto the surface of a complex cultural organism and expressing its prevailing taste and attitudes. Its shape, texture, and decoration might be analyzed in terms of abstract formal quality, symbolic content, and technical genesis. Like a Chinese bronze, it would be seen as an accomplishment in the most refined realm of design. But this view is insufficient for Western dress.

For the clothes of some societies it might be enough. Much ethnic dress or folk costume, not just the body paintings and mutilations of Africa, Australia, and South America, has the quality of making the wearer himself into a part of just such an artifact and reducing him to a symbol-bearing abstraction. Some Central and East European and much Middle Eastern folk dress has an unfocused and overburdened visual form, with a resultant depersonalizing effect in wear. The individual human being does not seem able to animate the costume. He does not give it any extra dimension, nor does it in turn enhance his face and body personally. Both together make the costume itself a walking example of traditional design and craftsmanship. Such essentially abstract clothes are often worn in societies that may have a rich craft heritage but no strong tradition of figurative art; and the person who wears them is an armature, easily replaceable. In fact such clothes tend to look better, as do many garments from the whole eastern hemisphere, when laid out flat, to display construction and embellishment, than they do when worn on a body.

But to consider a Western garment this way—an embroidered waistcoat, a ribbon-trimmed bonnet, a pair of overalls—would be to leave out the primary function of such a garment itself: this function, in the main tradition of Western dress, is to contribute to the making of a self-conscious individual image, an image linked to all other imaginative and idealized visualizations of the human body. Any such garment has more connection with the history of pictures than with any household objects or vehicles of its own moment—it is more like a Rubens than like a chair. Western clothing derives its visual authenticity, its claim to importance, its meaning and its appeal to the imagination, through its link with figurative art, which continually both interprets and creates the way it looks.

A great deal has been acknowledged about the psychological and social

importance of clothing. Unlike sex and art, however, dress usually fails to qualify as serious *in itself*. Clothes themselves are believed to be merely shifting ephemera on the surface of life, and so it is very easy to consider them trivial and to concentrate instead on the seriousness of what they mean. Deep personal concern about the details of one's own clothes may still be supposed to indicate a shallow heart and a limited mind; but serious thinkers, faced with the obvious power of dress even over very profound spirits, have been led to treat clothes as if they were metaphors and illustrations. To be objectively serious about clothing has usually come to mean explaining what they express about something else. But, just as with art, it is in their specific aspect that clothes have their power. This is what art proves and offers a means of seeing; since artists constantly create the look of clothes, clothing itself is constantly allied to all the other aspirations of figurative art. Clothes make, not the man but the image of man—and they make it in a steady, reciprocal accord with the way artists make, not lifeless effigies but vital representations.

Since the look of Western clothes is so closely allied to its changing image in art, all temporal changes and contemporaneous differences in them may best be perceived as changes and differences in the elements of an artistic form, not just as changes in social custom, economic pressure, or psychological emphasis. Because of their complex visual situation, clothes also cannot really be compared, as they often are, to kinds of verbal behavior such as informative speech, exclamations, or bursts of suggestive and persuasive rhetoric. If anything, clothes are rather like conventional expressions in a literary form, of which the canonical examples have been assimilated by the reading public. One might say that individual appearances in clothes are not "statements," as they are often called, but more like public readings of literary works in different genres of which the rules are generally understood. A genre naturally develops as groups and individuals modify it, but always in terms of previous examples within it and rules that define it. Thus Western clothing is not a sequence of direct social and aesthetic *messages* cast in a language of fabric but, rather, a form of self-perpetuating visual fiction, like figurative art itself.

Considering their importance for the individual self-image, it might seem right to think of clothes as entirely social and psychological phenomena, as tangible and three-dimensional emotions, manners, or habits. Their instant expressiveness makes clothes easy material for such interpretations and translations. And yet, the picture, the imaginative visual unit, the completed image that comes into being when clothes are put on a human body, is dismembered, dismantled, and essentially destroyed by

such kinds of scrutiny—just as it is when they are brought to bear on a painting. With clothes as with art, it is the picture itself, not the aspects of culture or personality it reveals, that demands the attention first and appeals directly to the imagination through the eye. Because they share in the perpetually idealizing vision of art, clothes must be seen and studied as paintings are seen and studied—not primarily as cultural by-products or personal expressions but as connected links in a creative tradition of image-making.

SEEING
THROUGH
CLOTHES

D·R·A·P·E·R·Y

Cloth is apparently something basic to civilization. Weaving is a skill of great antiquity, and it was well developed early in human history: the level of sophistication in the textiles of some "primitive" civilizations is very high. Postindustrial technology and modern chemistry have made cloth into an enormous industry; but it has been a thriving commercial enterprise, a fully developed craft, and part of the seemingly natural substance of life for as long a time as bread. The variety of possible fibers and possible methods of using them to form a fabric, quite apart from embellishment like printing and embroidery, makes cloth itself, like metal or stone, an essential material on which the artistic imagination may work. But beyond this basic potentiality is the visual appeal in the behavior of any cloth while it is being used. The history of art is full of representations or indications of cloth in use, chiefly, of course, as the dress of figures but also frequently as the dress of scenes. Thus a kind of visionary history of fabric is traceable through its poetic life in pictures and sculpture.

Representational art has always dwelt on the fascinating capacity of cloth to bunch, stretch, hang, or flutter, to be smooth or unsmooth under different circumstances, to be wrought upon and then restored, and wrought upon differently another time. The tailor's art makes use of this capacity directly, subject to fashion; and the tailor's art is apprehended and

appreciated through the same kind of visual effort that all art demands, from spectator and artist alike: the basic substance must be seen as expanded and elevated by its controlled, expressive use. Clothes, then, are objects made of fabric that convey messages beyond the power of the cloth itself to convey; but brute, raw fabric not directly in use by a tailor can yet be indirectly used by an artist, who will see in the bunched folds of a bed sheet the potential elements of a created fiction.

The appeal to the eye inherent in the workings of fabric is apparently as old as cloth itself. Constant idealization by artists has helped train the eyes of the world to take delight in it and create a desire to use it far beyond necessity. Fabric is thought to decorate and beautify, not only because of its direct appeal but because it has been shown to do so in an incredible variety of works of art since the remotest antiquity.

The original source and later justification for artistic drapery in the West has always been the variously interpreted example of surviving Classical sculpture. Late Roman sculpture and painting formed the drapery conventions used by the Early Christian artists; and these conventions for representing draped garments persisted into the Middle Ages, subject to merciless stylization but still recognizable. Classically draped figures, much modified but unmistakable, appear on sarcophagi and as architectural decoration, representing Christ and the Apostles in the clothes and attitudes of Roman statesmen and sages. A version of the costume of Classical times thus perpetuated itself and finally became codified into an enduring image of suitable dress for holy persons. This image was further developed by Renaissance artists, originally from the medieval examples but later in direct imitation of a reborn antiquity. The familiar long, loose tunic with wide sleeves and a cloak slung diagonally over it has been considered correct dress for Jesus down to the present day of plastic images. Saints and angels have worn it, too, whenever they have not worn ecclesiastical vestments, which, in their own fashion, are also much modified survivals from antiquity.

The formal peacetime costume of a Roman citizen, thus adapted for the Christian hierarchy by a wholly artistic tradition, is probably the single best source for all subsequent connections between draped cloth and lofty concepts or between the idea of nobility and the wearing of loose, flowing

clothes. There is no evidence that wearing full, draped clothing ever made anyone nobler or more courteous than wearing tailored tweeds does; and yet the association of the idea of drapery with the idea of a better and more beautiful life flourished, fed by the accumulated art of the past with its thousands of persuasive and compelling folds.

In sculpture the range of possible uses for drapery has been more limited than in painting, and the relation to past examples is simpler. Carved drapery has served a whole set of artistic needs for which no iconographic justification has been necessary. For example, students of Classical sculpture are quick to see how the drapery of the *Venus de Milo* gives a firmer base to the nude torso than naked legs would and how the marble cape of the *Apollo Belvedere* lends support to the outstretched arm. Drapery was given such subtle structural work to do by artists of all ancient periods. The vertical folds of the clothes worn by the Erechtheum maidens evoke the flutes of columns, and so do all the straight-falling draperies of the so-called "severe" style, which links the Archaic and Classical Greek periods. The garments of these figures seem not to clothe the bodies so much as to supplement them, indicating the position but not the shape of the legs, and they make the upright, standing figures seem to be bearing their stone weight as the folds simultaneously seem to support the body. The result, although it may present the image of a woman lightly clad in a sleeveless garment, is nevertheless monumental and impressive because of this tension between the plumb-downward drag of the marble cloth and the absolutely straight posture of the body, relieved only by the differing positions of the legs.

It has often been said that Classical drapery, besides performing such structural functions, also exists to reveal the body to advantage, emphasize its movements, and caress its contours. Actually the relation between the Classical body and its drapery is somehow always more complex and reciprocal than this. For example, the body of the *Ceres* in the Vatican Sala Rotonda is visibly distorted in some dimensions for the sake of displaying the clothes to advantage, rather than the other way around (I.1). The shoulders are broadened disproportionately and the breasts separated and set on an excessively wide chest so that the folds of the *chiton* may bunch around the tops of the arms without seeming to weigh down the upper body or be in danger of slipping, and the upper section of the dress may lie over the breasts to form a satisfying system of hills and channels. The identical body without the dress would look somewhat awkward, whereas a perfectly proportioned body could not wear such a fully draped costume without looking swamped and bunchy. Attempts to reproduce the dress

3

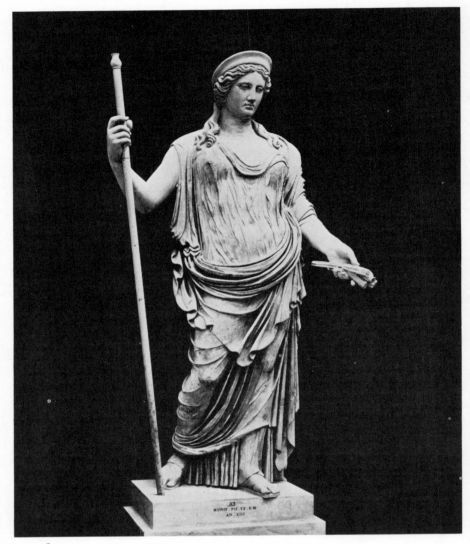

I. I *Ceres*

of Greek statues and photograph it on living models have shown how breasts tend to vanish under actual woolen folds instead of thrusting through them individually as those of the *Ceres* do. In this statue it is the clothing itself, supported by a body altered to display it to advantage, that is the primary element of expression; and so it is with many others.

Greek drapery, especially of the Classical period, has an obvious importance whether it is enhancing or enhanced by the body it accompanies or,

indeed, leading an elaborate life of its own. The free behavior of fabric did not apparently appeal to the imagination of the early Egyptians or the Archaic Greeks, whose use of it in art was always stylized, whatever it may have been in life. Ancient Minoan and Mycenaean art shows little interest in folds and pleats, stylized or otherwise: the clothes were evidently cut, fitted, and sewn. But the Classical Greek culture was able to develop its perception of informally draped woolen garments into an abiding source of aesthetic satisfaction, not only to themselves but to later generations of artists and art lovers who believed it could not be surpassed.

Woolen garments were created at home in ancient Greek households of all classes, through every stage from the shearing of the sheep through carding, spinning, and weaving. Clothes were woven into rectangles to fit the individual wearer according to length and width, so they were never cut to measure off a bolt. In the seventh century B.C. clothes were narrow and specially woven to fit closely, but they were never cut or sewn. Sixth-century dress was fuller and possibly the folds were pleated and held in place by glue, so the delicate formal folds of Archaic sculptured dress may be representations of actual pleats rather than attempts to stylize random folds. Later the rectangles out of which clothes were formed were larger and draped more freely, and they were occasionally sewn up the sides or across the shoulders; but the sewn shape was never more complex than a sack. Linen and cotton were used as well as wool and eventually silk, which in Hellenistic times provided artists with the opportunity to observe and record infinite varieties of thin, soft folds, often worn in layers. Underwear was not used. Sophistication, sexual allure, power, and austerity could all be expressed by the style in which simple rectangles woven of different stuffs were disposed around the body. Numerous and elaborate conventions developed, subsided, and coexisted—both for wearing these clothes and for representing them.

Awareness of cloth and clothes and firsthand knowledge of how to make them were thus universal among people of all regions and occupations. Artists and their public alike must have dwelt with pleasure on the beauty and plasticity of fabric itself, since everybody had direct experience of them every time he got dressed. The beauty of cloth must have had no less an appeal to the imagination than the beauty of the nude, which the Greeks are so famous for inventing. The dialectic of cloth and body is the secret of Greek art, as it may have been the key to Greek gesture and manners; and in those works of art in which no drapery appears, its absence is expressive. Nakedness and cloth together, whatever the logic of their connection, have maintained their quality of artistic rightness be-

5

cause of the absolute authority with which the ancient Greek artists dealt with every aspect of their combination. Complete nakedness in Greek art, without even the presence of a cast-off garment, is all the more striking, particularly when observed across the Christian centuries of discreet genital veiling.

Among the Greeks, modesty was an appropriate function of clothes for women but not for men. The absolutely naked female figure occurs in Greek art only rather late, and usually with drapery near at hand and with a forward-bending, self-protective posture (I.2). The Greek male nude stands upright and often abandons his drapery entirely or wears it down his back to display his bare beauty more emphatically. The drapery of the *Apollo Belvedere* (I.3) and the *Meleager* in the Vatican (I.4) hangs *behind* each of these famous nudes. Apollo's cape, "spreading as it does in pleasing folds . . . helps to satisfy the eye with a noble quantity in the composition altogether, without depriving the beholder of any part of the beauties of the naked," says Hogarth. Greek men evidently wore such garments entirely for the elegant effect and to emphasize frontal nakedness. Meleager's does not hang and drape but flies out to the side in shell-like folds from the arm—a flight unjustified by any need to show motion or drama, since the figure stands calmly still. These folds exist for the pure pleasure of cloth celebrated in marble; and yet these draperies, like those in all ancient sculpture, are definitely clothing even though they do not clothe. The cape, or *chlamys,* the same one worn by the Parthenon horsemen, is properly fastened and has a recognizable shape.

Centuries later, impelled by ideals that demanded the draping of statues according to Classical precedent, the Neo-Classical sculptor Canova could nevertheless permit himself to hang an enormous, inconsequent swatch of cloth over the outstretched arm of his *Perseus* (I.5). This huge bath sheet was doubtless intended for dramatic effect and for emphasizing the body's nudity, just as in the *Apollo;* but the long, heavy drape looks ridiculous over one slender arm. It clearly bears no relation to any actual method for creating real clothes out of drapery, has no reference to the vital facts of cloth, which are never absent from Greek art.

The problem of reconciling the flutter of cloth in action with the solidity of marble was an acceptable challenge to the Hellenistic Greek artist, who would have been schooled by centuries of a tradition based on rendering the one substance in terms of the other. Critics of later days have deplored the impulse, on the part of later Renaissance and Baroque artists, to yoke such different materials together under such difficult technical circumstances, although the Greeks remain exempt from criticism for it. The primitive, even vulgar appeal of carved flying cloth is undeniable,

6

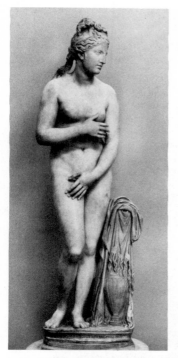

I. 2 *Venus,* 320–280 B.C. (Roman copy)

I. 3 (below left) *Apollo Belvedere,* 350–320 B.C. (Roman copy)

I. 4 (below right) Attr. SCOPAS, 4th century B.C. *Meleager* (Roman copy)

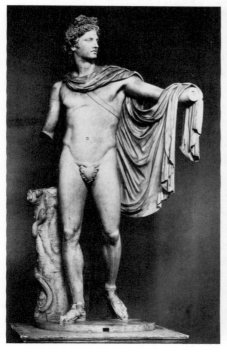

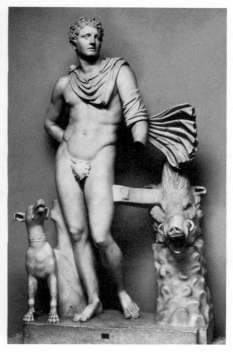

7

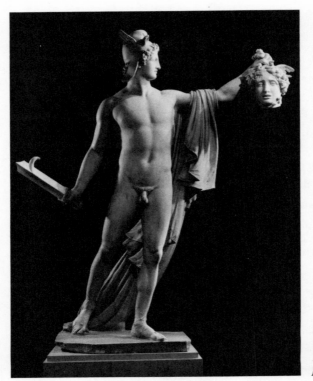

I. 5 A. CANOVA
(1757–1822)
*Perseus Holding the
Head of Medusa*

even if aesthetic judgment might deem any given example a wretched and contrived piece of work. The technical feat is fascinating all by itself, partly because of the basic charm of plentiful folds—the "darling principle," as Hogarth calls quantity in drapery.

The fluttering dress of the *Winged Victory* has received consistent praise for its expression of movement, the sense of the flying figure just alighted; but its more essential appeal is simply the cloth, the amazing stone folds. The vivid action needs no underscoring. The complex drapery of this and other Hellenistic statues has also been shown to exemplify the later Greek conception of sculptured cloth as plastic and fluid, with a variable surface catching a shifting play of light, in contrast to the smooth, linear treatment used in the fifth century and before. But besides this late, loose stylistic flavor, which the draperies share with Hellenistic flesh and hair, there remains the element of abstraction, which they have in common with the drapery of all Greek periods. The draped material, however naturalistic and random-looking, has not been copied faithfully from nature but designed. Attempts to reproduce in wool and linen what the folds do

8

in marble have proved that woven material will not behave exactly like sculptured Greek drapery. And yet nothing seems more "natural," even more inevitable, than the graceful hang and buoyant lift of these stone clothes. The blending of natural observation and skillful abstraction used by artists who were familiar with all the facts of raw cloth gave sculptured Greek drapery its immense and deserved prestige (I.6, 7).

Other, later schools of sculpture that have made dramatic use of draped fabric, such as the Gothic and the Baroque, have been censured not for excessive amounts of cloth or for the illogic of its presence but for its wild and "unnatural" habit of adopting a life independent of the body. So potent is the spell of those Greek breasts, elbows, and knees, breaking through the folds with such perfect timing, that wayward or enveloping garments that move without anatomical references seem suspect. And yet the drapery of Victory's clothes is as bizarre as that of any Bernini angel's. Sir Joshua Reynolds says, "Making drapery appear to flutter in the wind or fly through the air is an ineffectual attempt to improve the proper role of

I. 6 *Running Niobid*
early 3rd century B.C.

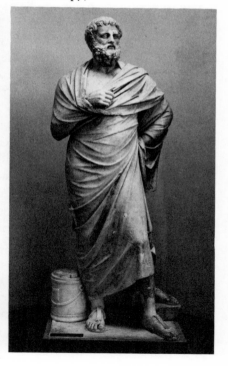

I. 7 *Sophocles*, 340–30 B.C.
(Roman copy)

sculpture." And later, "The folly of attempting to make stone sport and flutter in the air is so apparent that it carries with it its own reprehension." He goes on to scold Bernini, not only for doing this so that the drapery is a confusing element separate from the figure but seemingly also for being so good at it and making it so attractive.

This is one of many examples—as we shall see—of moral judgment about the rendering of cloth, wherein an implied "nobility" suffers for the sake of a detached delight in the possibilities of the stuff itself. In Reynolds' day the Greek use of cloth was read as a method of enhancing the body—its beauty or its movement. The opposite emphasis, whereby the body is distorted to enhance the costume, or the drapery is worked up and made to engage the attention independently, was not recognized by late-eighteenth-century admirers of the ancients.

Some draped female statues of Hellenistic times show the effect of thin stuffs drawn over one another in layers, to form folds overlapping one another in opposite directions (I.8). The body, though always conventionally revealed by the thin fabric, is here not so important as the complex surface pattern formed by the clothes. The sense that such concentration on the phenomena of fabric is somehow decadent, whereas drapery subordinate to bodily form is pure, helps to perpetuate the idea that Hellenistic art is also decadent.

The Greeks' interest in abstract drapery is, of course, most apparent in Archaic sculpture, in which bodies and clothes alike are wrought into patterns. The delicate, regular pleating of the dresses worn by sixth-century Kores challenges any effort to reproduce it in actual cloth, although attempts have been made for the stage, notably the costumes for Nijinsky's famous ballet *The Afternoon of a Faun;* carefully stitched and pressed pleats were applied to a most un-Greek silk marquisette to approximate the Archaic woolen folds. There is always the possibility that the actual garments of the period were randomly draped and only the representations required such rigid formality, but the arresting elegance of the sculptured clothes makes this somehow seem unlikely. At any period, representations in art of fashionably dressed figures obviously have firm roots in some practical sartorial ideal; a high degree of stylization is never completely at odds with the actual contemporary mode of rendering cloth into garments. Archaeological study has unearthed the practice of finger-pleating wool, which by the sixth century was woven thinly enough to take such handling, the pleats then being stiffened with size or glue. The regular, wavy edge visible on the sculptured dresses may not merely be

in marble have proved that woven material will not behave exactly like sculptured Greek drapery. And yet nothing seems more "natural," even more inevitable, than the graceful hang and buoyant lift of these stone clothes. The blending of natural observation and skillful abstraction used by artists who were familiar with all the facts of raw cloth gave sculptured Greek drapery its immense and deserved prestige (I.6, 7).

Other, later schools of sculpture that have made dramatic use of draped fabric, such as the Gothic and the Baroque, have been censured not for excessive amounts of cloth or for the illogic of its presence but for its wild and "unnatural" habit of adopting a life independent of the body. So potent is the spell of those Greek breasts, elbows, and knees, breaking through the folds with such perfect timing, that wayward or enveloping garments that move without anatomical references seem suspect. And yet the drapery of Victory's clothes is as bizarre as that of any Bernini angel's. Sir Joshua Reynolds says, "Making drapery appear to flutter in the wind or fly through the air is an ineffectual attempt to improve the proper role of

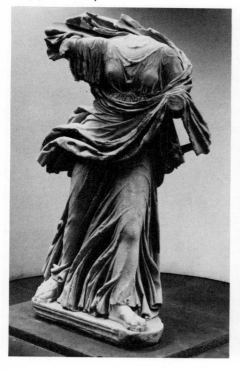

I. 6 *Running Niobid*
early 3rd century B.C.

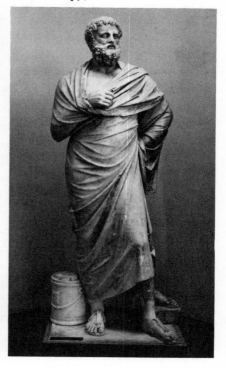

I. 7 *Sophocles*, 340–30 B.C.
(Roman copy)

sculpture." And later, "The folly of attempting to make stone sport and flutter in the air is so apparent that it carries with it its own reprehension." He goes on to scold Bernini, not only for doing this so that the drapery is a confusing element separate from the figure but seemingly also for being so good at it and making it so attractive.

This is one of many examples—as we shall see—of moral judgment about the rendering of cloth, wherein an implied "nobility" suffers for the sake of a detached delight in the possibilities of the stuff itself. In Reynolds' day the Greek use of cloth was read as a method of enhancing the body—its beauty or its movement. The opposite emphasis, whereby the body is distorted to enhance the costume, or the drapery is worked up and made to engage the attention independently, was not recognized by late-eighteenth-century admirers of the ancients.

Some draped female statues of Hellenistic times show the effect of thin stuffs drawn over one another in layers, to form folds overlapping one another in opposite directions (I.8). The body, though always conventionally revealed by the thin fabric, is here not so important as the complex surface pattern formed by the clothes. The sense that such concentration on the phenomena of fabric is somehow decadent, whereas drapery subordinate to bodily form is pure, helps to perpetuate the idea that Hellenistic art is also decadent.

The Greeks' interest in abstract drapery is, of course, most apparent in Archaic sculpture, in which bodies and clothes alike are wrought into patterns. The delicate, regular pleating of the dresses worn by sixth-century Kores challenges any effort to reproduce it in actual cloth, although attempts have been made for the stage, notably the costumes for Nijinsky's famous ballet *The Afternoon of a Faun;* carefully stitched and pressed pleats were applied to a most un-Greek silk marquisette to approximate the Archaic woolen folds. There is always the possibility that the actual garments of the period were randomly draped and only the representations required such rigid formality, but the arresting elegance of the sculptured clothes makes this somehow seem unlikely. At any period, representations in art of fashionably dressed figures obviously have firm roots in some practical sartorial ideal; a high degree of stylization is never completely at odds with the actual contemporary mode of rendering cloth into garments. Archaeological study has unearthed the practice of finger-pleating wool, which by the sixth century was woven thinly enough to take such handling, the pleats then being stiffened with size or glue. The regular, wavy edge visible on the sculptured dresses may not merely be

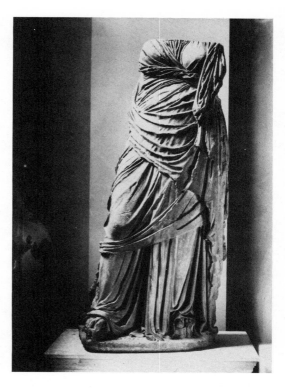

I. 8 APOLLODORUS OF PHOCAEA
second century B.C.
Draped Female Figure

stylized drift but may represent the finished weft edge of the cloth, where
the warp threads are turned back into the weave and thus create a scal-
loped pattern.

The striking fact that Archaic male statues are often completely naked,
whereas female figures are always completely dressed, also had its origins
in custom. Since notions of modesty demanded clothes for women, artists
had to develop separate techniques for representing the two sexes in
sculpture. Male nudity became a subject on which the plastic imagination
could dwell with great intensity, producing an evolving dynamic image
charged with readiness for the changes it was to undergo. The hidden Ar-
chaic female body, on the other hand, a more static and simplified shape,
was inseparable from its formal garments, somehow incapable of energy
without the drapery. It is this female body, by custom requiring a con-
cealing dress, that made drapery a sculptural necessity for the Greeks.
Carved clothes for women began with solid, blocklike tunics almost de-
void of folds and proceeded through the linear patterns covering the
bodies of the Acropolis maidens to the amazing sophistications that begin

to develop in the fifth century. The male body, as we have seen, could wear its drapery like a back cloth; but for centuries the female shape had to show through clothes or not appear. The cloth, although fairly independent of the male body, thus had to be used expressly to help model feminine shapes, as anatomical realism for both sexes gradually gained ascendancy as a sculptural ideal. Then came the breathtaking variety of draped female figures in Greek sculptures—Nikes and maenads in motion, staid deities in repose, ladies wrapped for walking, women fastening clasps, clutching skirts, drawing aside veils, and huddling in cloaks.

Male figures are, of course, frequently shown clothed, sometimes even completely shrouded, and an even greater variety of garments appears on them than on women. But for the male, who need not be covered, the function of the drapery could be entirely to express the character and status of the man. Therefore a naked man clothed only in his strength, beauty, or divinity appears distinct from a naked man wearing ornamental or supportive cloth draped over one arm or flying behind him. For the Greeks, that drapery represented real clothing with specific meaning, and the absence of all drapery was equally significant. For subsequent periods, the attendant drapery of the nude in art was a visionary generalization invoking antiquity, not a reference to antique practice.

Pictorial representation of drapery in later Western art clearly derives from the sculpture of antiquity and not from its painting. Separate conventions existed in Classical art for the two-dimensional rendering of drapery, as comparison of sculpture with vase or wall painting quickly shows (I.9). Although related to the sculpture of each period, two-dimensional cloth in Greek and Roman art was conceived on its own terms and never made to look as if it might have been carved. That habit was reserved for later centuries, during which the attempts to render the three-dimensional look of folds in sculpture were echoed in painting and graphic art.

On the Greek vase paintings the lines indicating hanging folds or bunched material appear unnaturalistic when compared with sculptured solutions to the same problems dating from the same time. The vase painters seem to have stylized the cloth more than the anatomy, for which the use for foreshortening was developed in the fifth century without an analogous technique for making the drapery seem more real. Three dimensions were evidently considered necessary for the fully developed naturalistic rendering of cloth. In two dimensions obvious schemes of stylization were maintained. There is often a certain lack of definition in the course of the painted folds or the outline of the hems, although exe-

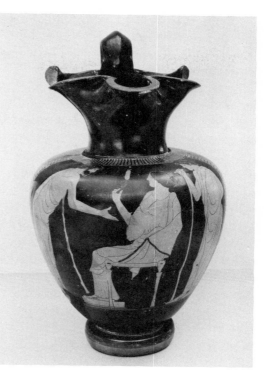

I. 9 Attr. "Orchard Painter"
Red-figured Oinochoë:
Conversation Scene, C. 460 B.C.
Free rendering of folds

cuted elegantly and expertly, which the sculptor never permitted himself. Neo-Classic linear styles of drawing, which later imitated the antique, usually made the mistake of following through each fold with a thoroughness the Greeks reserved for sculpture. Free, delicate, almost calligraphic lines indicating drapery are to be found on Greek vases of all periods and show the persistence of a graphic tradition unadulterated by sculptural values.

We lack, of course, a sense of the colors and patterns of Classical Greek clothes. These wore off the originally polychromed statues, which thereafter were perceived in monochrome by subsequent centuries. Patterns appear on clothes in vase paintings, but the abstract technique makes them difficult to interpret; and, of course, the colors were limited to black and red, some yellow and white, and only rare touches of green and purple at a late date. Thus a strong visual conception of the true colors of the clothes of antiquity has been denied to later generations; our eyes have been most commonly instructed by stone-colored fragments and red-and-black vases. Documents tell of colors that are somehow unbelievable without visual examples.

13

The Roman wall paintings at Pompeii and Herculaneum, derived as they are from Greek models, are a source for color and for a demonstration of another two-dimensional drapery style not indebted to sculpture. The brilliant painted folds that dress and adorn these figures are wrought with an extraordinary freshness and economy, a painterly directness that did not evolve again in Western art until the late sixteenth century. There is a great simplicity in the actual brushstrokes that convey the bunching up or drag of fabric, and this fresh method is all the more effective for being applied to certain conventional motifs—"phrases" or "episodes" of drapery that occur everywhere in Classical art: an arch of drapery sweeping over the head of a dancing figure, a fan of cape folds behind a lunging warrior. These decorative cloth gestures never look labored or rhetorical in the Classical wall paintings because they are offered with the same brisk, cool authority characteristic of the most austere and unruffled garments (I.10). This fresco style never insists on the linear patterns formed by hemlines or on delicious, repeated scoops of draped fabric or on the thorough, sinuous tracing of individual folds. All these are for sculpture.

In the best of these wall paintings, the feathery, sure brushstrokes drape the clothes and model the muscles with a clear attempt only at "impressionistic" visual reality—the effect of light on a colored, mobile surface. The mundane beauty and everyday quality of cloth is thus celebrated in these wall paintings rather than its separate aesthetic potentialities or its ability to create drama. Intended for intimate viewing at fairly close range,

I. 10 *The Woman in Terror* and *The Flagellated Woman and the Bacchante*
Frescoes from the Villa of the Mysteries, Pompeii, late first century B.C.

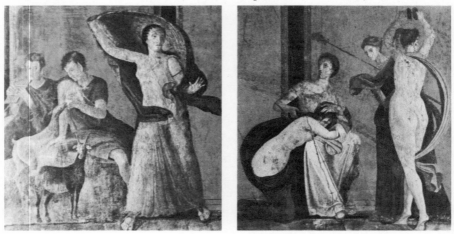

most of these mythological pictures were neither monumental nor sacramental, though still not purely decorative. And even the walls in the Villa of the Mysteries at Pompeii (an unusual example), although they are saturated with dramatic and devotional feeling, never show the drapery during the emotional work, as is the case in so much Western religious painting and, indeed, in much Classical sculpture.

It is possible to trace the course of sculptured drapery elements from their Classical sources through the Middle Ages, even transformed as they came to be into rigid formulas or abstract decorative schemes. The reappearance of naturalism, first in thirteenth-century sculpture in both France and Italy, led eventually to sharp distinctions between the Renaissance drapery styles of Italy and Northern Europe, and, even more essentially, to an expression of the change in attitude since Classical times concerning the relation between bodies and clothes. The newly evolved naturalistic drapery of the early Renaissance was reborn into a Christian world committed simultaneously to the idea of fleshly corruption and to a flourishing textile trade.

Ancient Greeks had made their woolen cloth at home and lived familiarly with it. Like oil or milk, it was a natural element of which the humble source was seen and known. Medieval Europeans lived not so much with it as on it; and cloth to them was an economic rather than a natural staple, a manufactured commodity of prime importance. As a material substance it had something of the status of wrought gold or glass, representing a triumph of man's impulse toward artificial luxury rather than his harmony with the natural resources of the earth. Consequently, as with precious metals, the specific attributes of its luxuriousness—texture, color, weight—could become the substance of myth. The beauty of precious cloth came to nourish imaginative visual lives, but the riches of the body's beauty were not seen in the same light. The nature of man and the nature of cloth were no longer seen to arise from the same source.

This separation of the body from its dress, so contrary to the Classical spirit, is behind the whole later idealization of cloth in Western art. It gives rise to the concept of drapery as something that, while it conceals, yet

confers an extra ennobling or decorative dimension on the essentially wretched and silly human form. The seemingly legless angels of Renaissance art are buoyed up not so much by their wings as by gloriously wrought masses of bunched skirt, which do not clothe but appear to replace unangelic and awkward limbs (see I.13). Cloth is not only better than flesh, more purely beautiful, but it can also seem to be more holy and thus more appropriate to the figuring forth of paradise. It is not, after all, subject to sin.

Nakedness during the Middle Ages came to mean something to be concealed for significant moral reasons and thus to be revealed in pictures only in an atmosphere of heightened moral awareness. With the development of such a morality, clothing began to take on a new aesthetic function in despite of the body. Ancient Greeks and Romans, however sumptuously they were bewigged and bejeweled, and however elaborately patterned and draped their clothes were, never wore trains, padding, corsets, high, stiffened collars, huge sleeves, hoopskirts, or long, pointed shoes. The dialectic between clothes and body was sufficient; it was not necessary to establish another—for example, between tight and loose elements in a single costume or between basic construction and ornamental additions—or to indulge in any aesthetic variations based on the prime necessity for close covering.

Ancient Cretan and Minoan dress, on the other hand, shows characteristics one might readily call primitive. Developed and extinguished long before Classical drapery had evolved, this way of dressing was similar to some African styles that combine distortion, exaggeration, and vivid ornament with a considerable use of nudity. This nakedness becomes only one of the formal elements in a decorative style of dress rather than a fluid entity analogous to draped cloth, as in the Classical manner. The bodies of the ancient Cretans were encased, cinched, clasped, and bedizened, the clothes cut and fitted, leaving breasts and legs bare to form symmetrical patterns with the garments. The aesthetic possibilities of flowing or pleated cloth, so important to the Greeks and Egyptians, were evidently not of interest to these people, who nevertheless worked the flowing forms of fish, plants, and water into objects of extraordinary sophistication.

The combined free movement and clever draping of fabric as a decorative scheme for dress existed among other early civilizations, but representations of it are almost always abstract and stylized, to an even greater degree than bodies and faces are. "Naturalism" for cloth seems to begin with the fifth century B.C. in Greece, and nowhere else. And it is these

first naturalistic sculptural traditions for drapery that have taught all later generations of European eyes to look at cloth specifically for the beauty of its random behavior. During the developing Christian era this appreciation was never lost, but it had to allow more and more for the Christian principle of shame about nakedness and sex, which among other things required strong dress signals to distinguish the sexes, as well as the obscuring of most of the body. Not only must bodies be covered, they must not show artlessly through. This combination of abundant drapery—the legacy of Classical times—with self-conscious surface sexuality, further complicated by the effects of commerce and difference in social class, eventually produced the flowing, complex, theatrical garments of the fifteenth century so much admired by nostalgiasts and fairy-tale illustrators and so magnificently celebrated by contemporary artists.

Early medieval draped clothes were modified versions of Mediterranean Classical dress, combined with certain elements contributed by Northern and Eastern invaders. They had little shaping or fitting or distortion of the figure; but instead of being made only of draped rectangles, they were sewn into baglike garments with sleeves and openings for the extremities, which, of course, hid the body much more efficiently. The fabric, simply tailored as it was, continued to fall into wonderful shapes, lines, and angles, to fly up, trail behind, or hang in massy folds; and just as Classical costume had bequeathed loose fullness to medieval dress, so Classical art had demonstrated the expressive possibilities of representing it in images. Debased or simplified though they may be, variations of freely draped folds continued through twelve centuries to form the basic look of clothing in art as well as in life.

Sometime during the thirteenth century, the aesthetic impulse toward significant distortion and creative tailoring (as opposed to creative draping and trimming) arose in European dress and established what has become the modern concept of fashion. For the first time women cinched their waists and shaved their foreheads; for both sexes, sleeves and shoes began to have unfunctional but symbolic and decorative shapes; headdresses and hats were molded and stiffened; skirts were longer or shorter, collars rose or fell, and different parts of one costume were tight or loose on different parts of the body. Such variations have provided the substance of change in Western fashion ever since, in a way unknown to the Classical world or to early medieval centuries. Draped loose fabric remained a constant, however, whether sleeves were slashed or bodices molded. Until the late sixteenth century it always appeared *somewhere* as an element of fashionable dress, a necessary display of raw luxury.

D rapery in Renaissance European art was not wholly derived from Mediterranean antiquity. Since the late Middle Ages an autonomous Northern European conception of represented cloth followed its own Gothic traditions without the need for Classical authority. In Germany and the Netherlands the fluttering corners of veils and the massively spread skirts of robes appear over and over again for two centuries, carved in wood, cast in metal, painted and engraved, all without Classical quotations. They instead contain an independent, distinctively Gothic set of cloth gestures and drapery phrases; one early Northern trademark is the fluttering up of one corner of a garment in an otherwise completely still atmosphere, like the scarf of the man on the ladder in Rogier van der Weyden's *Deposition*. This single upswept corner in an otherwise immobile group of garments is in keeping with the busy and broken look of all the folds, even in their repose; it seems to stand, like their nervous energy, for the infinite but unexpressed possibilities of cloth, the primary worldly good for Northern Europe. The clothes in these works of art have perfect integrity. However numerous and active the angular folds, they express an unimpeachable garment; and this truthfulness gives the separate abstract vitality of the drapery a greater power than it could ever achieve by taking liberties with facts (I.11).

Italian drapery in the Renaissance followed the Byzantine, which had followed the Classical, in a gradual idealizing process that tended to use the folds to follow and echo the lines of a body, whatever the style. Harmonious curves of cloth, more or less stylized, were modified from observable nature in the direction that made them rhyme with the curves of ideal bodily movement. By the fifteenth century the painted or sculpted clothes had created a notion of ideal physical grace even better than did the more abstract, sometimes awkward nudes of the same period. With draped clothing, the ancient Greeks had managed the impossible—a stylization of cloth and bodies so subtle that the actual and the ideal were apparently identical; in the Christian and neoplatonist Italian Renaissance, artists concentrated on the ideal, with a set of conventions for figuring it forth in drapery designed for this sole purpose (I.12).

The Northern Gothic tradition separated itself from the Italian proscenium-stage perspective in favor of a ladderlike arrangement in which distant objects are placed higher and look smaller, and the foreground tips downward as if to meet the viewer's toes. This tipped-down surface is often the one on which is spread the excess yardage worn by the chief figures; and since it looks spacious because we can see all of it without fore-

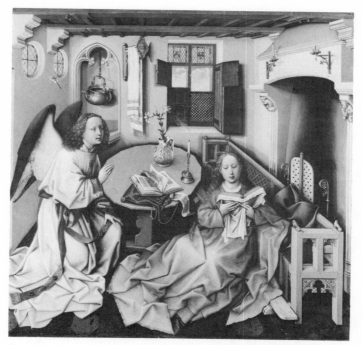

I. 11 MASTER OF FLÉMALLE
(1378/9–1444)
The Mérode Altarpiece
central panel

I. 12 FILIPPINO LIPPI
(C. 1457–1504)
Tobias and the Angel

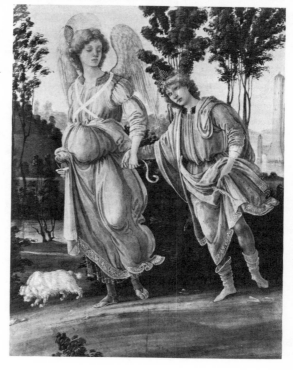

19

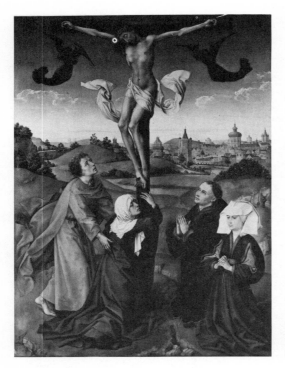

I. 13 ROGIER VAN DER
WEYDEN (C. 1400–1464)
Crucifixion

shortening, there is a greater possible area that the cloth can occupy. Here the drapery leads a busy, self-expressive life, unencompassed and unimagined by the serene, still hands and heads far above them. The heavy woolen skirts of flying angels are suspended in still air in random disarray, as are the floating ends of scarves and veils; it is their own crackling energy and not the wind that agitates them. These antigravitational draperies in Northern art have the same irregular poetry in their arrangement as the worldly stuff that spreads on the ground. The most compelling feature is the random look of the breaking angles, each fold perfectly followed through and seeming to obey a relentlessly perverse logic of cloth rather than any comprehensive logic of design. The struggle seems not to have been for a smoother grace but for an almost painful distillation of truthful details. In the Flemish paintings this effect is aided by refined techniques for rendering texture, which, of course, were also applied to skin, hair, wood, and glass. But a special quality is conveyed by the wayward independence of the voluminous material (there is always so much), whose quirky rules the artist seems to have respected rather than bent to any purpose of his own (I.13).

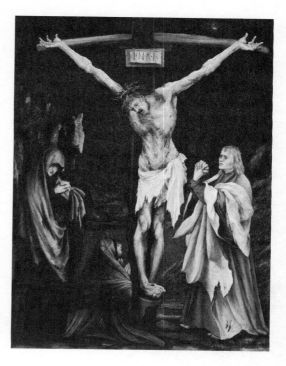

I. 14 MATHIS GRÜNEWALD
(c. 1460–1528)
The Small Crucifixion

The most extreme poetic possibilities of cloth were apparently felt by Northern artists much sooner than by the Italians. At the very beginning of the sixteenth century, German painters like Altdorfer and Grünewald created new, visionary dimensions for fabric—ragged, feathery, luminous drapery impossible in Classically minded Italian art until several generations later, after the convulsions of Mannerism (I.14). So certain of control over the rendering of cloth were these German and Flemish masters that they could permit themselves great expressionistic indulgence: the drapery in the Crucifixions and Madonnas of Albrecht Dürer maintains a solid, unhysterical authority, despite its most extraordinary behavior. The oversized loincloth of the crucified Jesus may flap its unbelievable extra yards out into the air on both sides; but so perfectly reasonable seems every nervous twist of the fabric that the total composition has a cumulative solemnity and no flavor of emotional license (I.15). (This quality may be what makes it seem appropriate to illustrate the music of Bach with Dürer engravings, despite the disparity in dates; it is the same inexhaustible linear invention, with the combined air of inevitability and audacity.)

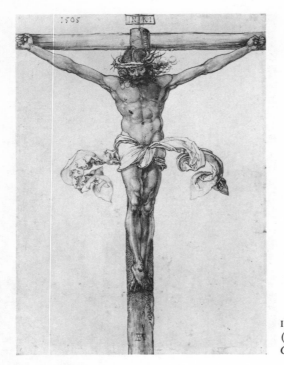

I. 15 ALBRECHT DÜRER
(1471–1528)
Crucifixion, 1505

Dürer was, of course, an outstanding genius, and his drapery motifs were much quoted by his contemporaries and by later Northern artists during the sixteenth century. The dissemination of prints and engravings made artists' characteristic habits familiar to other artists and subject to endless copying. North European religious-image-making had long exhibited the impulse to follow established models, to repeat old formulas while refining the technique; and in accordance with this love of perpetuation, the folds of clothes might be similarly designed and disposed over a long period. The small elements that went to compose the whole spread of garment might be used again and again, as were the standard facial types for holy personages. Dürer was an innovator in an archaizing tradition; he could infuse hosts of new words into an old language without changing the idiom, and artists after him seized on these new materials.

Flemish and German Mannerism in the sixteenth century had a distinctive character, unlike the simultaneous Italian manifestations. It consisted largely of artists' dealing with aesthetic shock resulting from confrontation with Italian art. Dürer, full of a creative and encompassing humanism, had managed very well, synthesizing an individual and triumphantly German style out of alien elements. He went to Italy, but he

never lost his head. Other artists who also went to Italy were less comprehensively and comprehendingly affected and tended to adopt Italianized manners but not principles. The results are bizarre and awkward or magnificent, depending on the artist's essential talent. But in all these curious paintings, despite the use of Italian costume for the Madonna or a *sfumato* rendering of faces à la Leonardo, the drapery style maintains its respectful attitude toward the facts of cloth. Despite some softening of outline, the folds continue to break in naturalistic angles, and their busy action (which gives a Baroque look to these much earlier works) remains true to the real shape of a possible garment (I.16). Antwerp was the center of a group of Mannerist painters whose works were created for export chiefly to Spain, where there was a vogue for decorated and extravagant fantasies in the Flemish manner. These religious scenes are full of fancy costumes with enormous sleeves and fluttering scarves, all somehow the more remarkable because they seem realistic, unlike the obviously invented folds of Pontormo's and Michelangelo's fancy dress from the same date.

We are continually faced with the significance of the many emphatic, excessive ways artists have used cloth, especially in religious and allegorical art; so much expressive freight is carried by drapery itself that its presence lent an inferred religious or allegorical flavor to any picture, even if it is a portrait. In the late sixteenth century, when fashionable garments were cut intricately and fitted tightly without much free play of fabric, drapery of a most vivid kind frequently appears in the background of portraits; and it usually looks too aggressively vigorous to be a domestic detail.

The pictorial convention of a hanging cloth behind a portrait subject has its origins in the actual use of an honorific hanging behind the place where a king sat or stood—the Cloth of Honor, which had also been used by centuries of Christian artists as an appropriate backdrop for an enthroned or standing Madonna (I.17; see I.16). Its appearance behind a prosperous citizen was a satisfactory pictorial, if not symbolic, extension of its use behind the Queen of Heaven. But the originals of such back cloths were stiffly and smoothly hung, like tapestry, to display their weave or pattern; and they often function in Early Renaissance pictures like mosaic or painted walls, with no clothlike quality. The dress of the fifteenth century was characterized by a natural drape and sweep of free-flowing material; and so artists could put it to elaborate use on figures in compositions that would not require much extra drapery to satisfy the eye's pleasure in it. The Cloth of Honor did not need to swag or billow until dress temporarily ceased to do so.

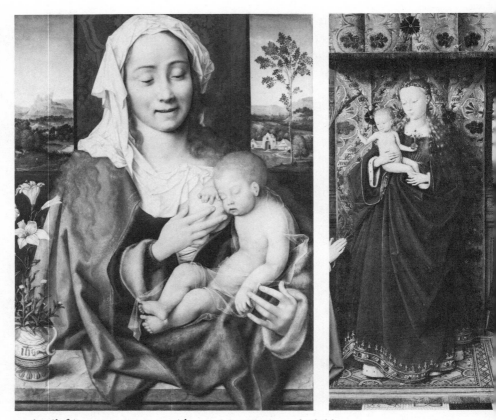

I. 16 (left) JOOS VAN CLEVE (d.1540/1), *Virgin and Child*

I. 17 (right) JAN VAN EYCK (active 1420–1441)
Virgin and Child with Saints and Donor (detail)

Many portraits by Bronzino and his followers, for example, show how a pictorial need for the look of draped cloth can transfer itself from the figure to the background, where the vivid and energetic stuff commands attention though it lacks any reasonable connection with the setting (I.18, 19). During roughly the same period, some Elizabethan portraits include swags of stiffly rendered metallic-looking cloth that do not hang behind the subject but are drawn aside to reveal or frame it (I.20, 21). The icon-like rigidity of the clothes and bodies in these pictures, so different from Bronzino's poised and nonchalant subjects, gives these painstakingly crushed and asymmetrical folds a bizarre poignancy. These are not Cloths of Honor but examples of instant dramatic emphasis in the form of cloth, tacked on as a dutiful afterthought in accordance with the current artistic

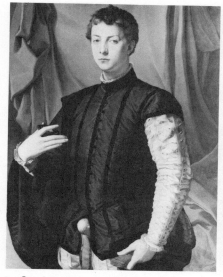

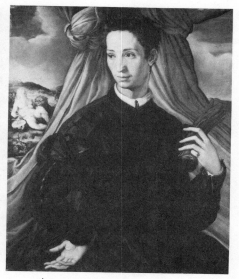

I. 18 AGNOLO BRONZINO
(1503–1572)
Lodovico Capponi

I.19 Attr. MICHELE TOSINI
(DI RODOLFO) (1503–1577)
A Florentine Nobleman

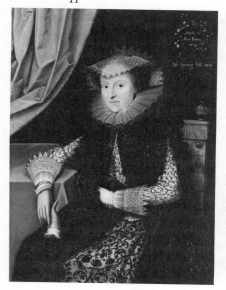

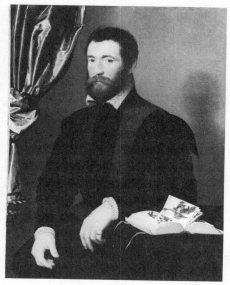

I. 20 MARCUS GHEERAERTS
(c. 1561–1635)
Lady Mary Scudamore, 1614–15

I. 21 FRANÇOIS CLOUET
(c. 1510–1572)
Portrait of Pierre Quthe, 1562

mode—and this even though the essential spirit of this school of portraiture runs contrary to drama or sensuality.

The middle sixteenth century saw an increased stiffening and shaping of the material for clothes. The remarkable development of the starched ruff, for example, begins during this period, along with stuffed codpieces and farthingales and other rigid arrangements of padding, all of which were later discarded. But so strongly had the look of flowing drapery entrenched itself in concepts of visual beauty that during this stiff period in fashion just before the Baroque era, quantities of fabric began to appear in art for the first time as purely imaginary, decorative scenery.

Curtains are practical arrangements for achieving a number of purposes. They may divide large spaces into small sections, shut out drafts and light, and conceal the presence of anything that does not smell or make a noise. They can do all this in a conveniently temporary way, and then be folded back and made to reverse the same functions by permitting the passage of light and air, opening up large spaces, and revealing what has been hidden. All this may be accomplished without the trouble and expense of solid construction or elaborate technical devices other than rods for support. The purest use of curtains thus would appear to be that ancient invention, the tent—a whole building made of cloth. Tents are freighted with all the mythological power of any sudden manifestation: they may appear overnight in huge numbers in the desert wastes, or rise like visions in dark, empty forests, and then just as suddenly vanish. In the Western European imagination tents were associated not only with military camps but also with the exotic customs of the East; and so they lent themselves to visualizations of both biblical scenes and the heroic, legendary events of Classical times.

One important version of the tent is the pavilion, which is a kind of free-standing platform with a roof held up by four corner supports. Such open-sided, canopied structures were part of the interior architecture of churches from early medieval times. They were often honorific settings for tombs, but they had their origins in the *ciborium,* the dwelling place of the Eucharist or Easter Sepulcher. Religious drama often made use of these pavilions in churches for enacting scenes of special importance, and they appear in medieval paintings for the same purpose when emphasis is required for a central group of figures. A curtain across one side of such a structure could form a background; across three sides, a completely enclosed niche. When all four sides were curtained, the result looked like a tent. The closing or opening of hangings around a pavilion was an obvious dramatic as well as a

ritualistic device, and the secular theater also made use of it. The drama in many Early Renaissance paintings is emphasized not by the action of the figures but by its occurrence inside a pavilion, with or without curtains.

Tomb sculpture of the fifteenth century, following the Church custom for the Easter Sepulcher, often shows the sarcophagus inside a pavilion, sometimes revealed by angels drawing aside stone hangings. Tents and pavilions are often interchangeable in Renaissance scenes; a hero may legitimately appear in a tent, and a king in an actual pavilion or in a symbolic one surrounding a throne. A canopied throne, with hangings at the back and sides, is an honorific tent, and so is a bed similarly caparisoned when it is used in art as a setting for the birth of the Virgin, for example. Cloth put up as a background or tacked around three sides of an unroofed space, on the other hand, was used in the secular theater simply to symbolize an interior.

When hangings are represented in art in the late Middle Ages and early Renaissance, the drapery is visibly attached to some throne or pavilion logically present in the picture. In actual life, such hangings of thrones and indoor partitions are to be carefully distinguished from any purely decorative drapery. They were ways of using cloth—whether for ritual or honorific or practical purposes—as a movable architectural element similar to a screen; the point is that a flat curtain altered the existing space. In art, folds that occurred when the curtains were drawn back are shown as a necessary result rather than as a specially created, pleasing effect. So, too, in the case of tapestries; although their practical function was to keep out drafts and damp, rather like vertical carpeting, the aesthetic satisfaction came not from folds but basically from the flat expanse of color and pattern.

Hangings obviously date from the earliest uses of cloth; but until the sixteenth century their three-dimensional plastic beauty was a consideration secondary to their function. Purely decorative cloth hangings, distinct from ceremonial and dramatic ones and from the essentially practical tapestries, were indeed used through the Middle Ages and the Renaissance on festival occasions. The arrival of a king in a city would be greeted with a display of cloths hung on buildings, arches, and gates. The stuff, however, was not swagged or bunched but spread out flat to provide color and sometimes painted to show scenes, emblems, and coats of arms. Cloth, as we have seen, was by this time closely associated with luxury and treasure. For garments its excessive use had long been a sign of wealth, and artists had demonstrated the casual beauty of lush folds of clothing or curtains. But real cloth for *decoration* was evidently spread flat. Flags, pennants, and military standards were obvious exceptions, and would have been admired for their flap and flutter.

27

The whipping of flags and standards is shown in Renaissance art, and the phenomenon is further exploited in the pictorial use of swirling banderoles with names or utterances or mottoes on them that provide useful glosses to the pictures (I.22). They are often held by figures, or they may simply float in the air. They are very frequent in the illustrations for emblem books and in the decorative material surrounding pages of printed text, where they are held by allegorical figures or swagged across arches. These informative strips of cloth or parchment were used in Renaissance theatri-

I. 22 MASTER OF FLÉMALLE (1378/9–1444), *Nativity*

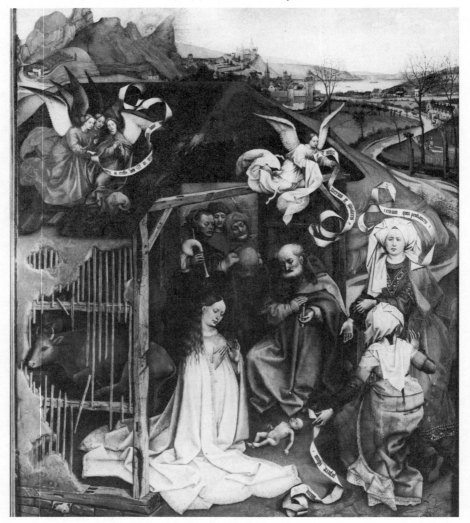

cal performances and particularly in the *tableaux vivants* set up for state occasions; and when they appear in pictures, as in the case of curtains, their formal elements may be decorative but it is their useful purpose that justifies their presence.

Renaissance decorative material in printed books contains no free-floating drapery much before 1550 that is neither a tent flap (pavilion or throne hanging), a banderole with a written message, nor part of a garment. Swagging and swirling for purely ornamental effect is done instead by yards of garlands, leafy motifs, flames, animal and human forms, clouds, or water. Then, about the middle of the century, for the first time ornamental pieces of draped cloth appear, without even vestigial pavilions to account for them. Interior backing or framing for parts of scenes and for portraits had already begun to consist of fancily draped material that seemed to have no practical or formally honorific purpose and often no visible source.

Holbein's portraits of Magdalena Offenburg as Venus and of Sir Thomas More, from 1526 and 1527, have a profusion of sweeping draperies behind the subject that might conceivably hang from a canopy or cover a door, but no specific reference is made to these possibilities (I.23, 24). Another one of many startling examples, this time from the middle of the century, is Clouet's portrait of Pierre Quthe (see I.21). Here the gentleman wears a rather somber tight black suit, but next to him, in the same plane, hangs a glittering green satin drapery, falling from somewhere above and caught up halfway down. It does not frame him or hang over and behind him; instead it seems to accompany him rather like a beautifully dressed wife. There are many cases of such living, breathing drapery, like a presence brought into existence to speak a poetic language of its own, in counterpoint to the straightforward diction of a portrait likeness wearing dark and simple clothes.

We have noticed how crushed curtains seemed needed to decorate many portraits of rigidly clad Elizabethans and to back up Bronzino's chic youths in their form-fitting doublets, but the tight clothes do not entirely account for all the draperies, since they are not invariably worn. Another vivid example from Bronzino is the transparent striped fabric falling behind the likeness of a lady, called Eleonora of Toledo, in the Galleria Sabauda in Turin (I.25). Here the stuff falls down plentifully on the left but then it bunches and billows up again on the right, seemingly heaped on a shelf as if the lady were buying yard goods.

It is striking that during the period of increasing use of drapery with, and not only behind, a portrait subject, the cloth in the painting is often

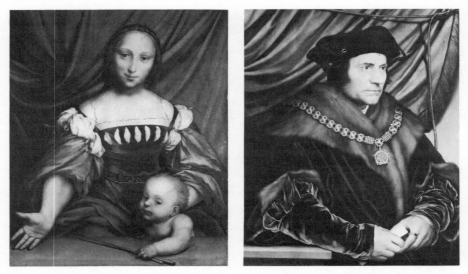

I. 23 (left) HANS HOLBEIN THE YOUNGER (1497/8–1543), *Venus and Amor* (portrait of Magdalena Offenburg), 1526

I. 24 (right) HANS HOLBEIN THE YOUNGER (1497/8–1543), *Sir Thomas More,* 1527

an insistent green in color. The habit appears all over Europe, beginning with Raphael and Holbein, and continues throughout the sixteenth century at the hands of artists good and bad. Green was a color that had, of course, acquired layers of symbolic and literary significance by that time; but so had all the other strong, constant colors in nature. Whatever the reason, the extraordinary prevalence of bright green for the decorative draping of portrait settings did not survive into the seventeenth century, when red, brown, gold, and various grays came to be favored.

The decorative swagging and looping up of stuff seem to have become self-justified in pictorial art during the sixteenth century, but it would be interesting to know whether this artistic practice was reflected in actual interiors of the time. The custom of festooning and bunching up cloth to create gratuitous drapery, for no other purpose than to enjoy the way it looks, seems to have been invented not by interior decorators but by the artists of the sixteenth century, who first used the kinds of pictorial drapery rhetoric so conventionalized in following centuries. Before the seventeenth century, European rooms were apparently furnished with little hung and draped material except for the hangings of beds, which had the purpose of keeping out drafts and light. Curtains covered doorways for the same reason, but windows were evidently not curtained at all for hun-

dreds of years. The swept-up excessive hangings that share the picture frame with so many sixteenth-century likenesses do not appear in any of the pictures of the actual rooms in which such personages lived. Tapestries and cloth coverings for walls were spread out to hang straight; and when fabric did drape, it did so when bed curtains or door hangings had to be pushed aside for convenience, not beauty.

The seventeenth century brought back a fashion for full, loose clothes and with it a love for full, loose drapery to decorate surroundings, probably in imitation of the purely pictorial modes invented during the preceding century. Interior scenes began to show curtains swept back dramatically from doors and beds (though still not near windows) rather than pushed back neatly. Scenes of humble cottage life might include a torn, rough door hanging as elegantly draped as a velvet curtain. Whether it was the artist's idea or actual custom that produced these folds is, of course, difficult to judge. But it is nevertheless clear that in fashionable early Baroque portraits, the dynamically active miles of fabric that invest so many settings have little to do with current schemes of interior decora-

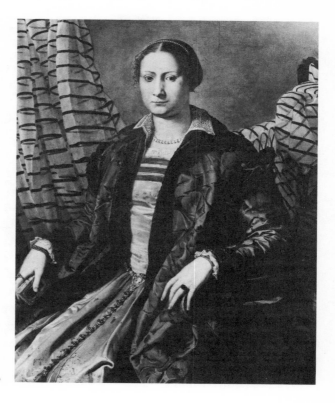

I. 25 AGNOLO
BRONZINO
(1503–1572)
Portrait, called
Eleonora of Toledo

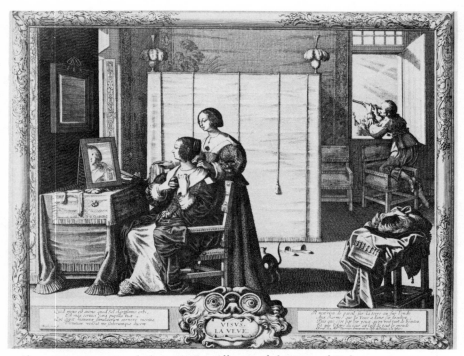

I. 26 ABRAHAM BOSSE (1602–1676), *Allegory of the Sense of Sight,* c. 1630
Domestic interior with flat tapestry, boxlike bed drapery, and no
window curtains

tion (I.26). Later on, the phenomenon of life imitating art may be observed in the elaborately developed art of window draping in the early nineteenth century. Neo-Classic taste required the use of drapery in clothes and for domestic interiors to carry the look of antiquity even into the usages of everyday life (I.27). The spell of Classical drapery, never entirely broken, was asserting itself yet again in cloth-conscious industrial Europe. Ultimately, in the late nineteenth century, it appeared in the draping of absolutely everything from bustles to banisters.

Evidence for the usage of draped cloth in the interiors of antiquity is sparse. Coverings for seats and beds do constantly appear in all Classical art—spread out, rucked up, and tousled rather than draped to advantage; and lengths of fabric tacked up at regular intervals appear as backgrounds. This room-dividing stuff is clearly meant to spread fairly flat, dipping slightly from point to point of attachment without emphatic swagging. Draperies were similarly tacked up around beds, with knots of fabric to hold them up, and also around couches, presumably for privacy. Specifi-

cally for decoration, however, elaborately draped hanging cloth does not seem to have been much used, nor is it painted on for decoration in the Roman houses. The painted or carved swagged cloth, used exactly like garlands, which characterizes Neo-Classic decor, has no source among Classical decorative motifs. But once the High Renaissance convention was inaugurated for using ornamental drapery off the figure, either randomly or formally arranged, without any visible specific function, it became a universally useful element. It lent itself with great accommodation particularly to Neo-Classic artistic ideals, first in the seventeenth century and later in the nineteenth.

Reconstructed Classical scenes in the art of both periods, displaying great efforts at accuracy in costume and architecture, might also include a profusion of invented drapery to clothe columns and arches. An exaggerated example from early-nineteenth-century Romantic Neo-Classicism is the third panel, *Consummation,* of the set of five paintings entitled *The Course of Empire* (1836) by Thomas Cole (I.28). This shows an imaginary, more-or-less Roman triumph taking place in a harbor city glittering with riches and celebrations. The procession occurs in the foreground under arches decked in huge, unimaginable and unmanageable lengths of bright-colored draped material. Indulging this grandiose fancy, Cole goes

I. 27 ANONYMOUS
The Borghese Family in Their Palace of Borgo Pinti, Florence, c. 1828

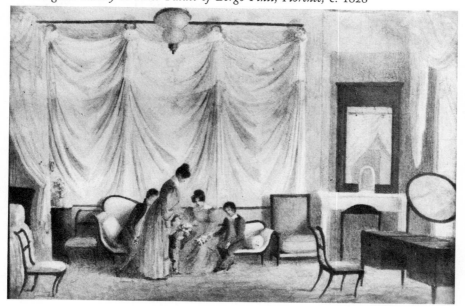

I. 28 THOMAS COLE (1801–1848), *The Course of Empire,* No. 3 (*Consummation*), 1836

further with such colossal curtains in *The Architect's Dream* (I.29), in which literally thousands of yards drape the architectural elements in the foreground, dwarfing the tiny figure.

I have tried to distinguish this specifically decorative stuff, which first appears in the art of the High Renaissance, from the functional drapery intended to represent discarded or disarranged clothing, bed linen, or the conventional hangings of beds, tents, and canopies, which Western artists had always put to ornamental use and, of course, continued to use. But it is also not quite the same thing as the new, expressive pictorial cloth used in the visionary religious art prefigured by Michelangelo on the Sistine Ceiling, a fabric that appears in Mannerist painting, where no decorative or functional trappings can account for it.

The billowing bag in which Michelangelo's God is wrapped and borne forward by his attendant angels is an early example of such visionary cloth. The drapery drawn back from an unsupported heavenly curtain rod to reveal Raphael's Sistine Madonna is another. This new, proto-Baroque scene drapery shares its unaccountable qualities with the kind of clothing also invented for the religious art of the sixteenth century. The garments first given by Michelangelo to his divine and legendary characters began in his early years with the same conventions everybody else followed: gowns, tunics, armor, and cloaks, all rational in their construction, with visible shapes and seams. Most of the clothed figures on the Sistine Ceil-

I. 29 THOMAS COLE (1801–1848), *The Architect's Dream*, 1840

ing (1512) wear comprehensible, if fanciful, garments; but in the Pauline Chapel frescoes, painted during the 1540s, the figures are often dressed in bubbles and pockets of fabric, sometimes readable as draped rectangles but more often impossible to interpret except as unpredictable stuff analogous, though not similar, to rays of light or clouds.

Mannerist painters all over Italy were creating such fabric fancies just at the period when the ascendancy of the Counter-Reformation required religious art to generalize the stage properties of sacred scenes. Unspecific drapery, on or off the figure, could serve, like clouds, as an expressive vehicle good for both worldly and spiritual subjects; and now, since Michelangelo, it demanded no clear indication of its structure, the way buildings and furniture do. Furthermore, the magnificent drift of cloth could just as correctly be shown to characterize the lowly garments suitable for shepherds as it might the sumptuous hangings proper to princes. And so it might safely be used to enrich a biblical scene without falling into the error of a too specific, and perhaps canonically incorrect, detail.

Once the visual acceptability of indeterminate swatches of fabric had been well established, they could be called into play whenever needed, for figures as well as for scenes. The floating little bits of pubic drapery added by Daniele da Volterra to Michelangelo's *The Last Judgment* would have been impossible for an earlier public to accept, not because it had different theories about genitalia but because it was accustomed to pictures of

35

clothes and drapery making basic sense. Classical sources, which are responsible for our acceptance of any sort of artistic drapery, never used the smallest amount that was not rational, even if it were very stylized or exaggerated. The same scruple applied to most medieval drapery, with a few exceptions usually arising from a shaky misreading of a clear prototype. And the drapery of the early Renaissance through the fifteenth century, however unnaturally it may flutter, is always nevertheless in perfect essential harmony with fact. Tunics and gowns have comprehensible forms and construction, and cloaks and veils have edges and corners, whether worn by angels or shopkeepers.

By the mid-sixteenth century, however, a distinction appears between such "visionary" cloth exempt from realistic properties, whether on or off figures, and the careful rendering of actual clothing. There was a division in portraits between gaudily draped scenic curtains and severely cut clothes, but there was also a division between vague, baffling, Michelangelesque draped clothing (suitable for high themes and heavenly beings) and ordinary people's cut and sewn garments. One picture might by this time contain both, so as to show common men transported to higher spheres or heaven brought down to earth, all by means of fabric.

Clothing in Mannerist religious scenes in the late sixteenth century might consist, as in El Greco and much Venetian art, of garments from which it would be impossible to draft a pattern or, in portraits, of detailed costumes with no kind of extra fabric in the picture. It also became possible to combine them not just by draping the background but by showing a man in an elegant tailored suit, with a sort of free-floating vague drape worn over it, presumably indicating a cloak. The vagueness itself would invoke all that such yardage had come to suggest during the preceding decades: that it was not ornamental but somehow transfiguring.

By the early seventeenth century cloudlike, flamelike rivers of cloth could billow behind a prosperous citizen or flow over his shoulder and across his lap. Rigid modes in fashionable dress now included such loose accessories—until taste shifted entirely toward billow and the new Baroque sense of cloth asserted itself. Draped cloth per se accumulated an immense expressive visual power, first from its august origins in Classical sculpture, on through its medieval associations with holiness and luxury, and finally through its emergence as a purely artistic basic element, ready for use in any representational convention. During the seventeenth and eighteenth centuries, not only did widely differing Baroque artists invade this visionary fabric warehouse but also profuse draped stuff itself, drawing on its vast pictorial credit, came into its own in interior decoration.

During the first half of the seventeenth century, painted flesh, clothing, and backgrounds were continuing to undergo change. In European portraiture, elegance had ceased to be expressed only in conventional formal terms. The great portrait heritage born of Renaissance humanism, begun in the days of Dürer and confirmed by Bronzino and Titian, had finally given unlimited scope to the art of painting individuals. The sitter's unique character could be the *subject* of the picture, even in an official court portrait; his soul could be revealed by his expression, not by his attitude of prayer, and his high station by the set of his head and shoulders, not by the number of his pearls. The movements and modeling of a living face could be conveyed with suggestive, feathery brushstrokes; and the richness of clothing and surroundings could be rendered obliquely, so that indistinct allusions to jewels, fur, and satin or to marble and tapestry took the place of explicit clarity.

The great Venetian portraits show first and best how this could be done. Notions of chic had come to allow (as they had begun to do earlier) for the strong effects of black clothing, which enhances the distinction of the face and shows up sharply against any setting. Elemental drapery, now fair game for all, could swag, loop, drip, or flow in shimmering paint behind and around a likeness, sneakily giving a flavor of luxury to a man's austerely dressed person; or it might convey the energy of his personality, otherwise shown by his sober face to be under strict control.

The emblematic quality of so much sixteenth-century art had been of great importance in portraiture, where a single image may be invested with many layers of meaning. Portraits were filled with specific allegorical material, such as Queen Elizabeth shown holding the Sieve of the Vestal Virgin or people pointedly presented as mythological characters. The general habit of reading meanings into the details of portraits also made it possible for drapery to acquire some of the same emblematic significance carried by such trappings as skulls and mirrors. In Bronzino's portrait of Andrea Doria as Neptune, the admiral is nude, carries a trident, and stands before what could be the mast of a ship (I.30). Down from the upper right flows a drape that sweeps across the space behind him, and then is caught modestly across his front by his left hand. This useful cloth, appearing from offstage in such a context, becomes partly a sail, in keeping with the nautical milieu, and partly a Classical garment, in keeping with the mythological subject. Again, Holbein's Magdalena Offenburg (see I.23) wears sixteenth-century dress, but her profusely draped backdrop may be an implied Classical reference in itself. Similarly, in El Greco's portrait of Vincenzo Anastagi in the Frick Collection the arbitrary drapery that dips

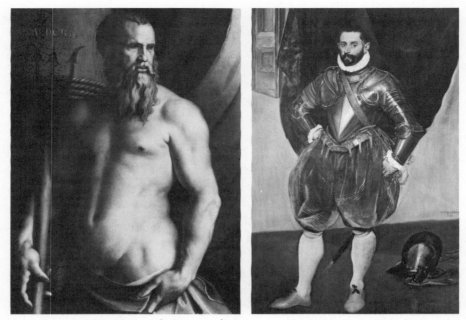

I. 30 AGNOLO BRONZINO (1503–1572)
Portrait of Andrea Doria as Neptune

I. 31 EL GRECO (1541–1614)
Vincenzo Anastagi, 1571–1576

down and up again behind the armed man suggests a military standard, now at rest and drooping to match the unworn helmet set aside on the floor (I.31).

In the portraiture of the seventeenth century, Velásquez, Rubens, and Van Dyck have fabric under expert management chiefly as an appurtenance of self-confident nobility at its ease. In contrast, the portraits by Rembrandt and other Dutch artists who depict sober burghers in their Sunday best rarely have any drapery in the background or on the figure. These garments are furred, rich, and dark, the linen and lace are perfectly ironed and expensive, but there is no romantic or aristocratic rhetoric in operation. Van Dyck, however, to achieve the note of sumptuous nonchalance appropriate to his noble sitters, might irrelevantly hang drapery in a setting quite unsuited for it—with curious results. The painting in the Frick Collection of James, earl of Derby, with his wife and child shows the family out of doors, standing on bare earth with shrubbery in the foreground and trees behind (I.32). But on the right side of the painting, behind the earl, next to a column that might conceivably be part of a house, fifty yards of dark red stuff cascade to the ground from

nowhere. So skillfully does Van Dyck fling down these folds that their ludicrous inconsequence is unnoticeable, and they appear appropriately elegant.

The column and drape, which Van Dyck made to seem so perfect an accompaniment to the image of leisured self-assurance, has at least one source in Bronzino's portrait of Stefano Colonna (I.33). Here the emphatic column in the background puns on the sitter's name, and the drape next to it, as in the El Greco, has the air of a limp military standard at rest

I. 32 ANTHONY VAN DYCK (1599–1641)
James, Seventh Earl of Derby, His Lady and Child

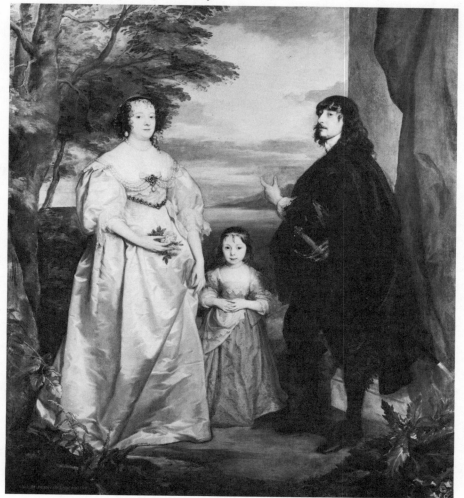

I. 33 AGNOLO BRONZINO (1503–1572) I. 34 A. VAN DYCK (1599–1641)
Portrait of Stefano Colonna *La Marchesa Spinola Doria*

behind the unhelmeted armed man. By Van Dyck's time no symbolic meaning was necessary for these props (beyond the vestigial reference to a Cloth of Honor)—only the suggestiveness of rich, plentiful tissue combined with Classic architecture (I.34). This visual formula has sufficed ever since to indicate a general atmosphere of stateliness and ease, with overtones of historical or mythological reference. Some modern decorative motifs are reflections of this early Baroque theme: shop windows displaying *bibelots,* silver and china, or small sculpture will often show the objects set in cascading puddles of mussed-up taffeta. These alone, an echo of the seventeenth century, create a tangible whiff of raw elegance that would not be present if the same stuff were spread out flat.

As shining folds were being generated from indefinable sources behind Rubens' and Van Dyck's courtly sitters and as huge clouds of similar stuff were appearing above the heads of Velásquez' royal Spaniards, pictorial fabric was generally increasing in bulk and movement during the seventeenth century while further declining in definition. There seemed to be an unwillingness to show exactly what the drapery was doing, perhaps even a positive desire not to know. The unique vision of El Greco offers a pure and extreme example, just at the turn of the century, of the new uses of artistic drapery. In his private extrapolation of Venetian Mannerist methods, El Greco used blurry, febrile shapes to create an extraordinary

amount of movement and tension on the surfaces of his pictures. The clothes worn by his trembling, soaring, distorted figures are of that same irrational cut first invented by Michelangelo; but now, not only are they used in the same way as clouds, water, or flashes of light, they are also made of the same material. Drapery in El Greco's religious works has none of the power of literary or historical allusion that even very sketchy folds have in the work of more conventional artists. It bursts like lightning out of the atmosphere to envelop his angels and saints, often indistinguishable, except for its color, from the stormy clouds that support or hang over them (I.35).

Such a desire to blur the distinctions between mundane woven cloth and various kinds of elemental matter is one Baroque tendency; and it is pointed up most sharply, as the seventeenth century progresses, by the Baroque sculptor's impulse to make billowy cloth and frothy clouds out of heavy metal and stone. No later Baroque painter in any country ever quite matched the fluid fire of El Greco's drapery; but in the realm of sculpture the great Gianlorenzo Bernini demonstrated how far the new freedom

I. 35 EL GRECO (1541–1614)
Baptism of Christ

for folds could take a genius in three dimensions. Sculptural representation of flesh and of most objects still required some basic naturalism, and techniques had become elaborately refined. Bernini's early nude statues from the 1620s—the *Rape of Proserpine* and the *Apollo and Daphne*—show the delicacy he could employ. Drapery, however, was by this time exempt from kinship with the ordinary objects common to human life, such as books and keys, arms and legs, or, indeed, clothes. It had become a potential manifestation more similar to unusual turbulence in the heavens than to household linen—so far had Western Europe come from ancient Greece.

In Bernini's statue of Constantine (1654), at one end of the portico of St. Peter's in Rome, the armed Roman emperor rides his horse bareback on a pedestal inside a niche (I.36). He wears a crown and a perfectly comprehensible windswept cloak over his armor, and he holds his rearing horse's mane with one hand. Horse and man are more than life-size, according to the requirements of this artist and this enormous church; and larger than life, too, is the huge, swaying airborne stucco curtain behind them. Rudolph Wittkower thought this overwhelming stuff represented a Cloth of State; but in fact it manifests itself more as a supernatural cloth bundle out of which a toy horse and rider have been tumbled forth. Some of this fabric is piled up on itself overhead, more is heaped behind the horse's hindquarters, and the one visible edge has swung heavily to the right to sweep the group forward. Coming from nowhere and supported only by itself, this material is pure persuasive rhetoric—a visible gust of wind, a tangible flourish of trumpets. Carved in low relief against the wall behind it is a perfectly conventional canopy and back cloth, suitable for an emperor but here almost completely obscured by the intervening mass of stucco folds. The crazy look of this drape is paradoxically more noticeable because it is still rather naturalistically treated in comparison to Bernini's later confections. The garments worn by many of Bernini's saints and angels defy, as Wittkower says, "all attempts at rational explanation."

Not only do they defy it, they are in opposition to it. The aim is not to cheat by suggesting real clothes with faked folds but to replace clothing with instances of spiritual enlightenment and divine ecstasy. The transitory but eternal moment of grace is seized by these flickering, suspended bunches of marble material, and by this time spectators might read such messages in these statues, untroubled by the lack of logic in the garments. The clothes of allegorical or divine figures could acceptably be floating rivers of stone, molded to convey the motions of the soul. They are no longer exaggerated extensions or extrapolations of recognizable garments

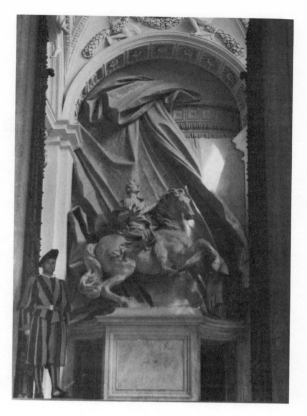

I. 36 G. BERNINI (1598–1680)
Constantine

but pieces cut off the same visionary bolt that El Greco and Van Dyck used. On Bernini's great religious carvings, the *Saint Teresa* and the *Saint Longinus,* for example, it is spiritual in application; but on the bust of Louis XIV (1665) Bernini has ripped down one of Van Dyck's aristocratic curtains and whipped it around the chest of the king like a cloud on which his head and shoulders may regally float, otherwise clad in lace cravat, armor, and wig (I.37).

In this way, incidentally, Bernini solved the sculptor's problem of gracefully finishing off the bottom edge of a bust while making use of the currently elastic fashions in attendant drapery. The trick was widely imitated.

Louis's drifting swatch might indeed be a cloak, but Constantine's enormous tarpaulin could be nothing but sculpture. Certain figures, such as actual ecclesiastics, need some recognizable attributes to be properly identifiable; and Bernini's popes and archbishops and the nun Saint Teresa satisfy this requirement with their hats and a little trimming, otherwise

43

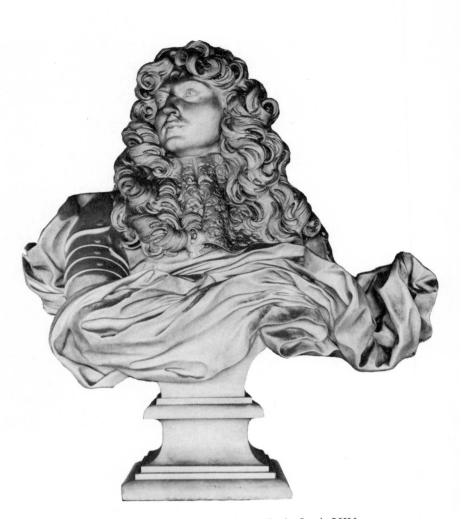

I. 37 GIANLORENZO BERNINI (1598–1680), *Louis XIV*

wearing vestments quite unlike the stiff, heavy robes of the Church. Copes and chasubles do not, cannot, float and flutter and swirl around—unless, of course, they are made of stone (I.38).

One important use of cloth in real life, not exactly for decoration, is funerary drapery, which was and still is widely used as a symbol of grief to drape coffins, biers, and parts of buildings. The custom allowed Baroque sculptors in particular to swathe and festoon monumental tomb sculpture with decorative stone folds, representing rather animated funeral palls

44

(I.39). Bernini's tomb of Pope Alexander VII in St. Peter's is decked with a ponderous green marble pall, in which thick folds occur as it is shoved aside by an emerging sculptured skeleton brandishing an hourglass. Bernini's funeral palls are always more agitated than mournful, but other, more Classically minded artists made them hang in folds that nevertheless were still randomly draped in the requisite artistic disarray rather than spread out smoothly, as they were in actual practice. Modern cemeteries are still populated with the descendants of these Baroque tombs in the form of monumental stone urns bearing towellike stone drapes artfully disarranged over them. The cloth is the emblem of mourning; the disarrangement is a device of art.

European Baroque art had many modes of expression, of which Bernini's is only one. In painting, the strong thread of realism stretching from Caravaggio's grubby saints to Rembrandt's Jews included the peas-

I. 38 G. BERNINI (1598–1680)
Fathers of the Church

I. 39 F. DUQUESNOY
(1594–1642)
*Tomb of Ferdinand
van den Eynde*

ants and beggars of Velásquez and their serene French counterparts in the works of La Tour as well as the jolly tavern brawlers of Frans Hals. Whether the subjects were religious or homely or unpretentious folk chosen by the artist for their paintable looks, the pictures in this broad tradition laid stress on the rougher surfaces of life. Whatever the exact technical style or school, this form of seventeenth-century painting dealt with careworn faces among picturesquely lowly attributes of poverty. By the beginning of the century Caravaggio had shocked his public with the wrinkled soles of his Saint Matthew's bare feet; but as Baroque taste progressed other schools of painting in Spain and Holland made this brand of naturalism an accepted mode, as conventional as elegant portraiture.

New methods were necessary for composing and presenting these newly fashionable harsh facts. Since marble and rich materials could not inhabit such scenes to fill the spaces and create the balance of shapes, light itself came to be used almost as if it were drapery. The arbitrary, vivid

spotlighting originated by Caravaggio is not very naturalistic; it is more a dramatic and rhetorical tool, just like the persuasive festooning of an invented curtain. Drapery has a limited role among the poor, but swaths of light and shade may decorate the meanest squalor. The Caravaggesque painters abandoned altogether the generalized light that bathed most paintings in the previous century, even those with added flickering flashes as in Tintoretto and El Greco. Beams or one beam streaking in from a single and sometimes mystifying source might furnish the only light by which the subjects of these paintings could be read at all; but apart from their function as illumination, these beams could also strike fiercely or wanly across backgrounds and bounce off irrelevant objects, to provide an unspecifically dramatic setting in the same satisfying way that fabric did in other contexts.

The very absence of drapery in such scenes also indicates a rejection of the whole Classical spirit and the celebration of opposing artistic principles. Still, Baroque extravagance and Neo-Classic impulses were potent enough to affect the work of those who were essentially followers of the "realist" school. There appeared, not only in Italy but all over Europe, biblical and legendary scenes peopled with grim-visaged peasants and lit with lurid spotlights and also awash in fabric (I.40, 41). Genre scenes continued to have mundane props and scrupulously scruffy realistic dress

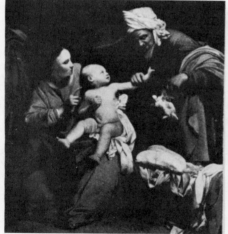

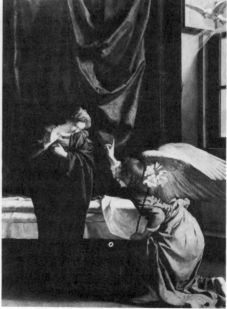

I. 40 CARLO SARACENI
Madonna with Saint Anne

I. 41 (right) O. GENTILESCHI
The Annunciation, c. 1623
Drapery and poverty

47

for gamblers and soldiers, whores and fortune-tellers, bandits and beggars; but countless religious pictures were done in which the standardized vague and heavy draped garments of the saints were combined with equally heavy and vague suggestions of tent flap, bed hanging, or canopy, the whole mixture vigorously whipped up and then sprayed with similarly indeterminate beams of light.

The greatest painters have always scorned rhetoric. Georges de La Tour permits no dramatic lighting of which the source is not only visible but believable, and no garments, however nobly draped, that do not have contemporary structure with seams and hems, nor any movement without the exact amount of physical energy needed to create it. Later on, the same was true of Velásquez and Vermeer, whose artistic heritage also stems originally from Caravaggio. Similarly, Rembrandt and Hals never irresponsibly sling light and cloth around the body or the background, but only with a very controlled purpose. Although seventeenth-century Dutch painting was expressive of bourgeois Protestantism, and sharply divided in spirit from Catholic Italy and Spain as well as from the romantic and courtly Flemish art of Rubens and Van Dyck, in portraiture the Dutch could make what appears to be an ironical use of certain courtly elements.

In Frans Hals's portrait of Willem Van Heythuyzen, for example, the subject has been posed in an almost grotesquely haughty attitude, like a parody of Van Dyck's *Charles I*—and, sure enough, behind him hangs a bright red drape, quite unusual in Dutch portraits (I.42). This one is a parody like the pose itself, hung with blatant artiness from two sticks across a Classical portico as an emphatically fake noble attribute. Another example is the 1627 group portrait of the Civic Guard of Saint George in Haarlem, behind whom, instead of the details of the room, Hals shows a huge, portentously draped swath of satin reverberating in the space like an orotund speech (I.43). One or two of these smug guardsmen also add to the grandiose effect by carrying a loosely furled standard over the shoulder, and all wear the diagonal sash then fashionable everywhere. These sashes were not sword belts but, along with the equally fashionable randomly draped cloaks, show the decorative use of crushed fabric for dress accessories that had become so chic all over Europe during the first quarter of the century. Baroque drapery, having seemed so satisfying in royal portraits and images of sacred moments, thus became personal and portable, even in sober Holland. Plucked from the paintings and flung over the shoulder, they were like free-floating bits of careless elegance mixed with spiritual energy—we have seen how Bernini, later on, did it in stone for

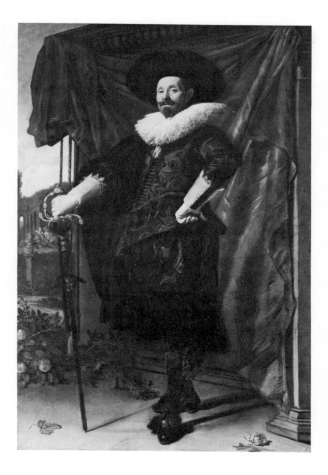

I. 42 FRANS HALS
(1581/5–1666)
Willem van Heythuyzen

Louis XIV. Ladies wore a version, too: Van Dyck and other painters allow them to hold fluttering scarves in front of their smooth bodices, sometimes with graceful but occasionally with ludicrous effect, as in Van Dyck's portrait of Lady Castlehaven at Wilton (I.44). Here the lady's dress and hair hang stilly decorous on her straight-frontal image, and her background is void and dark; but directly in front, she clutches a whipping, billowing piece of gauze that flies up over her shoulder. This untamable object is carried, not worn. It has the effect not so much of embellishment as of an allusion to refinement, like a Latin tag or a French phrase, and as a chic accessory it seems most like a squirming lapdog.

The third great movement in Baroque art contributing to its general expression through fabric was the Neo-Classicism so purely exemplified by Nicolas Poussin. As a French artist who worked in Rome, where Ber-

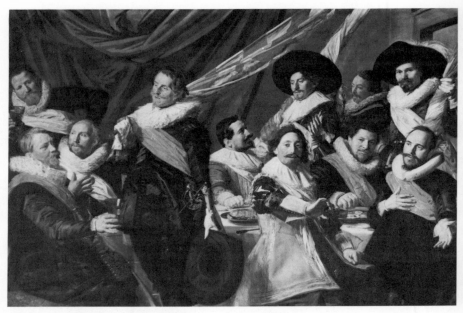

I. 43 FRANS HALS (1581/5–1666)
Banquet of Officers of the Civic Guard of Saint George at Haarlem, 1627

nini's vigorous expression held sway, he came to be appreciated both there and in France chiefly by intellectuals and literary men. His clearly tinted and restrained formal compositions represent the triumph of the artistic ideals originating in the work of Raphael and his followers in the late sixteenth century. This tradition depended on clarity of formal design and an even temper that precludes excess, whether of visual dramatics, psychological emphasis, or spiritual zest. Poussin expanded the possibilities of using this idealizing style for Classical subject matter, and he based his rendering of the requisite draped folds on original Classical drapery motifs. The Christian legends could also be treated as if they were Greek myths, solemn and remote and cool, and naturally figured forth in Classical costume.

The emotional purity of this vision and its heavy reliance on abstract ideas made it the perfect arena for displaying drapery as the visible distillation of these very things. The pictorial habit was well established of dressing all imaginary characters in the same kind of drapery that dressed settings (that is, valid by artistic license only), and therefore the impulse to embody intellectual concepts in pictures could safely use unlimited yard goods as a vehicle. The more conventional High Renaissance and Ba-

roque painters in this Classic tradition did not copy the Greek and Roman cloth gestures so faithfully as Poussin did in his evocations of the antique. They tended rather to follow the High Renaissance program of cloth as bulk. Whereas Michelangelo and the Mannerists had used drapery to

I. 44 ANTHONY VAN DYCK (1599–1641), *Portrait of Lady Castlehaven*

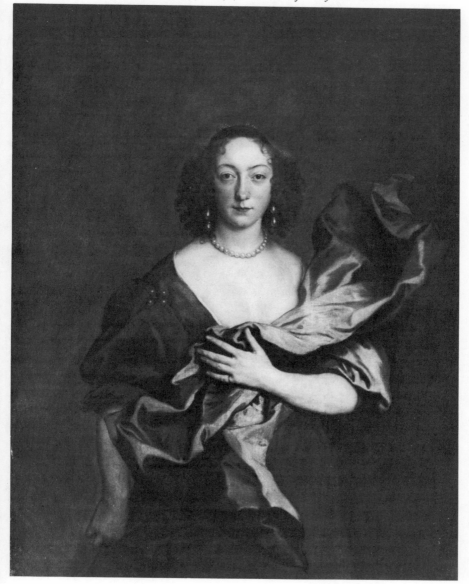

transcend reality instantaneously, Raphael and his followers had used it to help idealize the world, to thicken and weight and slow down the human figure and thereby solemnify its movements (I.45).

Fleshly bulk itself was a desirable thing for both sexes during the sixteenth and seventeenth centuries; but like the opposite ideal of thinness in the present century, it was not universally achieved, although it was in art. All the elements of fashionable clothing for two hundred years tended to broaden and thicken the look of the body, even during periods when complex tailoring had replaced sweeping folds. Padding and puffing made ordinary bony and skinny men and women look as if they might possibly have the powerful torso of a Rubens Hercules or the lush belly of a Titian Venus. Heavy, aggrandizing garments appear in all kinds of portraits throughout both centuries, and High Renaissance and Baroque artists of the Classic temper would also take the same desirable bulkiness, so visually satisfying in actual clothes, and apply it to the chaste robes of the saints.

This Classicizing style did not permit extravagance or vagueness of cut—the clothes in paintings by the Carracci, for example, have perfectly

I. 45 GUIDO RENI (1575–1642), *Lot and His Daughters Leaving Sodom*

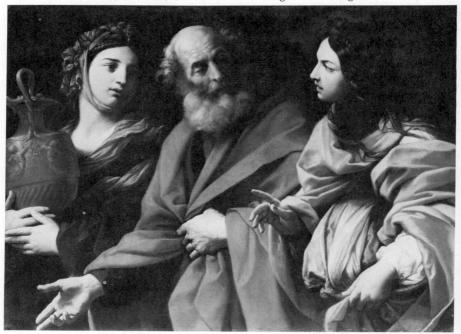

good sleeves—but it required a solidity nicely provided by what looks like layers of cotton quilting under the tunics of Jesus and the angels. Elbows and knees have no knobs as they poke bluntly through these gowns (I.46). Arms and thighs of both sexes seem incredibly thick under them, as they undoubtedly did under the quite different-looking sleeves and skirts people actually wore. Mid-nineteenth-century taste probably exalted Raphael and Guido Reni partly for the comfortable prudery of these blandly padded clothes, so much in accordance with the full and concealing fashion of that later time. The painted garments—a draped cloak over a long-sleeved robe—were often, of course, exactly the same as those worn centuries earlier by Byzantine and Romanesque saints, who are all scrawny arms and knobby knees poking through thin, clinging folds.

Despite their formal logic, clarity of outline, and smooth modeling, Baroque–Neo-Classic draperies are essentially boring. Ruskin rightly said they were untrue, meaning not false but somehow unbelievable. It is not so much the uninteresting conventional behavior of the stuff as its lack of energy. In Guido Reni and the Carracci, even in Raphael, the excessive dull material looks like a tedious, cluttering, and restraining agent rather than a vehicle of expression, and its clear rendering serves only to emphasize its difference from the interesting and expressive clothes people were really wearing. The smooth and polite folds are as perfectly indicated as any "realist's" vivid rags or any portrait painter's careful ribbons, but they fail to engage and focus attention or to come alive as either cloth or truth (I.47).

Some of the most appealing drapery in the seventeenth century is that which shows a combination of modified traditions. Classic, ideal cloth instead of naturalistic clothing, and sober, diffused light instead of fierce beams, are often used by those of Caravaggio's followers with a more tempered vision and by Dutch artists such as Honthorst and by the Spanish Ribera. In these religious or mythological scenes the fabric is "nonrealistic" with respect to its very presence, but quite realistic in rendering. It avoids either Classical or rhetorical gestures and has the random, ruckedup look of familiar experience applied to an ideal setting, which often consists of nothing but draped clothes and draped background in a shallow space. The fabric so conventionally disposed in Gentileschi's *Danaë* in the Cleveland Museum of Art has nevertheless a lovely artlessness that derives from the careful realism of the satin and linen surfaces. Similarly, Ribera's *Magdalen* in the Prado, in which the figure is sitting in the wilderness but also wrapped in satin, borrows extra eloquence from the touchingly natural folds.

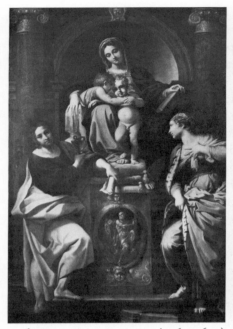

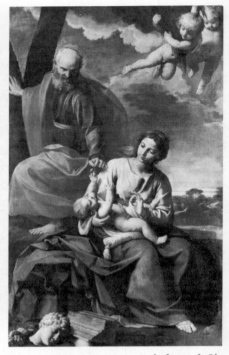

I. 46 ANNIBALE CARRACCI (1560–1609)
Madonna and Child with
Saint John the Baptist, the Evangelist,
and Saint Catherine

I. 47 SIMONE CANTARINI (1612–1648)
Rest on the Flight into Egypt

This is one of the best secrets with fabric shared by all the greatest Baroque artists. When Velásquez bunches drapery around the so-called Rokeby Venus, it has the distilled ideal quality conveyed by its conventional presence; but it is transmuted by the utter lack of swagger in its folds (I.48, 49). Rembrandt is the absolute master of this, not so much in hangings and coverings as in idealized costume. Many of his allegorical portrait subjects are obviously wearing fancy dress; but this idealized, dressed-up look is fused with the immediacy of the sitter's personality—fused with it, not subordinate to it, since the clothes are quite as noticeable as the face. These clothes are clearly not fashionable garments, but they lack the theatrical look of those in many other painters' allegorical pictures (I.50).

Italian High Baroque drapery, whether it followed stricter Classical principles or more expressionistic ones corresponding to Bernini's sculptured excesses, was characterized by a large vocabulary of conventional

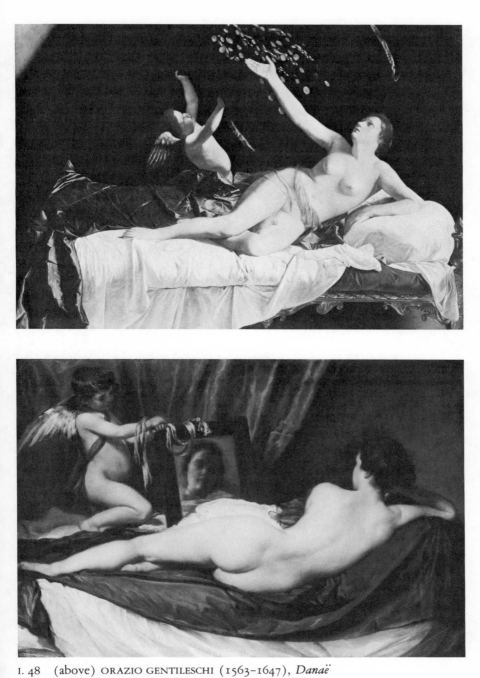

I. 48 (above) ORAZIO GENTILESCHI (1563–1647), *Danaë*

I. 49 (below) DIEGO VELÁSQUEZ (1599–1660), *The Rokeby Venus*, 1657?

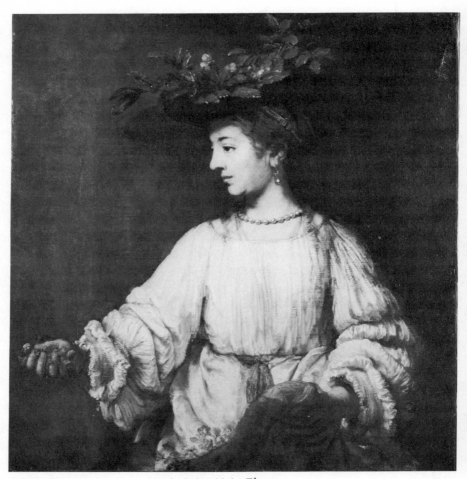

I. 50 REMBRANDT VAN RIJN (1606–1669), *Flora*

cloth phrases. Drapery had begun to lose some of the moral and emo-
tional momentum it had gathered in the sixteenth century, and it became
rather an indispensable formal element for all artists, divorced from the
facts of actual costume but necessary as the dress of painted figures. Since
painted draped stuff was so dissociated from clothes, it could lead an en-
tirely conventional, unnaturalistic existence. In the huge compositions of
Pozzo, Solimena, and Luca Giordano, there is usually no difference of
texture or action between a garment, a standard, or a hanging: all whip
and fly in the familiar arches and bunches, leading the eye, catching the
light, and filling the space. Figures are encumbered, enwrapped, buoyed
up, and swept along by cloth that never completely covers anybody or

completely settles into recognizable tailored shape. The rendering of this stuff is usually masterly but visually truthful not so much to the realities of cloth as to the vast cumulative heritage of its conventional representation. Even though it is shown in constant motion, it has none of the original force of El Greco's streaky flashes, Michelangelo's or Pontormo's strange knots and body tights, the telling, allusive shimmer of Venetian drapery, the realists' crushed and sweaty linen.

Early in the seventeenth century, in Rubens' large compositions, for example, where there is also a large amount of cloth in disarray, the very physical energy of the figures seems itself to account for the disarrangement of their clothes: the powerful bodies swirl and flail, and the drapery, always subordinate, tries to keep up. But in the great ceiling compositions of the late-seventeenth-century Italians, there is more cloth than muscle. The drapery is visually tedious because too much suspension of disbelief is required of the spectator, in exact proportion to the suspension of floating fabric that is interwoven with bodies rather like crumpled tissue paper, keeping the figures from bumping. Though floating in air, everyone seems to be uncomfortably and clumsily half dressed in ponderous Classical clichés. Some of the forms of this pictorial *déshabillé* are derived from much earlier Renaissance models, in which more stylized modes of representation could suspend them in abstraction, exempt from obedience to natural forces such as chance or gravity. Perfect parabolas of scarf or balloons of cloak might dress the linear figures of Botticelli with absolute truth; but by the late seventeenth century sophisticated naturalism of technique applied to the same conventional drapery figurations gives a ludicrous, lying look to all these nonclothes.

By contrast, fashionable dress itself was undergoing a new crispness and sharpness of outline and a new abstraction in trimming. Flowing cloaks and hair, the full sleeves and soft lace that had been worn with the full, rather shapeless torsos of the first half of the century, were being replaced by stiff cuffs, long, tight torsos, lace in rigid folds, and hair in rigid curls. The more formal these fashionable garments became as the century waned, the more extravagant became the imaginary drapery of nymphs and angels. Artists now needed to obey no rules of tailoring, not even the simple one of gown and cloak; the vast storehouse of drapery tropes need only be tapped and the selections combined and recombined for every purpose. As in the earlier days of crushed sashes and casually grasped scarves, fashions in dress arose that allowed the delight in this pictorial freedom to be given some small play in real life. Formal clothing continued to stiffen, but fetching *déshabillé* consisting of loose garments care-

lessly worn in disarranged layers became appropriate wear for at-home life and for portraiture. (Horace Walpole called this pictorial mode "a kind of fantastic nightgowns, fastened with a pin.") In this way the Baroque extravagance of an Italian ceiling might no doubt be shown to enhance the charms of an earthbound English duchess (I.51, 52).

Traditions other than the Italian had developed fabric vocabularies in their different languages, although most of them derived from similar sources in antique sculpture. Folds in Classicizing French paintings, following the example of Poussin, developed a chilly dignity and chaste demeanor, further intensified by strong and uncompromising color almost like that of comic books. This Classically inspired drapery in French seventeenth-century painting uses fabric motifs that have the cloth fall rather than fly, but they are no less rhetorical than the Italian ones. In any stylistic language this pictorial yardage now had the same function that, in poetry, literary figures of speech performed. The experience of "reading" paintings thus had to involve a semiconscious assimilation of such tropes, which, just like inversion of word order or other basic elements of poetic diction, were part of what actually identified the utterance as a work of art. Their presence gave artistic validity to the enterprise; and the "reader" could respond to their rhetorical effects without examining the original meanings or their possible role in the prose speech of everyday life, in words or in clothes.

By the mid-eighteenth century the Baroque style had achieved a capacity for self-mockery, irony, and lightness of heart. European art acquired a detached and enlightened quality, even in widely differing idioms. The fluffy works of Boucher and Fragonard, the black-shadowed and glittering squares of Canaletto and Guardi, the cool scenery of the English watercolorists, have in common the kind of confidence in technical mastery that permits restrained deftness and wit instead of requiring tours de force. The art of the eighteenth century provided a common milieu for both the artistic representation of rhetorical drapery and the stuff of fashionable dress. The elegance reflected in fashionable portraiture was infused with the characteristics of Baroque artistic taste apparent in allegorical frescoes of the previous century.

Drapery, once a contrasting, purely artistic element behind formally clad figures, was by now a more flexible and useful part of elegant dress itself

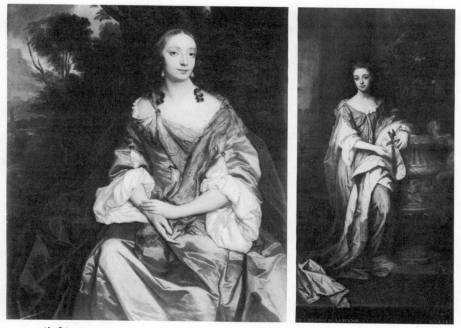

I. 51 (left) SIR PETER LELY (1618–1680), *Portrait of a Lady*
Untidy drapery as elegant dress

I. 52 (right) SIR GODFREY KNELLER (1649?–1723)
Lady Diana de Vere, Duchess of St. Albans. Draped costume for portraits only

and, simultaneously, of elegant interior decoration. Hals and Van Dyck had
shown the rich Dutch and English wearing casual cloaks and scarves over
rather heavy formal costume. Now elegant European dress, along with the
decorative arts, underwent a gradual lightening of substance and shape.
Male dress and wigs became crisper and less bulky, and female dress more
expressive of movement, with well-articulated waists, tight sleeves with
high armholes, and skirts that ballooned out instead of dragging. *Déshabillé*
and *négligé*—the look of being casually wrapped, which had been adopted
for quasi-mythological portraits (and at home, perhaps, if not in company)
in the late seventeenth century—came to form a style of fashionable dress.
Prescribed court costume remained stiff and elaborate; but lightweight,
simply spreading skirts and frothy, ruffled cuffs and caps, along with ca-
sually tumbled curtains, were elements in the new refined mode in actual
life, descendants of the pictorial modes of the preceding century.

The eighteenth century saw the invention of domestic intimacy as a sphere of elegance, a field for high cultivation. Comfort was also invented during this period—perhaps not actual comfort but the look and air of unpretentious ease, preferably enjoyed in the country, in informal circumstances such as those most artfully created in England by Capability Brown outdoors and the brothers Adam indoors. This was an austere comfort, quite different from the Rococo expressions of French pleasure and Austrian sentiment; but in the aristocratic life of all these countries, not only were delicately colored and softly rustling fabrics used in clothes, they also came to be hung in huge bunches in windows, heaped over screens, and draped unevenly over dressing-table mirrors. Judging from many interior scenes in art, the yards of taffeta shown behind a painted marquise might, by 1760, actually be decorating a corner of her bedroom instead of being tacked up in a painter's studio or created in his head. This blowsy method of hanging curtains was a latter-day expression of the Baroque drapery rhetoric, translated from the grandiose language of art into the refined conversation of society, where it could then be transmuted back into art in the form of Rococo confectionery.

Dress and curtain fabric was also for the first time ruffled and puffed and flounced into decorative trimming, for purposes formerly served only by lace, gauze, braids, or ribbon. By 1750 a cloudy, puffy look was desirable for cloth in elegant life (reflected in genre scenes and portraits) and also for the same cloth in imaginary scenes of mythological painting. The draperies clutched around the figures on Giambattista Tiepolo's ceilings are made of the same materials as those worn by the nobility at play—cut somewhat differently but still recognizable. In fact the robust naturalism of the drapery is one of the specific virtues of Tiepolo's magnificent compositions. Refined French eroticism, expressed by Boucher, Fragonard, and others, was made even more acutely exquisite by the use of reciprocally suggestive images: a naked Venus, for example, wallowing among the same silken fabrics used the same way as those shown elsewhere decorating a real lady's boudoir or making up her morning gown. The real lady's possibly Cytherean nakedness is thus conjured in the imagination by the surroundings she seems to share with the goddess, whose actual epiphany among the yards of taffeta is similarly made to seem more than likely (I.53, 54; see II.32). Artistic and actual drapery coincided, in a way not common since the early Renaissance.

There was still a residuum of Baroque decorative custom. Plentiful drapery of an imaginary sort, unconnected with dress or interior trim-

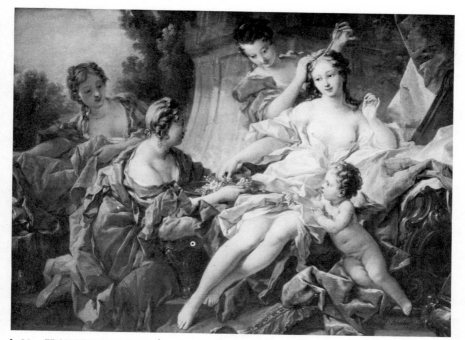

I. 53 FRANÇOIS BOUCHER (1703–1770), *La Toilette de Venus,* 1746

I. 54 FRANÇOIS BOUCHER (1703–1770), *Madame Boucher*

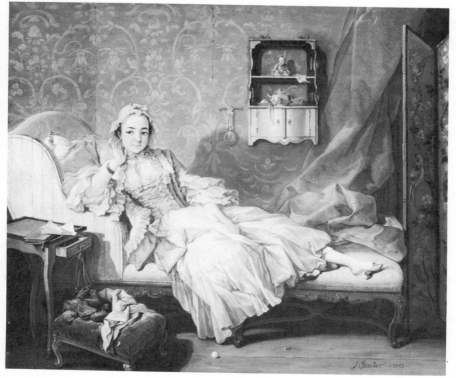

mings, went on embellishing formal portraiture and allegorical ceiling frescoes in imitation of earlier habits, but by now the stuff seemed lighter in weight and consequently even more unaccountable in behavior. The rendering of texture in eighteenth-century painting was a matter of individual artistic decision rather than a distinguishing regional characteristic: English and French art showed an awareness of the earlier Venetian and Flemish treatment of velvet and satin, and of the dry, undifferentiated surfaces of Florentine art. Chardin could paint wool and linen as Rembrandt had and, like him, use them to translate simple folk into enduring images largely by the arrangement of the rough, muted textures of fabric. Even in Chardin, however, the dressing-table mirror may have its casual taffeta drape (I.55).

The great alternative artistic style that arose in the eighteenth century in sharp opposition to the extravagant or delicate Rococo refinements was yet another version of Neo-Classicism. This time, fortified by archaeological study and allied to both political ideology and moral purpose, instead of being an intellectual concern as in the days of Poussin, the new revival of the aesthetics of antiquity took on cumulative and widespread force. Ancient Greece and Rome were plundered for their looks and their ideas, both at once. In England interior designers used unadorned Classic moldings for their cool Protestant version of grace at the same time that Catholic Austrian architects and designers were still using gilded whipped cream for the decoration of churches and palaces, and hiring Italians to paint pictures of it on ceilings as well.

In the name of the secular virtues of reason, scholarship, common sense, and egalitarian principles, the Classical world was being examined and its artifacts imitated more self-consciously than ever before. Educational ideals came to focus on the use of art as a pedagogic medium for conveying moral truth. Three impassioned teachers of this period, Winckelmann in Germany, Reynolds in England, and Diderot in France, were all committed to the idea that art must instruct and elevate or at least aim to do so. In this aesthetic climate, any art forthrightly claiming only to please seemed somewhat reprehensible, including many of the undoubted masterpieces of the past, particularly Flemish and Venetian; and at the same time Classical art itself was seen to have been the pure exponent of the "nobility" of Classical culture. The idea that any form of Classical art might have had a frivolous or perverted purpose of its own seems hardly to have occurred to the idealistic and fervent aestheticians of the eighteenth century.

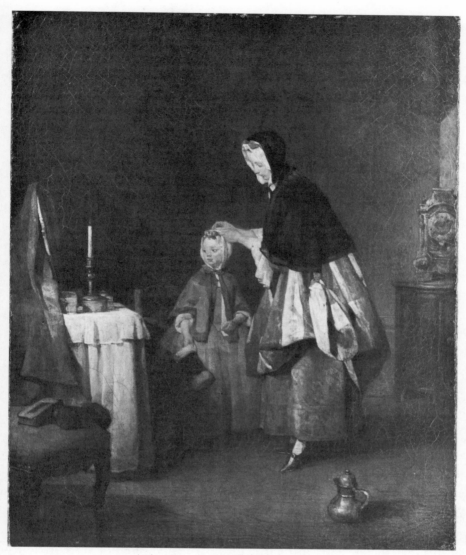

I. 55 J.-B.-S. CHARDIN (1699–1779), *La Toilette du Matin*

The look of the textureless, subtly draped clothing of the Greek and Roman statues dawned anew on a consciousness glutted with flying gauze and whipped marble. The fall, or "cast," of fabric obeying the law of gravity as it hung about the body seemed again to express some kind of eter-

nal truth unadulterated by either excessive drama or prosaic modern fact. "Drapery" was by this time an artistic institution, and it was specifically separated from clothing by Reynolds and the other Neo-Classic aestheticians, who were devoted to the General—which might approach or at least attempt an ideal—as opposed to the Particular. Even for portraits Reynolds advocated a generalized drapery instead of fashionable clothing, and especially for sculpture, about which he says: "Working in stone is a very serious business, and it seems to be scarce worth while to employ such durable materials in conveying to posterity a fashion of which the longest existence scarce exceeds a year." Fortunately for lovers of art, almost no portrait sculptors of earlier or later days agreed with him: it would be quite a loss to have missed Louis XIV's stone lace cravat or Lincoln's great marble shoes.

Reynolds saw dignity as compromised by fashion, and dignity was one of the principal characteristics of the Great Style, which the Neo-Classic spirit reinvented as the loftiest mode of artistic expression. Anything smacking of actual reality was inferior to idealized representation in the tradition of the ancients, which was newly perceived to have skipped over the centuries and to have been firmly caught by Raphael, Michelangelo, the Carracci, and Guido Reni. Representation of ordinary experience or any specific rendering of real flesh or cloth was in this light occasionally acceptable but essentially petty (so much for Van Eyck and Vermeer); Baroque drama, in the manner of Caravaggio or Bernini, was considered depraved, and lush Venetian color nearly as much so (too bad about Titian). None of the potent idealism immanent in these other modes was perceptible to the new vision of art's true aim: to inculcate virtue and point out pure ideals to follow.

Drapery with its convenient plasticity lent itself as admirably to this high purpose as it had to rhetorical persuasion or fun. This time, however, it had more ideological support than did the drapery ideals of previous Classicizing periods in art. Winckelmann and Reynolds both liked to think that the ancients in their draped garments were not susceptible to any vagaries of fashion—a ridiculous view but one that was strengthened by observing the contrast between those loosely worn rectangles and the ever-changing tailored shapes of eighteenth-century clothes. The look of "noble" nudity, set off by equally "noble" drapery, seemed to preclude baseness or pettiness of spirit and, in France, at least, to encourage the cultivation of Republican views. In modern America, of course, we are trained to think that people dressed in eighteenth-century clothes were the ones with the great vision of freedom and equality. In Revolutionary

France, however, knee breeches could be associated with tyranny; and the new Republic honored the Roman hero Brutus, clad in his toga and thus immortalized by the Revolutionary artist Jacques-Louis David.

Accordingly, frivolous fashion itself mocked the supposedly fashionless and heroic antiquity, and clinging Greek-like draped dresses in marmoreal white were increasingly modish for ladies all over Europe (I.56). For men, it is interesting to note, no consular robes or exposed chests corresponded to these feminine manifestations except in art. Tailoring for men remained in vogue, soon to be arrestingly altered by the radical adoption of the long trouser; but under it the unmistakable posture of the *Apollo Belvedere* became suitable for the expression of gentlemanly virtue, judging from the number of men who stood in exact imitation of it for their portraits, clad in buttoned coats and tight sleeves but gracefully (and, of course, "nobly") resting the weight on one leg while bending the other behind and gazing out over an extended arm.

In line with Reynolds' precepts about dignity, George Washington and Napoleon were both sculpted in draped seminudity rather than in con-

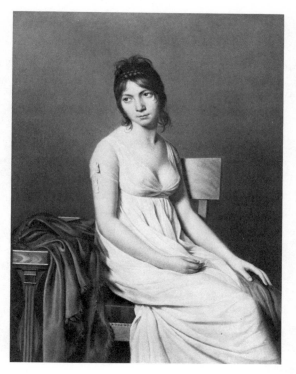

I. 56 Circle of J.-L. DAVID
Portrait of a Young Woman in White

temporary clothing, and the results give the effect of the Statesman Emerging from the Bath, particularly in the Horatio Greenough statue of Washington, in which the general is curiously decked in wig, toga, sandals, and nothing else (I.57). So much for dignity. David's famous portrait of the dead Marat, however, avoids the ridiculous and achieves a genuine nobility by immortalizing the contemporary trappings of an actual bathtub—Fortune having favored the artist, of course, by arranging the hero's murder there. Immediacy and generality are fused in this powerful image of the naked man, the linen cloth, the blood, and the martyred pose, surpassing all the faked-up costumed renderings in *The Death of Germanicus* and others of its kind composed at this period (I.58; see II.38).

At the turn of the nineteenth century, the emerging Empire style of interior furnishings shared in the ideological cult of the Classical, and it demanded practical drapery to match the dignified yardage adorning paintings and statues. Texture and movement were incorrect attributes of cloth at this date; fantastic liberties could no longer be taken with it. Real curtains and real clothes could now more than ever resemble the look of artistic stuff, which was being faithfully copied from those wonderfully

I. 57 HORATIO GREENOUGH (1805–1852), *George Washington*

I. 58 JACQUES-LOUIS DAVID (1748–1825) *The Death of Marat*, 1793

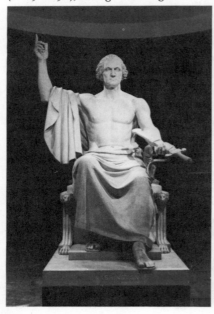

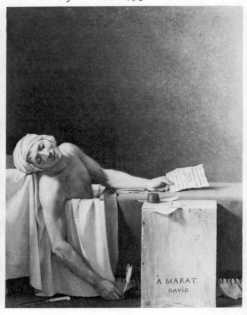

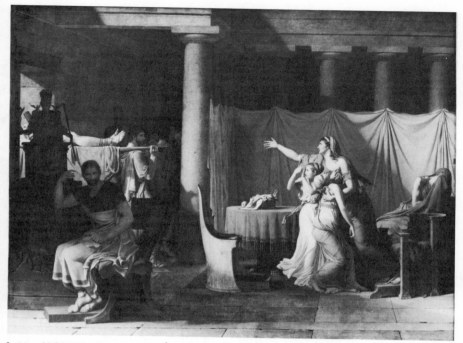

I. 59 JACQUES-LOUIS DAVID (1748–1825), *Brutus,* 1789

subtle ancient models. In the early eighteenth century a billowing swatch
of shimmering taffeta, unevenly flung over a mirror or cascading across a
sofa, probably could not be trusted to stay in place and keep billowing
except in a picture; by 1800 a dignified swag tacked between two columns
could certainly hang there forever, looking just like the background for
David's *Brutus,* which in turn was meant to look like a room in a Roman
dwelling, efficiently partitioned with cloth (I.59). Rhetoric had certainly
not been banished by Neo-Classic conceptions—only newly organized in
preparation for the Romantic upheavals to come.

The invention of wallpaper in the eighteenth century made it possible
to decorate walls colorfully with paper and to save cloth for other uses,
notably and for the first time the elaborate draping of windows. Window
curtains, as we have seen, had never been a feature of earlier luxurious
dwellings. They tended to be functional extensions of wall hangings if
they existed at all, and their decorative draping was not thoroughly ex-
plored until the Neo-Classic taste began to celebrate the catenary. This is
the shallow curve formed by a cord or cable (or drape) suspended from
two points and pulled gently downward by its own weight. Repetitions of

this curve expressed in draped fabric formed one of the principal decorative motifs of the early nineteenth century, derived ostensibly from the draped partitions and bed alcoves of Classical times.

The ancients undoubtedly cared more for the functional than the decorative aspects of such festooning, since they represented it so rarely; but Neo-Classic zeal caused it to drip everywhere in multiple combinations of graceful, formal parabolas across the frames of windows and doors, suspended over horizontally mounted iron spears, or covering walls—there, hung not straight but in evenly draped rhythmic folds. The horizontally suspended catenaries of fabric were usually accompanied by a few formal vertical pleats at the points of suspension, or by more vertical folds hanging behind or draped to the right or left, or both. White drapery, the officially recognized dress of Classical life, came to be used as the clothing for rooms as well as for figures, and particularly in windows. Early in the vogue for Classical decor it might hang unaccompanied at windows, lightly veiling the frame and panes as it did the limbs of marble nymphs.

The Neo-Classic taste in bourgeois Germany, which soon mellowed into Biedermeier sentimentality, seems to have doted on the effect of a little filmy white gauze artlessly, sometimes asymmetrically, and even rather skimpily adorning a window in an otherwise severe and carpetless interior. The charming genre scenes of Kersting, usually containing one figure absorbed in reading or embroidering by a window, owe much of their appeal to this delicate decorative touch, which reflects a certain modest aspiration to pure, unfunctional embellishment without drama or ostentation (I.60). White gauze over windows can, of course, lay claim to being functional, once the aesthetic idea has been established. Like frosted glass or the scrim in a theater, a gauze curtain reflects the light striking it from one side and hides what is on the other side, so long as that is in comparative darkness, no matter how filmy the curtain's texture. For the preservation of daytime privacy it is thus an effective window cover, while still permitting a pleasantly diffused daylight into the room. (It will also keep out flying insects from the garden if left hanging in front of an open window.) Present-day European windows, opening inward like casements, must still contend with this customary gauzy shield, which, if it is not pushed back first, will get caught on the corners of the swinging frames.

Hundreds of nineteenth-century pictures show an informal looping back of hanging white drapery to allow the window to open; but just as many windows are shown with it permanently festooned above, to dispense with any practical function and preserve the look. One painting, *A Room Giving on a Balcony,* by Adolph Menzel (1845), illustrates and cele-

brates the magical role of gauze curtains in the artistic dialectic of indoors and outdoors (I.61). Menzel's curtains, left hanging, are pushed inward and caught by the corners of the opening casement. They are also blown slightly inward, making a private display of the action of the breeze, and they seem forced in by the thrusting sunlight itself as it comes dazzling into the room. It blurs our vision as the curtain blurs the window, making its own shimmering nimbus around the harsh wood and glass like a private indoor sun to match the private gust.

Later in the century, white curtains became a sort of elegant draped underwear for more massive festoons that increasingly surrounded windows as the prevailing taste became first Romantic, then sentimental, and finally stuffy. The image of a window frame, totally muffled in mighty hangings relieved only by thin white folds that further muffle the panes, is a legacy of the mid-nineteenth century that remains *de rigueur* down to the present day for purposes of ostentatious domestic display. The primary function of windows being thus literally obscured, Victorians could find their drawing rooms as decorously clad as their similarly obscured and festooned wives and daughters. To call attention to something by elaborately hiding it is a well-established social and sexual habit. Mid-nineteenth-century Europeans added conspicuous consumption to the method, with heavy drapery for the means, thus creating a style of interior (complete with ladies) that was a triumph of the combined principles of opulence and prudery.

I. 60 (left) FRIEDRICH GEORG KERSTING (1785–1847), *Couple by a Window*

I. 61 (right) ADOLPH MENZEL (1815–1905), *Room Giving on a Balcony*, 1845

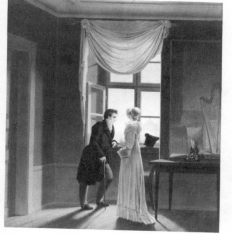

The Romantic movement loved curtains. Heavy hangings, obscuring veils, sable draperies, along with delicate tissues, gossamer raiment, clinging robes, and so on, made their appearance in Romantic literature as the properties of mystery, passion, exoticism, and anything legendary, morbid, or erotic. Such literary attention to cloth had its reflection in the extremely literary art of the Romantic period, with its strong emphasis on illustration and narrative. Early Romantic artists struggling with the severity of the Neo-Classic style, such as Fuseli and Blake in England and Goya in Spain, tended to break out of it into visionary extremes. For these rebels drapery could function—as it had for Grünewald and El Greco—as a vehicle for undiluted spiritual force. Later on, more academic Romantic painters drew on the history of art as a pictorial analogue to literature and produced painstaking confections in which the treatment of drapery was everywhere figuratively stamped with the name of its source in the antique, the Middle Ages, or the Renaissance—or in Raphael, Guido, or Van Dyck. It is small wonder that Baudelaire, fed up with this perpetual pictorial reference to something else, should cry out for some aesthetic recognition of the passing visual moment and elevate the caricaturist and fashion artist.

The early Romantic Germans in Rome who called themselves Nazarenes deliberately and reverently took the Italian Renaissance for a model and painted Perugino-like figures (and also portraits of one another) dressed in perfect copies of Renaissance clothes. These garments show a characteristically Nordic precision in their folds that a devotion to Italy could not eradicate; they share the thick and monumental look of Italian High Renaissance drapery—the knee thrusting bluntly through many layers, the folds swaying with heavy decorum—but they are still rendered with the Northern European respect for the qualities of cloth itself (I.62). The Pre-Raphaelite painters, on the other hand, coming along a generation or two later in England, were ready to abandon the complacent, bloated look then so much admired in Guido and Raphael by the bloated and complacent English, and look with new eyes on the austerely clad, gaunt figures of the Middle Ages.

Moral fervor, also expressed verbally by Ruskin in hundreds of essays and lectures, would not permit Pre-Raphaelite painters to confine their nostalgic techniques to literary subjects, as academicians had been accustomed to do. Natural phenomena and contemporary subjects, laden with meaning and instruction, were treated as if they were medieval, as well as the other way around; the lucidly drawn draperies of a Guinevere or a Beatrice would be rendered in the same way as the complex folds of a con-

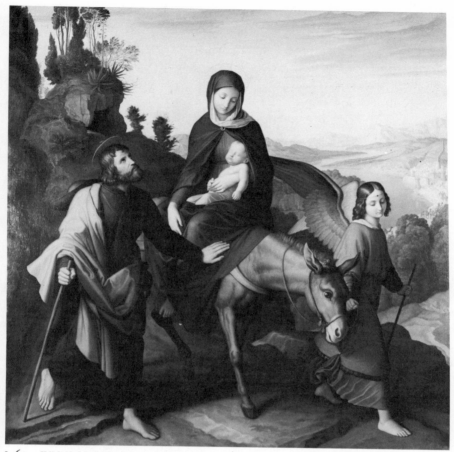

I. 62 JULIUS SCHNORR VON CAROLSFELD (1795–1872), *Flight into Egypt*

temporary lady's dress, and vice versa. The visual inconsistencies in two such modes led to fancy dress' actually being designed by the artists and worn by the ladies of the Pre-Raphaelite circle. The better to lend themselves to the limp but crystalline images of Rossetti and Burne-Jones, Elizabeth Siddal and Jane Morris forsook hoopskirts and corsets for long, loose dresses of soft, clinging material calculated to form many folds and resemble the paintings.

Curiously enough, it is in the painted Pre-Raphaelite drapery that one can detect the first appearance of a tendency to fake the folds and sidestep the obligations of fully representing pictorial cloth—a tendency eventually to be deplored by critics at the end of the century. Draped clothing was never more ideologically approved of and at the same time never

more literary a notion than during the overripe and academic extension of the Romantic movement in art. The very literariness of its prestige enabled artists to put drapery in pictures without stopping to render it from life or even to copy it from other works; they needed only to express the right ideas about it. The ladies and angels of Burne-Jones wear clothes that may droop and flop as chastely as a Florentine saint's, but they are often disposed in inconsequent, unfulfilled creases and may include extraneous drapes and swatches that have no logical genesis in the garment (I.63).

This habit is particularly bad because the pictorial style is based on the meticulous compositions of the early Renaissance, when essential facts were never sacrificed to design even when a high degree of stylization was attempted. These botched Pre-Raphaelite drapes—by no means all of those painters were guilty of them, but Burne-Jones is the worst—were not like the results of raw creative energy at work once again on the possibilities of cloth, as in the works of Michelangelo and Bernini; nor were they like the carefully wrought abstractions of fabric created by Renaissance artists such as Botticelli and Mantegna, although they were intended to be. This drapery is more like a literary allusion made without checking the source, the kind that will impress and satisfy an audience also not thoroughly familiar with the original.

An interesting corollary subject is the phenomenon of Pre-Raphaelite hair. More than at any other time, women's hair was important in the nineteenth century in the same literary and Romantic way as drapery, but

I. 63 EDWARD BURNE-JONES (1833–1898), *Love and the Pilgrim*

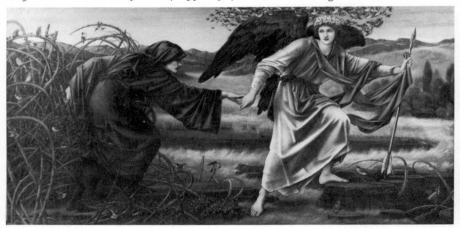

with immediately erotic overtones and a strong connection with real life. Thick and abundant female hair safely conveyed a vivid sexual message in an atmosphere of extreme prudery, as did shapely tight corsets under buttoned-up bodices. But behind the social implications of heavy window curtains and the indirect sexuality of heavy hair were the aesthetic yearnings expressed, for example, by the Romantic "sable draperies" in Poe's "The Masque of the Red Death," and by the enormous hairpieces of Rossetti's ladies. In France in the 1850s Courbet the Realist, who, of course, scorned conventional drapery in favor of rumpled and slightly soiled clothes, nevertheless gave unrealistically thick, Romantic, and erotically disheveled hair (sometimes in place of drapery) to many of his heavy-limbed, suggestive ladies, nude and clothed (I.64; see III.10). In art, hair like this has at other times, too, seemed more like a version of drapery than like a physical attribute.

The hair of Botticelli's Venus, which wraps her body like a snaky scarf, is compelling partly because it is so unhairlike. Its obviously unnatural abundance and the artificiality of its texture make it look deliberately faked to look more like cloth (I.65). Although false hair was frequently worn in the Renaissance and was sometimes actually made of silk (see III.32), most painters showed it being worn in some suitably subordinate relationship to the costume or body, with its false look muted or modified. In general, artists before the nineteenth century treated women's long, loose hair with discretion, even at the height of Baroque extravagance. The exquisite rippling hair of an early Flemish Virgin and even the luxuriant hair of Titian's famous beauties never went beyond the bounds of natural possibility in quantity, texture, or behavior—indeed, beards were often given more expressive scope than women's hair. The occasional Magdalene is always an exception because her hair constituted a scriptural reference and was thus an identifying attribute.

Pre-Raphaelite hair, like the Pre-Raphaelite face and body, was one of the truly original images invented by nineteenth-century art. The kinky, thick stuff weights the head and shades the face, as it is also heatedly described as doing in various kinds of Romantic literature. Lines such as Swinburne's "Thou shalt darken his eyes with thy tresses,/Our Lady of Pain" and many more in the same vein parallel the emotional and suggestive—though not so erotic—use of drapery in art. Romantic artistic hair in its own variety of styles displays some of the false, draperylike qualities of Botticelli's hair, in having an extravagant existence separate from the face and head, like a lowering, heavy turban when it is bound up or like a removable garment when it is loose. The wiglike look is not avoided but,

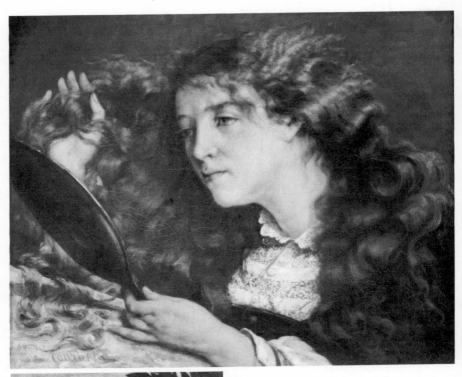

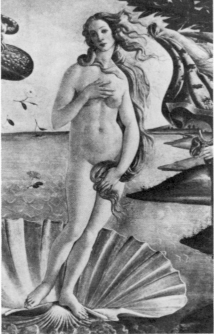

I. 64 GUSTAVE COURBET (1819–1877)
Portrait of Jo (*La Belle Irlandaise*),
1866. Hair as erotic clothing

I. 65 SANDRO BOTTICELLI (1445–1510)
The Birth of Venus (detail)
Hair as drapery

rather, almost sought. Later decoratively minded artists, such as Klimt and Beardsley, made further use of this kind of separable-looking hair, which is not to be confused with the traditional artistic hair, intended to look natural, which flows over clothes and bodies in loose but disciplined profusion throughout art history.

A moral sense of the appropriate behavior of fabric in pictures and statues, and of its relation to the action of cloth itself, varies according to the prevailing standards of what is "natural" and "ideal." Conviction is surprisingly fierce on this subject among the art critics of the past. The discomfort and disgust expressed by John Ruskin, writing in 1878 about some carved seventeenth-century angels in Venice, are an example of such selective appreciation:

If you study the drapery of these four angels thoroughly, you can scarcely fail of knowing, henceforward, what a bad drapery is, to the end of time. Here is drapery supremely, exquisitely bad; it is impossible, by any contrivance, to get it worse. Merely clumsy, ill-cut clothing, you may see any day; but there is skill enough in this to make it exemplarily execrable. That flabby flutter, wrinkled swelling, and puffed pomp of infinite disorder;—the only action of it, being blown up, and away; the only calm of it, collapse;—the resolution of every miserable fold not to fall, if it can help it, into any natural line,—the running of every lump of it into the next, as dough sticks to dough—remaining, not less, evermore incapable of any harmony or following of each other's lead or way;—and the total rejection of all notion of beauty or use in the stuff itself. It is stuff without thickness, without fineness, without warmth, without coolness, without lustre, without texture; not silk,—not linen,—not woollen;—something that wrings, and wrinkles, and gets between legs, that is all. Worse drapery than this, you cannot see in mortal investiture.

It is clear that Ruskin is emphatically, even puritanically opposed to works of art that celebrate the sensual delights of cloth for their own sake, whether it be its flight or fall, and particularly when it is shown to form exaggerated angles, which he cannot abide. Any actual capability of fabric to form such angles he would perhaps deny and be sure to deplore. All this sounds appropriate and true for the mid-nineteenth-century sensibility, now in training to appreciate the cool, curved chastity of Early Renaissance drapery.

The English public that Ruskin so passionately desired to educate had long been accustomed to revere the academic concept of "realistic rendering," to which drapery in particular lends itself with ease. All that is required is careful observation, painstaking drawing, and very little imagination. This ideal, however, was giving way—partly under Ruskin's influence—to the new Pre-Raphaelite spirit, which repudiated such values in favor of a purer realism and the representation of what Ruskin praises as "simple types of natural things," ideally rendered on the model of Giotto and Fra Angelico.

Ruskin is careful to urge that drapery be represented with due regard for scientific truth ("It is nothing, but it is essential") so as to avoid the false and confusing excesses in the disposition of folds of which even a number of Pre-Raphaelite painters are guilty; but after observing the "truth" of how cloth behaves, the artist must proceed to idealize it in one direction only. Nothing in the cloth itself must distract attention from the subject. The positive value of any fabric in a picture must be confined to showing either the movement of figures or the pull of gravity on them, and always in the service of lofty expression. Ruskin's sense of the "natural" behavior of cloth is infused with this specific idealism, which blinds him to the equally "natural" properties of other kinds of represented fabric or to the authenticity of any expressive exploitation of drapery in pictures. He is severe with Botticelli's elegant, shell-like, fluttering folds, for example, and more so with later schools, investing them with the same "baseness" that so offended him in the academic art of his own day: "Drapery trusted to its own merits and given for its own sake—drapery like that of Carlo Dolci or the Carracci—is always base."

So much for the moral tone, expounded through cloth, of the whole Baroque era or of German and Flemish Renaissance painting. Medieval Christian use of drapery Ruskin admires because it was used to represent "saintly and severe repose. The wind had no power upon the garment, as the passions none upon the soul." But when an other-worldly wind begins to assert its power on the garment for aesthetic purposes other than showing motion or gravitation, Ruskin utterly repudiates it. The spiritual afflatus that buoys up the marble fabric of Baroque statues is not discernible to a sensibility attuned only to an alternative spirituality of stillness and simplicity. Flemish and German artists of the Late Gothic period show how the drapery of figures may by itself invest an image with visionary force, as when the cloth is made to whip up and swirl without any apparent physical force exerted on it. Certain scenes from this period

will combine the mundane figures of donors, whose clothes hang and lie in folds, with those of saints and angels, whose garments fly, subject to gusts of inexplicable energy, often in opposite directions. It clearly seemed appropriate to the creators and beholders of such paintings that celestial drapery float but that earthly clothing, however sumptuous, obey the common law of gravity (see I.13).

Ruskin's distrust of extra yardage and its independent behavior in pictures is comparable to Sir Joshua Reynolds' famous remark in the *Fourth Discourse on Art* (1771), wherein he states that the historical painter should not concern himself with "minute attentions to the discriminations of drapery. It is the inferior stile that marks the variety of stuffs. With him the cloathing is neither woollen, nor linen, nor silk, sattin, or velvet—it is drapery; it is nothing more." Reynolds' Neo-Classic vision repudiates the look of any pictorial cloth that does not share the clarity and generalized texture of antique drapery, undoubtedly considered to be most perfectly realized in uncolored marble. The luscious, indulgent painting of drapery is not immoral to Reynolds, but it is inappropriate to the "Great Style," the properly marmoreal vehicle for truly serious subjects. Painters must control the impulse to render specific texture or the play of light over it, despite the tempting capacity of the medium to allow it. That way lies the "inferior style," suitable, presumably, only for vulgar ephemera like cartoons or, of course, genre scenes in the pleasing but frivolous Dutch mode. Even color must be subdued to the Classical ideal, and no unseemly riot of pigment must interfere with formal perfection when dealing with serious themes or serious portraiture. Ruskin calls this principle "heroic," with some charity.

Ruskin shares with Reynolds the obvious view that soulless, studied rendering of cloth is worthless. Implicit here is the notion that it is very easily done and always attempted as a matter of course. The real difficulty lies in composing the drapery appropriately once one has achieved simple technical mastery of it. Such mastery, however, after enjoying centuries of established prestige in all academic schools of art, came by the end of the nineteenth century to be held in general disrepute once the lessons of Ruskin and other modern views had seized the public imagination. So far had art students obeyed Ruskin, the Impressionists, and other prophetic voices that they had abandoned the careful study of drapery almost entirely, and it was seen by at least one critic to be in need of revival.

G. Woolliscroft Rhead wrote a number of handbooks for art students, including one called *The Treatment of Drapery in Art* (1904). In it he

quotes Reynolds and then dryly remarks: "It should be remembered that since the time of Sir Joshua the English Pre-Raphaelites have amply demonstrated the fact that great art is not incomparable with the closest attention to the details of nature." But drapery had become completely a matter of the imagination, too independent of proper minute observation in the traditional manner. At about the same time and in a similar vein, A. L. Baldry writes, in the *Art Journal* of 1909, an article, "The Treatment of Drapery in Painting," about the neglect of drapery study in contemporary art education. Drapery and costume, he says, are "slurred over" by painters of the present time. "Nondescript and unaccountable garments" too often adorn well-painted heads and bodies. Citing the works of great artists of the past, Baldry remarks that draperies were always given as much attention as flesh and were seen as "vital facts" in the pictorial scheme.

Drapery had indeed apparently remained so indispensable a part of artistic composition, so entrenched in concepts of appropriate subject matter for painting, that its gradual separation from customary practical usage was somehow not taken into account as a sufficient reason for abandoning its representation. The "vital facts" of drapery in much art of the past were the facts of life, during centuries when people wore clothes composed of flowing drapery in one style or another. Even when some garments were tight and stiff, others, such as undergarments and outer garments, were loose and flowing or full and pleated; and the careful standards that artists applied to the representation of such real, familiar clothing were also applied, by extension, to the possibly imaginary folds in backgrounds. Justly suspect is the idea that draped clothes when they have ceased to be worn or even seen are nevertheless required to appear in paintings. The action of cloth, if it is conceived as only pictorial, makes any representation of it automatically self-conscious and false. The complaint by Rhead and Baldry that artists are no longer sufficiently trained in the proper rendering of drapery indicates that artists nevertheless persisted in using it, and a look at the works of such painters as Lord Leighton and Albert Moore reveals that even when technical mastery and stylistic control had been achieved, the plentiful use of drapery in late-nineteenth-century pictures is somehow ridiculous (I.66).

Charles Baudelaire and Oscar Wilde had both paid attention, as art critics, to the problem of creating some unifying concept of beauty that would include both modern dress and antique drapery, at a time when these were never more divergent. During Reynolds' day some attempt to bring fashion into line with Neo-Classic aesthetic taste was apparent, at

I. 66 ALBERT MOORE (1841–1893), *The Dreamers*, 1882

least for women. By the late nineteenth century, however, only "aesthetic dress," a bohemian, rarefied mode, was making use of traditional concepts of drapery in modern life. Ordinary clothes were complex, intricate, composed of cut-out, worked, and reattached bits of fabric, varied in texture. They tended to deform the shape of the body, and they were completely divided in fabric, color, and shape according to sex. Baudelaire urges the proper apprehension of beauty in modern dress without crippling reference to its obvious difference from Classical or Renaissance dress; whereas Oscar Wilde, in keeping with the aesthetic views of his time, wholeheartedly deplores modern clothing, as well as the unfortunate current impulse to dress modern artists' models in fake antique drapery. This impulse, indeed, was being obeyed by painters who, if we are to believe Baldry, were by no means competent to deal with it on canvas. Drapery as a basic artistic element was evidently coming to the end of its long life.

The arresting beauty of the drapery in great Western painting, its tremendous expressive importance—extravagant or restrained—had made it possible for writers on art to invest the very use of plentiful material with the power to ennoble and dignify the wearer. Ruskin, this time not issuing edicts about the rendering of folds, invites us in *The Stones of Venice* to consider the splendor and "nobility" of dress in some of the great portraits of the past: "What perfect beauty, and more than beauty there is in the folding of the robe around the imagined form. . . ." He describes splendid costume as having been "one of the main helps to dignity of character and

79

courtesy of bearing." The association of heavy drapery with dignity, if not nobility, had been made more lightheartedly by Hogarth before Neo-Classic ideals had crystallized: his *Analysis of Beauty* (1753) includes the charming remark, "Quantity, or fullness in dress, has ever been a darling principle," and he goes on to speak of heavy folds as adding "greatness to grace." Unlike Ruskin, however, Hogarth does not allow his consideration of drapery to be clouded by a pastoral or Romantic vision of the gracefully robed past in order to heap scorn on contemporary clothing. Like Baudelaire, he has no trouble seeing current fashion as a true distillation of the ideal forms of his own day, developed on the same principles of beauty as those of the ancients but naturally in different modes. His examples of "quantity" include the huge hoopskirt of his own time, of which he speaks with appreciative pleasure even while deploring its occasional excessiveness.

Hogarth's glad view of "fullness" can be seen as a remnant of Baroque sensibility. It is quite different from Oscar Wilde's rejection of the corseted and bustled silhouette of 1889 in favor of an ideal drawn from mistily comprehended Classical dress: ". . . in construction simple and sincere . . . an expression of the loveliness it shields and the swiftness and motion it does not impede . . . folds breaking from the shoulder instead of bunching from the waist. . . ." Contemporary fashion in 1889 was no more or less ridiculous or distorted than in Hogarth's day, nor was the knowledge of Greek costume much further developed; but the concept of it had become detached from viable aesthetic truth. "Draperies" were either a lofty and impossible ideal, representing a nobility forever vanished from human action as the stuff itself had from human life, or an awkward stumbling block to artists vainly wishing to avoid the pictorial effect, as Wilde put it, of a fancy-dress ball.

The new versions of representation that arose in the nineteenth century and became the tenets of modern art brought most of the serious conventional uses of drapery in art to an end. This aesthetic resource was still not abandoned by some late Victorian academic painters, such as Alma-Tadema, who draped models in pleated muslin sheeting to create still more of those same enduring Classical images that were evidently never again destined to inspire directly the true genius of an age. Twentieth-century versions of Neo-Classicism were to acquire new terms in which to refer to the legacy of antiquity.

One place for drapery in art survived in the very limited traditional sphere of still life, in which its neutral function had kept it distinct from its various meanings in connection with figures. The abstract convention

for still-life drapery, dating back to the seventeenth century, stands behind Cézanne's revolutionary versions of crumpled tablecloths. But the powerful traditions celebrating the expressive force of cloth rather than its formal possibilities ran contrary to the radical new principles whereby all material substances were to be transmuted by the artist into that unique visual element of which his work was to be made. Visible nature was henceforth to be not only referred to and represented but added to. The only serious painters in the present century who could legitimately make use of pictorial drapery in the traditional way have been the Symbolist and Surrealist artists who have raided the entire corpus of representational art for old images so as to use them in new forms and combinations.

The artistic medium through which the modern world has been encouraged to apprehend the expressiveness of drapery has been the theater. The many yards of fabric now used as curtains in movie theaters and for the proscenium stage in legitimate theaters are direct descendants of those practical draperies that were first used in churches but were given their dramatic power through painting and sculpture. Draped garments and hangings survive in the theater and cinema, conveying the same ideas that were expressed on altarpieces and ceilings: in costume drama heavy robes still mean authority or sanctity, white drapery means Greece and Rome, and whipping capes mean masculine dash. Inside the movie frame, a fluttering skirt, a weighty curtain, and the special beauty of a sailing ship have acquired their emotional power through centuries of images that have translated these physical actions of cloth into poetry and meaning for generations of Western eyes. Just as representations of draped material once were a satisfying decoration for the settings of heroic or holy scenes, so it has come to appear the proper framework for the intensified events of dramatic art. Even if a curtain does not rise or part but only surrounds the action, the plenteous folds on either side indicate the presence of magic and myth, with the emotionally nourishing suggestion of luxury and excess.

The strong appeal of fabric has never lessened. It perpetually survives to spur the immense textile industry, for which practical need alone would not account. This vast aesthetic range of cloth was created not by the spinners and weavers of textiles but by the hands and eyes of the artists who continually represented it and celebrated it and made it beautiful in our sight.

N·U·D·I·T·Y

CHAPTER

F
or the Western world the distinction between being dressed and
undressed has always been crucial. The same has been true of
other civilizations, but the definition of "dressed" may some-
times be so elastic that the distinction seems quite different from
the one we are used to. Anthropologists and sociologists have demon-
strated that peoples who do not wear garments nevertheless develop
habits of self-adornment that seem, as Western clothing does, to be a nec-
essary sign of full humanity: they are ways of clothing the human body in
some completed concept of itself without actually concealing any portion
of its surface or shape.

At the time when the scientific method was first applied to the study of
human customs, Western society wore many layers of complex clothing.
Modesty and protection were then considered to be the original motives
for putting on clothing, and the idea of the "naked savage" could have
some currency. In the twentieth century, however, educated Westerners
have come to wear fewer and simpler garments, which nevertheless have
very complex meanings, and so recognition has lately been given to the
profound and complicated motives governing all kinds of dress, includ-
ing that of the "uncovered" nations. The state of undress has a constant
share, obviously, in this same complexity. The more significant clothing
is, the more meaning attaches to its absence, and the more awareness is
generated about any relation between the two states.

Surveys of many cultures lead us to conclude that the truly natural state of the adult human is dressed, or decorated, but that his sense of nature demands from him a deep respect for nakedness. This respect may lead him to invent ideas not only of the "wickedness" of nakedness, to which generations of Protestants became so accustomed, but also of the "naturalness" of nakedness, which is all the more powerful for being a fiction. Nakedness is not a customary but rather an assumed state, common to all but natural to none, except on significantly marked occasions. These may be ritual, theatrical, or domestic, but they are always special, no matter how frequent.

Occasions for nakedness often have to do with sex, and so among those for whom sex was associated with shame, a sense of the shamefulness of nudity could arise. The Christian West, however, though thoroughly committed to this ancient Hebraic idea, also had its origins in other Mediterranean cultures devoted to the celebration of human physical beauty. From both these traditions Western civilization synthesized a sense of the essentially virtuous beauty of human nakedness, apart from its simple physical pleasantness—an idea of its spiritual beauty derived from its common naturalness and its corruptibility, not its physical charm. For Christians the corruptibility of the body, dressed or undressed, lies in its fragile susceptibility to decay and sin, but the special corruptibility of nakedness among naturally clothed humans lies in its readiness to seem not only erotic but weak, ugly, or ridiculous. If nudity were going to represent anything good besides crude sexual desirability among the much-dressed Western Christian nations, art was going to be required to make it beautiful, strong, and apparently natural. Moreover, this transformation had to be accomplished in ways that expressed the beautiful truth of nudity and also allowed for the requisite sense of its shameful sexuality. Above all, Western representational art had to invent a nudity that allowed for the sense of *clothes*—their symbolic importance, their special organic life, carried out in fashionable change, and their influence.

The idealizing function that is inherent in the serious nude art of a dressed society—to express longings for a primal virtue, a primal human beauty, a primal sexuality—had an inevitable by-product. This was the costume of nudity itself, which might be described as a visual extrapolation of the sense of being "with native honor clad." Paintings and sculptures of nudes offered the opportunity to make a style of clothing out of nudity, in a way that the natural undressed behavior of the sartorially committed usually inhibits.

The idealizing of the state of nakedness seems to take two forms. One respects the body as essentially innocent when unadorned, like an animal's, and thus beautiful in its purity. The other conceives of the undressed human form as a kind of divine artistic achievement and therefore pure in its beauty. That some significant virtue was represented by the bare human figure was a concept that could thus be cherished in both spiritual and mundane speculations; and doubtless the common private pleasure of nakedness in publicly well-covered cultures helped to sustain such exalted notions. But these notions must have been stimulated even more by the fact that the body was most familiar, most habitually seen and responded to, when it was dressed. Its nudity underneath had to be inferred, sometimes with difficulty. Clothing—so distracting, so different from flesh but so necessary to it—came to be conceived of either as an inessential trapping, a gaudy show that was always less beautiful than the sacred living body it conceals, or as a protective and deceptively beautiful cloak, required to hide man's wretched original state, which had been perfect but became shameful after his fall.

Just as the theory of the natural virtue of human nakedness must have been bolstered by personal delight in it, so the Christian theory that clothing is unnatural or profane in its very essence, the result of man's fall, undoubtedly grew out of the direct experience of the erotic pull of dress—even modest dress. People's clothes had the effect of making their inferred nude bodies seem more, not less, desirable. Nakedness, of course, has its own fierce effect on desire; but clothing with nakedness underneath has another, and it is apparently even more potent. The Classical invention of clinging or transparent draped garments that covered but showed off the body was only a primitive version of this dialectic. Clothing that envelops, swallows up, and seems to replace the body also enhances its importance, differently but no less powerfully. Most tricky, most effective, sometimes most deceptive, is the artful clothing that creates a form, a visual arrangement made up of body shapes, insistent clothing shapes, and the combined movements of each. This kind of dress is what the Western world wears. For six centuries fashion has perpetually re-created an integrated vision of clothes and body together. There is a strong eroticism in this method, since it plays on the dialectic of dress and body while constantly changing the rules. Fashion is in itself erotically expressive, whether or not it emphasizes sex.

Changes in fashion alter the look of clothes, but the look of the body has to change with it. An image of the nude body that is absolutely free of

any counterimage of clothing is virtually impossible. Thus all nudes in art since modern fashion began are wearing the ghosts of absent clothes—sometimes highly visible ghosts.

Images of the nude in the art of the West have taken some of their justification from the resonant myth of Adam and Eve, which crystallizes and illustrates the wishful concept of naturally virtuous nudity. Then the image of nude virtue, once it came to be at home in the myths of Christian art, could be cognate with Classical naked truth and borrow the formal kind of beauty proper to an abstraction. Nude figures could acceptably be made to stand for truths while being rendered with a Classical formality remote from the truth of common experience. But behind Adam and Eve, that pair so pure in the beauty and virtue of their unfallen coupling, stand the figures of Venus and Adonis, in the even more ancient beauty of an erotic human sexuality impure by nature, apt and eager for depravation. Although pornographic images do full honor to this concept, all nude art seems to share in it, ever since clothing became its most expressive vehicle.

When the tailor's art combines with a body to complete an ideal living dressed image, it may use all sorts of artificially created materials—paint or beads or silk or burlap—and unlimited amounts of skill and imagination. The body, of course, remains plain flesh. But the combined result may be so stylized or abstracted that the body is seen as stylized, too. When many different people wear similarly designed clothes, their bodies appear to have been cast in one mold—or to seem as if they should have been. A company of uniformed soldiers illustrates this extremely, but even a group of men in similar business suits reveals the attempt to stylize the body and its gestures in one general way. People usually see one another dressed; the most general perception of bodies is filtered through clothing. When, after such conditioning, nudity is confronted directly, the observing eye may tend to idealize it automatically—to edit the visual evidence. Nude photographs taken at different epochs demonstrate this process; they are good examples of vision edited by fashion but posing as objective truth.

Without clothes bodies show the amazing irregularity of human nakedness, an untidy, unpredictable diversity of all kinds, at odds with the conception of an ideal—even an ideal of variety. Art, however, may impose its own ideal diversity or its own ideal similarity on the nude images it offers, thereby helping to create a more acceptable order in the variety of human looks according to the needs of the contemporary eye, which is trained by the looks of contemporary clothes. The conception of what the

naked human body looks like is thus influenced not only by the long habit of seeing most people dressed but also by the subtle, idealizing force of nude art, including popular photography, which also stylizes according to the mode. Films and pictures, moreover, may often provide more opportunities for observing a range of nude looks than real life does. Nakedness thus undergoes fashion changes not only in artistic tradition but in living experience. A sense of "natural" nakedness in actual life is trained more by art than by knowledge; people tend to aspire to look like nudes in pictures in order to appear more like perfect "natural" specimens. The unclothed costume, when it is intended to be looked at—by an intimate, a camera, an audience, or in a mirror—is subject to current standards of nude fashion. Its "natural" gestures and postures of the head, neck, and shoulders, of the spine and legs, will be worn according to this mode, in correct period style—and consequently even nude snapshots will betray their date. People without clothes are still likely to behave as if they wore them; and so "natural" nudity is affected by two kinds of ideal nudity—the one created by clothes directly and the one created by nude art, which also depends on fashions of dress. Clothes, even when omitted, cannot be escaped.

Although nakedness is everywhere significant—in some primitive cultures people strip to induce rainfall in times of drought—its significance among us is chiefly erotic, particularly female nakedness. We have seen that until the late fourth century B.C. the Greeks required women, though not men, to be represented fully clothed in sculpture, and Christian art has inherited and intensified that sense of particular modesty about the female body; its more generalized sexuality makes nudity or covering a more crucial matter in a society that seems to make women embody sex itself. Nakedness, with its meaning enhanced by clothing, has lent itself to notions of ideal beauty and of natural reality, and it can express not only the loftiest abstract concepts but the most personal physical feeling. But the durability of the female nude image in art derives specifically from its extra erotic freight.

On the reverse of any picture of a naked woman represented as abstract truth or everyday reality is printed her image as sexual power, an image that seems always to show through. Kenneth Clark has instructed us that no proper female nude lacks an erotic message, whatever its degree or method

of idealization; and one element governing the way this message is carried is the visible relation of the nude body to its absent, invisible clothing. Since the erotic awareness of the body always contains an awareness of clothing, images of bodies that aim to emphasize their sexual nature will make use of this link. They will tend to display the emphatic outline, posture, and general proportions of a body customarily clothed in fashionable dress, so as to make it seem denuded. Western taste in clothed bodies has varied so, however, that the nude of one age may seem erotically uninteresting to the eyes of another. We may even mistake an erotically intended image for an idealized one—if it lacks the shapes, proportions, and details we are accustomed to responding to in contemporary life (II.1). The girls in magazine photographs seem sexier to modern eyes than those in Titian paintings, but his patrons undoubtedly saw Titian's nudes with *Playboy* eyes. Even Giulio Romano's pornographic *Sedici Modi,* showing various coital positions, so shocking to his contemporaries, have a curiously unsexy look to modern eyes because everyone is "wearing" the Renaissance figure now associated with idealized formal nudity.

Artistic idealizations of the nude are not confined to tailoring them into a generalized beauty beyond the possibilities of nature. They may also go in the opposite direction—toward "realism," toward a celebration of the acutely specific. This method may be disguised as no idealization at all, as an unedited expression of facts; but we have seen how such facts are already unwittingly edited by direct and indirect awareness of clothes. Truth in nude art, like beauty, follows the mode.

Both methods of idealization may purposely emphasize the erotic dimension, and they do so more successfully when they refer visually to the influence of fashion. This influence shows particularly in certain bodies purposely rendered so as to seem grotesque, yet satisfying to an erotic morbidity: the witches of Hans Baldung Grien, for example, and a number of Dürer's and Urs Graf's harlots from the same period. Gothic representations (including the modern ones of Klimt and Schiele) of aged female bodies, shown in contrast to tender young ones to illustrate the vanity of vanities, are intended to be repellent but also perversely erotic—and the fashionable outlines are exaggerated, along with the wrinkles and the sagging, baggy flesh. Or, to take another example, perfect Classical or otherwise formal nudes, purporting to have only abstract and impersonal beauty, may sneakily be given a strong erotic cast by the simple means of slightly altering them to suit the current sense of the undressed body—a slight widening or sloping of the shoulders, an elongation or a shortening of the waist, a thinning or fattening here and there. Such details based on

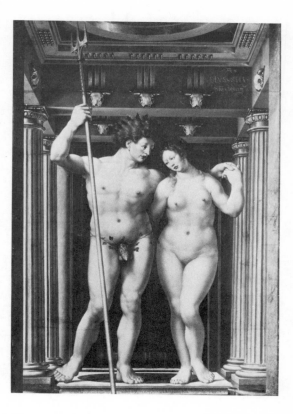

II. I JAN GOSSAERT
(c. 1478–1533/6)
Neptune and Amphitrite, 1516

clothing make the nude look "realer" for its epoch and therefore sexier and more nude, even while safely avoiding exaggerated sexual characteristics and remaining thus theoretically chaste. Neo-Classic statues at different epochs, all purporting to follow the originals, can be dated according to the dress of their own period and its influence even on incorruptible Greek perfection (II.2).

The degree to which a nude image in art departs in form and line from the influence of its implied absent clothing is a good index of its aim to appear primarily nonerotic and to appeal first either to the spectator's sense of common humanity or to a detached sense of form. For the latter, copying Classical formulas has always been a convenient trick. But almost all the greatest nudes in Western art owe their enduring and transcendent appeal to a delicate balance of all these: human immediacy, Classical reference, and sexy, modish undress. Pornographic images, on the other hand, although perhaps exaggerating the insignia of sex, will also exaggerate the current mode in nudity, to add credibility, a factitious truthfulness to their message.

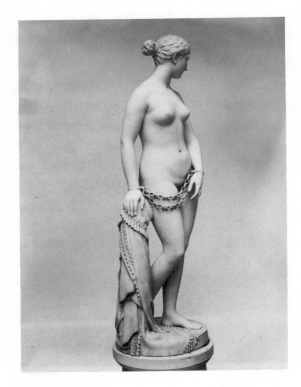

II. 2 HIRAM POWERS
(1805–1873)
The Greek Slave, 1847
Victorian Classical nudity:
sloping shoulders, long waist,
rounded arms

The direct reflection of fashion in the image of the nude body can be demonstrated only during those centuries of Western society when true fashion actually existed. If fashion in dress means constant perceptible fluctuations of visual design, created out of the combined forms of tailored dress and body, then many early civilizations and much of the eastern hemisphere have not experienced "fashion" as we know it. They will have undergone changes of surface fashion, such as those in different kinds of trimming, different details of hairdressing, different colors and accessories; but basic shapes will have altered only very slowly by a long evolutionary process, not dependent on any aesthetic lust for perpetual changes of form. The changes in true fashion, ongoing in the West since about 1300, demand reshaping of the body-and-clothes unit, so that some areas of the body are compressed, others padded, some kinds of movement are restricted, others liberated, and later perhaps all these are reversed. The average body then seems at certain periods to have longer or shorter legs, a bigger or smaller head, skinny or heavy arms—and this quite apart from variations in the female torso owing to changes of taste in sexual desirability at different times.

The erotic messages conveyed by fashion involve the whole body and both sexes, but they are most acutely focused in the proportions of the female torso. It is the most significant field of fashionable alteration—and at the same time the one where the shape of fashion most readily appears to wear the authentic look of nature. The placement, size, and shape of the breasts, the set of the neck and shoulders, the relative girth and length of the rib cage, the depth and width of the pelvis and the exact disposition of its fleshy upholstery, front and back—all these, along with styles of posture both seated and upright, are continuously shifting visually, according to the way clothes have been variously designed in history to help the female body look beautiful (and natural) *on their terms*. Nude art, unavoidably committed to Eros, accepts those terms.

Goya's famous naked and clothed *majas* in the Prado are universally recognized as erotic, and not just because of the shadowy suggestion of pubic hair. One of the most telling features of the nude *maja*'s body is that it seems to show the effects of corseting without the corset—which, on the other hand, is very definitely present in the dressed version. The high, widely separated breasts and rigid spine of the recumbent nude lady are as erotic as her pubic fuzz or sexy smile (II.3). Her breasts indeed defy the law of gravity; and her legs, accustomed to appearing through the lightweight and rather narrow skirts of the day, are self-consciously disposed for effect, like those of a twentieth-century woman. It is the emphatic effect of her absent modish costume that makes her a deliberately sexual image.

II. 3 FRANCISCO DE GOYA (1746–1828), *The Nude Maja*

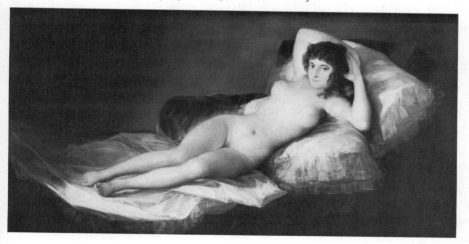

Rembrandt does it another way. His nudes seem to appeal primarily to the sense of common humanity in which the erotic element is enfolded rather than thrust out onto the surface. Their bodies have a psychological perfection, a kind of idealized distillation of individual personality. Yet a fashionable sexuality also shines on the nude in *Bathsheba,* for her body shows the influence of garments, although it is quite different from the triumphant kind of results miraculously visible on the *maja*'s torso. Bathsheba's unmiraculous midriff is somewhat flaccid (the unused muscles have relied on stays for support), but her waistline is at the proper raised level fashionable at that date, and her body is proportionately long from waist to crotch (II.4). Her fullish breasts and upright spine reflect the

II. 4 REMBRANDT VAN RIJN (1606–1669), *Bathsheba*

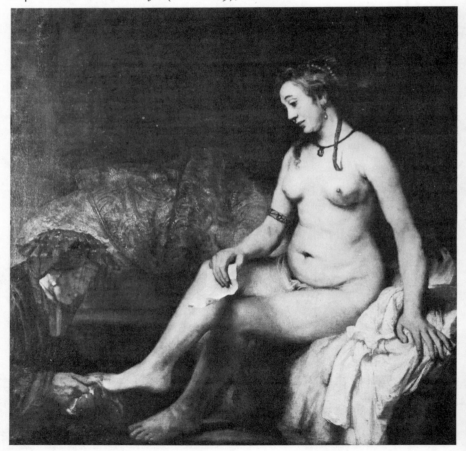

mid-seventeenth-century shift in fashion toward a more emphatic bosom and less protuberant belly, and the corresponding shift in posture.

Bathsheba's legs display, as do those of all Rembrandt's nudes, the unselfconscious awkwardness of legs that are never seen, and have learned no carefully graceful poses. Seventeenth-century bodily gestures that were considered elegant for women evidently included a rather crude spreading of the knees under the heavy dress, judging from the way they appear in many seated portraits. Women's legs were apparently envisioned as massive and heroic or possibly pathetic rather than provocative and graceful. In seventeenth-century nude art they clearly show their supportive function or, as in Rembrandt, a range of expressiveness that owed much to their lack of decorum. After about 1610 women stopped wearing farthingales and began to wear heavy skirts that dragged thickly against the legs, muffling them and prohibiting the passage of air under the skirts. (Such ventilation was formerly permitted by the hoop or roll worn around the hips to hold the skirt away from the legs.) These new, stifling skirts made necessary the spreading of the legs under them, and art made an aesthetic virtue of the necessity.

Twentieth-century life has produced a new convention for feminine leg posture since the widespread adoption of trousers by women. A "natural" sprawl, borrowed from men, with knees at angles and very noticeable feet, has been transmuted into a new, graceful ideal by such artists as William Bailey, for example, and by a number of photographers. Feet had not carried much separate emphasis in representations of the female nude when the conventions of dress enclosed women's legs in a single covering, as was always the case even in thin-draped antiquity, and permitted the feet only to flash out from under it. The exception to this occurs in Late Gothic Northern Renaissance art, in which nude ladies' feet are rendered large and clumsy by Hugo van der Goes and others (II.5). These feet did not "steal in and out" from under the hemline but were trammeled under so much yardage that they were evidently both erotically and aesthetically uninteresting. They seemed to serve simply as a broad double pedestal, steadying the body as it held up the cascading folds of wool. Trouser-wearing, on the other hand, divides the legs and gives importance to each foot—its placement, movement, and individual plastic beauty. Feminine trouser fashions have intermittently created a complementary fashion for large, heavy, colorful shoes with exaggerated soles and heels. Short skirts alone could not produce the need for them; they had to appear to blossom outrageously at the bottom of two long, trousered stems. At least one of Bailey's nudes looks as if she had just removed her tight blue jeans and

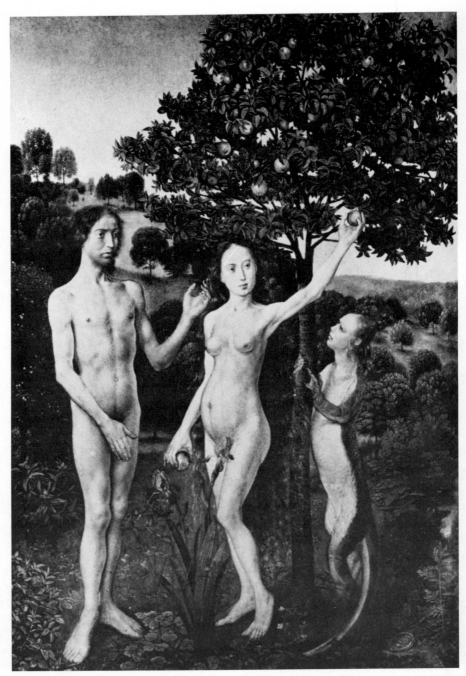

II. 5 HUGO VAN DER GOES (active c. 1467–1482), *Adam and Eve*

cork-soled clogs in order to pose, the elements of her costume still dictating the easy disposition of her leggy body and big expressive feet (II.6).

Whatever fashion prevails, the legs of deliberately Classicized nudes in any period will wear the graceful arrangements invented by the ancients. Such legs were intended as references to art, not life—particularly during periods when women's legs actually did not show through their skirts, as in the stiff sixteenth century. Nevertheless, their poses—balanced, harmonious, idealized—echo that natural effort at grace made by women who, like the ancients, are accustomed to exposing the action of their legs, either through or below their garments. The great artists of the nude in the sixteenth century, such as Michelangelo and Titian, invented a code of behavior for legs, synthesizing it out of the established Classical repertory and the observation of nature unmitigated by fashion, and produced what always looks like universally beautiful footwork—an invincible authenticity of leg. In the less exalted but equally authoritative nude art of Cranach, the same method governs the action of the legs but uses different materials. In Cranach the aesthetic stakes are lower; in the overall design of these nudes fashion has been allowed to dominate over realism and

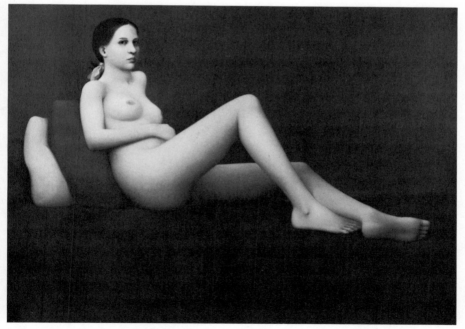

II. 6 WILLIAM BAILEY, *Reclining Nude*

Classical reference to ensure erotic pull. But their poses show the same combination of piquant naturalism, feet and all, and the kind of truly Classical grace that always evades the obvious formulas and creates its own proprieties (II.7).

In the heavy-skirted centuries, ordinarily invisible female legs might, in conventional nude art, freely adopt the poses of the famous Greek and Roman statues—one leg bearing the weight, the other gracefully flexed to steady it, both knees touching, as in the Medici *Venus*—and not refer at all to current facts. Yet the composition of the remainder of the body would be likely to suggest in some way the body shapes dictated by current taste in dress—even if it were also intended as a Classical quotation. Poussin and Ingres, both masters of Classical adaptation, show how this may be done. Ingres' technique never varied in sixty years, and neither did the range of his imaginative subject matter; but his idealized nude female bodies, no less than his portraits, reflect his keen eye for both the subtle and the gross modifications of fashionable dress and their effect on anatomy during that lengthy span, even though the nudes are accompanied only by exotic or antique trappings, with no hint of modern finery. (Compare his nude sketches from 1819 and 1863 [II.60, 61].)

In the fifteenth century the European imagination, inspired in Italy by the revival of antiquity, seized upon nudity as a proper means for representing perfection while it simultaneously developed some of the most elaborate fashions in clothes ever devised. The shapes and details of Northern European, Burgundian, and Italian styles of dress varied a great deal, as did the modes of art that portrayed them. The nude, following fashions both of dress and of art, appeared in its new importance, clad in the varying influence of both. Italian Renaissance dress, like the Italian representational convention of the same period, developed in a Classically minded way, with a primary ideal of harmony and felicitous proportion. This kept the size of subsidiary elements (headgear, shoes) in rational relation to the actual scale and movement of the human body. Gothic, or Northern European, dress tended rather toward an expressive exaggeration of form, with an emphasis on extra shapes leading away from the body's center (very high hats, long, pointed shoes), which distorted the form in a somewhat piecemeal manner. In Italian Renaissance fashion detailed embellishment tended to serve the total scheme, to harmonize and blend with the complete costume; in

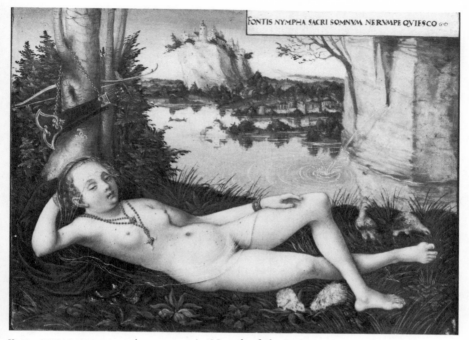

II. 7 LUCAS CRANACH (1472–1553), *Nymph of the Spring,* c. 1540

Gothic fashion embellishment tended to concentrate in separate areas and to catch the eye in its own behalf. These differences characterized all aspects of design in these two contemporary artistic traditions; the representation of the nude is simply another example, but it is naturally linked as intimately with the design of clothing as it is with the formal and spiritual differences of representational style.

In both North and South, the new, expanded Renaissance awareness of fleshly beauty seems to have been concentrated—as it was to be for centuries—on the female belly. All dress for women, regardless of differences in detail and other strong formal variations, was unvarying in its emphasis on the stomach. The girdlestead in the fifteenth century was worn high, with the garments tightly fitting above it around the bust, armholes, and upper arms, and with expansive yardage of sleeve and skirt below. (The girdlestead was lower for men, at the "natural" waistline, and had a very small circumference. The chest swelled out in front and the male spine was very erect—almost a military posture.) Fashionable female posture all over Europe required the stomach to swing forward well in advance of the bosom, which, though clearly defined, was minimized in bulk below a comparatively large neck and head. The volume of the entire female body was seen

97

to be greater in Italy than in the skinny North, but the Italian profile por-
traits of the fifteenth century also show this neat, tightly clad upper body
with the sweeping outward curve of belly below, creating the look of con-
siderable distance between the raised waistline and the lowered pelvis,
where the hip joint bends when the figure is seated. The female torso is
thus elongated through the middle. Many seated Madonnas have this ana-
tomical structure, and the fifteenth-century nude shares it. There seems to
have been no impulse to constrict what we call the waist—the indentation
below the rib cage and just above the pelvis—which would have cut across
the center of the desirable fleshy expanse of the feminine stomach. Men
constricted their waists instead, and such nude figures as the Adam in the
Garden of Eden of Hugo van der Goes and of Pol de Limbourg display the
results (see II.5 and II.26).

In the erotic imagination of Europe, it was apparently impossible until
the late seventeenth century for a woman to have too big a belly. This has
decidedly not been true since then; breasts and buttocks have become
(and remained) far more acutely erotic than bellies. We have already no-
ticed how fashionable female dress emphasized the protuberance of the
stomach more than the swell of the breasts; and although the bosom was
often exposed by a low-cut neckline, it tended to be flattened by the
clothing rather than pushed out. The breasts of all the famous Renais-
sance and Baroque nudes in art, however fleshy the rest of the body might
be, are delicate and minimal. Heavy breasts are shown to be characteristic
of ugly old women and witches, or characters like Dürer's Avaritia, whose
weighty bare breast, conceivably desirable to modern eyes, was undoubt-
edly thought to be loathsome in 1507 (II.8). Heavy bellies, on the other
hand, were worn by the tenderest virgins or the most seductive courte-
sans, whether in the austere works of the Gothic North or in the lushest
productions of Venice.

The Gothic nude reveals a preoccupation with the kind of slenderness
that shows the skeleton underneath, such as modern taste also prefers.
The delicate bony bumps on shoulders and knees, the ridges of clavicle
and rib, seem in German and Flemish female nudes to combine the appro-
priate view of mortal flesh subject to decay with an obvious relish in their
specific erotic charm. The Gothic artist, feeling no need to bow to Classi-
cal proportions, could also render the human leg without that subtle
elongation between knee and ankle that helped produce the grace of so
many ancient Greek and Roman nudes of both sexes. This slight length-
ening of the lower leg makes fleshy female torsos seem elegant, and mus-
cular male ones seem lighter on their feet. It was apparently an accepted

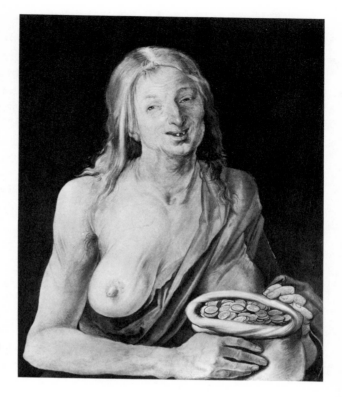

convention of Classical proportion. The habit was preserved in Classically minded nude art for centuries, indirectly supported by the desired look of fashionable dress, which always seems to require length of leg for its best effect. The average human leg is actually rather ungracefully short between the protuberant bones of knee and ankle; and the Gothic nudes, preserving this fact, have a slightly stubby look that in the female figure is emphasized by the length and swell of the belly.

This big Renaissance stomach looks especially strange on the slim and bony Northern bodies, and it manages to conjure the idea of pregnancy, which it was probably not specifically intended to convey. We have observed that modish costume required long, heavy skirts spreading out from below a tiny rib cage, encased in a meagerly cut bodice with high, confining armholes. But in the North, devoted to the wool trade, the skirt not only spread to the ground but lay in pools around the feet, unless it were held up in front. The belly thrust its sexy swell through the fabric, providing a shelf for carrying the bunched-up folds, which further increased its seeming bulk. The lower legs and feet were swallowed up in

wool: Van der Goes' nude Eve has them shrunken; they seem almost vestigial from their long life spent under wraps. Adam's body, for all its ingenuous modesty, has not only the indented waist modish for men of his period but the straight shoulders accustomed to wearing the high-shouldered sleeve padding of the Burgundian courtier, the correctly straight back, and feet well suited for shoes with seven-inch points.

The female nude body in art, following the fashion in clothes, increased considerably in overall fleshy upholstery after the fifteenth century, but the correct posture remained the same, with the belly leading. The well-defined waistline high on the rib cage vanished entirely during the fifteenth century, and European nudes came to be virtually shapeless, tending to resemble long, lumpy sausages with no strongly marked bodily divisions. Venetian nudes and the Florentine Mannerist Venuses share this long, rippling shape, despite the very different way they are painted— a torso with a series of slight undulations, the largest still the belly (II. 9, 10).

Governing this new mode in female bodies was an altered style of elegance in the fashionable clothes of European ladies. By the mid-sixteenth century the chic torso had come to be encased in a corset almost cylindrical in shape (II.11, 12). The breasts, once well defined under a fitted and shaped bodice, were now pressed flat inside an unyielding, elongated tube. The vertical distance between the shoulders and the girdlestead was very much lengthened, so that the skirt began its fullness at what looks like hip level. The waist itself was enlarged to have almost the same apparent width as the bustline, and the rib cage also seemed to have approximately the same circumference under the straight bodice. Consequently, the actual hips lacked any lateral emphasis, since the stays came well down over them instead of indenting the waist. Skirts were exaggeratedly padded or stiffened around the pelvis to hold them away from the legs, since the actual hips, suppressed by the stays, offered insufficient support for the heavy folds. The resultant female shape, complete with clothing, was very much increased in bulk, and the head above it looked very small (II.13).

High Renaissance nudes reflect this shift in overall proportions. Along with the thick trunk, the legs have been correspondingly lengthened to balance the elongated torso and bring the whole composition more into line with the now well-established Classical canon. But the extra length of nude leg, so characteristic of Mannerist figures both in Italy and in the North, also corresponded to the new fashion for floor-length skirts, which showed exactly where the feet actually were instead of swamping them in

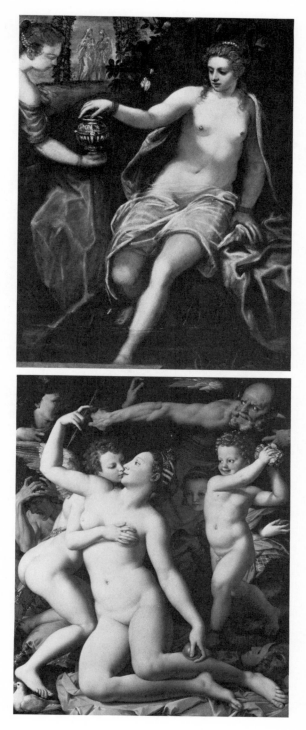

II. 9 TINTORETTO
(1518–1594)
Susanna

II. 10 AGNOLO BRONZINO
(1503–1572)
Venus, Cupid, Folly, and Time

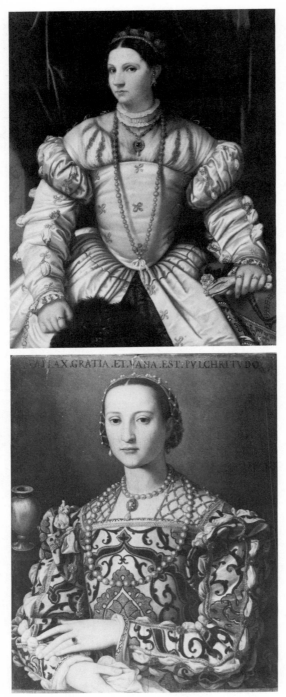

II. 11 MORETTO DA BRESCIA
(Il Moretto) (c. 1498–1554)
Portrait of a Lady in White

II. 12 AGNOLO BRONZINO
(1503–1572)
Eleonora of Toledo

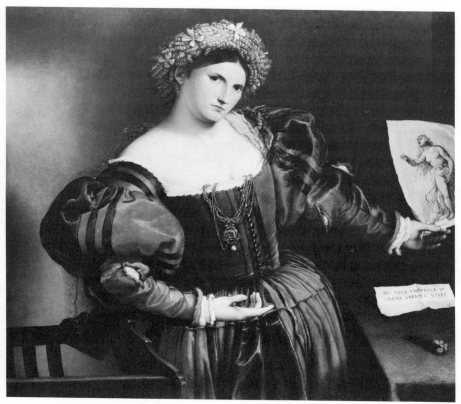

II. 13 LORENZO LOTTO (c. 1480–c. 1556), *Lucretia*

extra fabric. Beginning at hip level instead of high on the rib cage, the
fashionable skirt at the middle of the century took a stiff bell or dome
shape, spreading out and downward to a well-defined bottom edge. Since
the fullness began so low on the body, the length of skirt (and therefore
of leg) had to be increased to produce a graceful lower counterpart to the
fattened bodice above, which in turn was even further aggrandized by the
addition of full, padded sleeves. When dressed, women no longer dis-
played the shape of their legs through the fabric, which was now held out;
but in Venice, at least, clogs were worn to increase their apparent length
under the skirt (II.14). Nude legs in art, of course, could be made to look
naturally long and not in need of props.

Most nudes from the late sixteenth century show this basic female cyl-
inder, which was evidently admired as the ideal shape; pliant and undu-
lating upon release from its stiff garments, it was still fairly uniform in

II. 14 *Venetian Courtesan,* in Bertelli, *Diversarum Nationum Habitus,* 1592 The print has the skirt cut away to show the clogs and the underpants; they were not worn to show

width for the whole length of its mass, indicating the influence of the absent bodice (II.15, 16; see also I.48). Broad hips were apparently of little interest in the erotic conception of the female torso; the sixteenth-century nude shows very little width of beam, just as she shows very little swell or droop of breast. Vertically extended expanses of belly and thigh were still the favorite nude-female landscapes, and breasts and buttocks were seen as subsidiary attendants of these. In general the female body of the High Renaissance appears to have been conceived as a long, large stomach stretching from the collarbone to the crotch, with breasts the shadowiest of swellings visible chiefly because of the placement of the nipples.

There is a smooth-fitting quality to the flesh of these Late Renaissance ladies, comparable to the smoothly padded garments of the prevailing mode. Muscles, bones, and bulges are not permitted any more license than the rushing flow of wool, silk, and velvet; silk and skin alike are stretched tight over an inflated basic shape, with no unseemly creases. Not only the rich nudes of Titian and Veronese but the pearly creatures of the School of Fontainebleau and the nervous nudes of Dutch and Flemish Mannerism all wear versions of this smoothly padded, enlarged, and elongated body, above which the head remains neat and small, with well-suppressed hair, balanced by small feet far down at the other end.

European half-length portraits of both sexes also show how ideal bodily proportions had changed since the previous century; formerly, fifteenth-

II. 15 BERNARDINO LUINI (c. 1475–1532), *Venus*

II. 16 TITIAN (c. 1478–1576), *Danaë*

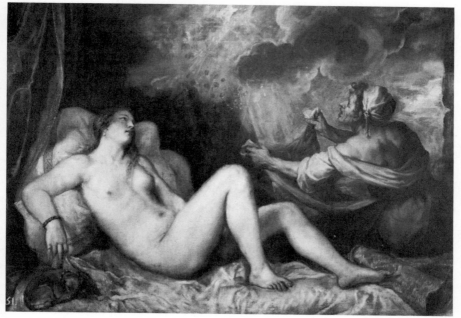

105

century portraiture had run to an enlarged head, wearing a good deal of hair or hat or veil, and a full neck rising above a foreshortened and generally reduced upper body (II.17, 18); now vast shoulders, expanded by sleeves and an enormous jeweled front, fill most of the picture space below a compactly dressed head (II.19, 20). Baroque fashion abandoned the formal padding and the long, confining corset, and began to emphasize a kind of puffy, fluid bulk in both flesh and fabric, in embellishment and hair, all in keeping with the other manifestations of the Baroque sensibility. In the hands of Rubens, the bodies of women came alive in eddies and whirlpools of nacreous paint. Nameless anatomical bubbles and unidentifiable waves agitated the formerly quiescent adipose tissue under the mobile hides of nymphs and goddesses as they simultaneously agitated the satin sleeves and skirts of the newly fashionable free-flowing clothes. During the first half of the century the fashionable lady's waistline rose again, and below it the fashionable belly swelled forward more than ever. The cylindrical shape of the bodice remained stiff and uncompromising, but it was much shortened above a thick waist, and the breasts remained pressed flat under it against the chest wall. The rather broad, short-waisted bodice was worn with an excess of puffed-out sleeve, which was also somewhat shortened to reveal the forearm—typically in a backward-tilted posture, which threw the abdomen into even greater relief because of the suppressed bosom and the thick gathering of the skirt folds above the waist. No sharp distinction was made apparent between the shape of the torso and the fabric of the sleeves or between the shape of the bodice and the skirt. The parts of the dress, though obviously cut and decorated separately, blended together into a single large mass.

In the full-length Van Dyck portraits, fashionable ladies wear this new massive, mountainous look, with random satiny glaciers catching the light (II.21; see also I.32). The play of light over broken surfaces of fabric, so beautifully celebrated by Van Dyck, was evidently a primary new element in elegant dress ("O how that glittering taketh me!" said Herrick in 1648 about the "liquefaction" of Julia's clothes), and similarly the play of light over skin required a broken, gleaming surface. Rubens' nudes, famous for fatness, are actually not so much fat as multifaceted. They ripple with unaccountable fleshy hummocks exactly like the mobile substances of the clothes they have removed (II.22). These Flemish nude women actually take up less room than certain late-sixteenth-century Venetian nudes; but their glistening, wayward bulges make them seem much more corpulent than the sleeker ladies of Titian, however huge, who wore their skins like their dresses, snugly tailored to fit over the upholstery.

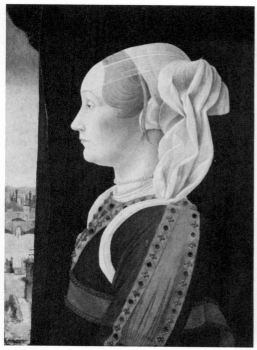

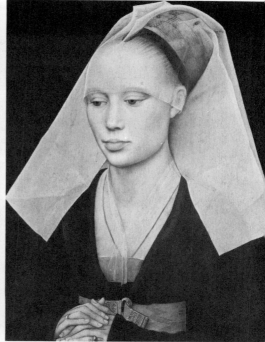

II. 17 ERCOLE ROBERTI (C. 1450–1496)
Ginevra Bentivoglio, C. 1480

II. 18 ROGIER VAN DER WEYDEN
(C. 1400–1464), *Portrait of a Lady*

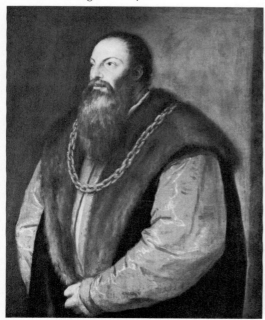

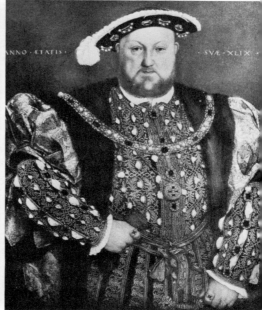

II. 19 TITIAN (C. 1478–1576)
Pietro Aretino

II. 20 HOLBEIN THE YOUNGER
(1497/8–1543), *Henry VIII*

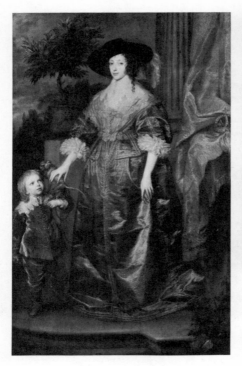

II. 21 (left) ANTHONY VAN DYCK
Queen Henrietta Maria with Her Dwarf

II. 22 (above) P. P. RUBENS
The Three Graces

Fashionable breasts remained modest in swell, but now the elegant neckline descended to expose the upper portion, sometimes the nipple as well (II.23, 24). The straight shape of the corset below made no allowance for the undercurve of the breasts; and once again the skirt fell heavily down from a rather high level around the rib cage. The bodice was sometimes extended downward in front by a stiff stomacher but also thrust outward by an enormous massing of the top of the skirt, which further emphasized the projection of the stomach—as the name might indicate. The female torso was more belly-centered than ever; but the hips, now free to expand below the short stays, also began to acquire new erotic interest.

The fashionable silhouette was masterfully reflected in the nude images of the early Rembrandt, whose ladies have the modest breasts, fat shoulders, huge bellies, and general massiveness below the waist that was then so much admired in female bodies (see III.2, 3). The male clothed silhouette of this period had a similar look above the divided legs; sleeves full at the elbow, a very flat chest sloping outward and downward over a protu-

II. 23 (left) P. P. RUBENS (1577–1640), *"Le Chapeau de Paille"*

II. 24 (right) GERRIT VAN HONTHORST (1590–1656), *Pastorale,* 1627

berant stomach, with a great thickness of garments around the waist and hips. The heads of both sexes were enlarged by curled or flowing hair and large hats.

Because of the desirable quality of a big female stomach for so many centuries, pregnancy was usually not represented in art by showing a distended belly, even in genre scenes. If an unmistakable indication of pregnancy were intended, it seems to have been customary to show an otherwise unwarranted disarrangement of clothing: stays unlaced a little from the bottom, for example, or corsets left off entirely and extra loose folds of smock noticeable in front. The sacred subject of the Visitation, representing the pregnant Virgin Mary visiting the pregnant Saint Elizabeth, often shows the women each with a hand placed on the other's belly, to demonstrate their condition for their own spiritual elevation and ours—but the bellies are no more enlarged than they would normally be. The swelling abdomen was too conventional a female attribute to be useful for specific references to pregnancy. Giovanna Arnolfini, in Van Eyck's famous double portrait, often thought to be pregnant, is in fact demonstrating how a young bride's fashionably slim shoulders and chest might be set off by an equally chic abdominal swell, exaggerated on purpose to

display the fur-lined green excesses of her gown. Her own desirability and her husband's riches both show: a well-known mode of bourgeois female self-presentation (II.25).

In this particular style of dress, a woman's belly provided the central accent point of her costume. It was the place where the balance was struck between elaborate headdress and dragging skirt—or, for virgins, between a dragging skirt and a long mane of hair. The domelike belly was not only erotically pleasing but elegant; it connoted elegance rather than fruitfulness. In the nude art that corresponds to this kind of fashion, it would also have done so. The big stomach remains on a nude figure that is otherwise stripped of its sartorial augmentations because it is at least one costume element (like the virginal cascade of hair) that is conveniently part of the body. When Van Eyck and the Limbourg brothers put big stomachs on their nude ladies, they could obliquely allude to the refined and elevated quality of their beauty by thus referring to their possible customary appearance in sumptuous clothing—even when their pictorial character as Eve, for example, would prohibit any direct reference to dress at all (II.26). Similarly, Rembrandt's nude women may seem meant to be ordinarily fat, as well as transcendent; but their big stomachs would have carried, even in their distilled realism, an unmistakable message of luxury, an echo of richly gathered satin skirts.

After the mid-seventeenth century, the long-waisted stiff corset with a deep point in front was revived. This corset was reminiscent of the late Elizabethan bodice, only this time the breasts were thrust into prominence while the belly receded. Back in 1590, fashionable posture had suppressed the bosom and swung bellies forward, even under the longest and stiffest boning. But now in 1690 the bosom was thrust out in front, the buttocks stuck out behind, and the belly seemed to vanish. The habitual, forcible compression of the female torso had again made for a long-waisted shape, but this time the posture was different. The very long front point of the new stylish bodice stuck straight down, and the body tilted forward, for the first time leading with the bust. High heels were also adopted for the first time, to increase the effect. This particular stiff-backed, forward-tilted posture, with its new kind of erotic emphasis, had not been fashionable before, but it became so several times afterward in the history of dress, and it affected the general concept of attractive female nudity. The late seventeenth century abounds, for example, in paintings of ladies with very emphatic breasts escaping from their necklines—breasts that seem larger, rounder, and shinier than those unveiled in ear-

II. 25 (left) JAN VAN EYCK (active 1428-1441), *Giovanni Arnolfini and His Wife,*
1434. The stomach enhanced by clothes; a marriage portrait with mirror as witness

II. 26 (right) POL DE LIMBOURG (active c. 1399-c. 1416)
The Earthly Paradise, from *Les Très Riches Heures du Duc de Berry* (detail)

lier centuries. Even the most consciously erotic mammary displays in the
Renaissance were modest in size and sometimes vague (see III.35) in
shape by comparison with those in certain Dutch, French, and Italian
versions painted after 1650.

During the succeeding fifty years, the fashionable bodice began to push
the bosom up rather than in: its double swell was meant to stick out and
show a good deal, raised over the top edge of the straight-boned dress.
Earlier décolletages had been cut lower to expose more, but now the
neckline was cut shallowly, with the bust raised up instead, to billow out
on top of the stiff cone (see III.59). At the end of the century dresses also
developed extra fullness over the behind, sometimes in the form of draped
bustles, to balance the prominent bust. In sixteenth-century nude art, fe-
male buttocks had been represented in rear views as fairly modest swell-
ings, harmoniously finishing off the tops of heroic thighs; but by the end
of the seventeenth century the female backside appeared to have become

II. 27 J. OCHTERVELT (c. 1634–1682)
A Musical Party

II. 28 NICOLAS POUSSIN (1593/4–
1665), *Mars and Venus* (detail)

much enlarged, to correspond to the newly emphasized lateral extension of the hips, and it began to dominate rearview nude figures, which also became more common (II.27, 28).

Fashionable female dress in the early eighteenth century increasingly emphasized the bosom. Corsets and bodices were cut much more narrowly in back than in front, so as to force the shoulder blades together, and this pulled the arms back and separated the breasts on a much-expanded chest; the neck and head were, ideally, held rigidly straight above it (II.29). This posture throws out the chest, West Point style, and later the bust was further increased in prominence by the addition of puffy neckerchiefs, along with a recurrence of the forward-tilted posture (II.30). In the last quarter of the century the actual waistline was compressed, instead of the entire rib cage, and the breasts were separated, outlined, and molded into hemispheres by the shape of the bodice. The hourglass figure with the straight spine, so provocatively displayed by Goya's nude *maja,*

II. 29 (left) THOMAS GAINSBOROUGH (1727–1788), *Sarah, Lady Innes*

II. 30 (right) LOUIS-LÉOPOLD BOILLY (1761–1845), *The Optics Lesson*, c. 1796

was reinvented for the first time since the days of ancient Crete (II.31). In general, a marked fullness of breast and corresponding fullness of backside had become the chief sexual charms of women, for which a slender waist provided the appropriate foil. The protuberant female belly, in any corporeal arrangement whereby it took precedence over other bulges, had apparently lost its erotic primacy for good.

Watteau, Boucher, and Fragonard attempted a self-aware reworking of the Rubens nude. Just as a Classicized nude based on the standard ancient models may show only traces of being affected by current fashion, so a Rubens-like nude tended to suppress current criteria of female clothed beauty in favor of the pictorial convention on which it was modeled. Boucher and Fragonard developed a standard erotic nude wrought out of Rubensian elements, a nude image that seemed to have little to do with the fashionable clothed shape of the moment but that provided a model of bareness as refined in its tailoring and embellishments as any costume (II.32).

These painters also excelled in rendering the fashionably dressed female body, and they had a great capacity for striking the exactly tuned note of perfect chic. This was a matter newly complicated by the relaxation of court etiquette after the death of Louis XIV and the advance of Rococo

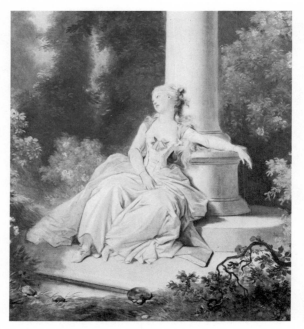

II. 31 JEAN-HONORÉ
FRAGONARD (1732–1806)
Reverie (detail)

taste. Dress had become both more frivolous and, supposedly, more com-
fortable; an artist had to convey the new look of lighthearted ease, al-
though his subjects were ladies wearing corsets as severely tight, long, and
narrow, and skirts as huge, as those of Elizabethan days. In the new, spe-
cially designed nude body, of course, ease and frivolity were easier to
express. Boucher and Fragonard could show their plump, bubbly, but
neatly made young women in excessively abandoned postures without
ever approaching the raunchy wallow so characteristic of Rubens' un-
dressed ladies, who all seem to be reveling in having left off their heavy
stays and skirts.

Nudity, in fact, is the natural state of these pink fictions. No corseting
has either stiffened or wrinkled their soft middles or thrust up their rosy
breasts; neither has any naturalistic awkwardness nor any suave Greek
statue dictated the decorum for their legs. Their legs are indeed rather
short and thus more suitable for tossing askew in clouds or burying in
satin pillows than for standing up to support a putative skirt. When Fra-
gonard does give us a clothed erotic lady, such as the one in *The Swing,*
her overall length of leg is necessarily exaggerated under her billowing
skirt in the conventional way; but her exposed, stockinged calves are pro-

vocatively short, as if to invoke the nude convention (II.33). As a result of this combination of two kinds of sexy modishness, her thighs seem to be grotesquely elongated, if we are to believe that they are attached both to her trunk and to her knees. The overwrought froth of silk, intervening between her fitted bodice and her exposed knee, skillfully hides and glosses over this anatomical discrepancy.

II. 32 FRANÇOIS BOUCHER (1703–1770), *Venus Consoling Love*

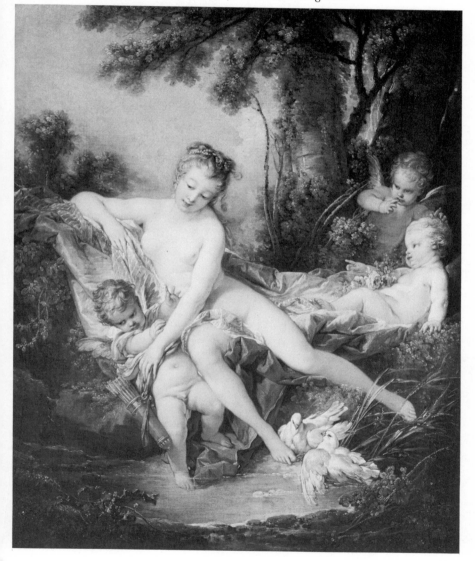

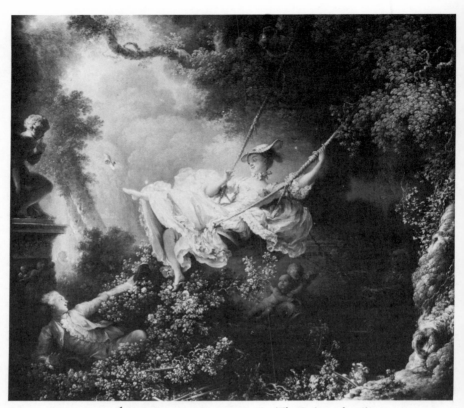

II. 33 JEAN-HONORÉ FRAGONARD (1732–1806), *The Swing* (detail)

The nudes of Boucher and Fragonard wear their skin and flesh fashioned into a delicious union suit, made half out of juicy, childish innocence and half out of self-conscious sexuality. The somewhat narrow shoulders, the round heads, and the short legs give them the infantine look they share with their attendant cupids. The substance of their bodies, unlike the Rubens prototype, is indistinguishable from baby flesh, which also, of course, habitually lives in the nude. The shortened legs of the ideal *dix-huitième* nude required a shortened torso but with no diminution of the desirable bosom or backside. It was the belly that gave up the space, becoming foreshortened and often recessive in the disposition of the figure. It became a new pictorial custom to drape nudes around the middle, hiding not only the pubic region but the belly and diaphragm as well, so as to stress the full bosom, plump legs, and round bottom without intermediate fleshy distractions. A convenient arm might cross the stomach instead of cloth (see I.53).

Neo-Classic ideals of style, when applied to the female body, inevitably required the summary abolition of the new tight waistline, which had finally achieved a pronounced vogue in the 1780s. Greek *chitones,* however much modified for practical wear, needed the long vertical folds one saw on the ancient statues, and could not be interrupted by too vigorous un-Classical indentations. The full, round breasts had come to stay, however; therefore Neo-Classic art produced a female image that consisted of two well-defined hemispheres above a long, hoselike body with no clearly indicated places to bend. Romney, the late Goya, and many others made use of this new composite silhouette (II.34). The breasts are separated from the rest of the torso by the high line of the belt—the so-called Empire waistline—which apparently satisfied everyone's contemporary sense of the authentic Classical mode besides nourishing a preoccupation with the bosom (see I.56). Even cursory inspection proves that actual Classical dress was belted at a variety of levels, so that any point at which fashion chose to place the girdle might conceivably be authorized by at least one actual instance of antique practice.

During the first fifteen years of the nineteenth century, the clothed female body was ideally tubular below the breasts. This long cylinder, so eloquently figured forth in Ingres' great drawings, was clearly imposed and enforced by corseting as insistent as that in any previous period but with a shift of emphasis. Originally, especially among the fashionable French, who had first invented the acutely neo–Greco-Roman female cos-

II. 34 GEORGE ROMNEY (1734-1802), *Initiation of a Nymph*

tume of this period, no corsets were worn, and a truly revolutionary nudity was permitted for a short time to show through thin muslin—often presented, nonetheless, through the medium of flesh-colored tights. But the long habit of stays above and skirt below, which had anchored Western female dress to the same basic conception for five centuries despite all alterations of fashion, could not easily be abandoned. Both Englishwomen and European ladies soon went back to stays but this time cut in new shapes to suit the new figure.

The characteristic English nude, like English fashion, by this date acquired qualities quite separate from those of French art and French culture. Informal English country life and country dress had come to be the last word in late-eighteenth-century noble elegance, and it was often imitated by the *haut monde* in other countries who were still struggling with concepts of rigid formality and sumptuous texture as the proper attributes of *noblesse*. Simple long white dresses were not news to English duchesses; by the beginning of the nineteenth century they had been wearing them for two decades, and so had the French in imitation of them, albeit with conventional corseting, adequate petticoats, and elaborate hair. But by the late 1780s Sir Joshua Reynolds, in his august capacity as president of the Royal Academy and thus official arbiter of aesthetic standards, had decreed that line was superior to color. English art, as well as dress, went in for Classical outline. The metallic, graphic style of Fuseli and the pallid precision of Blake's watercolors nevertheless apply this principle to the rendering of the nude in a way too extreme and proto-Romantic for Ingres and David in France. A feverish, bleached kind of Nordic eroticism infects the English Neo-Classic nudes, which seem to require especially well-outlined breasts and buttocks, particularly when they are shown through clinging fabric.

The pictorial and sculptural custom of clothing the nude in skin-clinging dress has many and often-copied Classical precedents, but the erotic emphasis of this convention seems exaggerated in English art of the Neo-Classic period more than at other times and places. The shadowy meeting of thighs, the smooth domes of bosom and backside, are all insisted on more pruriently through the lines of the dress than they were by contemporary French artists or by Botticelli and Mantegna and Desiderio da Settignano, who were attempting the same thing in the Renaissance—or, indeed, than by the Greek sculptors. The popular artists Rowlandson and Gillray naturally show this impulse most blatantly in erotic cartoons and satirical illustrations, in which women have enormous bubbly hemispheres fore and aft, outlined by the emphatically sketched lines of their dresses.

The Fuselian nude, even with its strong expressionism born (like the artist) in the Swiss Gothic North, is never overendowed, and Blake's standard nude female image is even more meager. But both use a kind of transparent extraterrestrial fabric to clothe the lines of the body with caressing emphasis. Both thus borrow the fashionable Neo-Classic artistic principle of using drapery for any kind of clothing, but both take the extra liberty of using it in the Mannerist mode, as Tintoretto and El Greco had—as if it were light or water, not linen. They go still further: under the hands of these two artists and some others even the very nudity or nonnudity of figures may become a moot point (II.35). The long, flowing Neo-Classic but unearthly clothes create a nimbus around the

II. 35 WILLIAM BLAKE (1757–1827), *Angel Michael Binding the Dragon*

nude body, a flow of extra electric charge. It has a strong erotic power, especially when, as in Blake's case, the bodies have minimal sexual projections. This veil of lines, indicating drapery but emphasizing nudity, does so by tracing the edges of the muscles and the joints; and when it is absent, it can thus still seem to be there. The graphic articulation of the body in the nudes of both Blake and Fuseli forms a Classically correct but also Gothically erotic nude costume, a one-line tracing of the suggestive absent folds.

English Neo-Classical eroticism expressed by referring to the effect of clothes on nudity was not only a property of fanciful and visionary works of Fuseli, which were always rather overtly sexual, or of the intense and luminous Blake. In Reynolds' own *Death of Dido* (1781), an unimpeachably Classical subject, the half-draped body of the dead queen is disposed in such a way as to thrust her breasts into quite unnatural and un-Classical prominence. Her figure is a direct reflection,* like Goya's *maja,* of the contemporary notion of the sexy female body, molded by corseting to have large, high, separated breasts pushed well forward of the chest. Dido's backward-falling posture has not produced any gravitational pull on her succulent and outstanding bosom, nor has a strict reverence for Classical or Renaissance precedent or proportion restrained its thrust. Fuseli admired this painting, and in the following years he seems to have borrowed some of the same unnatural mammary effects for various versions of his famous *Nightmare* (II.36, 37). Works by the sculptor Thomas Banks dating from about 1780 also show a slightly overwrought attention to erotic detail, not just breasts in particular. The effect of these details is further intensified by the disposition of bodies in un-Classical attitudes of extremity, rendered with chilly precision—a hallmark of English Neo-Classic art. John Flaxman seems to have been one artist of this school whose draperies really conceal and whose Classical figures in both form and behavior keep some equilibrium with the current English taste in sexual emphasis.

During a slightly later period on both sides of the Channel (and apparently on both sexes), the long, tubular body shape seemed cursed with an inability to sit or lie down properly. Nudes by Prud'hon, for example, and the nude in Thomas Banks's *Death of Germanicus* (II.38) are propped up like stuffed bolsters. There is a precedent for this posture in the Italian Mannerist art that eventually flowered in the School of Fontainebleau and even earlier in many images from antiquity, particularly by the Greek vase

*It has a prototype in Giulio Romano, but it is an altered version.

II. 36 SIR JOSHUA REYNOLDS
Death of Dido (1781)

II. 37 J. H. FUSELI
The Nightmare

painters. But the Neo-Classic female version of the pose had an added visual acceptability, produced by its resemblance to attitudes imposed by fashionable dress. We have seen that, about 1800, the ideal torso for women was a cylinder reaching from just under a raised bust to well down on the thigh, with no sharp angles at the waist or pelvis.

II. 38 THOMAS BANKS (1735–1805), *The Death of Germanicus,* 1774

Actually supporting this ideal under the filmy dress were various arrangements: for the fat, a long, steel-boned corset that pushed up the breasts and compressed the hips and thighs; for the less fat, a long, tight body sheath in knitted flesh-colored fabric that pressed the thighs together, sometimes worn with a false bosom above it; for those with a perfect natural bosom, a brassierelike construction in the upper bodice, designed to pull the breasts up high, almost to the shoulders, or possibly a "divorce corset"—short stays with a metal plate sewn in to separate the breasts, a sort of ancestor of the underwired bra. Certain seated clothed ladies—drawn or painted by Ingres between 1810 and 1815 with his usual feeling for elegance—show prominent, divided, and pushed-up breasts propped on a long paper-towel roll of a body, clad in a very narrowly cut dress and supported in a sloping, shallow curve: no belly, no rubber tire around the waist, no spread, and no bend (II.39). Above, only the bosom escaped, and then, very much farther down, the knees. For the body in motion, a mincing walk was evidently necessary.

The Neo-Classic female nude based on this curious fashion has an amazing vagueness of skeletal construction and a paralysis of muscular movement around the middle; these characteristics distinguish it from the supple elongations of Mannerist nudes or the slim, athletic Greek figures on which it is modeled. French nudes also display a rather emphatic modeling of the breasts—not by outlining them, as in England, but by sharply defined creases below them or an insistent shadow cast by them (II.40).

II. 39 J.-A.-D. INGRES (1780–1867)
Madame Vesey and Her Daughter, 1816

II. 40 P.-P. PRUD'HON (1758–1823)
Venus and Adonis

ashionable masculine dress in the late eighteenth century, though very different in construction and expressive principle from feminine costume, also lent itself to the bolster style of posture. This Neo-Classic attitude was in fact best suited not to the new turn-of-the-century tailored mode, identified with Beau Brummell and contemporary with the Greek style for ladies, but to the final stages of the silken coat, waistcoat, and knee-breeches fashion. This mode was fast becoming obsolete in the climate of revolution, but fashions in male nude art had followed the shapes and proportions suitable to its long-torsoed, narrow-shouldered clothes. At mid-century the modish male body was encased from shoulder to knee in overlapping layers that were tight-fitting but not very well tailored. Coat, waistcoat, and breeches clasped the body but produced many small wrinkles resulting from the lack of darts and tucks that might have shaped the garment to the body's curves. Shoulders, chest, waist, and hips were apparently ideally uniform in width: no padding augmented the chest or extended the shoulders—or provided, as in the sixteenth century, a smooth foundation for sculpturally padded sleeves and breeches. Potbellies were not concealed but even emphasized on the close-covered bodies. Male

II. 41 JOHN SINGLETON COPLEY (1738–1815), *Portrait of Elkanah Watson*, 1782

bodies seemed to have their greatest width at hip level, where the coattails flared away behind and the belly swelled in front (II.41).

A sinuously curved standing posture was used by artists to give an easy Classical grace to figures clad in this constricted mode, in portraits and history paintings. Benjamin West's *The Death of Wolfe* (1771) and James Barry's painting of the same subject (1776) show the hero's body curved smoothly up and back without angles (II.42). This half-lying, half-sitting draped posture made an ideal display of the tight clothes, showing a smooth composition of wrinkles in the fabric of the long coat and waist-coat—in a less disheveled and heroic vein, the portrait by Joseph Wright of Derby of Sir Brooke Boothby dwells on the same effect (II.43). Stand-

II. 42 (above) JAMES BARRY (1741–1806), *The Death of Wolfe*
II. 43 (below) JOSEPH WRIGHT OF DERBY (1734–1797), *Sir Brooke Boothby*, 1781

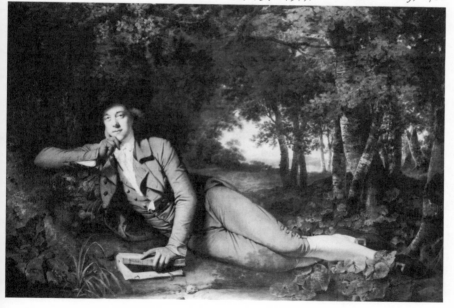

ing figures have the same curved and wrinkled string-bean look (see V.9), and both horizontal and upright poses had Classical authority as well as sartorial advantage to recommend them. Nude figures, such as the one in Raphael Mengs's *Parnassus* (1761), often stand in the same deco-

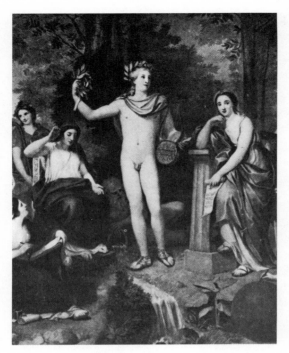

II. 44 R. MENGS (1728–1779)
Parnassus, 1761 (detail)

rous Classical pose, as yet unagitated by any obligation to express the sublime (II.44). It was an early Romantic moment of pictorial balance between fully flowered Rococo ideals and emergent Neo-Classic taste.

The vigorous, fluid muscularity of eighteenth-century male nudes on the Rubensian model (characteristic of the satyrs who sometimes accompany the Boucher nymphs) had given way to a certain amount of Rococo delicacy, but this was also just beginning to combine with a static Neo-Classic smoothness. In the 1760s this kind of male nude also kept the long torso, straight back, and modest shoulders that the still-prevailing mode required to show off the long waistcoat and the long sweep of the open coat's decorative edges. Benjamin West's *Choice of Hercules* (1764) has a modestly muscled Hercules quite similar to Mengs's Apollo; each has a long torso that looks carved out of soap, and both assume the discreetly curved stance apparent in many dressed portraits and in the attendant figures in *The Death of Wolfe*.

In the last two decades of the century, the nude male figure began to change. The changes developed according to new visual conceptions of male body shape and posture, conveyed through new fashions in dress, as

well as through the new artistic ideals that promoted a fresh view of antiquity. Male dress moved well ahead of female costume in expressing an ideal of modern comfort and ease of movement—tempered, as always, by the even more important ideals of personal attraction and social definition. The masculine body that accompanies the stiffly encased Ingres ladies in the first two decades of the nineteenth century is wonderfully nonchalant. Trousers and tailoring had gradually been adopted—padding had come to be used with utmost subtlety, to shape the body only a little in certain places while it elsewhere blended into a loose fit, and all in the same garment. The male body could gracefully display this kind of costume in almost any relaxed or extreme posture. The sharp break and bunch of woolen fabric or doeskin at elbow, waist, or crotch was part of the intentional design. Tight or smooth effects, such as those around the neck and shoulder and upper chest, could be modulated by discreet padding and artful neckwear, however casually the body disposed itself.

One reason for the strong and enduring sexual attractiveness of this Regency male costume (which now survives in full evening dress) is its balanced combination of tightness and looseness, of rigid control and Romantic careless ease. Windblown hair and an untidy open collar went just as gracefully with this kind of tailoring as did the most perfect grooming of the head and neck; and exaggerated poses—cross-legged, slumped—went just as well with it as Classical decorum. Ingres, always the ultimate master of chic for both sexes, provided the most economically expressed images of this new mode in his drawings, although the works of British painters such as Raeburn, Hoppner, and Lawrence present magnificent life-size, full-color versions, with gentlemen arrogantly leaning against trees and horses. Angles formed by such indolently posed bodies look all the better in these clothes. The male nude might likewise begin to bend with greater ease.

Whereas length of masculine torso and a straight, even arched back were emphasized by the mid-eighteenth-century knee-breeches costume, with its long, curved waistcoat, length of leg was emphasized by the new fashion of long pantaloons or trousers that were worn below short waistcoats and swallowtail coats; and these themselves demanded a widening of the shoulders (II.45). Male nudes in both French and English Neo-Classic works at the turn of the century show a greater freedom of leg movement (always in accordance with the antique, of course) and a much more insistent musculature above the waist. Torsos were truncated, so that the level of the fork was much higher and the legs much longer—the nude

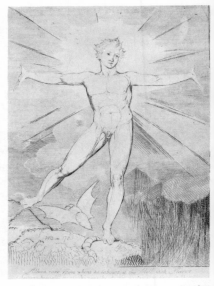

II. 45 Fashion plate from *Charis,*
Leipzig, 1802

II. 46 WILLIAM BLAKE (1757–1827)
Glad Day

male figures of Blake and Fuseli already had these proportions by the
1780s, given a strong assist by the study of Michelangelo (II.46). Ideal
male nude bodies gradually grew broader of chest and narrower of waist,
to match the increasingly padded and tailored clothes, which indeed
sometimes came to be worn with corsets.

Neo-Classic tubular shape for female dress did not last. We have seen
how its original manifestation, as a clinging Classical drape over an ideal-
ized visible body, had soon been abstracted into a smooth bolster topped
by a pair of hemispheres; and that abstraction, once established, soon al-
tered. The waistline was speedily relocated back under the rib cage, where
it could be tightly cinched as before. Skirts began to be cut wider at the
hem and to taper upward to the narrow waist. The traditional full skirt
with some stiffening under it regained ascendancy after only a brief cling-
ing, Classical eclipse, and the hourglass figure resumed its erotic sway.

We have shown how the bosom had retained its eighteenth-century im-
portance even during the elongated period—Lawrence's portrait of Lady
Blessington is a vivid example of respectable Neo-Classical mammary
prominence presented as a feature of casual chic (II.47), whereas the
bare-breasted fantasies of Fuseli more explicitly refer to the general preoc-
cupation. During the second quarter of the nineteenth century, however,

the gripping nudes of William Etty, even more than Delacroix's impassioned beauties, offer a new and more fully realized erotic female ideal, based on the new small waist, which remained the focal point of the ideal feminine body for a century. Etty's nudes show a rapturous preoccupation with female bodies that caused a certain doubt about his artistic seriousness; but apart from their glowing texture, these bodies are erotically charged chiefly because they wear the insistent marks of the latest fashion. They have big, shapely breasts with large, plummy nipples, slim waists set rather low, enlarged hips, buttocks, and thighs, and modest bellies (II.48).

This kind of figure still appeals very strongly today, but it would probably have seemed grotesque to Titian or Bronzino, devoted as they were to

II. 47 SIR THOMAS LAWRENCE (1769–1830)
The Countess of Blessington

II. 48 WILLIAM ETTY (1787–1849), *Nymph and Children*

glorifying the midsection. The ideal feminine waistline was now not only small but descending every year. By 1840 dresses had again acquired the deep, stiffened point in front that they had first achieved in the late sixteenth century, and Etty's nude women show this long-waisted, small-bellied silhouette. To this have been added the rather massive shoulders adumbrated by the huge sleeves of the 1820s and 1830s. Sleeves and shoulders alike had drooped somewhat by 1840, and a sharp downward slope appears from the base of the neck to the point of the shoulder in all female images, nude or clothed, in this decade (see II.2).

 The forty-five-degree slope of the shoulders had been adopted at least twice before, in the early sixteenth century and also in the mid-seventeenth. In each case it was a shape imposed by the tailor's careful cutting and the clever design of collars. It was also adopted by both sexes, and the nudes of the date show its influence—male and female nudes by Dürer, for example, both wear such shoulders. In the 1840s the posture had been thought to have expressed feminine submissiveness, since it also often re-

quired the upper arms to be held immobilized against the body by a tight off-the-shoulder neckline; but the same shape for shoulders was simultaneously adopted by the other sex in all cases of its vogue, where it expressed male arrogance just as effectively. Bronzino's elegant Florentines wear downward-angled shoulders with short hair, neat caps, and a slumberous sneer; in 1645 Rembrandt's unassuming nude women and Van Dyck's dressed noblemen wear them with flowing locks and a melting gaze; and in 1845 Ingres puts them on the Comtesse d'Haussonville with a smooth coiffure and a bland stare that is not at all submissive (see VI.10; V.50).

With this mid-nineteenth-century feminine version of the sloping shoulders went, besides a long waist, a large and smoothly protuberant bosom, and in the nude image appear the correspondingly enlarged breasts absent from most nudes before 1660. By the 1850s the waist was less exaggeratedly long and the shoulder slope a little less extreme; but the bust and hip projections were just as emphatic, and the hourglass was even more pronounced for being slightly shortened.

Courbet was the master of this very erotic female shape, which was all the more compellingly ideal for being cast in a "realistic" mode. Courbet's convincingly smelly-looking women, with their enormous buttocks and ripe breasts, wear minimal neat bellies and tiny waists, according to the fashion established in the late eighteenth century (II.49; see also III.10). In Germany, Corinth was painting the same lush body a generation or so later as a "realistic" phenomenon, but it also appears over and over in the academic art of Europe and England, suitably polished and idealized, as well as in semipornographic popular art and in early photographs.

Conventional dress for women almost until the end of the century was anchored to an ideal torso of this same kind, with slight variations. The bust and hips expanded above and below a very small waist. After 1850 the rib cage might also expand above, to support the very full, wide bosom, which by that time filled the whole space between the neck and the diaphragm. Dresses were lightly padded across the front all the way over to the armhole at each side, to provide a single smooth swell from shoulder to shoulder, without individually defined breast shapes. Behind, a similar swell was exaggerated by the puffy folds of full skirt bursting out below the tight-waisted corset. The various bell-shaped skirts of the nineteenth century always had the largest fullness in back—and, indeed, even the Neo-Classic tube had been worn over discreet padding on the rear, to balance the egregious bosom in front (see the left-hand figure in II.39). By the early 1850s a huge, circular bell shape was achieved for skirts; but

II. 49 G. COURBET
(1819–1877)
La Source

in the 1860s this symmetry once more gave way to back fullness, which
characterized female dress for the rest of the century.

Along with an unprecedented emphasis in both art and dress on the
shape of the buttocks swelling out below a tiny waist, there arose a
matching new dirty-minded interest in underpants. In fact these had not
been worn by most women in the western hemisphere until the middle of
the nineteenth century. Varieties of pants, under or outer, had been worn
by men ever since the Nordic and Eastern enemies of Greece and Rome
had contributed the idea of separately covered legs to a Classically draped
civilization. But the separation of women's legs, even by a single layer of
fabric, was thought for many centuries to be obscene and unholy. In the
early Middle Ages the fact that men wore underpants and women did not
was hidden under the long tunics worn by both. When men's tunics grad-
ually shortened, during the fourteenth and fifteenth centuries, their un-

derpants emerged and were refined into elegant, visible individual leg coverings, while women's garments developed into even longer and fuller skirts.

The sharpest differentiation made by clothing between the two sexes thus came to be the wearing of pants or skirts, a distinction that gradually came to seem like a law of nature. Pants were an absolute masculine prerogative, not to be worn by women even invisibly under a skirt. Women wore underskirts, and stockings gartered around the knee, but no close coverings over the thighs, belly, or behind. This was true even in periods when sleeves might be long and tight, necklines fairly high, corseting very stiff, and skirts very heavy. Underneath, nothing.

Female acrobats and dancers wore underpants while performing, of course, throughout the history of the theater. They were a feature of theatrical life that doubtless only strengthened the association between the stage and sexual depravity in the public imagination. Once the idea of male sexual definition became attached to the wearing of pants, any hint of this kind of secret transvestism on the part of women became a sign of slight sexual perversion and consequently not only forbidden but somewhat erotically stimulating.* Certain fast court ladies and courtesans in sixteenth-century Europe had worn rather elegant underpants, not for comfort but for the thrill (see II.14). In the early nineteenth century prepubescent little girls wore pantalets, but respectable women did not. Only very advanced and ultrafashionable ladies wore pantalets or pantaloons during the Neo-Classical and early Romantic period; and underdrawers became a respectable accessory, finally a conventional necessity, only after about 1850.

The hint of depravity, the legacy of centuries of taboo, had given an element of strong erotic importance to the existence of women's underpants rather than to their absence, which had been the common state of things for so long. In Paris the notorious cancan was invented toward the end of the century to cater to this particular prurient interest, and a great deal of semipornographic art was produced showing enormous behinds clad in very elaborate panties (II.50). Suggestive underpants have remained a low-down erotic preoccupation in modern times; but before the last quarter of the nineteenth century, the underdrawers made for women were very simple in cut and modest in trim. The suggestiveness of black lace, elastic material, or slippery, tight-fitting, intimate clothing for the

*Men's clothes *publicly* worn by women is a different subject.

133

female rear was conceived only at the end of the century and exploited after the First World War. The underwear-obsessed popular art of the late 1880s and 1890s, however, including photography, insisted heavily on a figure with an arched back and an outthrust behind (II.51).

Corseting indeed coerced the female torso more and more into this posture as the century waned, and the new full and fancy underpants were suitably displayed by a jutting rear in many French postcards and spicy illustrations. Nude popular art followed this model for the pose of the female figure; and serious nude art, however remote in intention from dirty French postcards, nevertheless bears the unmistakable stamp of the same influence. Degas' joyous, light-struck nudes getting in and out of bathtubs and brushing their hair were clearly conceived with a total lack of prurience; but even in their artless, unselfconscious privacy they assume the fashionable posture, with its emphasis on fore-and-aft projections—a posture that had clearly come to seem "natural" (II.52). It appears not only in scenes of domestic nudity, in which a woman's body might be expected to show the effects of her discarded constrictions, but in idealized, Arcadian circumstances and in lofty historical contexts (II.53). *Wood Nymphs,* by Julius L. Stewart (1900), is one example of careful antique nudity inescapably dated by its pose; Gérôme's *Pygmalion and Galatea* is another (II.54, 55).

II. 50 Erotic postcard, 1900 II. 51 Erotic photograph, 1880s

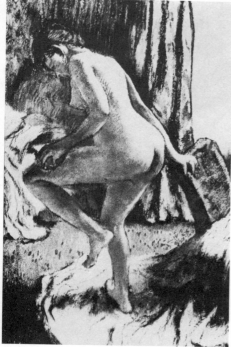

II. 52 EDGAR DEGAS (1834–1917)
Après le Bain

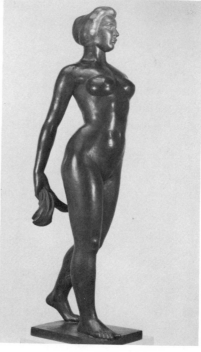

II. 53 ARISTIDE MAILLOL (1861–1944)
L'Île de France, 1910

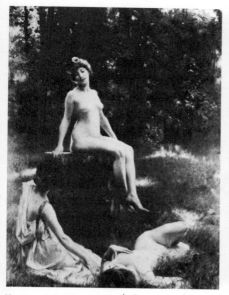

II. 54 J. L. STEWART (1855–1919)
Wood Nymphs, 1900

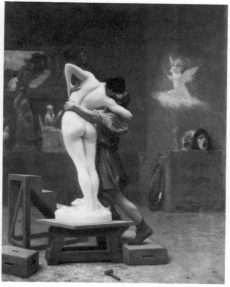

II. 55 JEAN-LÉON GÉRÔME (1824–1904)
Pygmalion and Galatea, 1881

In connection with changing taste in images of female nudity, pubic hair is an extremely ambiguous and elusive subject to pursue. Nude art raises a great number of questions about the relation of conventional image to conventional practice; for example, when the female pubic region is shown in art to be hairless, does this always reflect some contemporary custom of actual depilation or only a pictorial requirement? The ancient Greeks invariably depicted a shorn mons veneris in sculpture. At the same time, Greek graphic art insisted that male pubic hair be represented, in however stylized a manner. Eroticism, rather than any version of prudery, was apparently served by this distinction—documentary evidence indicates that it was customary for courtesans and elegant ladies to depilate themselves and simultaneously for tender, attractive youths to be admired for a downy pubic tuft. Certain Greek vase paintings nevertheless show women with an obvious fleece and some very young men without any. In ancient Rome, according to Martial, Seneca, and others, body depilation for men was practiced, but it was ridiculed as a sign of effeminate dandyism; and it was evidently a customary refinement, though not a hygienic necessity, for women. In any case, whatever the custom, nude art from its very beginnings in antiquity has adopted separate programs for pubic hair in representing the two sexes.

One obvious difference between male and female naked bodies, if they can ever be viewed stripped of conventional visual rhetoric, is that the male genitals constitute a distinct interruption in the formal scheme—a clump of flesh differentiated (except among certain black groups) in color and texture from the rest of the composition. In Greek vase painting, pubic hair served to formalize the vexing transition between genital and body flesh, to help create an abstract ornament out of the male genital flower, even if no other hair shows on the body. Women's bodies have no such egregious interruptions of shape: breasts are like buttocks or knees —projections easily assimilable to any three-dimensional sense of corporeal harmony. The temptation to remove the matted hairy triangle is easy to understand, whether in real life or in sculpture. Stylized, linearly and flatly conceived painting, however, seems to have less difficulty keeping the pubic triangle of fur as part of the conventional nude female image.

Some independently well-developed traditions of graphic art, such as those of Northern Europe and of Japan, for example, seem to deal more comfortably with the rendering of female pubic hair than do artistic traditions essentially based on sculpture, in which the two-dimensional rendering intends to create an illusion of three-dimensional reality. Such pictorial styles arose for the later Greek vase painting and for Roman

murals and came to flourish eventually in the Renaissance. Before Greek vase painting developed foreshortening and other forms of illusionism, the abstract, linear style did permit some women to be shown with pubic hair—although it cannot be known what relation such images had to actual practice. But from Classical times onward, the harmony of the female body seemed to require the absence of pubic hair, whereas the opposite seems to have been true for male bodily beauty.

This divided convention, whatever its original genesis, dictated the whole conception of nude beauty in the West until the twentieth century, a conception based on hair for men and hairlessness for women. The hairy female vulva, by contrast, developed a sinister, separate existence signifying the most bestial and dirty aspects of human sexuality. Nude beauty in Northern Renaissance art, exemplified by the famous Cranach ladies, could show some delicate fleece, providing it was discernible only at close range and did not interrupt the modeling, and then it played the same role as all the other refined exactitudes of detail so important in the Northern artistic tradition (see II.7). Later Venetian painters, working in a style full of the subtleties of color gradation, could solve the problem by the use of ambiguous shading that prevents definite conclusions from being drawn from the pictures about actual contemporary custom (see III.11). Florentine painters developed an image based on the Classical absolutely hairless female body; and so abstract was this formal vision that it could subdue the female nipple, as well as the pubic fleece, and even cause the hair of the head to form linear arrangements as neutral in texture as the lines and shapes of the body.

It would indeed appear that when head hair is thus formalized, as in fact it was in Greek art, female pubic hair must be absent. The High Renaissance Venetians could show suggestions of pubic fuzz because their representations of head hair were similarly fleecy in texture and indefinite in line, in general harmony with the painterly Venetian technique, and the flesh likewise has a fuzziness of modeling and tone. The pictorialization of the female nude could, in this tradition, encompass real indications of pubic hair without any degeneration from the highest level of erotic communication (II.56).

The somewhat expressionistic and graphic quality of the fifteenth- and sixteenth-century Northern style produced a nude that now looks more prurient than the Florentine or Venetian ones, partly because the hair-by-hair rendering of the female pubic fleece makes a definite contrast with the thick golden braids or smooth, rippling fall of the coiffure. Pornography has always conventionally stressed this very contrast. In naked porno-

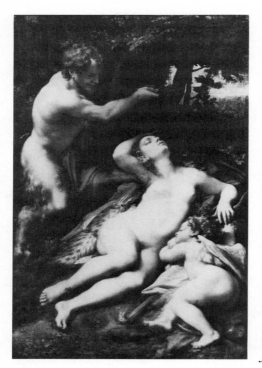

II. 56 CORREGGIO (1444–1534)
Jupiter and Antiope

graphic figures it helps to emphasize the difference between being clothed and being unclothed (which, as we have seen, is so erotically dynamic) by indicating clearly that female head hair—so silky and malleable—is a potential element of *clothing,* whereas crisp, downy body hair makes common nakedness more secret, slightly more bestial and ignominious, and thus more provocative. The less they match, the dirtier the image.

Eighteenth-century pornographic art often showed the fuzzy pubic region under lifted skirts, looking quite different in substance from the powdered wig above. If the pubic hair is missing altogether and the woman is officially clothed only in her coiffure, as in most European nude paintings, she is therefore *nude,* as if accompanied by drapery, rather than *naked,* as if accompanied by clothes. Such a one is Bronzino's arresting Venus (see II.10), lasciviously embraced by her son but completely clothed in the nacreous surface of her hairless flesh, under her perfect headdress. She needs no gauze to make her nude because she is otherwise not naked. The lewd action becomes emblematic rather than naturalistic, even because of the caress of the coiffure itself by Eros' hand.

II. 57 EDGAR DEGAS
(1834–1917)
The Client, an illustration
for Maupassant's
La Maison Tellier

In the nineteenth century the Realist and Impressionist artists devised new methods for making essentially conventional nude female figures both plausible and telling, as well as artistically acceptable (even if not socially respectable). Manet's famous *Olympia* is well known as an unidealized image of a mundane courtesan, shocking in its unequivocal harshness; and yet the artist carefully sidestepped the question of pubic hair by crossing the model's legs and then by shielding the juncture with a startling, self-caressing gesture of the hand (see III.9). Thus, while maintaining perfect contemporary erotic verisimilitude, he could still keep the body of Olympia in the historic visual company of Titian's Venuses without descending even one rung toward banal suggestiveness or falling back on conventional Classic poses. Olympia also wears, along with her modern neck ribbon, invisible Renaissance nipples, which further sanction her inclusion among the classics, as does her draped bed. The women in Degas' etchings of brothel scenes, contemporary with *Olympia*, wear similar neck ribbons and stumpy bodies; but their pubic bush is very clearly rendered (II.57). They offer a good example of how easily a graphic tradition, as opposed to a painterly one, may assimilate the phenomenon. In

this century Edward Hopper left the pubic hair out of his extremely sexually evocative paintings, but he was able to put it into graphic works, such as *Evening Wind,* with no distortion of emphasis (II.58).

Modern vision kept the formula, dissolved only recently, that absence of pubic hair meant Art and Beauty and its presence meant Gross Sex. During the development of photography in the nineteenth century, the "artistic" (as opposed to pornographic) character of a female nude was de facto guaranteed by the absence of pubic hair, however salacious the pose or gaze. Instead of discreetly hiding the meeting of the legs with veils or clever poses, photographers aiming to fumigate their pictures of bare bodies by referring them to the conventions of art might blot out the pubic fleece with an airbrush. This produced, of course, a very dirty-minded image. It nevertheless remained a photographic convention until well along in the twentieth century, under increasingly false pretenses—since it was neither realistic nor an authentic mode of photographic idealization. Avowedly pornographic or aggressively realistic photographs might, on the other hand, include a very thick pubic bush on a gracelessly

II. 58 EDWARD HOPPER (1882–1967), *Evening Wind*

II. 59 THOMAS EAKINS (1844–1916), *William Rush and His Model,* 1907–8

posed model. Thus photography, despite the increasing capacity of the camera to make art out of simple facts, helped to crystallize further the established double perception of female nudity.

The pubic hair of women apparently could not become a totally comfortable element of visual reality, made beautiful by the idealizing force of art—like nudity itself—until late in the twentieth century. There were, of course, exceptional artists who did make an attempt. Thomas Eakins, who was both a painter and a photographer, made a kind of ironic Realist manifesto out of his third version of *William Rush and His Model* (II.59). Although most painters had left the pubic hair in on small female nude studies done from life in preparation for a large painting (such as Ingres' for *Perseus and Andromeda* and *Le Bain Turc* [II.60, 61]), they would leave it out of the final version. The sketch would not be intended for display. Courbet, and undoubtedly others, did specifically pornographic paintings showing very thick pubic hair, but these were for private patrons.

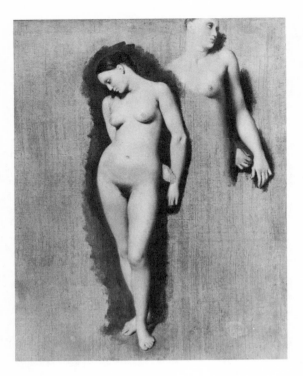

II. 60　J.-A.-D. INGRES, Study
for *Perseus and Andromeda*

The Eakins painting—a public work commemorating an even more
public work—is designed to celebrate the unassuming natural look of the
female body, neither excessively erotic nor formally beautiful, for which
the pubic fleece is a harmonious and becoming adornment. With his back
to us, the sculptor gazes at the plain, modestly behaved, and unselfcon-
sciously naked girl as he hands her down from the studio platform. Re-
spect is in his gesture and the set of his head. In the bare studio, his
honoring gaze itself idealizes her body and instructs us how to view her.

Only since about 1970 has the spirit of Eakins' nudes become general in
the photographic treatment of female nudity. Pubic hair has become a ne-
cessity in any proper rendering of the realistic nude for avowedly aesthetic
purposes, where it was once virtually forbidden. Indeed it is only in specif-
ically erotic art that pubic hair is occasionally suggestively concealed.
Modern eyes have at last thoroughly assimilated the pubic fleece to an
idealized image of "natural" beauty.

Even in earlier modern decades an obvious female pubic bush remained
the chief sign of an overtly erotic message, as in the Surrealist works of
Delvaux and Magritte. Both Pascin and Modigliani, who incorporated
pubic hair into serious nude art, could use it because of the special proper-

142

ties of their idiosyncratic styles: Modigliani's paintings had a linear abstractness of design and flatness of texture that permitted head hair, pubic hair, flesh, and bed covers to make acceptable formal compositions on neutral ground, so to speak, without the undue prurient emphasis that occurs when the *difference* in texture of the two kinds of hair is indicated, as in Cranach. Pascin's fuzzy graphics and watercolors did the same in the opposite manner—if all other textures in the picture are as fuzzy as pubic hair, it may be gracefully included, too. Both these artists, however, were producing intentionally erotic images anyway: the abandoned postures and provocative gazes, the black stockings, the beds—all conveyed the message first, along with the magnetic close-up effect in Modigliani's paintings of legless torsos (II.62). The pubic hair, then, seems to be a badge or a sign confirming, though not creating, the established erotic flavor rather than simply representing the beauty of a natural phenomenon, as Eakins made it do.

II.61 J.-A.-D. INGRES (1780–1867), Study for *Le Bain Turc*

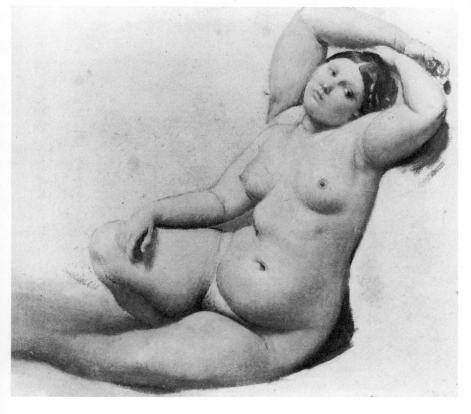

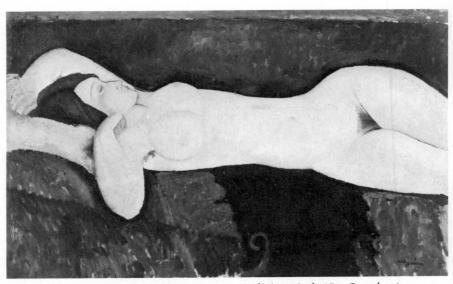

II. 62 AMEDEO MODIGLIANI (1884–1920), *Reclining Nude* (*Le Grand nu*), C. 1919

The convention existed, during the hairless generations of European art, of indicating but partially concealing the pubic hair. In Van Eyck's Adam and Eve panels from the Ghent altarpiece, both figures have pubic hair appearing around the concealing leaf, as they also do in Dürer's engraving of the same subject, though not in the painting (II.63). The Dürer engraving shows it silky and waving, like the head hair; the Van Eyck shows the head hair soft and fleecy as pubic down. This pictorial harmony for hair undoubtedly intends to ennoble the pair's nakedness. Original sin is symbolized by this solemn indication of the common human lot, as the sense of sin is symbolized by the attempted concealment. The Dürer, like many others, shows the pair before the fall—the concealment is accidental, and the sense of sin is the artist's. The Van Eyck shows them covering themselves after tasting the apple; but the hair shows deliberately in both, a reminder that this is nakedness, not nudity—God's handiwork in its original beauty, not yet in need of art.

Quite different artists in the Northern Renaissance tradition dwelt pointedly on the contrast between the two kinds of hair, creating a precedent for pornographers ever since. Urs Graf's allegorical whores show their untidy, furry crotches in sharp contrast to their sleek braids, and Hans Baldung Grien's *Death and the Maiden* shows that traditional comic phenomenon, a black crotch topped by a head of fake-looking blond hair (II.64). Now this same lady, like most of Cranach's, has draped her loins

with an absolutely transparent gauze bandage that conceals nothing. Such minimal Renaissance bandages, which reappear constantly on nude images, always too thin or too narrow to be useful for anything, are as specifically erotic as fur itself and, indeed, sometimes replace it. They have no formal connection with either clothing or Classical drapery but, rather, serve the function of a visualized caress. Simultaneously, of course, they create significant nudity out of mere bareness, with authority borrowed from more amply draped and opaque cloth; emblematic images of Fortune and others need only the barest ribbon (see II.15). In Cranach paintings, in which the ladies also wear elaborate jewelry and hats, the incongruous gauze strip, worn or held (instead of disarranged underwear, for example), seems to produce the sudden pictorialization of a gust of wind or a delicate touch moving across tender areas.

Insufficient concealment is a device whereby pubic hair may be indicated but minimized so as to preserve a unity of plastic conception. Correggio was very good at this, and so was his latter-day French disciple

II. 63 ALBRECHT DÜRER
Adam and Eve, 1504

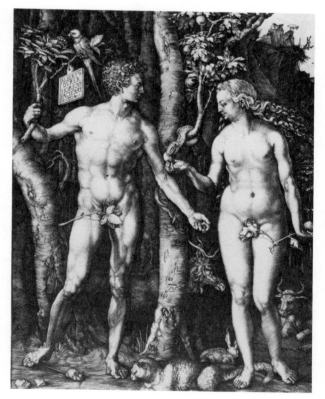

145

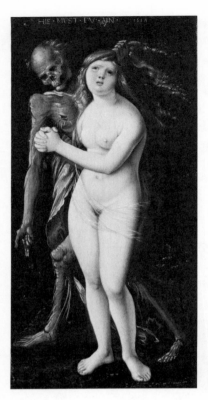

II. 64 HANS BALDUNG GRIEN (1484/5-1545)
Death and the Maiden

Prud'hon. Prud'hon's beautifully finished nude study in the Cleveland Museum of Art, as well as many others of his like it, shows a compelling blend of erotic delicacy with strong, nearly Michelangelesque anatomical fervor and the most sophisticated handling of shadow (II.65). The shadow suggesting the pubic hair harmonizes effortlessly with the other shadows under chin and elbow. Concealing the fleece completely, by moving the angle of the knee up another degree, would have created just as harmonious an image; but leaving it partially visible made it poignant and erotically immediate, with no loss of grace.

It has been suggested that a hairless mons veneris helps to convey not only all the abstract ideals that have crystallized around feminine nudity but also a direct suggestion of the hairlessness of childhood. Such a reference would have particular value in that it would also bring with it an indirect suggestion of virginity, if not of purity. Lascivious virginity has indeed always had a traditional erotic appeal, along with the innocent or reluctant kind. The hairlessness of Bronzino's dirty Venus, together with her hipless contours, has vague connotations of a smooth eleven-year-old

prostitute skilled in vile practices. The twentieth-century Belgian artist Balthus has made many haunting, explicit images of hairless virgin lust.

It is difficult to find consistent evidence for the actual practice of depilating the mons in the history of Europe. John Baptista Porta's early scientific treatise *Naturall Magic,* first published in Naples in 1558 and translated into English in 1658, has a recipe for hair removal that suggests that it be used for pubic depilation, as well as for armpits and face. A *galante* French print from 1700 shows a chemise-clad lady sitting on a bed holding a razor and a bowl, her smooth mons exposed. Pornography, however, tends to show pubic hair, as we have seen, the better to emphasize the bestial aspects of sex. Renaissance literature makes much of the pubic forest, the wooded grotto, the mossy hill, and so on. Deliberately naturalistic images of nude bodies, such as Adam and Eve or domestic scenes, sometimes leave it in and sometimes take it out or beg the question with posture and drapery; and how much depilation was practiced

II. 65 P.-P. PRUD'HON
Study of a Nude Woman,
c. 1810

147

and by whom remain something of a mystery. Leaving it or removing it can be an erotic device, in art or life, and "truth" can be convincingly represented either way.

Whatever the fashion in female proportions or posture, the artistic creation of ideal nude feminine bodies between the sixteenth century and the First World War seemed to be guided by at least one universal rule: bones are unsightly. In earlier times a corollary rule also seemed to be in effect: some bones are more unsightly than others. Even the early-fifteenth-century fragile Gothic nudes, whose skeletal formations clearly show through the feminine flesh, have jaw bones carefully obscured by an incongruous roundness. After 1500 the vanished jawbone was followed by the clavicle, which also disappeared altogether from female anatomy. Already consigned to oblivion were the ribs and any frontally discernible bony sculpture of the pelvis, all of which were banished by the need to celebrate the extent of the soft abdominal landscape. Soon the only bony framework made visible under the flesh of a female nude seen from the front was indicated by her knees and ankles, an occasional elbow and perhaps some metatarsals. Rear views permitted some indication of vertebrae and shoulder blades but no sharp angles of the shoulders themselves. A degree of slenderness itself was clearly often admired; but even the slim Bronzino Venus and all the attenuated nude Mannerist confections tended to be disposed in postures that prevented ridges of rib or the jutting of the pelvic blades from showing. Michelangelo admits openly to the female clavicle—but even the wondrous terrain displayed by the bodies of his *Night* and *Dawn* is mostly formed by muscle, not bone.

There were, of course, Classical precedents for the boneless female body—and, it must be admitted, visual evidence for the existence of a subcutaneous layer of fat in the female: women's bones simply do not show so much as men's do. Nevertheless, the female skeleton does thrust itself through the smooth covering, in response to certain kinds of poses or movements; it remains for the creative eye either to seize upon the phenomenon or to ignore it. The skinny figure of Pisanello's *Luxuria,* as in certain recent photographs, illustrates the erotic possibilities of bones in female nude art (I.66), but Classical female nudes tended to display both

II. 66 PISANELLO (C. 1395–C. 1455), *Luxuria*

bone and muscle with utmost discretion. The nascent Venus who raises her arms on the front of the so-called Ludovisi Throne (460 B.C.) has a visible rib cage under her delicate dress; but later Greek sculptors in the Baroque style of Pergamum (second century B.C.) used other methods for elaborating the surface of the female body, while male bodies were designed with ever more complexity of both muscle and bone. Dramatic arrangements of drapery accomplished the same aesthetic purpose for the bodies of women, and even the actively fighting or dancing female figures in ancient Greek sculpture show no ribs, hips, or shoulder angles. The violence of the action is expressed by the behavior of the clothing they wear rather than by any visible straining of the skeletal frame or tension of the muscles, like those in the convention developed for male figures. Only one of Niobe's suffering daughters (c. 440 B.C.) exposes the same delicate arch of ribs apparent on the body of the Ludovisi Venus.

Men, of course, always had plenty of noticeable bones, in ancient Greece and in the later history of nude art. The dead Christ and many martyrs display the great vaulted arches of their ribs in all the varying tra-

ditions of European art; and Caravaggio's youths thrust their shoulders out at us, throwing sharp clavicles into relief (see III.51). Even the masculine damned souls in Rogier van der Weyden's triptych of the Last Judgment have more bony projections than their female counterparts in similar violent and desperate attitudes. Italian and Northern European Renaissance female nudes of the fifteenth century do indeed sometimes have visible bones, but they are never shown lying down in such a way that the belly hollows out and the pelvic ridges stick up, nor do they arch their backs so that the arc of the rib cage shows; and they never have jawbones. Even later, after the tempered and harmonious vision of the Renaissance had been readjusted to suit a more extreme visual taste, the nude women of Mannerist and Baroque art tended to display fatty rather than bony excesses of bodily shape.

The attractive bony female nude with a flat stomach is an aesthetic conception that has been confirmed only in the twentieth century. It had its genesis, nevertheless, in certain aspects of late-nineteenth-century Romanticism. One quality of the physical type created by the Pre-Raphaelite and Symbolist artists was a peculiar kind of fatal slimness. This physical condition, which had first appeared in Romantic literature, was presented as the corporeal result of a wasting passion, a debilitating obsession, or an excess of spiritual energy. In this kind of Romantic visualization, religious ecstasy and personal heroism—which had once required a visible reflection in heroic-looking flesh—came to seem more appropriately housed in a thin frame, just as abandonment to sexual passion or to occult forces was seen to be physically wasting.

This particular way of looking—hollow-eyed and hollow-chested, languid but without repose—was worn by the mythical and legendary characters portrayed by Burne-Jones and Gustave Moreau (II.67). In slightly altered form, the same look survives in the mordant images of Toulouse-Lautrec, in the gaunt ghosts of Edvard Munch, and later still in the harsh Gothic visions of Egon Schiele. With the decorative and elegant kind of decadence illuminated by Aubrey Beardsley and Gustav Klimt, the attenuated look of "Romantic agony" has been appropriately refined and adapted to illustrate effete erotic fantasy as if it were a kind of outgrowth of heroic legend. Toulouse-Lautrec and Munch, however, made different changes. The look of legendary suffering is replaced by the ravages of disease and hunger, and the look of exhaustion through ecstasy gives way to an aspect produced by complex neurosis, anxiety, and other forms of modern strain. These skinny images offer, nevertheless, not a grim lesson but a new ideal.

The thin female nudes of late-nineteenth- and early-twentieth-century art could rely for their appeal partly on the legacy of that heterodox Romantic slenderness that had been born underground, so to speak, during the full tide of the fashion for plump and boneless women with round cheeks, smooth hair, and placid expressions. The look of sickness, the look of poverty, and the look of nervous exhaustion were gradually able to acquire the visual authority of a fashionable ideal type; and this was undoubtedly possible partly because of their original connotations—first established by early Romantic writers and artists—of amorous energy and spiritual capacity.

Until about 1910 the plump feminine ideal remained entrenched; but it soon had to alter, to incorporate both the recently formed taste for Romantic decadence and a new, enforced taste for an awareness of sober reality as society altered and war approached. Innocent buxom curves became amalgamated with decadent masses of hair and sinuous bodily shapes to form a bizarre feminine aspect: a head enlarged and weighted with hair

II. 67 EDWARD BURNE-JONES
(1833–1898)
The Tree of Forgiveness

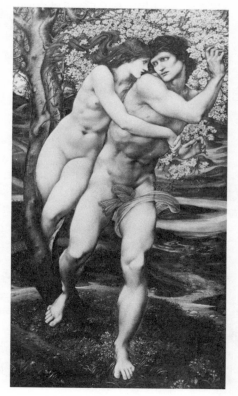

down to the enormous eyes; a serpentine, forward-tilting body with a grotesquely dropped and overhanging "mono-bosom" balanced by an outthrust "mono-buttock" behind (II.68). The extreme linear peculiarity of this female shape was bound to alter soon, and indeed its latent ideal of overall slenderness finally asserted itself by the 1920s. The exaggerated hair and curves were speedily modified, and the slim modern woman was achieved.

The strong appeal of female slimness in the twentieth century is usually accounted for by social and economic changes rather than through a purely aesthetic development of style. Feminine emancipation from many physical and moral restraints, the increasing popularity of sport for women, together with new possibilities for gainful employment and political power, all eventually contributed to the new physical ideal. Good sense and good health, mental and physical, were seen to be properly served by freedom and activity, and feminine clothing evolved so as to allow for these and (more importantly) for the look of these. What is meant by "modern" looks developed after the First World War with the aid of clothing that expressed (although it did not always provide) an ideal of comfort and the possibility of action.

The most important expressive element in this new visual conception of female dress was not the uncorseted torso but the shortened skirt. After women's skirts had risen off the ground, any given clothed woman was perceptibly smaller in scale than formerly. Hair was shortened, as well as skirts, and worn close to the head. Hats shrank. During most of the nineteenth century a fashionable woman's dress, including coiffure, headgear, and a possible muff, handbag, and parasol, had consisted of an extensive, complicated system with many different sections (sleeves, bodice, skirt, collar, train). These were all separately conceived and embellished and all tended to enlarge the total volume of the clothed body, partly by being difficult to perceive all at once. After the First World War a woman's dress came more and more to present a compact and unified visual image. This is what men's clothes had already succeeded in doing a century before. The new simplified and reduced clothes for women, although they were designed and made absolutely differently from men's clothes and out of different fabrics, nevertheless expressed the new sense of the equality of the sexes—an equality, that is, with respect to the new character of their important differences.

Female sexual submissiveness, either meek or wanton, was no longer modish and no longer avowed by elements of dress. Feminine sexuality had to abandon the suggestion of plump, hidden softness and find expres-

II. 68 Corset advertisement, c. 1908
Proto-modern slimness

sion in exposed, lean hardness. Women strove for the erotic appeal inherent in the racehorse and the sports car, which might be summed up as mettlesome challenge: a vibrant, somewhat unaccountable readiness for action but only under expert guidance. This was naturally best offered in a self-contained, sleekly composed physical format: a thin body, with few layers of covering. Immanent sexuality, best expressed in a condition of stasis, was no longer the foundation of female allure. The look of possible movement became a necessary element in fashionable female beauty, and all women's clothing, whatever other messages it offered, consistently incorporated visible legs and feet into the total female image. Women, once thought to glide, were seen to walk. Even vain or fruitless or nervous activity, authorized by fashionable morbid aestheticism, came to seem preferable to immobility, idleness, passivity. The various dance crazes of the first quarter of the century undoubtedly were an expression of this restless spirit, but its most important vehicle was the movies.

The rapid advance of the movies as the chief popular art made the public increasingly aware of style in feminine physical movement. Movies taught everyone how ways of walking and dancing, of using the hands and moving the head and shoulders, could be incorporated into the conscious ways of wearing clothes. After about 1920 the fact that women's clothes showed such a reduction in overall volume was undoubtedly partly due to the visual need for the completely clothed body to be satisfactorily seen *in motion*. Perfect feminine beauty no longer formed a still image, ideally wrought by a Leonardo da Vinci or a Titian into an eternal icon. It had become transmuted into a photograph, a single instant that represented a sequence of instants—an ideally moving picture, even if it were momentarily still (II.69). For this kind of mobile beauty, thinness was a necessary condition.

The still body that is nevertheless perceived as ideally in motion seems to present a blurred image—a perpetual suggestion of all the other possible moments at which it might be seen. It seems to have a dynamic, expanding outline. The actual physical size of a human body is made

II. 69 Fashion photograph, *Vogue,*
November 10, 1930
Clothes and body in motion

apparently larger by its movements, and if its movements are what constitute its essential visual reality, they must be what gives it its visual substance. Even if a body is perceived at a motionless instant, the possibility of enlargement by movement is implicit in the image. Before consciousness had been so much affected by photography, a body perceived as ideally still could be visually enlarged by layers of fat or clothing with aesthetic success, but a body that is perceived to be about to move must apparently replace those layers with layers of possible space to move in. The camera eye seems to fatten the figure; human eyes, trained by camera vision, demand that it be thin to start with, to allow for the same effect in direct perception. The thin female body, once considered visually meager and unsatisfying without the suggestive expansions of elaborate clothing (or of flesh, which artists sometimes had to provide), has become substantial, freighted with potential action.

It came about that all the varieties of female desirability conceived by the twentieth century seemed ideally housed in a thin, resilient, and bony body. Healthy innocence, sexual restlessness, creative zest, practical competence, even morbid but poetic obsessiveness and intelligence—all

II. 70 THOMAS EAKINS (1844–1916)
William Rush Carving His Allegorical Figure of the Schuylkill River, 1877

seemed appropriate in size ten. During the six decades following the First World War, styles in gesture, posture, and erotic emphasis have undergone many changes, but the basically slim female ideal has been maintained. Throughout all the shifting levels of bust and waist and the fluctuating taste in gluteal and mammary thrust, the bodies of women have been conceived as ideally slender, and clearly supported by bones.

Reclining nudes, lying on their backs in paintings and photographs, show both the costal and pelvic ridges; shoulder blades jut out, elbows poke at angles; and clavicles and jawbones have become well-established aesthetic elements in the rendering of female beauty. In 1877 the delicate figure of Thomas Eakins' nude model in *William Rush Carving His Allegorical Figure of the Schuylkill River* was shocking, specifically for the gracelessness the spectators found in her bony shoulders and visible ribs (II.70). At the time, painting the bumps and ridges seemed to deprive the undressed model of her proper cloak of idealized flesh, exposing her as nakedly ugly instead of beautifully nude. In the twentieth century these very details seem beautiful, since the idealization of the female body in art has changed its methods and its means. Eyes instructed by the lessons both of photography and of artistic abstraction can invest with poetry and sexual allure the very bones and tendons that were once considered to be God's mistakes in the composition of female nude beauty, perpetually in need of correction by the superior taste of artists.

U·N·D·R·E·S·S

K enneth Clark has made a useful distinction between the "naked" in art, meaning the image of an unidealized individ- ual bare body, and the "nude," which must be an idealized depersonalized image. This somewhat arbitrary distinction quite properly keeps getting blurred, since idealization is so complex a process; but it serves very well in dealing with the relation of any un- clothed image to its absent clothing. If one follows Clark's rule, the naked figure always appears to have some connection with actual garments, usually contemporary; the nude implies drapery. The blurring of the dis- tinction, however, can itself become a dynamic element in nude art, delib- erately used to intensify the effect of the image. Artists have made capital out of the possibility of portraying neutral-looking, Classicized bodies emerging from real clothes or idealized drapery accompanying very realis- tic naked bodies. There is also a tradition of showing Classical, idealized nudes keeping company with fashionably dressed figures whose own bodies must clearly be constructed on quite different principles.

The success of this device depends on the talents of the artist. One odd example is a painting by Hans Eworth of Queen Elizabeth and some of her attendants encountering some goddesses in a landscape (III.1). The royal party wear their stiff and heavy clothes over somewhat meager bodies. Two of the goddesses, wearing flowing dresses and Classical

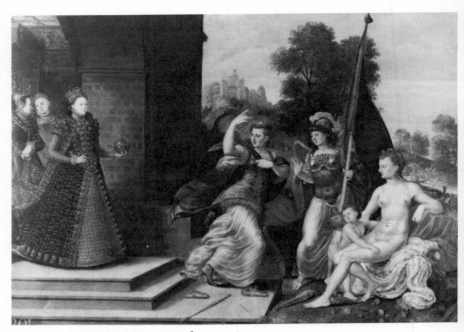

III. I HANS EWORTH (c. 1520–after 1573)
Queen Elizabeth and Three Goddesses, 1567

armor, have the ample and heroic bodies that were designed by many late-sixteenth-century artists to set off such garments and that are clearly incapable of fitting into Elizabethan court dress, even with stays. These goddesses use theatrical gestures. The third goddess, however, is Venus, and so she must, of course, wear no clothes. Her figure, more clearly than the other two, shows the small bosom and long, stiff, narrow torso dictated by fashion, together with an overall smallness of proportion (in relation to her head) quite suitable for a dress much like the queen's and a decorous posture like hers. Venus looks, in fact, not nude but undressed—or naked. To point this up more clearly, the artist has shown her sitting not on an unidentifiable swatch of Classical drapery but on a contemporary chemise, complete with sleeves, collar, and trimming. To establish their identity, Juno and Minerva must appear with Classical trappings veiling their Classical nudity; Venus' chief attribute, in this picture, is the fashionable body, exposed by the removal of fashionable dress.

The powerful suggestion of removed clothing, which gives the nude its erotic force, is thus obviously intensified when the artist puts some kind of clothing in the picture. But here the pictorial distinction between dress and drapery may be just as deliberately blurred as the one between ideal-

ized nudity and immediate nakedness so often is. By the late Middle Ages clothing and pure drapery in real life had already become widely separated. The development of complex tailoring for clothes forced drapery more and more into a decorative role—it was an elegant subsidiary feature of clothing, not its essence. But underwear remained rudimentary in shape and substance for a long time, except for the varieties of corseting for women.

The smock (or shift, or chemise) was the one basic undergarment for all European women for a thousand years, and it was a voluminous white garment of extreme simplicity with little or no shaping and trimming. Full folds of white linen, gathered on bands at the neck and wrists, fell straight down to around knee level. When it was removed or half removed, this basic garment could easily seem to be only a bunched-up mass of material. It was also an essential domestic accompaniment to any actual nakedness, being always the last thing to be taken off and the first thing to be put on. It varied in style only a very little, sometimes reaching up close to the base of the neck and sometimes having a wide décolletage, sometimes with a shorter or longer sleeve; and sometimes the gathered material at the neckline and wrists would be allowed to form ruffles and include some embroidery or lace. But the main bulk of the garment was full, plain, and white, and everybody wore it. Men also wore it, and wear it still in modified form, but the male version was called a shirt. Both were called a *camicia* in Italy. It was a universal undergarment, and in fact it acquired a certain symbolic importance. It stood for the humility of nakedness at a time when real nakedness was usually very well covered. Public penance might be done in one's smock or shirt, for example, or public punishment received as if one were naked.

Representations of this homely garment were correctly realistic for scenes of poverty and luxury alike, and it could be manipulated very easily so as to resemble the *himatia* and *chitones* of Classical antiquity. On the other hand, its homeliness could be emphasized by the clever exposure of its cuffs or neckline and drawstring. Rembrandt's etching of 1630 called *Diana* shows a naked young woman sitting on her bunched-up smock outdoors on an embankment (III.2). The smock cuffs and collar are clearly visible, along with all the flaccid lumps on her belly and the bumps on her knees. A similar image is in the *Naked Woman Seated on a Mound* of the following year, in which, this time, the lady sits on her dress and leans against her smock, again clearly showing its cuffs (III.3).

It is not only the ungainly posture (particularly the awkwardly held shoulder in the second example) and the fatness but also the indications

III. 2 REMBRANDT (1606–1669)
Diana, 1630

III. 3 REMBRANDT (1606–1669)
Naked Woman Seated on a Mound, 1631

of real clothing that de-Classicize these images. They also help to produce the stimulating suggestion of actual removal of clothing in a natural setting—not unguarded but self-aware and conscious, as the candid gaze of each shows. Their gross bellies are troubling to modern eyes, particularly in combination with youthful faces and suggestions of virginity in the title *Diana.* Indeed, if instead of the obvious, homely smock these big girls were accompanied by ostentatious drapery, they would look like harsh parodies of Classical themes. With their own clothes piled under them, however, they are appealing figures of tender female solidity. The intention to make these bodies look not only "realistic" but specifically desirable is conveyed by their resemblance to the currently modish clothed look for ladies: high waistline, plump but narrow shoulders, huge stomach, and lots of rippling texture—in these instances flesh, not silk.

The great painting *Susannah and the Elders* by Tintoretto shows not only a smock with lace trim but also a fringed towel and a corset—in this case a stiffened bodice and not an undergarment (III.4). The use of this garment as a stage property in a nude painting had a sharply erotic appeal now lacking its complete effect on the modern, uncorseted sensibility. The direct naturalism of this detail, which could easily have been omitted to show the dress only as a pile of red cloth, amplifies its sexual significance: the lady's defensive armor is ostentatiously laid aside. But at the same time, her aggressive weapons are at hand; and the comb, necklace, and cosmetics jar are also joined in this category by the stiffened bodice,

made visible as part of the paraphernalia of allure. Added to these, the near presence of Susannah's mirror indicates her own knowledge of her attractions, dirty old men notwithstanding. And yet surrounded by all these trappings of a conventional Venus, plus the smock and stays of a real naked woman, her body is an abstraction. The erotic message has been shifted to the surrounding emblems; the nude figure itself does not have to convey it. Susannah's body has been more eroticized by her abandoned corset than by any of its extraordinary linear distortions.

Abandoned contemporary finery can also add an erotic charge to the image of an otherwise neutral, Classicized body. In Renoir's *La Baigneuse au griffon*, for example, the figure stands on a riverbank where her dressed companion reclines, looking like the Praxiteles *Venus of Cnidos* and consciously copying the pose (III.5). But we are forced to see her as a modern naked woman because her elaborate clothes are conspicuously piled up near her, and her lace-trimmed chemise hangs from her fingertips. Here the actual body wears both the Classical pose and the modern fashion at once, to ensure a double response. The spectator may recognize the Classical allusion with a detached appreciation for the harmony of the nude

III. 4 TINTORETTO (1518–1594), *Susannah and the Elders*

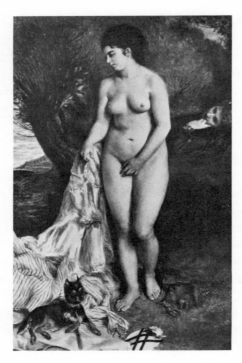

III. 5 P.-A. RENOIR (1847–1919)
La Baigneuse au griffon, 1870

form perfected by ancient Greek genius; but the painter has raised and diminished the waistline and hunched the shoulders slightly to enclose the somewhat enlarged breasts, in a perfect copy of modish clothed posture for 1870. We can see exactly what form the shapeless mass of striped silk would take if the lady were dressed in it; and her hair is arranged in readiness for the hat now lying at her feet.

The spectator is urged to see this Praxitelean woman as a denuded Parisian, not only because her accompanying drapery is clearly clothing but because her body is still stamped with the visible awareness of its customary dress—it is as if we were seeing through it. The pose becomes ironic when thus adopted by such an acutely contemporary nude fashion plate. The lush, warm texture and shading probably contributed less to the appeal of this body for its original audience than did the unmistakable suggestions of modish clothing in the proportions—a stock trick of the pornographer, here neutralized for Salon display by the Classical allusion. It was a very popular painting.

Artists in the sixteenth and seventeenth centuries often achieved a clever compromise between overt references to the actual removal of actual clothing, with its raw appeal, and the sanctified, conventional uses of

drapery. This compromise worked for both the aesthetic enhancement of nude figures and their iconographic requirements. We have suggested how the smock alone could be made to serve this double function; but it was also possible to show a nude figure out of doors, for example, sitting or lying on (or draped by) a kind of filmy white meta-garment, with a length of heavier colored stuff spread under or behind the white one. The sumptuous, stiffer fabric, however shapeless, would suggest a dress, and the thin white fabric next to the skin would automatically suggest underwear because of its color, texture, and position. The combination, though designed to indicate drapery, always looks remarkably like clothes, since it refers directly to the juxtapositions of fabric used in contemporary costume.

A thin white chemise visible next to the skin under a richly colored heavy silk dress is a staple combination in High Renaissance female costume, dramatized over and over again by painters such as Titian in the celebration of female beauty. When the nude figure is shown outdoors, accompanied only by the recognizable raw elements of the familiar mode of dress, she looks much more like a woman with her clothes off than like a Classical nymph enjoying customary half-draped nudity. A truly Classically minded painter, such as Poussin, however, was careful not to make modern erotic references out of Classical allusions. His outdoor nudes wear drapery that cannot possibly be anything else—no suggestions of discarded skirt or stripped-off chemise. Poussin nymphs and youths take off their clothes, but they are firmly Classical clothes: simply woven rectangles in bright hues and flat texture, always readily doubling as blankets or towels and interchangeable as to sex.

In yet another mode of using cloth to make nudity significant, Giorgione, in his *Sleeping Venus*, carefully places the skin directly against a rich silken fabric (III.6). Apart from painterly considerations of contrasting texture, this device emphasizes Venus' removal from any kind of ordinary nakedness, either Classical or modern. Despite the warm weight of this sleeping body, no comfortable crushed linen needs to protect the precious silk from the divine flesh; Titian employs the same motif in his various versions of *Venus and the Lute Player* (III.7). Rendered even as they are in sumptuous worldly terms, these nude bodies are primarily ideas made real—having, of course, all the greater potency for their amazing resemblance to naked women. The rich stuffs cradling them are neither garments nor bedclothes but the visible agents of myth. It is "artistic" drapery, a substance later to be much debased but here first used in the High Renaissance for its original and highest purpose.

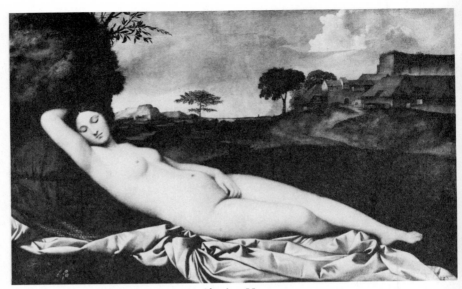

III. 6 GIORGIONE (1476/8-1510), *Sleeping Venus*

For most indoor nudes in art, thin muslin and heavy silk painted near or under reclining bodies assimilate themselves visually to bed coverings and bed hangings. The lengthy pictorial tradition of bed drapery to accompany the nude, like that of other kinds of pictorial indoor hangings, seems to have developed a separate existence from practical interior decoration after the middle of the sixteenth century. Once the subject of a picture was established as a nude or nudes on a bed, artists often assumed license for unbelievable excesses of fabric in the picture—all legitimately based on the fact that most European beds of any pretensions had hangings of some kind. The erotic or otherwise symbolic significance of beds could thus be controlled according to the degree of realism or rhetorical emphasis with which the bedclothes were offered to view in connection with the nude. Indoor nudes might seem depraved or noble or cozy—or, as we have seen, mythic—depending on the character and behavior not of their limbs but of their cloth surroundings.

The carefully recorded bed hangings in fifteenth-century Northern European art included indications of the mechanics by which the curtains were suspended and manipulated for practical purposes, the customary layering of linen sheets and heavier coverlets, and the placement of pillows. These draperies did not become fictionalized, any more than clothing, when the bed became the background for a legendary nude, as in Dürer's painting of Lucretia, or for a popularized naked trollop, as in the

engravings of Urs Graf (III.8). The beds in such early-sixteenth-century images of ideal nudity were as responsibly recorded as those in any Birth of the Virgin. The draperies preserve their forthright clarity of function and shape. But as with other forms of visionary drapery, bed covers and hangings in art, like tents and thrones, were transmuted into emblematic decor in the sixteenth century and became purely artistic in the seventeenth.

Still, the actual custom of curtaining beds on all sides gave compositions involving nudes on draped beds an automatic naturalism that was missing from portraits swathed in gratuitous accessory yardage. Endless curtains, dubiously attached, hanging heavily down around the head of a bed, and a great quantity of undefined disarranged fabric covering its surface were acceptable pictorial accompaniments for reclining nudes for centuries after Titian first evolved them in the early sixteenth century (see I.48, 49). They looked just enough like domestic reality to be used, unchanged in formula, by Courbet and Manet in their deliberately unmythologized nude paintings, which are otherwise accoutered with modern stage properties.

III. 7 TITIAN (c. 1478–1576), *Venus and the Lute Player*

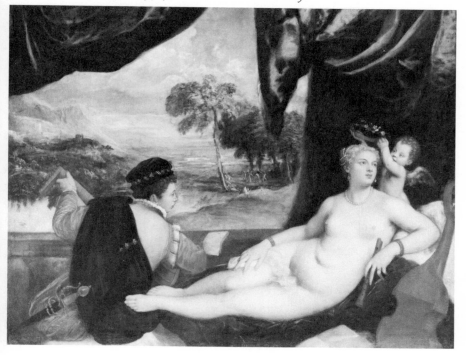

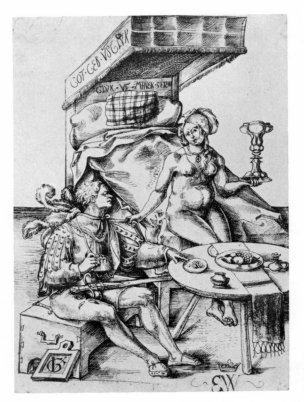

III. 8 URS GRAF
(c. 1485–1527)
Soldier and Whore

Manet's *Olympia* and Courbet's *Le Sommeil* were both meant to be un-compromising visions of contemporary erotic life, unmitigated by artistic euphemism (III.9, 10). The beds in both pictures, however, are strictly conventional, especially the hangings. These huge, untidily swagged bro-cades and, in the *Olympia*, the untidily tucked sheet have their visual source not in wicked bedrooms, where steamy couplings disarrange the counterpane, but in the idealized couches of the Renaissance. Fifty years before, Goya had been far more uncompromising: the nude *maja* lies on an obviously modern sofa, on which an equally modern ruffled pillow and sheet have been specially spread for her. There are no hangings at all; she has been stripped and laid down in the salon, with no apologies to Titian (see II.3).

Titian's *Venus of Urbino*, from which the *Olympia* derives, is an obvious challenge to any aspiring painter of the reclining nude (III.11). The deeply erotic image is suggestive without being either sly or blatant or Classicized into erotic neutrality. The pose, the body, and the gaze man-

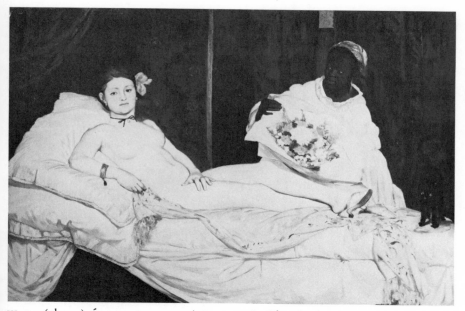

III. 9 (above) ÉDOUARD MANET (1832–1883), *Olympia,* 1865

III. 10 (below) GUSTAVE COURBET (1819–1877), *Le Sommeil*

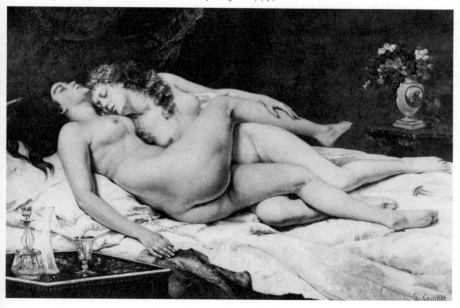

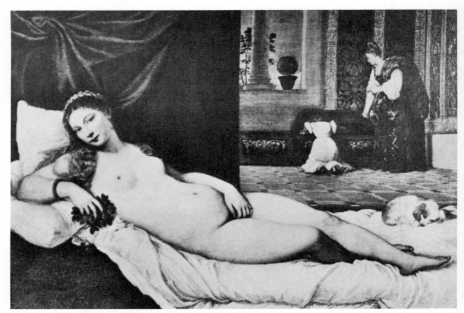

III. 11 TITIAN (1487-1576), *Venus of Urbino*

age this extraordinary feat by themselves; but other elements help, apart
from symbols like the dog and the leaves. The draped sheet and curtain
surrounding the figure in the foreground are generalized, not specified as
contemporary bedclothes, but the background details are domestic, with
special emphasis on the empty dress over the maid's shoulder, which is
clearly visible and clearly belongs to the nude lady in the foreground,
though its distant placement means that the process of undressing is not
suggested too insistently. Venus' mundane garments have been taken
away, to reveal her celestial beauty. The mass of fabric in the foreground,
interrupted by no details of bedstead or canopy, may be smoothly ab-
sorbed as a reference to august antique prototypes, showing Classical
nudes on draped couches.

Actual Greek and Roman couches were evidently backed or surrounded
by hangings, attached not to canopies but to rows of standing columns,
which had rings affixed to them through which a little of the fabric could
be pulled to hold the curtain in place. This arrangement could clearly be
temporary, and all the fabric could be folded and put away to leave the
space empty between the columns again. Drapery also covers the furniture
on which figures sit or lie in the Pompeiian frescoes, and, of course, in all
antique art it wholly or partially swathes many figures. Life in antiquity,

as perceived through art, was thus seen by later centuries to be character-ized by the perpetual, flexible ad hoc use of many swatches of cloth. The relation between such universal pieces of cloth—used for clothing, bed-ding, hangings—and the human figure seemed all the more remarkable to those later civilizations that had become committed to very complex and permanent uses of fabric. Visual references in art to these antique domes-tic simplicities carried connotations of all the other antique virtues, in-cluding an elevated concept of personal physical beauty. Nudes could thus acquire a certain extra aesthetic credit through artful juxtaposition with Classical-looking bedding.

Common nakedness is thus transformed into artistic nudity simply by the very presence of drapery, especially if it is unadulterated by specific banal details such as bedposts or curtain rods. We have seen how outdoor nudes could be carefully either eroticized or Classicized by the clever pic-torial arrangement of nearby cloth so as to suggest cast-off garments or of garments to suggest drapery. It was also possible, however, to suggest bedding in outdoor nude scenes, using the same kind of cloth around the figures but adding an extra swatch in the branches of a nearby tree, which neatly avoided the issue of furniture altogether. In an outdoor nude scene, the presence of overhanging fabric somehow creates an unmistakable bed out of the place under it, even if the stuff performs no other obvious function such as sheltering or screening.

In Rubens' *Venus and Adonis* in the Uffizi, the couple exchange their parting embrace under a tree laden with an enormous red drape that does not even pretend to cover them (III.12). It hangs in a bunch over their heads to indicate that the fabric around Venus' loins is not clothing but bedding, since otherwise you could not tell. (His cape, on the other hand, is a real cape, to indicate his eagerness for departure.) For these intimate indoor effects in an Arcadian outdoor setting, there need not even be a tree. The yards of blue fabric cascading down the right side of Boucher's *Diana at the Bath* are too voluminous for clothing and too bunchy for a tent (III.13). They are there to make an instant bedroom out of the forest clearing in which the nude goddess sits with her nude attendant nymph. The folds alone suggest many similar indoor scenes of mistress and maid performing the intimacies of the toilette amid just such oceans of bed curtains.

A look at pictures of post-Renaissance European interiors reveals a cer-tain sobriety in the drapery and clothing of real beds in ordinary life. Stiff, boxy, and tentlike beds appear in the backgrounds of French and Dutch interior scenes (see I.26), and lying-in and death scenes are shown to take

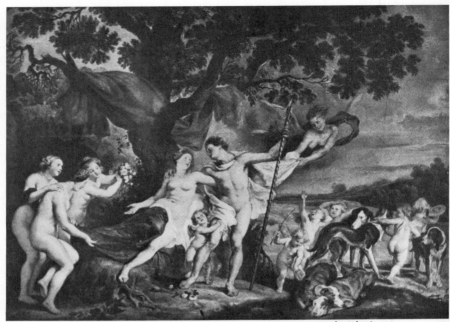

III. 12 (above) PETER PAUL RUBENS (1577–1640), *Venus and Adonis*

III. 13 (below) FRANÇOIS BOUCHER (1703–1770), *Diana at the Bath*

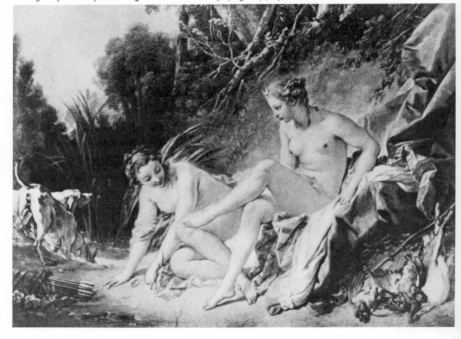

place on clearly constructed and neatly hung bedsteads. It is only the nude female in art who needs no definition for her bed; extra yards of hanging and draping stuff and bunched horizontal coverings of indeterminate purpose will do. These slight indications of a real bed intensify the erotic flavor of the unclothed image; but at the same time, they offer the conventional draped surroundings that elevate the woman's nakedness into nudity. Baroque artists might also use these same kinds of excessive bed draperies for heroic death scenes, but only for those occurring in antiquity. In contemporary circumstances, artistic birth and death beds are furniture, complete with posts and platforms, even for saints. Beds for nudes never needed to do this; they could be made entirely of cloth.

Artists who intended to produce a more insistently erotic image of the reclining nude might deliberately omit those suggestions, conveyed by drapery, of the sacred worship of the antique Venus—suggestions that Manet and Courbet left in. Certain nude pictures aiming at a piquant degree of smuttiness might run to bedposts, night tables, realistic bolsters, visible mattress ticking, and supportive canopies. Such details often appear in eighteenth-century French prints, along with the enormous amounts of bed-swathing yardage that were in fact realistic domestic appurtenances by that date. The Baroque sense of drapery had become well assimilated to fashionable decorative elegance. Along with delicate and exquisitely orderly furniture, plentiful curtains were untidily swagged over screens, sofas, and mirrors; bed hangings were arranged to billow out and down from a central point above to create a cloud of fabric around the sleeper. To de-Classicize a nude in such cloth surroundings, to modernize the image of Venus, a French artist of *galanteries* could include a chamber pot or a candlestick.

Apart from hangings, the disposition of bedclothes made a convenient means of controlling the level of prurience in a nude image while delicately alluding to drapery motifs in the whole canon of reclining-nude art. Because of their artistic respectability, bedclothes could be freely and suggestively manipulated for erotic effect by artists in prudish times, when such uses of daytime garments would seem unacceptable in serious works. A striking example is *The Sleeping Woman*, by Johann Baptist Reiter (1849); the image is essentially pornographic, but the theme and austere setting keep it quite legitimately immodest (III.14).

If only because of the body itself, the *Danaë* of Rembrandt is one of the most affecting reclining nudes in art (III.15). Equally important, however, is the amount of naturalistic bed furnishing surrounding the central figure. This seems to be an example of the generally Nordic

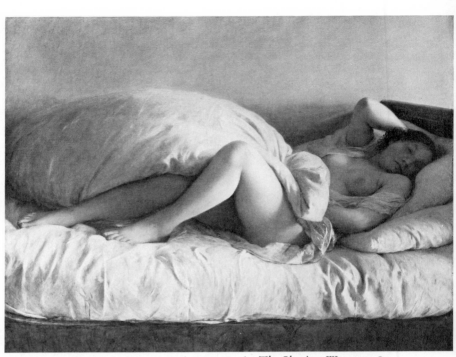

III. 14 JOHANN BAPTIST REITER (1813–1890), *The Sleeping Woman,* 1849

method of rendering myths in terms of genre that Joshua Reynolds found so unacceptable. The hangings, mattress, and bedposts in the Rembrandt, though imaginary, yet resist idealization or any assimilation to Classical prototypes in the Titianesque manner. They also make the nude woman seem more immediately naked, and so does the sheet shoved down to the ankles rather than gracefully festooned. The real bed surrounds the unformalized body, with its deeply shadowed sexual hollow and palpable weight, as it invites the light to invade and illuminate and fulfill it.

This solid but sagging bed, so thoroughly worked out in realistic construction, aims at an effect quite opposite to the one Manet evoked in the *Olympia,* in which the subject's bold bareness is mitigated by her art-historical couch. Olympia remains an emblem, somewhat forbidding despite her slippers and her neck ribbon. In the Rembrandt, not only the sweet body of Danaë but the whole composition, consisting almost entirely of the well-furnished bed, seems to invite the spectator as well as the light to approach and climb in. Titian's Danaë, on the other hand, lying amid generalized drapery and generalized landscape, is obviously accessible only to Jove (see II.9).

Modern painters of the nude have sometimes wished to explore (rather than avoid) the more complex reaches of erotic feeling. They, too, have found it useful to clothe the nude image in significant surroundings drawn from the experience of everyday domesticity rather than in landscape and drapery. Indeed the modern nude, presented on a draped couch or utterly unclothed in the open air, tends to suggest chiefly the careful deliberations of the studio rather than potent ancient myths or real life and real sex. Even in the shimmering nude images produced by the Impressionists, the element of detached visual appreciation keeps them from fully sharing in the ancient power of visible nakedness. It has the same mitigating effect as the excessive references to Classical nudity used by any heavy-handed academic painter. Except for the illustrative demands of history, painting the realistic nude image in serious art had become thoroughly associated with formal and visual considerations rather than with the direct expression of feeling. To be a vital element once more, it needed new settings.

III. 15 REMBRANDT VAN RIJN (1606–1669), *Danaë*

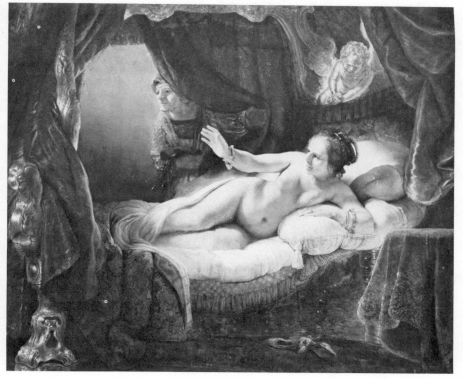

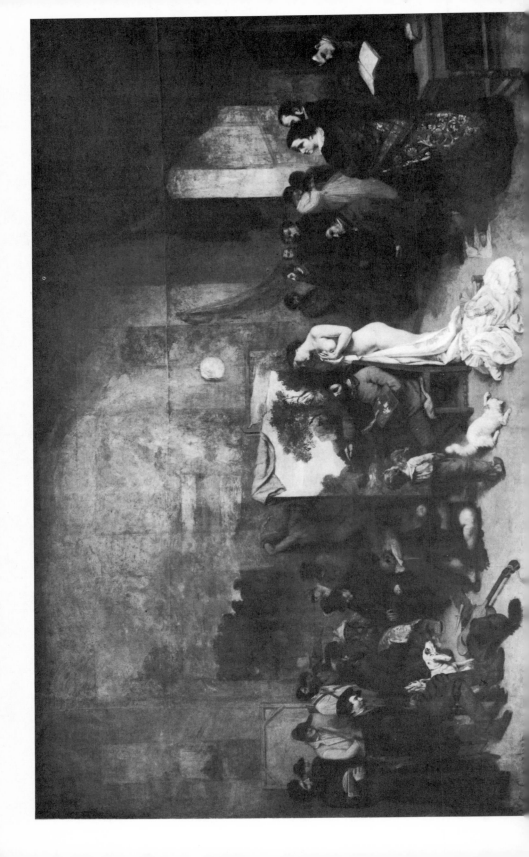

In the nineteenth century Courbet and Eakins took up this challenge, but mainly because it fell in with their other, more general artistic considerations. The nude was not yet simply an option for artists but a duty; and it certainly had to be taken on by any serious-minded revolutionary artist, if only as a construction to be undermined. Like Manet, Courbet and Eakins offered some ironical new views of nudity in old, familiar settings (couches, woodland glades). But by showing the nude posing as an artist's nude in a real studio, these two painters also opened new possibilities for the future of nudity as a serious subject—not object—in art. In these examples the subject is the relation between art and life and between the artist and his own work. In Courbet's *The Painter's Studio* and in Eakins' *William Rush Carving*, the nude appears in unedited workshop surroundings, with her clothes piled in the foreground (III.16; see II.70). In each, the bare body itself is unassumingly expressive, made neither grimly nor salaciously naturalistic; it is offered without the helpful guidance of a facial expression for psychological emphasis, as in Rembrandt. These ladies once more embody the inspiring power of the Naked Truth, following Botticelli and Bernini, but it is a new nakedness and a different truth.

In the art of the past, such images of an unselfconsciously undressed woman indoors had been simply and uniformly erotic in essence, whether they expressed the general spirit of genre painting or were pointed allegories of vanity or straightforward illustrations. The nude in a room with a cast-off pile of garments, particularly if accompanied by dressed attendants or observers, had always been an erotic theme, which had also gained in intensity through the inclusion, as we have seen, of everyday objects. For artists, use of such clothes and objects (as of any other pictorial convention) would lend the authority of traditional artifice to any such image. Now, Courbet and Eakins were devoted exponents of intense sexual feeling through nudity in art, but they also had commitments to the artists' serious task of dealing with everyday reality. By employing with amazing adroitness the well-established erotic theme of the undressed observed woman, these two paintings show how the two artists could invest a high purpose and a respect for sober (but not ugly) fact with an awareness of the importance of sex—and then use the result to illustrate the aims of art. It somehow seems to make them prophetic.

By elevating the theme of the-nude-as-a-subject-for-art into a symbol of the artists' serious views of ordinary life, these two painters made a new kind of serious subject out of the erotic power of nudity, one that combined a sense of significant fact with a sense of inner life. This prophesies the twentieth century's enlarged and complicated sense of the role of sex-

uality in common life and in art. In the two paintings the artistic nude was reconstituted for the modern erotic sensibility. The bare flesh, the cast-off garments, and the unidealized surroundings are familiar. What is unfamiliar is the new mode of expanded psychic dimension for nudity.

The settings appropriate for significant modern nudity, linked as it has to be with new forms of psychological awareness, are usually the landscape of dream or the domestic interior. Sometimes they may be a charged combination of both, such as Magritte and Balthus manage to convey with great force. Settings such as those used by Balthus and Edward Hopper for the nude owe some of their disturbing effect to their link with the old conventions of lighthearted erotic nude art. They are psychologically amplified versions of those seventeenth- and eighteenth-century amorous bedrooms that first exploited the simple sexiness of everyday nakedness. In the light of complex modern sexuality, these interiors help reclothe the nude with meaning, just as the Renaissance trappings and settings once had done for an awakened sense of the antique.

Edward Hopper dresses his nudes first of all in current erotic bodily styles: big, high breasts, prominent nipples, long legs. But after the apprehension of these details, a further sense of their sexuality is produced by the pressure immanent in their surroundings. There is no need of cast-off

III. 17 EDWARD HOPPER (1882–1967), *A Nude in Sunlight*

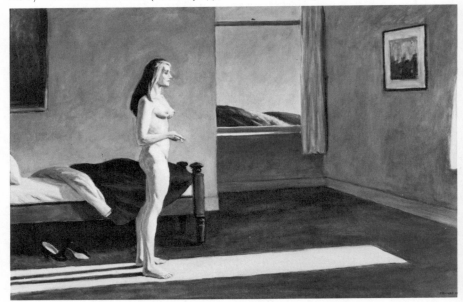

garments or of another presence; the very look of the body itself implies all that. Instead, the window frame allows the impersonal sun to cast a blank stare of light across the carpet. The bareness of the woman's sexy body and of the bedroom together seem to make an image charged with the contingency and psychic fragility of all human pleasure. We are invited not so much to admire the full breasts of the woman without her knowing it as to share her own ambiguous feelings about them (III.17).

Ever since the extraordinary inventions of ancient Greece, nudity and drapery go painlessly together in all situations for Western eyes. Real clothing or props suggesting drapery are also easily assimilable when juxtaposed with the nude. But clothing on some figures and nudity on others is an arrangement more difficult to apprehend. A woman getting out of her clothes or shown with her clothes nearby, depicted in company with a dressed figure, has always been a fairly straightforward erotic image, even though it may now borrow significance from Eakins and Courbet. But a carefully dressed male or female figure accompanied by a semidraped (not semiclothed) nude figure seems equivocal and mysterious, especially if the clothes on the dressed figure are those in common use and not fancy costumes or drapery themselves.

In the hands of the great masters of theatrical allegory, such as Titian and Giorgione, this image came to acquire a pictorial authority of its own, laden with an eroticism more or less oblique, depending on the opacity of the exact subject matter. But the famous *Déjeuner sur l'herbe* of Manet aroused direct contemporary objections because real naked women were shown with their clothing elsewhere in the picture, together with dressed men; and more than one figure gazed coolly into the eyes of the spectator (III.18). The sense of depraved erotic behavior, of immediate erotic action, was too strong. The eroticism of such a scene is not at all a function of which sex is shown dressed or of what degree of self-consciousness is represented; rather, it is a matter of how clearly expressed the exact action is. Among other things, the presence of drapery in such a scene rather than discarded clothing helps to clarify the theme as allegorical rather than representational. Drapery creates conventional images out of otherwise disturbingly equivocal or obviously unacceptable circumstances—in this case

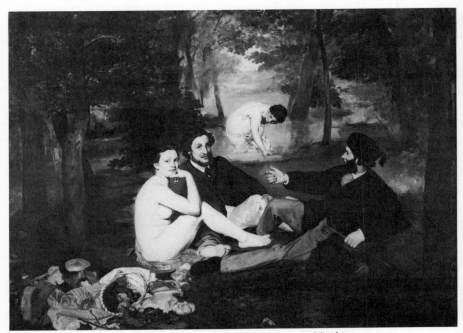

III. 18 ÉDOUARD MANET (1832–1883), *Le Déjeuner sur l'herbe*

deliberately offered by Manet's taking ironic advantage of the Renaissance conventions, as he did in the *Olympia*, to emphasize their difference from contemporary ones.

Sexual messages are always delivered by the image of an unclothed body; and even more intense ones must then necessarily be conveyed by a bare body shown in the company of a covered one, even in the most abstract arrangement. This is true simply because the dressed figure is usually perceived as aware of the undressed one or vice versa—or else the spectator is the *voyeur*, and that produces the eroticism by itself. An artist cannot expunge the erotic content from such an image. But the erotic level can depend on what kind of unclothed condition—nude or naked— is shown. For example, one image frequently repeated in Western art is that of the Pietà, or Deposition, the naked dead Christ taken down from the cross and held by his mourning intimates. It must be admitted that this image contains a strong erotic charge that contributes to its devotional impact: a passive and beautifully nude body in the hands and under the gaze of clothed personages. Michelangelo's Roman *Pietà* shows how far such a subject can be taken out of its narrative context and still hold its erotic element "in solution," as Kenneth Clark puts it.

In most Pietàs, however, the nudity rather than the nakedness of Christ is guaranteed not only by his conventional draped loincloth and his conventional beard and hair but by his conventional draped robe. Though stripped from him and absent from the picture, this well-authorized unworldly garment keeps his sacred nudity from ever sharing in common nakedness, no matter what anyone else wears. The beard and hair, the recognizable "Sacred Head" of Christ, do almost as much to deeroticize his bareness of body—which can be seen when they are omitted, as in Botticelli's famous *Pietà* or in Michelangelo's *The Last Judgment*. In the Botticelli, the beautiful and beardless Christ is draped nakedly and dramatically across the Virgin's knees, and the attendant clothed company seems overcome, not by his death but by his obvious attractions—especially the women in the foreground (III.19). Michelangelo's Christ-as-judge gains potency of judgment from his unbearded, naked sexual power, uncloaked by conventional imagery. Most religious images do keep their erotic equilibrium, specifically by means of the neutral draped garments worn by the *clothed* personnel.

An example of the opposite method, whereby the erotic content of the image is precipitated deliberately by fashion in dress, is given by the Botticelli *Venus and Mars* in London (III.20). Here again an unconscious young man displays his nude beauty to the profound gaze of a completely dressed young lady. He wears a bit of drapery, and his discarded armor simply identifies him, since it does not include the garments he might be expected realistically to wear under it, for he is a mythological figure. Moreover, we know who these people are and what their amorous relation is. But it is her complete, unruffled clothing that provides the sexual voltage for his nakedness, to a much greater degree than if she, too, were wearing loose drapery. Her modern clothes show her sexual dominance as much as her wakefulness does, and they make his bareness more erotic, despite his mythological trappings.

Without knowledge of their two roles, of course, this process would occur rather more obscurely, as it does in *Le Concert champêtre* in the Louvre, with the sexes reversed. In this picture, variously attributed to Giorgione or Titian, there is none of the disturbing latent depravity present in Manet's picnic (III.21). One reason is the complete absence of the ladies' contemporary dresses. These calm, enormous women already inhabit the sylvan landscape to which these moody and modish gentlemen have repaired. Since these women have clearly never owned clothes, their soft bulk cannot cancel the magical drama of their presence outdoors, protected as it is only by one delicate wisp of cloth. The nude maternal figure

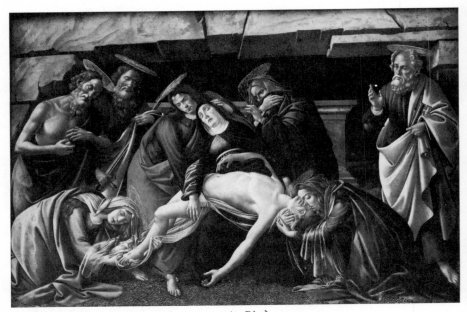

III. 19 SANDRO BOTTICELLI (1445–1510), *Pietà*

III. 20 SANDRO BOTTICELLI (1445–1510), *Venus and Mars*

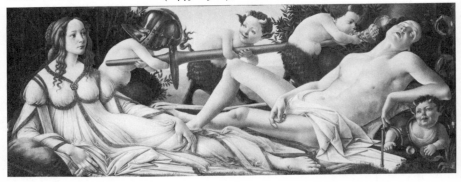

in the *Tempesta* of Giorgione also owes much of its powerful mystery to the use of the same extraordinary gear: only one strip of linen, to sit on and warm her soft shoulders in the chilly air while the completely dressed soldier stands near.

If in either of these paintings a pile of realistic-looking feminine garments had been included, much of the psychological power in the image would have been diminished, no matter how beautiful the nudity of the ladies. The drapery, not the bareness, of the nude figures is what gives

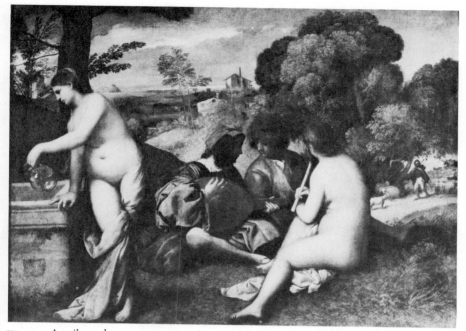

III. 21 Attributed to GIORGIONE (1475–1510), *Le Concert champêtre*

them the air of significance needing explication, the implied allegorical dimension that raises them from simple outdoor nakedness into the same world of myth inhabited by the antique gods and the nude Christ.

Another way of intensifying the effect of a picture with a legendary subject is to put the clothed figure into antique costume and show contemporary garments in association with the nude one. The Veronese *Mars and Venus United by Love* in the Metropolitan Museum has Mars in fanciful Classical armor, whereas Venus has removed not a piece of drapery but a recognizable smock, which can be seen hanging over the wall next to her (III.22). The ruffled collar and sleeves are insistently displayed. Although her identity as Venus is conveyed by her attribute—her diagonal golden girdle—her immediate sexuality is expressed by her fashionable, cylindrical figure and her stripped-off modern underwear. It would be like a twentieth-century image of the same subject, showing Mars in Classical armor and Venus draping a bra and panties over a chair.

The nude image of the crucified Christ in art is usually kept from being overloaded with erotic suggestion by the force of its devotional meaning. It does not matter what kind of clothed figures also appear with him. In crucifixion scenes the nudity of the two thieves, however, is often star-

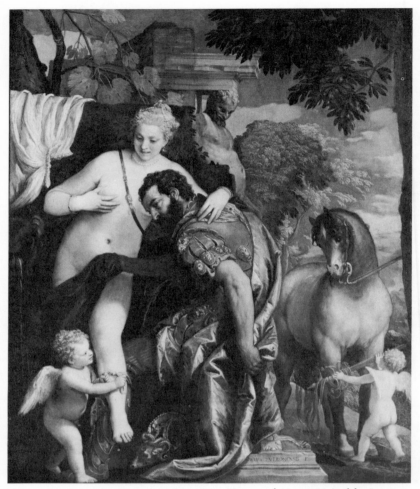

III. 22 PAOLO VERONESE (1528–1588), *Mars and Venus United by Love*

tlingly erotic by contrast, since they do not need to assume the ritual pose, and they can wear modern underpants when Christ himself has draped loins. Other nude male martyrs, shown just stripped of their contemporary dress and horribly treated by fashionable torturers, also carry a good deal of erotic freight.

Saint Sebastian is the outstanding example of the emphatically sexy saint, shown over and over in the Renaissance as a sort of sacrificial Adonis. One extremely subtle example, less obvious than hundreds of more blatantly beautiful Italian ones, is Memling's *Martyrdom of Saint Sebastian* in Brussels (III.23). In this forest scene some of the tender youth's gar-

III. 23 (above) HANS MEMLING
(1430/35–1494)
Martyrdom of Saint Sebastian

III. 24 G. DE LA TOUR (1593–1652)
Saint Sebastian Tended by Saint Irene

ments are shown delicately unfastened and pushed downward, as if by a lover's caressing hand. He gazes languishingly at the beholder; and his torso wears the elegant lozenge shape dictated by the prevailing mode, so that he seems a more deliberately desirable figure. His torturers are very near him, like prospective rapists pretending to be archers.

Another kind of Saint Sebastian is offered by Georges de La Tour in one version of *Saint Sebastian Tended by Saint Irene* (III.24). Again, as in Botticelli's *Mars and Venus*, the arched, unconscious nude body, here becomingly bathed in torchlight, lies helplessly displayed to the intense scrutiny of an extremely elegant lady. La Tour dresses Saint Irene (traditionally a noble Roman matron) in the height of seventeenth-century French fashion. Her corseted body and perfect curls give the scene an extremely amorous cast, not at all appropriate to the narrative but quite consonant with all the pictorial traditions regarding Saint Sebastian.

Dirk Bouts's *Martyrdom of Saint Hippolytus* explores the theme, using another saint (III.25). Hippolytus, naked, is spread-eagled in the center, his limbs tied to four horses about to be ridden in different directions by four richly dressed men. His own fur-lined velvet gown, hat, and shirt are all in a neat heap in the foreground, to emphasize his helpless stripped state and the immediacy of his naked beauty among these wicked gowned and hatted horsemen. He has none of the attributes of myth to save him from the possible perverse and obscene intentions of his tormentors before they rip him apart.

III. 25 DIRK BOUTS
(d. 1475)
*The Martyrdom
of St. Hippolytus*

The basic appeal in the juxtaposition of cloth and nakedness transcends both mythmaking and eroticism, and lies behind the creation of those Greek works of art that first celebrated it. The sensuous pleasure taken by the hairless human body in the sliding touch of fabric is conjured by any image of draped flesh. Since the feel of drapery involves the action of loose cloth working against the body's motion, it is quite different from the feel of tailored clothes, which provide a constant and immobile tactile reference for the whole surface of the body at once. During the antique draped centuries, the sensation of cloth in motion against the skin must have had a steady, underlying importance. It is easy to imagine the impulse to make art out of it. The connection between the way draped material feels and the way it looks produced satisfying mental images drawn from the circumstances of common life and then exalted by artists into heroic icons.

The cloth and flesh together, rather than the flesh alone, became the vehicle of a complete aesthetic concept. In actual life, draped fabric could make less-than-ideal or even ugly bodies feel more beautiful, more comfortable, and more harmoniously unified. The image of fabric, similarly shown enhancing idealized statues, could offer to ordinary humans a point of

common sensory identification with beings of divine perfection. Further, it might humanize the perfect images while it seemed to make more perfect the flawed bodies of men and women.

This almost religious function of antique drapery has been missing from art ever since the Middle Ages. Fabric replaced flesh and came to dominate it in the form of fashion. In the Renaissance, when the sensory appeal of nudity itself came again to be appreciated artistically, the look of cloth sliding over skin appealed to a different kind of consciousness. This appeal combined Classical reference with a hint of private and semiforbidden pleasure. Since in fifteenth- and sixteenth-century experience clothing was likely to be stiff, bulky, and confining, loose, thin fabric could move against bare skin only in intimate circumstances. This has been true for the most part ever since and has ensured the appeal of any representation of nudity caressed by drapery.

Nakedness, unaccompanied by cloth, *feels* less delightful to look at than nudity with drapery, even though it may be more directly sexual. Drapery near or on the nude figure in a work of art thus makes it easiest to take. It ensures both a high level of sensuous pleasure and a lowered quotient of disturbing, crude eroticism. For a thousand years of well-dressed spectators drapery has conjured lovely associations with the bedroom and the bathroom without obtruding any uncomfortable sense of the locker room. Simultaneously, its idealizing function has kept its authority: drapery automatically creates art out of life, and so it is self-justifying.

Absolute bareness—no cloth or clothing—has been the requirement for images of Adam and Eve, whether or not their genitals are screened by convenient branches. The total absence of woven stuffs lends both a subhuman and a superhuman look to all such figures. However their bodies are tailored, Adam and Eve always manage to look like helpless, furless beasts as well as unearthly apparitions, forever separated from ordinary humans by their unfallen state, even though their bodies may seem ordinary (III.26).

But the half-dressed or seminude image in art seems to have everything. It may offer fashionable clothing, mythological and sensuous drapery, and bare flesh all interacting in one visual scheme and all bearing the sanctifying *cachet* of mythic drama, sacred or otherwise. It begins with that obvious feature of draped Classical dress—the ease with which it could come off. Semiclad figures were common enough in the ancient world, so much so that it may not seem worth it to distinguish between them and skimpily dressed figures. But in any age there is a piquant quality about clothing disarranged by violence or mistake. The appeal is different from that of clothing intentionally drawn aside or partially taken off, and still different

III. 26 REMBRANDT
(1606–1669)
Adam and Eve, 1638

from that of special clothes designed to reveal portions of the body or of partially assumed ones. Classical statuary includes all of these: garments ripped off by ravaging hands or lifted provocatively by their wearers or sliding off in the course of action. But in all cases, more beautiful folds are created in the cloth—no disarrangement could do violence to the harmony of the costume.

During the tailored centuries of costume history, on the other hand, pictorial disarrangement meant a distortion of the clothes' design; artistic choices then had to govern the exact style of dishevelment, whatever the reason demanded by the subject, to make it look other than awkward. In this way artists could make drapery out of clothing in disarray.

Of all the situations in which clothing is disarranged, that which allows a woman to give suck is one of the most attractive. Its basic eroticism is always reassuringly transcended by the everyday sanctity of mother's milk. Breasts bring pleasure to everyone, and sight of them brings its own visual joy besides; and so images of breasts are always sure conveyers of a complex delight. Western traditions of art from Classical times have used two different kinds of exposed-breasts iconography. One depends on the exposure of one breast, the other of both; and they seem to mean somewhat different things.

Ever since the earliest Christian use of the theme, one bare breast signifies maternity, but it also seems appropriate to other forms of unselfconscious exposure. The fighting Amazon and the suckling Mother of Christ are, after all, both fierce virgins intent on matters other than pleasure; and their single-breasted descendants in art usually share either their ferocity or their artlessness or both. One bare breast certainly became an erotic signal in art, but as such, after the sixteenth century, it still tended to appeal to the voyeurism of the spectator. The breast's owner was supposed to be unaware that it showed. Most single bare breasts *not* being suckled are represented either in styles of art using the general disarray of dress for expression or in those devoted to reproducing the sartorial exactitudes of antiquity.

When an artist shows one breast exposed in a painting of a woman, it looks better if she is wearing something loose and indefinite, the graceful action of which can depend on the artist's skill. But the very artfully cut and fitted actual garments of the Renaissance represented an aesthetic impulse away from the looseness and shapelessness of medieval dress and coincided with a general crispness of representational style all over Europe. Fifteenth-century fashion in art and dress hindered the development of any taste for images showing the artless dishevelment of the female bodice. Nevertheless, stays pushed breasts up, considerable décolletage was commonly worn, and beautiful breasts were much admired in secular verse.

In pictures, however, until late in the fifteenth century, single bare breasts were strictly maternal. When the Virgin Mary exposed one breast to suckle the Infant Jesus in Early Renaissance Italian art, the breast appeared through a slit in the garment, a pale, isolated projection emerging from a sea of fabric (III.27). A Flemish Madonna in the same period nursed the Infant over the top edge of a sumptuous gown, from a neatly realistic but disproportionately small breast. No more bare flesh than was absolutely necessary surrounded this single nursing breast—the act was solemn and not sensuous, and the clothing worn by the Virgin in all early-fifteenth-century art was equally solemn. These gowns were similar to a type of dress actually in use, but they were much enriched and manipulated for hieratic purposes in art. Identical dresses might have been worn by figures representing the Virgin in pageants, but they were neither stylish nor common.

Fouquet's mid-century *Madonna and Child* was shocking at its date because the Madonna (probably Agnès Sorel, the king's mistress), contrary to pictorial custom, wears a very low décolletage and fashionable tight

III. 27 ANDREA DI BARTOLO
(active 1317–1347)
Madonna and Child

bodice, ostentatiously unlaced to liberate a most attractive large white breast (III.28). This breast bursts out of its confinement while the other one, for once equally visible under the dress, submits to its pressure with equally sexy effect. Though her dress is unornamented, this Virgin really looks as if she paid attention to clothes. Her gaze scans her own landscape. In itself, this gross disarrangement of the neat bodice would have been aesthetically disturbing at this period of symmetry in dress. The Virgin's usual adjustments of clothing for suckling are very minor, and pictures of women in distress or engaged in acts of heroism show no breast-baring di- shevelment of the normal bodice until after the turn of the century.

A new form of single-breasted display, however, which began to appear in the art of the fifteenth century, was deliberately founded on antique models. A number of Italian artists were able to copy Classical garments from original sources. These included the style of Greek dress that, though normally fastened on both shoulders, might be worn fastened up only on one side to leave one arm, shoulder, and breast entirely bare. Both

male and female figures in antique art wear this fashion; and it occasion-
ally, but not always, accompanies violent action, such as fighting or
dancing.

The famous *Nike* of Paionios is a beautiful windswept example
(III.29); various versions of the *Wounded Amazon* are even more famous.
This one-shouldered fashion for draped dress, although in fact a perfectly
normal custom in antiquity, could always seem to look accidental in Euro-
pean art—appropriate to unselfconscious movement. It could thus make
an image of the bilaterally symmetrical human body look more expressive
without harming the grace of its costume—especially the female body.

III. 28 JEAN FOUQUET (C. 1420–1481), *Madonna and Child*, c. 1450

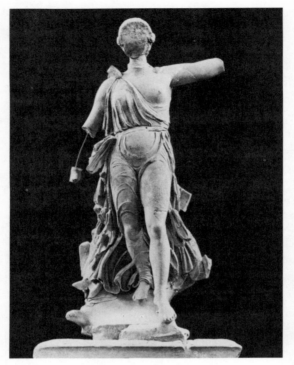

III.29 PAIONIOS, *Nike,*
C. 420–410 B.C.

The one-sided, one-breast-baring garment undoubtedly looked all the
more dynamic in the fifteenth century, when people's clothes tended to
match right and left; the very asymmetry of the fashion identified it as an-
tique, so it had aesthetic prestige as well as impact. Diagonal, asymmetri-
cal draping indicated antiquity in theatrical costume at this date. Because
of its erotic and antique associations, Piero della Francesca could make the
half-draped torso of a masculine angel suggest the baring of a female
breast (III.30). Other artists also made increasing use of the fashion, ap-
parently for the same purpose.

In the last quarter of the fifteenth century, the single exposed female
breast came for the first time to convey, along with its hallowed reference
to lactation, a legitimate reference to pure pleasure. Moreover, the one-
breasted female image began to suggest the same kind of emotional disar-
ray that seems to characterize the sleeping Ariadne, the dancing maenads,
or the fighting Amazons in Classical art. The revival of antiquity as an aes-
thetic principle permitted artists to take Classicizing liberties with the rep-
resentation of clothing—to make it do more draping, and do it more
freely.

III. 30 PIERO DELLA FRANCESCA (c. 1410/20–1492), *Baptism of Christ* (detail)

By the beginning of the sixteenth century the single bare breast in art, exposed by fancifully draped garments, had accumulated a combined significance. It referred initially to its august maternal function, with its long sacred tradition in Christian art; it had acquired the right to carry a direct allusion to the ancient world; and in a new humanist atmosphere it became a plain symbol of sexual delight—this last meaning probably made possible by the other two. Then, as Mannerist traditions were established and followed, a vogue for the conventional representation in art of emotional turmoil allowed one exposed breast to be the focus of such expression for a whole composition. The asymmetry of this revived tradition of artistic dress produced a look of instability, useful for connoting terror or license or devotional zeal. And the one-breasted fashion, of course, continued as well to signify Amazonian and maternal unselfconsciousness.

A lady's actual dress at about 1500 was unlikely to expose one breast by accident, since clothes were still formal and orderly. Breast exposure in a secular painting thus required a special costume—ostentatiously Classical, erotically symbolic—or perhaps just underwear disarranged by mythological force (see III.35). Much later on, when pictorial fabric had confirmed

its habit of free association, painters' society portraits could combine considerable imprecision in the painting of draperies partially exposing the bosom with a great deal of precision in the rendering of fashionable coiffure. But no such artistic habits had as yet been formed at the turn of the sixteenth century. In a secular figure composition, a lady calmly appearing with one uncovered breast was a nymph, a grace, or a goddess. In a portrait the theme conveyed symbolic pleasure, and it was always allowed for by special clothes, not vague draperies. One of Botticelli's fanciful portraits of Simonetta Vespucci has her thrusting one breast through the looped drapery of a scarf and otherwise clad in an imaginary drape and headdress. In Giorgione's enigmatic *Laura* the woman also has a mythological scarf encircling one subtle breast, and she is wearing her fur-lined coat over nothing (III.31). The pleasure in this picture is not only symbolic but visible—muted, but intense. The girl feels the fur and gazes broodingly into space, and the allegorical burden is removed from the exposed flesh to the background, where laurel leaves flourish. In Bartolomeo Veneto's *Portrait of a Lady* the woman stares meaningfully at the spectator as she supports a whole collection of voluptuous attributes: flowers, ringlets, jewels, myrtle garland—and one bare breast, carefully displayed by a one-sided draped garment too unwearably loose for real life (III.32).

III. 31 (left) GIORGIONE (1475–1510), *Laura*, 1506
III. 32 (right) BARTOLOMEO VENETO (active 1502–1546), *Portrait of a Lady*

III. 33 GIOVANNI BELLINI (c. 1439/40–1516), *The Feast of the Gods*, c. 1515

Artists using the one-shouldered tunic for male figures were also draw-
ing on an established Classical convention. The male version had heroic
rather than erotic overtones and was easily assimilable to the figure of
John the Baptist and other austere saints. But because it was a fashion
worn by both sexes in antiquity, it just as easily carried a touch of forbid-
den appeal at a time when male and female clothing was so clearly dif-
ferentiated; the androgynous rose-garlanded blond angel in Piero's
Baptism owes its subdued homoerotic flavor simply to this style of dress.
An august, still, and almost ritual eroticism pervades Bellini's *Feast of the
Gods*, in which several of the avowedly Classical figures gravely expose one
breast (III.33). No action, no vigorous spiritual or emotional force, is
causing this disarrangement. These unilateral Renaissance breasts are pure
signals—rounded reflectors of a gleam from the Golden Age.

III. 34 ROSSO FIORENTINO
(1494-1540)
Moses and the Daughters of
Jethro, 1523

In the course of the sixteenth century, the female figure with one breast
exposed gained in significance. The simple clarity of earlier meanings—
pleasure, motherhood, and the antique—was blurred by the theatrical
movement characteristic of Mannerist and Baroque figure compositions.
Certain artists wanted to show the unresolved progressions of ongoing
events rather than their cadences. This new convention was devoted to
immortalizing unstable conditions of being. It could therefore obviously
make great use of the compelling half-draped bosom. As a vivid manifes-
tation of instability, a woman thus semiclad in a picture could become a
sign that unsettling events were under way.

Rosso Fiorentino's *Moses and the Daughters of Jethro* affords an example
of emotional female exposure: the violent action in the foreground, per-
formed by vigorous nude men, is reflected by the look of the lady in the
rear (III.34). Her commentary on the event includes the display of her
right breast, which is presented as a natural accompaniment to raised
hands and open mouth. Her dress, at this date, is still irreproachably Clas-

ical, to make the exposure legitimate, although some of the drapery on the male figures already shows the illogic later to affect all mythological clothing.

Artists were gradually freeing themselves from the requirement that garments be represented as having comprehensible shape. Earlier traditions had permitted a very liberated stylization of movement in dress, such as one sees in Botticelli; but this license was chiefly used for the action of fabric in space as it moved *away* from the body. On the body itself, even fanciful clothes kept order, showing how they were made and should be worn. But by the middle of the sixteenth century clothes in sacred and legendary art had forsaken any sensible relation to clothes in real life. And so the baring of one breast, still unusual or awkward in fashionable dress, became a commonplace action for pictorial costume, which had its own way of behaving and its own mode of tailoring.

Women in narrative and sacred Italian paintings appeared in a combined fashion, using both real and unreal garments. These might be rendered in the feathery lushness of the Venetian style or in the cool outlines of Florentine art. A female costume might begin with the frilled smock actually in common use but shown widely undone at the neck (III.35). This garment might then be half swathed in a huge free-form satin drape, and the whole business either strapped diagonally with a jeweled belt or

III. 35 PALMA VECCHIO
(1480–1528)
Flora

195

III. 36 TITIAN (c. 1478–1576), *Bacchus and Ariadne*

sashed haphazardly with a scarf—the combination swirling and slipping
according to the turbulence of the subject. The strict Classical forms of
dress might thus be abandoned, although the reference remained to the
Classical *idea* of dress.

Control of the actual shape of the painted garment naturally varied ac-
cording to the artist's talent and purpose. Michelangelo was largely re-
sponsible for liberating artistic dress from the laws of physical possibility,
but Titian, for example, rarely took liberties with the capacities of actual
cloth, though he often did with those of clothes.

In Venetian art the theme of a white drape worn underneath a colored
one was borrowed from the conventions of real clothing, just as it was for
the background drapery of nudes. The combination seems satisfying, no
matter what shape the clothes take. In *Bacchus and Ariadne* the clothes are
unwieldy swatches clutched around the body, but all the women wear
white under a color, as if it were a chemise and a dress (III.36). And Ti-
tian also used the same elements for painting real clothes: the subject of *A
Young Woman Doing Her Hair* wears a respectable *camicia*, stays, and pet-
ticoat, even though her chemise is about to slide off. Other Venetian
ladies in similar postures may wear unearthly draperies, but they are of

very earthly substances. In the mythological and religious images by Titian, gleaming legs and breasts appear and vanish in a gracious counterpoint to the movement of the various crushed stuffs in which they are wrapped. Titian made a private obsession out of the seminude figure, and his lifelong invention in this mode seemed never to fail. All his countless combinations of agitated bodies in half-worn garments are visually satisfying and believable. Other artists more easily fell victim to bombast and cliché, though some, like Tiepolo later on, were equally inspired by the theme.

Veronese's *Rape of Europa* is a perfect example of the carefully expressive bare breast, Venetian style, served up in a cloud of Classical, sexual, and fashionable allusions (III.37). In this picture the round bare breast of Europa is in the center of the group of figures. Her modish chemise cups the breast in ruffles below, and a necklace of pearls echoes its curve above. It catches most of the light full on its upper slope. Yards of silk billow over the bull and around the bottom half of Europa's body. Insufficiently girded by her girdle, this enormous nongarment forms a turbulent sea, on

III. 37 P. VERONESE
(1528–1588)
Rape of Europa
(detail)

top of which the breast floats in its little boat of frills, further surrounded by a garland of emphatic clutching hands. Europa and her attendants grab at the fabric, none of which manages to cover even a square inch of the breast. Flowers and cupids fly, the bull begins to clamber to its feet, silk swirls. The untroubled bare breast rides out the storm, a clear symbol of all mythological violence. It will be quite safe and fresh for its next appearance.

The seventeenth century saw innumerable uses of the one significant bare breast. Mary Magdalene is a favorite for this motif. Her naked breast seemed to become one of her saintly attributes, a newly coined image of vulnerability and penitence, superimposed on the established theme of pleasure. Titian had gone as far as one could without blasphemy in his magnificent vision of the Magdalene caressing her breasts with her hair, on the verge of posing as Venus. Thereafter the Magdalene tended toward a more decorous one-shouldered drape, with one visible breast or sometimes two, with slightly less erotic loose hair (III.38).

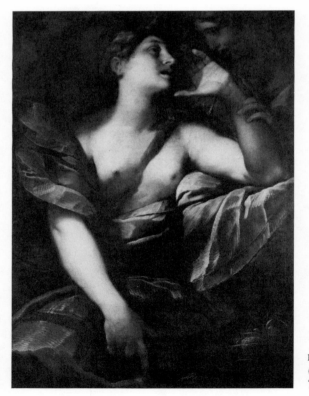

III. 38 G. C. PROCACCINI
(1574–1625)
The Repentant Magdalene

A late Baroque one is by Batoni; why the Magdalene can read or meditate in the wilderness more comfortably with one arm in her shirt sleeve and one out is difficult to understand, but the fashion apparently aptly echoes the imbalance of her spirit (III.39). Her clothes again are legendary wrappings over a real chemise—the Classical reference is indirect; it suggests Titian's nymphs rather than the originals. The one naked breast rests delicately on a cushion of cloth. Fleshly pleasure, represented by this detail, is further suggested by the resemblance between this image and ones like *A Courtesan at Her Toilet* by C. van Everdingen (III.40). Instead of brooding on a skull, this lush wench combs her hair while also unfunctionally wearing one arm in her smock and one out. The other sleeve is carefully tucked down under the arm to display the armpit and breast, in exactly the same way that Venus, trying to spare Cupid the lash in Bartolommeo Manfredi's *Chastised Cupid*, also permits one arm and one shiny breast to emerge from her Classical swathings (III.41).

All over Europe, breasts were shown to be larger and rounder in the seventeenth century than they had been a century earlier. They cast deeper shadows and reflected sharper highlights, and along with their use in art as signs of spiritual disorder, their display as pleasurable rather than maternal agencies came to be even more emphatic. Lewd Dutch ladies playing lutes might aim one breast at the spectator, along with a seductive glance, over the top of a loosened décolletage (III.42). Such paintings, like the Van Everdingen, served as allegories of Vanity. But later on, in the eighteenth century, the acceptance of straight erotic subject matter for painting permitted breast exposure without moral excuse.

Ever since the Greek Amazon and the Christian Virgin, however, images of women exposing one breast have been linked with ideas of self-forgetful female zeal—heroism, devotion, sacrifice. Romantic art in the late eighteenth and early nineteenth centuries could take full advantage of the combined violence, eroticism, and sanctity of the theme. Neo-Classic ladies in distress or ecstasy might very properly allow their unimpeachably authentic Grecian garments to leave one breast bare, as an indication of the strength of their throes, which might otherwise not seem clear enough from the evidence of their chilly outlines and smooth contours (III.43).

The greatest Romantic expositor of complex passion through mammary exposure was undoubtedly Delacroix. The thrilling central figure in *Liberty Leading the People* owes a large part of her appeal to her gloriously lighted bare breasts (III.44). This woman is a mythic apparition, come to palpable life among the street fighters. But her disheveled costume is a

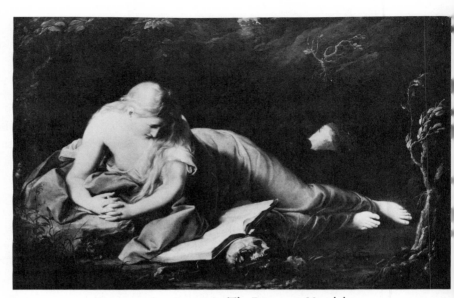

III. 39 POMPEO BATONI (1708–1787), *The Repentant Magdalene*

III. 40 CESAR VAN EVERDINGEN (1616/17–1678)
A Courtesan at her Toilet, c. 1650

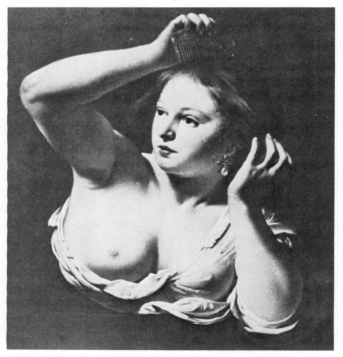

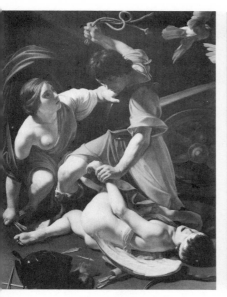

III. 41 B. MANFREDI (1580–1621)
Cupid Chastised, 1605–1610

III. 42 B. VAN DER HELST (1613–1670)
The Musician, 1660?

III. 43 FÉREOL DE
BONNEMAISON
*Young Woman Overtaken
by a Storm*, 1799

III. 44 EUGÈNE DELACROIX (1798–1863), *Liberty Leading the People*

study in the most careful pictorial tailoring, specially designed so that the
display of the bosom may appear to increase the power of the goddess.
This dress has been cut with only one sleeve, to leave bare the standard-
waving arm. There is not enough material above the waist, except for that
one sleeve, originally to have covered the bosom or even the other shoul-
der. Liberty has deliberately been clad in something uneven in design,
suggesting Classical rags proper to a working-class goddess. Furthermore,
her exposed bosom could never have been denuded by the exertions of the
moment; rather, the exposure itself, built into the costume, is an original
part of her essence—at once holy, desirable, and fierce.

Two breasts uncovered at once usually have a slightly different pictorial
message. Most garments made for general use even in Classical antiquity
did not expose both breasts *and* cover the remainder of the body. The ar-
resting examples of Egyptian and Cretan ladies date from long before the
draped periods. The double-breasted effect most noticeable in Classical
times is that produced by the *strophion*, a band worn all around the naked
body just under the breasts. This appears on paintings, statues, reliefs, and

ases, with no other garment or adornment. Visually it divides the female body into two parts: a head-shoulders-and-breasts section and a belly-hips-and-legs section.

The theme appears intact in Renaissance art—most notably in Michelangelo's *Dawn* and in Giulio Romano's *Jupiter and Olympia* and *Psyche* in the Palazzo del Tè (III.45). The upper portion of this female image, rendered as a nude half-length, became a Renaissance convention—a whole subdivision of the genre of bust portraiture—and it is possible that this particular female image grew out of the sense of the divided *nude* body. An emphatic horizontal line, cutting the body just under the breasts, might suggest a new sense of feminine beauty, whereby the breasts were somehow part of the face. Fifteenth-century women's fashion indeed tended to place the girdle just under the bosom, to emphasize that particular dividing point of the clothed form. Above the familiar line of the girdle, denuded breasts borrowed from antiquity might pictorially be included as part of the public display of head, face, and neck along with their embellishments. A

III. 45 GIULIO ROMANO (1499?–1546), *Jupiter and Olympia*

woman's public naked beauty, instead of consisting only of her head and chest, rising out of a garment concealing the breasts as well as everything else, might thus include the breasts as adornments.

Piero di Cosimo shows a distinct interest in dividing the breasts from the lower nude body. In the famous *Simonetta Vespucci* the lady wears a curving scarf that totally incorporates her breasts into the lovely scheme of her coiffure and profile (III.46). His nude Venus of *Mars and Venus* also wears a band of cloth that curves under her breasts. The right-foreground figure of a woman in the *Lapiths and Centaurs* has both breasts sharply outlined together by the curved neck of her blue dress. From such uses, it is clear that a pair of exposed breasts in Renaissance art constitute just like one breast, a kind of Classical allusion, but the bilateral symmetry seems appropriate to more solemn or formal conceptions.

Allegorical figures of serious meaning appeared early in Renaissance art wearing two bare breasts among other symbolic trappings. Late-sixteenth

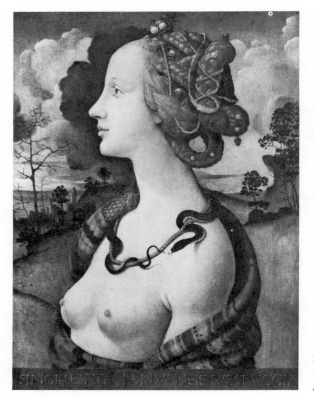

III. 46 PIERO DI COSIMO
(c. 1462–1521)
Simonetta Vespucci

century stage costume for personified virtues or abstract ideas might well be designed around bare breasts while the rest of the body remained heavily covered and the whole design insistently symmetrical, even architectural. Some of these seem to have faint echoes of the Minoan goddesses about them—some suggestion of august female power, released by the display of the breasts alone. In the same spirit, the breastplates of certain armed allegorical female figures—descendants or cousins of the Classical Athena—might have breasts separately molded in armor, like special weapons.

The narrow band under the breasts was not only copied directly for nude figures in Renaissance art but also incorporated into fanciful garments that clothed the lower portion only and gave the effect of a nude bust set on a fabric column. Michelangelo has some figures dressed this way in the Sistine Chapel, and both French and Italian Mannerist painters adopted the convention. It was copied yet again from them much later, when early-nineteenth-century Neo-Classic ideals of the female body required prominent breasts on top of a long, slim body. Fuseli and Blake both clothed female figures in such breast-baring half-dresses. These clothes have no precedent in antique art; nevertheless, they share with the one-shouldered tunic the ability to signify antiquity, and the special emphasis on the completely bare bosom indeed suggests something of the fell potency of the sphinx.

This Classical monster had a woman's head and breasts, the body of a lion, and the tail of a serpent. When images of her appear as slightly horrific decorative motifs, the breasts are particularly violent-looking. They are thrust forward while the lion's body stretches horizontally out behind, without human arms to soften the message of savage female aggression (III.47). Ingres' Neo-Classic version is one of the fiercest. All the deliberately bare-breasted women in allegorical art have a little of this flavor. Even Piero di Cosimo's suave Simonetta wears a snake and poses before black clouds. Although these may indicate her tragic death, they also lend a threatening quality to her naked breasts.

At the end of the sixteenth century, elegant ladies' fashion featured a new low in extreme décolletage. Descriptions refer to "naked breasts," although nipples do not show in aristocratic portraiture. Having been cut straight across during the sixteenth century, the low neckline began to curve downward, sometimes in an oval shape. Recently there had been an upper-class fashion for high-necked bodices with a ruff, a dashing masculine mode requiring a chic flat-chestedness; and the square-cut neck also pressed in against the chest. But in the early seventeenth century the new

205

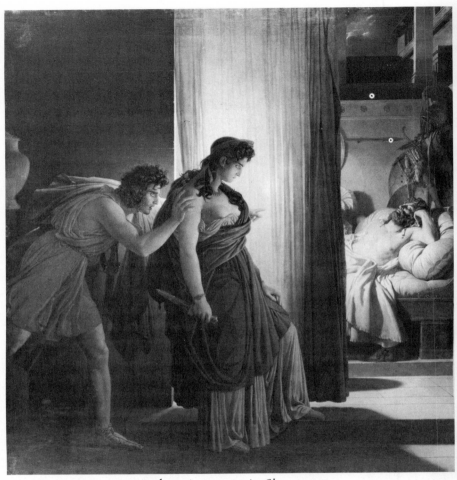

III. 47 PIERRE-NARCISSE GUÉRIN (1774–1833), *Clytemnestra*
Bare breasts as dangerous weapons

interest in the bosom demanded more exposure than compression, and the bosom began to look as if it might escape (see II.23). The exposure of the nipple, although not formally permitted, did occur, as can be seen from engravings and paintings of informal scenes.

Fifteenth-century nipples seem ideally to have been colorless. Sixteenth-century nudes, however, often have nipples like cherries or jewels; and this resemblance was emphasized in the half-length nude portraits. The bare-breasted portrait, as opposed to the idealized fantasy picture, made full use of the two breasts as sexual ornaments rather than as weapons (III.48). Like paired lips and eyes, they were pictured as another set of female dou-

ble adornments, and obviously idealized. Gabrielle d'Estrées and other French noblewomen had themselves painted in the bath or at the toilet table, following a famous drawing by Leonardo of an unknown or imaginary lady with bare breasts. These paintings portray nipples as if they were applied cosmetics—another paired element of feminine decor, like earrings or false eyelashes. They were almost certainly reddened, and the breasts whitened, as was the face. These smooth paintings are like the poetic blazons of the same period, catalogues of charms published in a self-congratulatory style of their own.

III. 48 School of Fontainebleau, *Lady at Her Toilette*, c. 1550

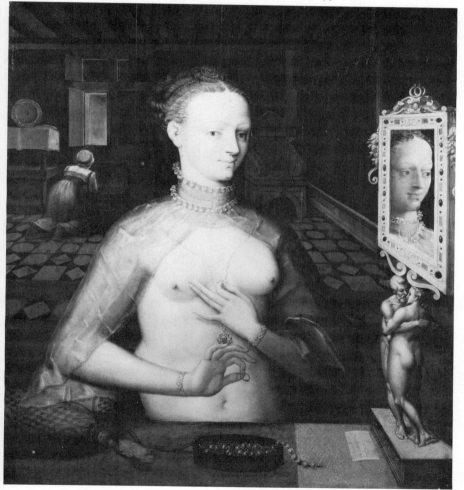

The nude male torso, completely bare or partly revealed, had its own erotic importance for the ancient world. But styles of dress in the Middle Ages had obscured male nudity even when the female décolletage was introduced. Masculine sexuality was expressed in the exposure not of skin but of shape as codpieces, padded shoulders, and long, tight hose were developed in late medieval dress. In the very early sixteenth century, however, a new way of expressing masculine charm revealed itself in elegant portraiture. Fashion finally exploited a décolleté open neck for the male shirt, as it had been doing with the female chemise. Paintings show it caressing the skin of men's shoulders and chests, and worn with long hair similarly caressing the neck (III.49). Dürer's seductive self-portrait of 1498 is one of the best examples (III.50) of what at this date was a subfashion.

Décolletage and flowing hair for men had a fairly brief European vogue, but the general trend of sixteenth-century masculine elegance was toward constriction, concealment, and short hair. In art, although male nude beauty was as thoroughly explored as that of the female, the deliberate exposure of masculine shoulders and chests was more strictly a matter of using the conventions of Classical dress, and not artfully disarranged shirts. Male semiexposure in paintings ran more to the asymmetrical disposition of animal skins, the one-shouldered tunic, or the large Classical cloak draped around the lower body and arranged over one arm.

III. 49 PALMA VECCHIO (1480–1528) III. 50 ALBRECHT DÜRER (1471–1528)
Portrait of a Poet *Self-Portrait,* 1498

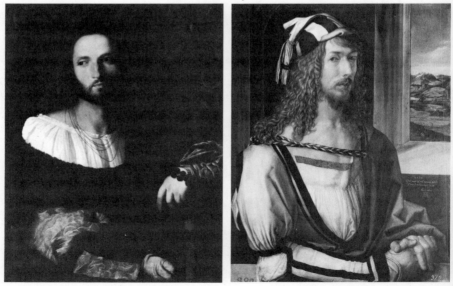

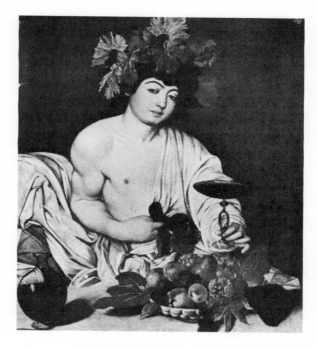

III. 51 CARAVAGGIO
(1573–1610)
Bacchus

Real male clothing was not represented as desirably revealing by its dishevelment—except in the work of Caravaggio. This very motif helps give his paintings a strong homosexual flavor. Smocks and shirts sliding off boyish shoulders, looking just a little like Classical drapery, have a great affinity with similar types of female image (III.51). They invoke memories of Bartolomeo Veneto's and Palma Vecchio's versions of *Flora* in similar getup, garlands included (see III.32, 35). Caravaggio also gives his male nudes the same kind of white and colored layers of fabric to sit on, used by innumerable outdoor Venuses to suggest feminine undress.

The seventeenth century saw the rise of the tenacious idea that rich clothing is more elegant when carelessly worn. The dishevelment of ordinarily neat dress as an attractive, upper-class masculine attribute began in England among the late-sixteenth-century melancholics (III.52). The famous portrait of John Donne with the undone collar and Nicholas Hilliard's "burning lover" in his shirt sleeves are turn-of-the-century examples. The style was confirmed by Van Dyck and his followers in the seventeenth century and later. Opened shirts (as opposed to wide-necked ones), unfastened to show the throat and maybe some chest, worn either with open coat or no coat, or cloak and messy hair, became a standard elegant pictorial mode for men, and remains one still. It has always ex-

III. 52 N. HILLIARD (c. 1547–1619)
Portrait of a Poet (thought to be
Henry, ninth Earl of Northumberland

III. 53 N. DE LARGILLIÈRE
(1656–1746)
*Anne Louis Goislard de Montsabert,
Comte de Richebourg-Le Toureil,* 1734

pressed careless, condescending ease, masking depth of feeling—with
variously submerged suggestions of sexuality. The ladies in their smocks
painted by Lely during the English Restoration share more than a little in
this masculine spirit of easy disdain. The flavor of this kind of aggressive
déshabillé is less erotic than aristocratic—or, rather, erotic *because* aristocra-
tic, that is, a little depraved and more than a little contemptuous (III.53).

In the eighteenth century, by contrast, the idea of sartorial dishevel-
ment for *women* achieved an even higher degree of sexual charge as an ex-
pression of submission. This idea developed in connection with the

concept of the Rake and with emerging connections between sex and social class. Women in simple dresses and linen neckerchiefs were becoming the prey of gentlemen in embroidered silk. Nevertheless, these modest maidens might wear very tight stays, now even better designed to push breasts up and out; and their gowns were cut very low and their kerchiefs tucked rather carelessly into the neckline so as insufficiently to hide the breasts. Certain French prints and illustrations for Richardson's *Pamela* and *Clarissa* show how this effect worked. Much was made by eighteenth-century artists of the dislodged neckerchief, both in genre scenes with erotic content and in elegant portraiture. Nipples peeping out of gauzy stuff, as if accidentally, became a standard device, probably in actual life as well as in art.

Later in the century, when advancing Neo-Classic fashion adopted the noncorseted, Greco-Roman look, the bosom could be even better revealed semiaccidentally by gauze draperies. A number of Greuze paintings show this kind of corsage carelessness (III.54). In any case, at the turn of the eighteenth century, breasts were supposed to be likely to pop out of clothes without warning, if given the least chance, but especially under the influence of male lust—a lust perhaps only imagined by the female subject of a given picture.

Nineteenth-century Romantic notions of female sexuality eventually produced a still more intense eroticization of the breasts, dependent on the new fashionable rule for strict control of exposure combined with emphatic protrusion of shape. By 1820 the nipple no longer escaped, but the recently reinvented corset saw to it that the breasts were larger, rounder, and more noticeable than ever. Masculine response eventually moved Manet to paint, in his *La Blonde aux seins nus*, a woman wearing a hat and a deliberately opened bodice (III.55). Indeed, a host of semipornographic photographers and graphic artists portrayed elegantly dressed women opening their clothes to display their breasts, sometimes coyly comparing themselves to statues of Venus, sometimes without excuse. Still, representing female seminudity in nineteenth-century serious art became, apart from such directly erotic preoccupations, a new problem in artists' concern for realism. Artists began to repudiate the need to incorporate into modern images the antique methods for showing clothes coming off women's bodies. Petticoats and chemises no longer had to be subtly made to look a little like *chitones* and *himatia*. Modern underwear itself became a subject of pictorial concern, for both aesthetic and erotic purposes.

During the nineteenth century female underwear lost all its simplicity, in fact and as an idea. Ever since the fourteenth century, stays of elegant

III. 54 (above) J.-B. GREUZE (1725–1805), *Girl with Birds*

III. 55 (right) E. MANET (1832–1883) *La Blonde aux seins nus,* 1876

III. 56 (below) H. DE TOULOUSE-LAUTREC, *A Passing Conquest,* 1897

cut and color had been worn. But if they were admired, it was often for themselves, as they were by Hogarth in his *Analysis of Beauty* and by many other artists who made aesthetic rather than erotic use of the stiffened bodice, real or fanciful, in countless pictures. Chemises and underskirts had a simple appeal, like that of household linen, and were just about as interesting in themselves. Poets and artists could make something of them but usually with the help of conventions established in antiquity. But the sexual imagination did not concern itself directly with the details of real underwear until the galloping advance of sexual repression in the nineteenth century.

Artistic realism of this period made capital out of underwear in a new way. Tintoretto and Veronese might give us Classicized chemises and allegorized corsets; Georges de La Tour and Rembrandt might show a peasant woman's smock, transfigured and ennobled. But it was Courbet, Manet, and finally Toulouse-Lautrec and Vuillard who gave us the unique, perverse pleasure in the awkwardness of tapes and laces, the touching ungainliness of a half-hooked corset (III.56). Of course, eighteenth-century satirists had fiercely ridiculed the artifices of fashion, including stays and padding. But such underwear itself had not appealed positively to the artistic eye.

Along with a new elaboration in the actual construction of female undergarments went a corresponding new effort to exaggerate their difference from publicly visible clothing. The tense consciousness of rough or rich outer garments worn over intimate soft undergarments was set up simultaneously in wearer and observer. Similarly, another polarity was conceived between delicate silken outer garments and the rigid steel and canvas supporting them underneath. Tight lacing, perennially a moral issue ever since the Enlightenment, became more entrenched in erotic ambiguity, an emblem of female narcissism and submission. The grotesquerie of underwear began to have its own slightly morbid but positive appeal, along with the increasingly deliberate seductiveness of its actual materials and trim. Machine-made lace came within easy reach of many for use on underwear, whereas for three hundred years precious handmade lace had been an outer adornment. It was pornographic works of art that now showed female nudity emerging from lacy undergarments, whereas in 1700 the same motif had appeared in formal portraits of duchesses. In imaginative life, the idea of feminine dishevelment had lost its connection with the heroines of antiquity and now formed a new one with prostitution and victimization, with physical awkwardness, ugliness, and sexual cruelty, with smut, and with farce.

The naked leg underwent a similar historical metamorphosis. Female legs seem to have lost their objective beauty in Western consciousness after the establishment of Christianity; they lacked all the moral and spiritual virtue that attached itself to breasts. Even antique art itself helped to confirm the subsidiary aesthetic status of human legs by establishing the theme of the draped lower body for both sexes. The female version has come to be most familiar in this century as the definitive look of the *Venus de Milo*—an abstract female torso with a head to individualize her, armless by chance but clearly legless by design. For men, the nude but draped-legged look is Classically embodied in "noble" images of poets and statesmen. In Western society, visible legs for men—first nude and later clad in tights—came permanently to be the properties of vigorous military and athletic types. Serious, peaceable, and holy men at least draped the lower half and later wore robes. Women's naked legs also appeared in Classical art only for military engagements or hunting, while draped legs occurred everywhere else—perhaps partially undraped, but only by accident. The association was made between naked legs and strength. Beauty and serenity were the properties of draped legs.

Clothing each male leg separately was a habit developed first in Greco-Roman life out of trousers and leggings adopted from the chilly and horsy North and northern Near East. The foreign fashion covered but further emphasized strong male legs and added a not undesirable hint of crude barbarism. (Women did not wear trousers in the West until they desired similar connotations for their legs; the Eastern passive eroticism associated with the loose female trouser has had only intermittent currency in the West.) On the other hand, masculine gowns and robes continued to seem appropriate to those civilized and peaceable occupations analogous, if not similar, to those personal and domestic ones engaged in by draped women: priesthood, scholarship, statecraft. Semidrapery in works of art for centuries was arranged in accordance with such views of legs: naked legs were active, draped legs were contemplative. One look at the habits of dress of the eastern hemisphere throughout its history proves that these distinctions are not essentially practical, as might be supposed, but conventional.

The fully draped lower body developed into the standard skirted female look of Western Europe. Naked legs indeed acquired an awkward look for both sexes in medieval art, during their period of practical obscurity. As a good deal of medieval statuary attests, bodies were seen for centuries to stand on their clothes, and most artistic indications of weight-bearing naked legs were much simplified. Then the discoveries of the Renaissance once again made supportive legs into interesting aesthetic objects, in both

two and three dimensions. The weight-bearing capacities of a pair of legs could, of course, always be made to show through a garment, as they had done in antiquity. But for artists in a much-dressed age the leg's subtle modeling—the beautiful, tense relations among bone, muscle, and tendon under a unifying skin surface—was much more difficult to encompass visually than the similar delicacy of faces, for example. And so the Renaissance study of antique artistic models made the specific beauty of legs more comprehensible to gowned Europeans than any scrutiny of real legs could.

The beauty of female legs was somehow theoretical, whereas the beauty of female breasts was not only an accepted idea but a visible fact. But even after décolletage became customary in the late Middle Ages, breasts seemed difficult to attach to the rest of the body in representations of the nude, even by such consummate artists as Van Eyck. Both hidden legs and visible breasts remained difficult to *see* as elements to be combined easily and harmoniously with torsos until generations of European artists had studied the way the Greeks had done it. Breasts in much earlier Renaissance art come in the right place and have a convincing luster and swell, but they are awkwardly connected to arm movements and unconvincingly acted on by the forces of gravity and compression (see II.7). The compartmentalized conception of feminine nudity came from perceiving women's bodies in relation to a visually compelling style of dress. The high, tight belt and tight sleeves thrust the breasts into a separate compartment of their own, and the whole effect was of excessive articulation above the waist. Below, the big skirt produced a contrasting lack of clarity, except for the distinct swell of the belly.

A refined stylization of women's bodies may have been inhibited even in great artists by the heavy moral freight attached to female nakedness. But centuries of rendering the nudity of Christ, in variations on earlier conventions, seem to have made the male nude body more tractable to unified composition. Male nude bodies could be represented in a calmer frame of mind, even in true spiritual repose. Contemplating Christ's martyrdom could put an artist in harmony with his nude subject. Male dress after the mid-fourteenth century seems to express more harmony with real masculine anatomy than female dress did with the female body. And in art the nudity of the two sexes reflected the same sorts of differences as their clothing came to have in life. The shape of male legs was better known to late medieval artists, and the actions performed by them were easier to observe and understand than women's leg movements. Women's breasts, however, although a good deal of the skin showed, were given static shape by their clothes, so the variations in shape and movement that

breasts undergo, according to the action of the muscles around them or the pressure of the arms against them in certain postures, did not register in the artistic eye. Furthermore, the *idea* of breasts as constantly perfect hemispherical projections seems to have stood in the way of correct observation.

Women's skirts continued to be long and full, and to hide their legs. But for the fifteenth-century Italian artists women's legs once again became beautiful, even though they were usually invisible. Their beauty was still the kind that thrust itself on the attention through drapery, but now in art the bare flesh might actually emerge through slits in the garment. The shape and behavior of feminine legs began to have distinctive charm for the eyes of Renaissance artists and their audiences—a charm, however, like that of the harmonious nude, derived completely from antiquity. The charm of male legs had, of course, already been a convention in art for several generations, as it had also been an observable phenomenon. Mantegna's *Parnassus* displays a bouquet of single nude female legs, each clearly unmasculine and equally unangelic, seductively unveiled in the dance. No bare breasts distract the eye from the startling beauty of these naked legs, so visionary and remote from common experience in the 1490s (III.57).

Giorgione's *Judith* shows how the new beauty of the nude female leg could be added to the old notion of its strength (III.58). In this unprecedented image, Judith wears the modest garments associated with the saints and the Virgin. No Classical trappings, such as Mantegna's muses wear, or merely a Classical subject, as in Pollaiuolo's Daphne, connects her naked leg with the antique and conventionally justifies such exposure. The bare leg comes through a special slit in the dress so that she may rest her bare foot on Holofernes' decapitated head. It is a triumphal leg, and Judith bares it like an arm. The origin of this image is indeed traceable to the lost *Triumph of Justice,* a fresco by Giorgione; but the lady in that painting evidently wore draped pictorial clothes, artistically hitched up to bare her leg. Judith's leg, emerging from the slit robe, has greater force—it already has the look of sexual danger that infuses so many later images of Judith.

The idea of associating a short skirt with female childhood is entirely a nineteenth-century one. In Greek antiquity active female adults were permitted to wear it, at least in art, only if they were fictional Amazons or the divine Artemis. Otherwise, short tunics like those worn in Sparta were thought indecent and were frowned on, and short skirts later continued to be. Nineteenth-century sexual attitudes seem all the more bizarre when

III. 57 (above) ANDREA MANTEGNA
(1431–1506), *Parnassus* (detail)

III. 58 (right) GIORGIONE (1475–1510)
Judith

one considers the impulse to superimpose the image of childhood on the
traditional connotations of wantonness attached to short skirts. Moreover,
any connection between female heroism and short garments remained an

artistic rather than a practical matter in European history. If women went to hunt or to war, they dressed in men's clothes or in long-skirted versions thereof. Dancers and acrobats, however, did wear short skirts, as they always had done, and were ogled and censured as always—but never little girls. Grown women might, of course, show their legs below the hem of a short chemise in private or in the bathhouse, but otherwise only by accident.

Being able to see up a woman's skirt—so long and voluminous for so many centuries—must have been a masculine, if not an artistic, preoccupation of long standing. Since women wore no underpants, the sight of the nude leg undoubtedly carried rather intense associations with undefended nudity higher up. And since the abstract beauty of the female leg remained an aesthetic proposition, not a constant experience, legs kept their strictly erotic associations. Artists in the sixteenth and early seventeenth centuries were discreet about legs but exploited breasts, which had so much more complex meaning and observable charm. Legs do appear in art when the theme is overtly dirty-minded, as in one seventeenth-century tradition of which Jan Steen's *The Trollop* is an example (III.59). Disheveled real skirts showing the legs were a special, sexy detail, suitable for scenes of whoring and tavern brawling; but a disarranged bodice could somehow trade on its higher-minded associations, even if the bosom it revealed were entirely sensuous in its appeal. Breasts, however realistic the subject, participated in nudity. Bare legs remained naked.

It is not until the many erotic genre scenes of the eighteenth century, ranging from Hogarth's *Rake's Progress* to Fragonard's *Swing,* that one can find suavely idealized, seminude subject matter permitting legs to show under raised skirts—real skirts or real smocks, not artistic drapery—conveyed with serious painterly commitment. Dutch genre painters and followers of Caravaggio had sometimes shown serious realistic legs but always in unidealized terms, whether in sacred or profane subjects. Elegant big skirts held out by padding and hoops were nothing new in fashion, but elegant *pictures* showing skirts sliding up or flying up had not been so familiar as the phenomenon itself may well have been.

The refined amorous vision of the eighteenth century produced a whole range of more or less delicately humorous scenes of domestic life, showing women in varieties of disarray. These were published as engravings and painted on fans and china boxes, and they also appeared in the serious works of artists such as Watteau. The artistic convention for such scenes grew out of the genre tradition of seventeenth-century Holland, where subjects might range from christening visits, deploying much decorous

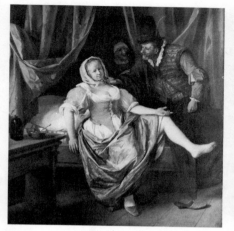

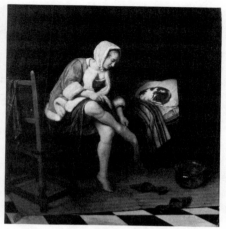

III. 59 JAN STEEN (c. 1626–1679)
The Trollop

III. 60 JAN STEEN (c. 1626–1679)
Woman at Her Toilet, 1663

costume, to kitchen scenes with bosomy maids manhandled by rustics. Courtesans of a certain pretension, however, also wore stiff and elegant clothing; and a number of pictures of well-clad women playing musical instruments are undoubtedly more amorous than domestic in meaning. So, more logically, are pictures of women sitting on beds or getting in or out of them. The details of these last provide models for the exposed legs in eighteenth-century art.

Woman at Her Toilet by Jan Steen shows a woman sitting on the edge of a bed and wearing all the bulky garments of prosperous bourgeois life (III.60). Her décolletage is partly concealed by her thick jacket and she wears a modest-looking linen coif. But below all this everyday dress, her crossed naked legs are startling as she pulls up her skirt with one hand and with the other holds a stocking into which she delicately thrusts one foot. The picture is not a domestic scene but an emblem of fleeting sexual pleasure. Another Steen painting very much like it shows the woman looking significantly at the spectator and portentously attended by a skull and a lute inside a formal arch. In such a heavily emphasized erotic context at this date, these bare legs under heavy skirts, leading straight up to an unclothed crotch and backside, illustrate a new fashion in sexual consciousness. Not only had breasts seemed to become more erotically interesting in this century; legs, as well, had acquired new attractions as female buttocks also became more interesting.

Viewed from the front, a woman in a late-seventeenth-century picture could be made to seem most attractive if her breasts and legs were promi-

nent and her belly kept obscure. The particular posture of Steen's allegorical lady ensures this. It became a pose characteristic of many eighteenth-century pictorial ladies, so much so as to seem like a period signature, even in very different styles of art; but it is uncommon before the seventeenth century. For Steen the pose is necessary to the action: women putting on stockings do cross their legs and lean forward. But in 1663 the choice of such a motif for an avowedly sexual subject shows the emergent desire to emphasize the attractions of the top and bottom, but not the middle, of a woman's body.

The legs of French eighteenth-century nudes tended to be slim and short, so as to kick and toss rather than support. These crossed legs of Steen's harlot already show an idealized delicacy of modeling to match her pretty face. This delicacy suits her emblematic function and is quite different from the lumpy look of his more naturalistic trollops or of other seventeenth-century exposed legs in the realistic tradition. Such idealization in the direction of refinement later affected the look of exposed legs in both French and English art of the eighteenth century, for both nude and clothed images. This fashion in legs differs greatly from the strong and heroic legs of the early seventeenth century and from elongated Classical versions in the sixteenth. The motif of the seated woman viewed from the front, leaning forward over prominently crossed legs, makes the most of calves and ankles, of promising suggestions of inner thigh, and of further delights adumbrated beyond them.

Earlier images of cross-legged nude ladies, such as Rembrandt's Bathsheba, still concentrated on the belly, with the legs treated as appendages and their crossed action not obscuring the lower torso (see II.4). In Tintoretto's *Susannah* the woman raises her farther knee so we may be sure to see her belly (see III.4); Titian's and Rubens' frontal nudes with emphatic legs (in *Europa, Danaë, The Daughters of Leucippus*) still have carefully predominant stomachs. Although for centuries heavy skirts and underskirts were worn by women over naked thighs and crotch, most European art until the late seventeenth century made indications of or references to the female pubic region with emphasis on the approach from above. Art usually expressed the sense of the vulva as a point at the bottom of the belly rather than as the meeting place of the top of the thighs.

The Classical convention of draped legs below a nude torso assisted this view; the pit of the crotch was often the lowest visible point of nudity on a half-draped image. But Steen's picture illustrates the beginning of the opposite idea. The notion of arriving at the vulva more quickly from the feet upward than down from above is expressed in Donne's poem "Love's

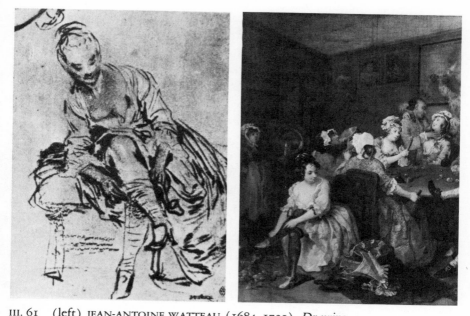

III. 61 (left) JEAN-ANTOINE WATTEAU (1684–1721), *Drawing,* 1715

III. 62 (right) WILLIAM HOGARTH (1696–1764), *The Orgy* (detail)
from *The Rake's Progress,* c. 1735

Progress." Written in the 1590s, this poem was refused license in 1633. It was printed only in 1661, in the same decade as Steen's picture, when, erotically speaking, its time had come.

Instances of the eighteenth-century seated lady with prominently and provocatively crossed legs, visible breasts, and obscured belly occur in several types. Watteau's drawing from 1715 is a version similar to Steen's, complete with shoe and stocking, and showing the new delight in delicately articulate ankles and knees quite missing from earlier styles of art (III.61). This is a sketch from life, not an emblem; the lady concentrates more convincingly on her task and does not specifically invite observation. This drawing, incidentally, also displays a still newer delight in the lovely shape of the shod foot. Steen's painting of fifty years earlier shows his woman of pleasure with simple mules, prominent in the foreground but not worn—her footwear makes her legs more attractive by their removal. But Watteau's lady demonstrates, for the first time, how an attractive leg may be enhanced by the addition of an elegant heeled shoe. A slightly later example of the same theme is the foreground woman in Hogarth's *Rake's Progress* (III.62). This figure assumes the same posture as

Steen's and Watteau's ladies, in order to exhibit her white bosom and her neat legs in shoes and stockings. The expressly sexy image further offers the shadowy glimpse of nude thighs above the stockings—at this date an avant-garde pleasure, at least in works of art.

Female shoes had become very abstract, sophisticated objects by the eighteenth century. They were curved, pointed, and heeled, and made of elaborate materials; and the new interest in legs undoubtedly occurred simultaneously with a new interest in feet and their clothing. Renaissance images of fully clothed ladies had usually hidden their feet. Elaborate shoes appeared for the first time below the hems of Jacobean ladies at the turn of the sixteenth century; but they are exactly like men's shoes, and anything but erotic. Later, women's shoes acquired some of the curved suggestiveness eventually to have such importance in the eroticism of feet and legs, and they came to be sharply differentiated from men's footwear. Along with caring about her shoes, the lady in Hogarth's picture also seems to gaze at the absolutely dazzling corset sitting on the floor next to her. Detached from her hunched, leggy, and bosomy body, it shows the shape her midsection would take if she were dressed—and so we get a wonderful double view of the erotic woman: the unlaced, soft body with skirts up and warm thighs showing, side by side with a prominent reference to the corseted, stiff-backed clothed image, which would certainly have skirts properly sweeping the ground and bosom under control. The belly is in obvious eclipse.

The eighteenth-century seated, cross-legged lady, however, most often appears without her dress and shoes, clad either in her smock, in drapery, or in nothing. Boucher's *Diana* (see III.13), from about mid-century, is a perfectly realized example of this pose—displaying the current ideal without undue vulgarity or awkwardness. The legs are beautifully tapered from plump thighs; the toes only touch the ground, as if she wore invisible heeled shoes. The belly recedes, and the breasts, of moderate size, are enhanced by luscious, fruity, and dark-colored nipples—a possible reference, like the subject itself, to the sixteenth-century courtly French tradition. The other figure, in another pose, confirms the theme: prominent, tapered legs, tasty breasts, and no middle.

As the century progressed the seated and crossed-legged motif clearly became an erotic cliché. In the frivolous little picture by Lavreince called *La Toilette interrompue,* which dates from about 1780, the lady's chemise is carefully pulled down to expose her breasts and shoved up high to display a well-lighted view of her open thighs as she toys with a stocking on the crossed foot and thrusts the other into a tiny, heeled mule (III.63). In

general, high breasts and a newly fashionable short-waisted corset were on view in 1780, along with a new forward-tilted posture. Lavreince's unself-conscious lady shows a tendency to assume this modish pose; she does not bend forward and fold her middle, as do Hogarth's whore and Boucher's Diana, who were charming in the fashion of two decades or more earlier, but seems to straighten her back and push out her bosom. The dressed figure shows the correct clothed look in a rear view. This painting is a good example of the eighteenth-century custom of showing a lightly dressed lady with fabric bunched around her middle. With less than first-rate artists, the top and bottom exposed parts of the female sometimes lacked all connection, and the middle was shrouded in drapery.

An amusing example from the same date of the effect of late-eigh-teenth-century fashion on the nude is one of Antoine Vestier's portraits of Mlle. Rosalie Duthé (III.64). This woman was a royal mistress, and her nude portrait needed specifically to celebrate her sexual charm, through pose and proportion, as well as modish hairstyle and makeup. Mlle. Duthé assumes the same well-known cross-legged posture, showing tapered legs

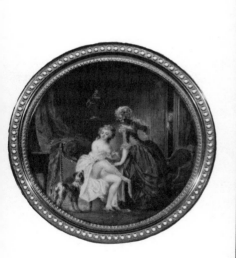

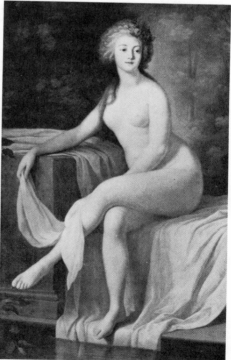

III. 63 NICOLAS LAVREINCE (1737–1807), *La Toilette interrompue*, c. 1780

III. 64 ANTOINE VESTIER (1740–1824) *Portrait of Rosalie Duthé*, c. 1780

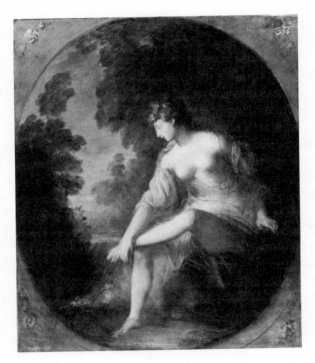

III. 65 THOMAS
GAINSBOROUGH
(1727–1788)
Musidora, c. 1780–88

and graceful ankles. With no dress, drapery, or smock to hide it, we can also see the elegant torso, nude but invisibly corseted, arching her back to thrust her bottom out behind and her bosom forward into fashionable prominence. She discreetly conceals her unfashionable stomach with her arm.

A sweetly awkward and poetic version of this same theme in another tradition is Gainsborough's *Musidora* (III.65). Again, the foreground is full of the lady's crossed slender legs, and the light falls dazzlingly on her naked breasts above—this time further enhanced by a garland of gauzy shift. The same gauze veils her entire midsection, conveniently glossing over the fact that her body is impossibly constructed. In order to combine legs sufficiently delicate from the knee down with a high bosom over the ideal neat midriff of the period, together with a forward-bending posture necessary for the hand to reach the crossed foot, Gainsborough has had to give Musidora an enormously elongated body from the waist to the knee. This is the same malady borne by the lady in Fragonard's *Swing* a decade earlier (see II.33), although that lady suffers it because of visible, not invisible, fashionable requirements of dress. Here only the drapery connects the top third of Musidora with her bottom third. It keeps her extra-long

middle from actually showing and spoiling the precariously arranged harmony of her widely distant bosom and legs. The drapery is also artfully aided by the extended arm and the disposition of the lighting.

After about 1800, the Neo-Classic fashion had confirmed itself in female dress, and the short coat and waistcoat and long, tight trousers became the new direction of chic for men. A general legginess became noticeable in works of art. Legs lengthened on all figures, both nude and dressed, as the short waistline became thought of as the natural one. William Blake's fanciful figures from the 1790s, whether or not they wear clothing, all have high waists, very high crotches, and long, well-articulated legs with big, Classical-looking feet. The long torso of the mid-eighteenth century—tight-laced for women and buttoned into a sausagy waistcoat for men—had favored short neat legs for both sexes, and nude art reflected this preference. But at the end of the century, high-waistedness was increasing the desirability of long-leggedness, and nude art now echoed this trend. In Blake's figures and in those of some other artists, the emphasis is increased by showing figures from a lowered eye level, as if they were seen by looking up at them, so as to lengthen the leg and shorten the torso. Musidora is in fact a hybrid figure, a Rococo image straining against the Neo-Classic mode. She is one of the last nude ladies to bend over at the waist and cross her legs while sitting.

Soon the long, curved bolster look went into effect, requiring the knees to stay together. Prud'hon's *Venus and Adonis* (1810) is an excellent illustration of this new nude fashion (see II.40). Legs now seem to reach all the way to the waist as the muscles of the thigh sweep upward into the high-placed hip. Ingres, among others, also began to make more of clothed legs in masculine seated portraits by showing them crossed prominently in front wearing the new tight, pale, and revealing pantaloons.

The new fashion in male dress soon crystallized into a basic scheme that dominated men's clothes for decades. But the early-nineteenth-century version laid most stress on sexual attraction. Calf- or ankle-length pantaloons, close-fitting as tights, replaced knee breeches for formal dress. (Loose trousers were for sport; conservative knee breeches remained for court appearances.) This skintight garment was usually very light in color and worn with shiny black boots. Breeches, when still worn, were also pale-colored and tight-fitting, sometimes made of soft doeskin. Coats and

waistcoats were of dark colors, very short-waisted, and cut away horizontally across the front with tails behind. This early Romantic mode very much increased the visual importance of the male body from knee to the waist, with particular emphasis on the genital region (III.66). Such an erotic fashion could not long survive. Later in the century, trousers loosened, waistcoats lengthened, coats acquired skirts, and suits of one color eventually predominated. Evidence of serious prosperity superseded romance and sex as the ideal in masculine looks. Elegance became sober.

In the first third of the century, at least in France, nude art showed this strong preoccupation with male genitalia, lengthened legs, and extreme posture. The naked bodies of men, sometimes corpses, in the foreground of a number of paintings having to do with war, pestilence, and other disasters, have very noticeable genitals. These are sometimes obviously exposed while other parts are covered (III.67; see III.44). In either case the pronounced realistic rendering is unprecedented. In eighteenth-century

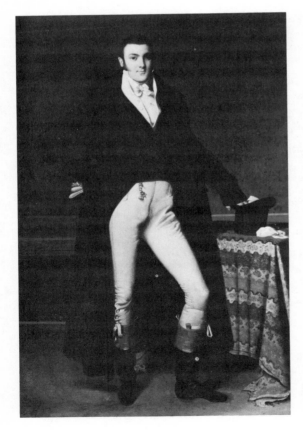

III. 66 J.-A.-D. INGRES
Portrait of M. de Nogent
1815

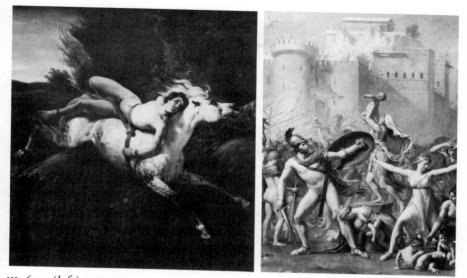

III. 67 (left) HORACE VERNET (1789–1863), *Mazeppa aux loups* (detail)

III. 68 (right) J.-L. DAVID (1748–1825), *The Sabines Enforcing Peace* (detail)

Neo-Classic art, the tendency had been either to veil the male genitals or represent them as small and hairless, after the Mannerist convention. Michelangelo, model for so many Neo-Classic artists, at least partially invented the male nude with enormous muscles and tiny genitals, with no hair visible on the body and the genitalia the same color as the rest of the flesh. Romantic male nudes may have smaller muscles, but they have bigger, realistically tinted genitals, embellished with lifelike fur. The leggy male nude corpses in the foreground of the *Raft of the Medusa* (1819) are arresting examples.

When it was insisted on by painters of subjects from antiquity, some of this genital emphasis undoubtedly harked back to its origins in Greek vase painting and Roman mosaics. It goes, moreover, with the ubiquitous Classical lunge—one leg bent in front, the other straight behind—copied from the Parthenon and many other places. This male pose, suitable for all aggressive action, survived the decay of antique civilization and appears repeatedly in the art of the Middle Ages, and was adopted by clothed figures and by nude ones, too, in the Renaissance. The expressive use of this pose in Neo-Classic and Romantic art, however, had the modish advantage of showing off masculine legs, with extra emphasis, if desired, on their point of meeting. The pose had a revival in the early Romantic period for both clothed and nude male legs, with distinctly erotic effect (III.68).

227

Naval and military uniform during this same period was admirably suited to the rather sexually emphatic display of men's bodies. Military trousers were white or buff, coats were dark and brilliant with braid and buttons, boots were black and shiny. Between the gleaming short-waisted coat (or breastplate) and the glittering boots was a soft, creamy expanse of pale, tight-fitting doeskin. Paintings of Napoleonic heroes in action display this costume, which has the effect of riveting the eye on the male crotch in a way not customary in art since the prevalence of the six-teenth-century codpiece. (Intervening Baroque fashion had indeed muf-fled the masculine pelvis almost as thoroughly as the feminine.)

The new form of insistent male sexuality is not inconsistent with the first form of nineteenth-century dandyism that flourished at about the same date, first in England and later in France. Even the Napoleonic wars could not keep this particularly English style of male thought and behav-ior from affecting all of Europe. Dandyism, once properly taken as a seri-ous moral attitude, later acquired enduring connotations of silliness, as the vigor of Romantic elegance was dissipated in sentimentality and re-spectability. But during the Regency period in England the Dandy aimed to embody the highest masculine ideals. Dandyism produced its own rul-ing class, based entirely on personal qualities consistently manifested in an uncompromising, controlled behavior.

Clothing had to do with these only expressively, not essentially. Beau Brummell, emperor of English dandyism, had been the landless upstart grandson of a shopkeeper and became the admired friend and adviser of princes, entirely by means of wielding personal style like a weapon, with total conviction and energy. Fashionable male portraiture of the period often breathtakingly illustrates the ideal mode and manner; but the effects of the dandy attitude also appear in paintings not dealing directly with elegance. History painting and Classical subjects in art gave some scope to this aspect of Romanticism in the treatment of the male nude.

Expressions of emotional extremity and scenes of physical violence are more noticeable, certainly, and these were substantively opposed by the spirit of dandyism. Nevertheless, one distinctive quality of nude male style in early Romantic painting is a restrained but forceful grace that seems to embody dandy principles even without clothes. Dandies them-selves, unlike other conventional male Romantics, were never in love. But they were very much, and very hopelessly, loved by women. Their care-fully schooled, detached narcissism was, moreover, purely male and had no effeminacy in it. Their programmatic display of sexual attraction was a definite challenge directly to the female—an exercise, like its traditional

feminine analogue, in looking at once irresistible and unattainable. Certain Romantic nudes that reflect this spirit have a pronounced heterosexual charm very different from the homosexual appeal developed by Caravaggio or, for that matter, by the ancient Greeks.

There are no rules for this, but the male nude in art whose charm is aimed at other men tends to look either very susceptible or rather aggressively overmuscled and much too unselfconscious. The dandy nude has powerful muscles only modestly displayed or even vulnerably disposed, and he indulges in fairly nonchalant genital exposure. There is also a certain lack of emphasis on the buttocks, although he usually has beautiful legs. These and other subtle differences distinguish him from nudes generated by Michelangelesque preoccupations or by a Caravaggesque tendency to coyness. Conscious but negligent elegance was a hallmark of clothed dandyism—the exacting hours before the mirror must never be evident. Any corresponding nude male beauty required the same nice blend of careless ease and absolute control, worn with the same perfection of restrained taste governing the choice of how many waistcoat buttons to leave undone.

The display of buttocks by a half-draped or half-clad figure has, in art, an unavoidably smutty element missing from other kinds of partial exposure or from simple nude rear views. Sartre has remarked that the essential obscenity of the rump comes from its contingency. It faces backward, away from the forward-looking head and forward-moving limbs, and its unconscious movements are governed by the action of the legs. It can therefore wobble or sway without the knowledge of its owner, unconsciously inviting desire or ridicule. Clothing has often been designed to emphasize the rear—that is, certain fashions have done so. The basic obscenity of the backside is then increased by the sexual function of clothing, which serves in any case to call attention to the body's separate parts. In art, whenever the already obscene rear is supposed originally to have been covered with clothing but now is shown exposed—accidentally or not—it acquires even more indecency from the extra consciousness expressed by choosing to picture it.

In nude Classical art, buttocks, like other projections, were assimilated into the total harmony. But they were obviously also admired separately. Freestanding female figures in a hunched posture, seeming to guard their frontal nakedness, simultaneously offer more obvious views of the rear. Masculine buttocks tend to be pronounced, in contrast to the firmly muscled, nonfleshy qualities of the rest of the idealized male body. Male statues insist on this emphasis partly as a result of the slightly swaybacked

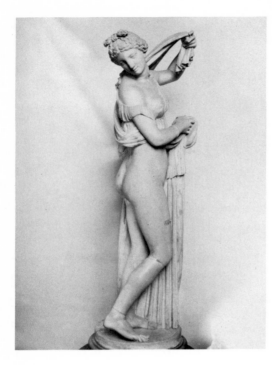

III. 69 *Venus Kallipygos*

upright posture assumed by many of them. Because of the different conventions of dress for the two sexes in antiquity, half-dressed figures accidentally revealing only their buttocks tend to be male or women, such as Amazons, adopting the short tunic.

The *Venus Kallipygos* in the Naples Museum, however, illustrates a special, deliberate interest in the female backside, with an extra erotic concern missing from any similar display of the breasts (III.69). The figure lifts her dress behind and strains to look over her shoulder at her own bottom. This image has a delicate prurience worthy of (and naturally much admired by) eighteenth-century France, but the theme is uncommon in European art until well on in the seventeenth century.

Concern among artists about really enormous female backsides, bigger than a comprehensive harmony of the body would allow, was another phenomenon that arose as the female belly lost some of its sexual interest. Watteau's *Judgment of Paris*, showing a delicate-limbed Venus with outsized buttocks, may owe a painterly debt to Rubens (III.70). But Rubens' women, wearing mobile, pillowy flesh, never have buttocks of such disproportionate plumpness. Rubens died in 1640, before the fashionable fe-

male spine straightened and thrust bellies down and back, thus causing rumps to stick out more and assert their appeal with more visual energy. Until then, back views of fleshy women in art tended to modulate the opulence of the female rear in accordance with the general abundance of the figure.

In the late seventeenth century the new concern with the female's top and bottom attractions encouraged the exaggerated treatment of the rump in art. It became common to show it bursting into prominence below a slender waist and a narrow rib cage. The delicate spine in Velásquez' *Rokeby Venus* (see I.49) is in apt contrast to the thick one in Titian's *Nymph and Shepherd* (III.71), as Watteau's Venus contrasts with the one in Rubens' *Three Graces* (see II.22). The passage of a century in each case brought about a new sense of feminine proportion.

These are all serious works of art with high erotic content but without an overt appeal primarily to lubricity. But by the 1760s Boucher's odalisque wallows among her cushions with no myth to illustrate (III.72). She has no other function than to invite us to inspect her rear. Jacob Jordaens (died 1678) produced a nice combination of the two pictorial activities, proper for mid-seventeenth-century artistic appetites demanding legendary justification for salacious nudity (III.73). The story of Gyges and Candaules permits an indoor setting with domestic trappings that automatically conduce to more dirty thoughts than a biblical outdoor bath could engender, as in Susannah's story.

In *Gyges and Candaules* Jordaens chose a nude rear view of the lady, otherwise clad in a lace cap and a partially removed smock. Her face turns back toward the spectator with express consciousness, and she caresses her right buttock for us with the back of her own hand. We are certainly supposed to look at her rump, even if she does not know of the presence of the hidden peeking men. The near presence of the shiny chamber pot adds even more modern smut to the allegedly mythological image. Later on, eighteenth-century backsides in art swelled out from under chemises or up from waves of bed linen or forest pools, all with egregious, plump enthusiasm. Semipornographic engravings of the same period might also take up the theme of the clyster, or enema, being administered by a maid, often for the benefit of a hidden watcher.

The erotic appeal of the male body, like that of the female, may sometimes seem to reside in one or another of its separate parts. And given their differences of design, it may even be easier to perceive the charm of the masculine body piecemeal, so to speak, rather than as a unit. A

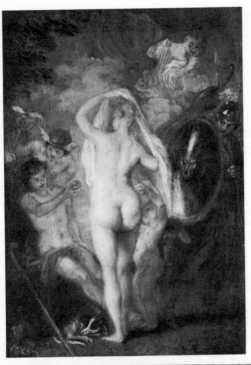

III. 70 (left) JEAN-ANTOINE
WATTEAU, *The Judgement of Paris*

III. 71 (below) TITIAN
Nymph and Shepherd, c. 1570

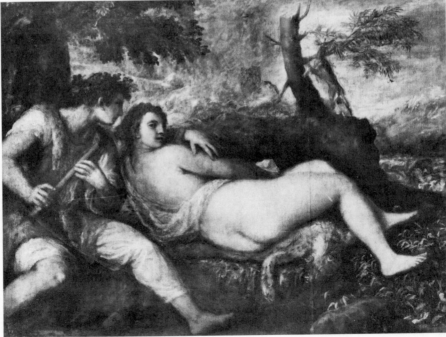

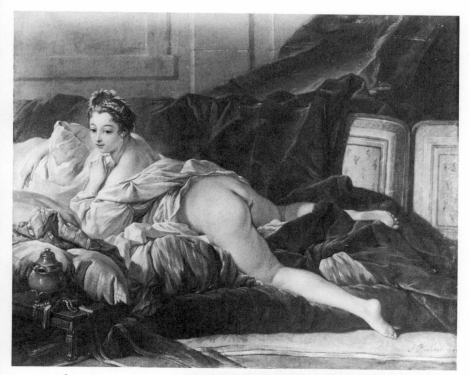

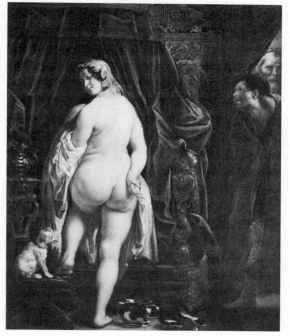

III. 72 (above) FRANÇOIS
BOUCHER, *L'Odalisque*

III. 73 JACOB JORDAENS
Gyges and Candaules

woman's body, its bony structure covered by a more general distribution of fat, lacks both well-articulated musculature and the visual focus of external genital organs. It has therefore been easier to stylize into an ideal of fleshly harmony, particularly since in antiquity its curves and projections were frequently perceived to be already harmonized by a unifying veil of drapery. The parts are less easily divided into sections—except, of course, under the editorial influence of later fashionable dress. But the male body seems readily to lend itself to articulation. Male fashion, beginning with the artificially musculated armor of ancient Rome, has usually tended to express this aptness of men's bodies for being visually divided up: separate legs, codpiece, and so on. Male buttocks, therefore, like male genitals, have always been more visually startling and abrupt than any part of the female body. And so the masculine backside has even more readily lent itself to specialized erotic preoccupations because it thrusts itself on the attention separately.

Venus may strain to look at her own rear, but the tradition of male beauty prohibits certain varieties of self-consciousness. Presumably, Narcissus looked only at his front view. The male behind is traditionally at least an unconscious charm, and so it appeals as a sign of submissive and receptive sexuality even more than the female version does. It is also fleshy even on the slimmest body and soft even on the most muscular: its erotic power is ensured.

Renaissance fashion through the sixteenth century made much of the male rear, always on view through tight garments. Renaissance art could borrow further license from antique fashion, however, and show it uncovered, too (see III.41). The fashionable male garment for the upper body grew shorter and shorter between the twelfth and the fifteenth century. The upper parts of male legs came more and more into view until the doublet often ceased to cover either buttocks or genitals. Hose in the form of separate stockings had to reach farther and farther up, finally becoming tights with a seam to join them in back and a codpiece in front. The modern classical-ballet costume for men reproduces some of the effect, although it has been abstracted and erotically somewhat neutralized.

The Renaissance costume, by contrast, obviously emphasized the sexy effect both fore and aft. Artists of the time, in both Italy and Northern Europe, gave plenty of stress to the rear view of this masculine fashion, often made the more striking by the use of striped and slashed fabrics. It also was embellished around the waist by the provocative dangling ends of the trussed lacings that held up the hose—or, as in Mantegna's *Martyrdom of Saint Christopher* (III.74), were unlaced, to allow for greater ease

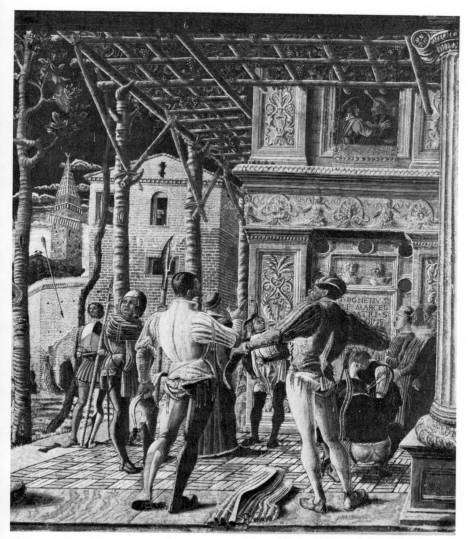

III. 74 ANDREA MANTEGNA (1431-1506), *Martyrdom of Saint Christopher* (detail)
Archers with tights unlaced behind

of movement. This particular rear view of disarranged masculine clothing
appears frequently in Renaissance art. Lacings are undone over the but-
tocks, the hose droop a little, and a bit of underwear or sometimes even
bare skin peeps out. It has all the quality of sexual provocation of the di-
sheveled feminine décolletage—perhaps, because of all the obvious differ-
ences, even more.

In art the body without its clothes is a pale shadow of its clothed self. But the body shown either partially nude or closely accompanied by cloth and clothing can carry a more complex message about itself and its dress. The dialectic of clothes and body is more sharply focused when both appear, and this is true whether they are shown on the same figure or whether some are dressed and some not. The separate bodily parts, shown individually denuded by artists in various images, may have special meaning according to the kind of clothing that exposes them. The partial dress and the partial body refer to each other, and each to the style of the other. Conventions in partial exposure further demonstrate how the significance of nudity is created by clothes themselves, not by their absence.

C·O·S·T·U·M·E

Theatrical events have altered much through time since their religious beginnings, and they have passed through some of the same metamorphoses undergone by representational art. But images in art may be made up of anything, whereas theatrical events require human beings; and human beings have the need to be dressed—not just covered but invested appropriately according to the circumstances. Since theater requires human bodies behaving in front of a human audience, all productions, no matter how abstract or fantastic, must be based on the inescapable drama of the body, a drama that is produced by the identification each beholder cannot help feeling with the performers, his empathy with their gestures and poses. Costume that conceals, stylizes, or dehumanizes the body still cannot eradicate that essential physical accord between actor and audience.

The particular mode in which a theatrical event pretends to be a representation of real life determines how its characters may seem properly— that is, "realistically"—clothed. Of primary importance is how its representational method relates to language. The performance of dance, for example, seems to require that the costume fulfill a visual function different from that required by poetic drama, though both may be using the same thematic material in somewhat the same way. When the characters utter no sounds, their clothes obviously speak more loudly, in a way that

is closely related to similar messages delivered by the static clothed figures in pictorial art. When theatrical personages sing, they must be especially dressed for that lengthened and intensified kind of drama. Such differences depend much less on the physical necessities of dancing, acting, and singing than they do on the different visual needs of the three audiences. When performers do all three, as in modern musical comedy, a carefully synthesized mode of dress seems necessary if they are not to look ridiculous. They must be stylized and simplified for the abstract activities of song and dance, and still remain believable during straight dramatic scenes. On the modern stage a character representing a poor medieval peasant in a play, a ballet, or an opera cannot be dressed in the same costume for these different modes, even if the convention of "realism" is observed in each.

The costumes worn by extras automatically convey more than the principal actors' or singers' costumes do, since they are performing a purely visual function. Audiences for naturalistic drama, classical or modern, will accept the most minimally conceived costumes on the chief actors, who can convey all the significant atmosphere by their speech and movement. Hamlet can wear anything; so can Gertrude; the only restrictions on their dress might be that no jarring symbolic elements be superadded. But extras in *Hamlet,* particularly if they are not expected to behave dramatically, must wear carefully conceived clothes, which may be a lot more elaborate than the ones on the chief actors. This difference can itself have a spectacular dramatic effect as long as the extras can effectively act the part of people properly wearing those clothes. If they cannot, and are insentient bodies, the fancy garments of extras will look ludicrous.

In ritual and emblematic rather than dramatic productions, such as masques and pageants, principals, whether they talk or sing, must wear appropriately significant garments, since the medium is visual and the theme ideal. The costumes *are* the drama, the characters are known by what they wear, and any accompanying words support the clothes instead of the other way around. Ballet, which finally emerged from such earlier forms of theater, could do away with all language and eventually with all mime, but not with costume, until choreography itself could more and more arrive at the condition of music.

In what exactly does the appropriate significance of any costume lie? What is a "good" costume? Has the concept changed at all, and is the standard different for different stage mediums? Obviously, yes. Dressing up meaningfully to perform a rite is as old an institution as religion itself. But not only do cultural habits change; the relations between them also

change. Modern performance now draws on a storehouse of historical conventions for utterance and movement, as well as on the independently developed traditions of representational art. More than speech and gesture, the clothes suitable for any kind of theater cannot escape visual conventions, established by art. They are what enable us to perceive and to judge costume correctly, to understand what a clothed figure on the stage is supposed to look like.

This is not to say that stage costumes have no well-developed visual conventions of their own. These have flourished, particularly in any mode of theater that has been produced according to a rigid formula for several generations and that owes its success to this very fact—Western movies and classical opera, for example. The clothes become part of the formula, visually satisfying only if they conform to certain expectations. To depart in the direction of greater realism or in the other direction, of more abstract, imaginative conceptions, will seem to violate the character even if an unorthodox costume makes him look more visually pleasing, more historically correct, or even more natural. But at certain moments, revolution and innovation in conventional stage dress, usually created by and associated with the success of a certain performer, become established and eventually create new formulas themselves.

The history of theatrical costume shows that the first purpose of dressing for theatrical events is to catch the eye with something unusual. This aim has never substantially changed, despite the ever-broadening range of theatrical purposes. The kind of serious domestic drama created for film, for example, which purports to reflect real life at close range, nevertheless offers ordinary clothes whose common look has been magnified and distorted out of proportion, simply by their appearance as costume. Ordinary clothes automatically become extraordinary on the stage or screen. The frame around the events invites intensified attention to what is being worn; we know it is there intentionally even though it represents something worn casually, and so it has the ancient status of dramatic costume.

This same intense perception of clothes, however, as they are being worn in the magnified circumstances of cinematic life, also has the opposite effect—that of making ordinary dress seem dramatic because it resembles what is worn in the movies. It is there that the true influence of movies on

fashion operates. It is an influence on perception, one that may have some similarity to the way garments worn at public theatrical events in the Renaissance—civic processions, essentially, which marked festivals year after year in the streets and squares of European towns—were perceived. Such Renaissance street festivals were in fact moving pictures in which both spectators and performers saw themselves sharing, both dressed to see and be seen, two groups of ordinary people in festive clothes made more extraordinary by ceremonial circumstances. Modern film audiences see extraordinary stars in ordinary clothes like their own; but the glow of the stars, and of the screen, transforms both sets of plain garments into extraordinary clothes. Movies, like Renaissance spectacles, make art out of life.

Since the seventeenth century most theater has been produced by professionals for nonparticipating spectators, but the ritual origins of theater have never been lost. The theatrical impulse to dress up and participate in special occasions has deeply affected people's lives. The wearing of special clothing in the sight of other people has in fact often been arranged to constitute a complete theatrical event in itself. To make a show with clothes, without the demands of song or dance or spoken text, is a way of permitting ordinary citizens to be spectacular performers without any talent whatsoever. Physical beauty is not necessary, either. A simple public procession of specially dressed-up ordinary people is one of the oldest kinds of shows in the world; it has probably continued to exist because it never fails to satisfy both those who watch and those who walk.

Clothes for such events in the past had a function quite separate from dress in either stylized popular comedy or religious drama, in which costume had a symbolic importance and was necessary, not to intensify the action, but to illustrate it with the full complement of visual meaning. Costumes for popular comedy or religious drama might even signify the action itself if they were seen out of context—Pierrot's suit, for example. This kind of dress is more properly called dramatic than theatrical costume; and the distinction is important, especially in modern theater, in which these two kinds of costumes may be used to dress different characters in the same show or may even be combined in one costume. Drama requires action in significant sequence, some representation of events; theater may produce the whole show at once, so that vision and movement and sound are synchronically significant. Although theatrically dressed figures may move about—march or dance or gesture appropriately—they are essentially still; that is, they are symbolic figures who happen to move, not characters undergoing experience.

In society, where dress has always had a degree of unacknowledged theat-

rical and dramatic importance, the performers are usually in competition, not cooperation. Consequently a good deal of anxiety is mixed with the theatrical satisfactions of a social occasion in gala dress. To see and be seen, measuring and being measured on the same standard, is very demanding, although it has its own perilous charm; and one of the most satisfying ways of combining these pleasures was clearly achieved by the festival-theatrical events of the Middle Ages and the Renaissance. At the civic procession of the fifteenth century, whether secular or religious, some people in gala clothes could look at others dressed up in remarkable costumes (or vestments), and all in one setting. The clear light of day illumined both at once and so kept a balance between them rather than an opposition. Audience and participants were mutually visible. No distancing mechanism, such as that of the later illusionistic theater, kept them apart in different modes of being, to make each group seem ridiculous to the other out of context. Moreover, in the fifteenth century, which was the high point of this kind of participatory theater, the means of confirming this unified reciprocal vision of costumed performers and dressed-up spectators was pictorial art—also then at a high point in its history.

Renaissance paintings have always been remarkable for the way the clothes worn in them are made to look. Clothes for citizens of earth and heaven, for men and angels alike, are elegantly and realistically presented together. They combine in a pictorial harmony so perfect that the modern eye can believe that the clothes all conform to current fashion. Robes for ancient saints and coats for modern dukes, though different in design, look as if they were fitted by the same tailor, whether in Bruges or in Florence. And the apparent living reality of celestial garments is matched by the apparent unworldly perfection of rich people's festive dress. But, in fact, both are representations of the kind of costume—rich clothes worn by spectators and rich trappings worn by participants—that was a regular ornament of public life itself.

The unified presentation of these different clothes reflects the unified perception of them possible at the time, when a single visual standard prevailed for both dress and dress-up. The privately produced entertainments of the nobility in the fifteenth century were done outdoors and were not exclusive. Nobles were visually accessible, even at play, to the general urban public. Moreover, their entertainments were no more sumptuous than the festival processions produced at the expense of the towns, to honor the entry of rulers, which everyone also saw. And they were certainly no more sumptuous than the religious drama, which by that time had reached a peak of gaudy display.

Theater in the different parts of Europe in the fifteenth century, like serious public art, developed many different styles; but in general most of it was very rich, glittering, elaborate, and colorful, and also open to the general public for free, outdoors in daylight. Furthermore, nobles, courtiers, and members of rich families not only rode and marched publicly in theatrical dress but danced, sang, and performed roles in theatrical shows, all in the public view. The poor man in the street, although he might have had little to eat and too much work, was certainly not visually starved. Indeed his eye could rest—from time to time—on the most sophisticated artistic productions of the age, whether live in the form of lavish public entertainments or represented on panels and frescoes in churches. If he were a craftsman or an artisan, he might have a part in the building of festival architecture or the construction of splendid theatrical garments, all as beautifully conceived as the pictorial masterpieces over altars—and sometimes by the same artists.

Thus one form of popular art, specially intended for the people at large, was embodied in aristocratic and ecclesiastical display of the utmost elegance. It was not a tawdry version fit for the debased sensibilities of groundlings but the best that could possibly be produced at the time. This high standard was evident not only in Italy but also in Northern Europe, despite vast differences in the themes and styles of theatrical display. Dramatic art, of course, had both vulgar and lofty versions. Terence was performed for the learned, and smutty farce enlivened the street theaters, for which the costumes were significant rather than magnificent. But beauty in dress, a magnificence that included sophistication of design and embellishment rather than mere idiotic glitter, was something for which everyone (at least in towns) could acquire the highest visual standards.

A personal identification with such standards, furthermore, must have been possible. People could see themselves participating in pageantry and looking like figures in the greatest paintings of the time. Citizens could believe themselves becomingly and beautifully, even if modestly, dressed—costumed, in fact—by virtue of their very participation in a tradition in which painting might be frozen theatrical festival, and a festival a living work of art. Both blended clothes and theatrical costume into a single pictorial harmony, and so the public consciousness of dress as costume was perpetually reinforced by art. It must have resulted, rather generally, in the sense of being a visual object, a kind of perpetual representation of a clothed figure, and no less satisfactory to look at than a saint or a king in a jeweled robe. The reciprocal visual action of art and theater in the fifteenth century could give the public the chance to see itself participating in the

visual arts through dress. Today, we have a similar phenomenon in effect through the movies, though we don't have Ghirlandaio and Bellini.

It is interesting that the *tableaux vivants* that were set up along the routes of various processions included both dressed dummies and living figures. The success of this device depends on the audience's acceptance of pictorial art as an exact recorder of visual fact: a person and an effigy could both stand in for characters in an altarpiece, since both were considered as lifelike as a painting and a painting as lifelike as they. The artistic authority of dress, made possible by this unity between public spectacle and public art, was destined to become fragmented and specialized in the sixteenth century and to remain so until the twentieth. Perhaps photography and film have revived some of the visual harmony between art, theater, and life for the general awareness of clothes. The intervening history of European stage clothes, not only for serious spectacle and lofty drama but for fun—smut, satire, dancing, and mime—shows how costume was both linked to and separated from dress in art and dress in the world.

T he idea that stage scenery and stage costumes are designed together and are properly perceived to go together is very recent or, rather, very intermittent. Only within the last hundred years has the concept arisen of the ideal dramatic stage picture as a total visual unit, with the clothes worn by the characters being primarily a part of the set and only secondarily human garments. Given the special meaning of clothes in human life, particularly clothes intended for public view, it is obviously natural that stage costumes should have their own separate history and their own complex connection with untheatrical garments and with figurative art. Scenery, by contrast, has pursued a high-minded and detached artistic course since antiquity. The setting of the dramatic stage, including the design and placement of the stage itself, is an ancient and honorable aesthetic concern. It seems to derive its importance from the ritual origins of theater and the sense of local sanctity that gave birth to it. The concern with theatrical dress has had quite a different kind of history; and there is probably a fruitful analogy to be drawn between the relative histories of architecture and clothing, and those of stage sets and stage clothes.

For hundreds of years in Western culture, stage scenery was visually and conceptually an aspect of architecture. Greek and Roman theatrical settings

depended on the architectural design of the stage. Painted or constructed elements to denote specific locales were then added temporarily to the permanent scene, which was actually an architectural arrangement. Such antique prototypes produced the idea that some kind of architectural standing scene was necessary to a permanent stage. A sequence of dramatic settings for a production might encompass many other effects, including remarkable physical illusions; but they were nevertheless incorporated into a basic architectural form, which was eventually to congeal into the form of the proscenium arch.

The proscenium arch has often been equated with a frame like that of a picture. For centuries after its invention in Italy, this idea had validity because picture frames were used to enclose scenes, especially those with architectural perspective, much as if they were theatrical presentations. The scenes were intended to produce the illusion that the spectator might enter them. But since "scenes" have ceased to be the primary content of pictures, picture frames are now seen to have four sides, not three with a floor at the bottom, as in the proscenium arch. In theatrical experience the fourth side, the floor, which used to be the common floor of actor and spectator where both might eventually mingle, as in the English court masque, has been newly perceived since the nineteenth century.

Wagner was perhaps the first theatrical visionary to realize that the proscenium frame, like a modern picture frame, should have four sides and that the action inside it should seem to be floating at a distance in space. Artists themselves had already come to realize this method of presentation gradually since the development of Romantic pictorial sensibility. Impressionist composition shows the method fully at work, and photography and film have taken it from there. The picture frame could, in fact, be entirely freed of its immediate function as a scene setter, and could carry the spectator into an encapsulated world; but apparently theater could not do this until painting learned to do it. The three-sided arch with a floor, rather than the four-sided frame, was the appropriate surrounding for those scenic events that had figures in them, in canvas or on stage. In such a milieu the spectator is always being invited to identify with the visible characters.

The scene itself—mountains, battlefields, oceans, castles—may be unfamiliar or totally imaginary, but the human beings must appeal personally to the spectator so that the drama has meaning. This is the only way an audience can be transported to mountain heights or palace precincts—by identification with the human figures he sees in these places, on some stable floor connected to his own home ground, even if it is made of clouds. The

setting (although it needed to depend on architectural principles and the current rules of perspective) could realize any imaginative conception without limits. Indeed, stage setting, after its long history as a subsidiary kind of architecture, continued into the late eighteenth century as a preoccupation of the visionary landscape artist.

In contrast to their imaginatively conceived surroundings, the clothes of dramatic or pictorial figures, like the three-sided frame, in order to keep their appeal needed a basic ground in common with the audience. During the centuries of art and theater when real people were shown inhabiting legendary or imaginary scenes, their clothes had to have some connection with the dress of the spectator. However fantastic, they had to connect with the public's sense of itself in its own clothes. Costume design was continuously wedded to current conceptions of appropriate and attractive dress, and current habits of mind about personal expression through dress. Until recently, these habits prevailed over the sense of history and the sense of fantasy, even when these were ostentatiously invoked. Actors themselves, not designers and audiences, demanded that costumes be personal clothing before anything else—and, as such, psychically comfortable to wear and beautiful to see according to the fashion in beauty. Thus Mrs. Charles Kean could appear in *The Winter's Tale* in 1853 in "absolutely authentic" Greek drapery but wearing a crinoline underneath. Similarly, a film star in 1953 might appear in equally "absolutely authentic" Greek drapery but wearing an uplift bra underneath. Yet again, a film star in 1923 might wear an "absolutely authentic" Civil War crinoline, but with a big, low waist and flat bosom above it.

Apart from processions, a great deal of theatrical activity went on during the history of Europe that did not require permanent or elaborate settings. The kind of show that depends on verbal rather than pictorial effects or on buffoonery and marvelous antics needs only a cleared space. But G. R. Kernodle has shown that even the most primitive theatrical construction intended in the late Middle Ages for platform stages or pageant cars had connections with the established traditions of scenery in pictures. These stage constructions usually contained images of architectural elements that would have already been familiar as settings for scenes in art. Even when the real action of a play occurred on a bare platform in front of a simple structure, that structure would have some pictorialized reference. Early mystery plays took place inside actual churches, but later miracle plays and morality plays were often done in front of church façades.

Thus the connection between stage scenery and the most serious forms of artistic expression was established in Europe very early. But the traditions for costume in popular theater, other than the festival or ceremonial kind, already depended on dramatic rather than theatrical standards. Costume was linked mainly to the action rather than to the apparition of the character.

Later on, in Italy, when the science of perspective was absorbing so much first-class artistic energy, perspective also lent itself to the rendering of localities for the stage. The proscenium arch, behind which the illusion of receding space was to be created scientifically, was clearly suitable first for painting and then for the kind of theater most dependent on painting: the theater of illusion. And it was for indoor courtly entertainments, produced (like panel paintings) at great cost by great artists for private patrons, that this kind of theatrical effect was developed. Most serious dramatic theater for most people took place outdoors in the general view, without much benefit of illusion until the seventeenth century.

This link between pictures and theater was maintained for stage dress through the sixteenth and early seventeenth centuries, but only in the kind of theater that was nourished at refined courts for royal self-celebration, and no longer in view of the general public. The final distillation of the Renaissance connection between dress in art and on the stage occurred in the Stuart court masques of the early seventeenth century. Designs for clothes worn in them show this connection, and so does the design of the theatrical space. After the dramatic part of the masque, the empty floor filling the space between the actors and the audience was the meeting place of both, and here nobles in courtly dress danced with other nobles in fancy dress, both then intermingling the beauty and significance of each other's mode of costume. The two modes blended together because they were constructed and embellished according to the same high standards and out of the same materials. The scale of trim and degree of detail were the same; they were intended to be seen from the same range of distances, under the same quality and intensity of artificial lighting. An entirely fanciful costume designed by Inigo Jones for Queen Henrietta Maria would also have been made by the same persons who made actual court dresses, with real pearls and cloth of silver tissue used for both (IV.1). Trumpery magnificence or tinsel finery was not, in this court theater, made and then transformed for the eye by stage magic, although the illusionistic painted sets and scenic machinery certainly were.

The design of these costumes came from known pictures, and indeed the Jones sketches are great works of art themselves. The artistic tradition

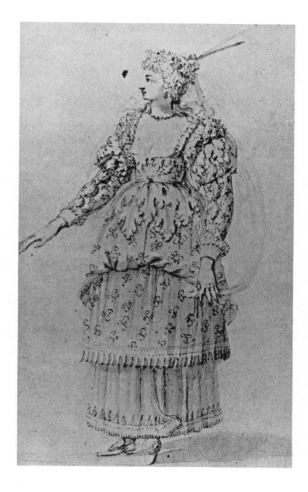

IV. I INIGO JONES
(1573–1652)
*Queen Henrietta Maria
as Chloris*, in Jonson's
Chloridia, 1631

from which these stage clothes were derived was that of Italian Mannerist pictorial allegory, which had been made familiar by the emblem books of the sixteenth and seventeenth centuries. Such garments were originally conceived as costumes, special clothes for allegorical figures rather than proper dress for dramatic characters. Their stagy look was part of their original quality in the paintings of such artists as Vasari (who also designed for the theater) and Bronzino.

Besides emblem books, costume books had also been published during the sixteenth century, offering hundreds of engravings of figures in everything from regional costume, through antique and exotic garb, to fanciful designs intended specially for use on the stage. Not much of the exotic clothing pictured in these books could be called authentic, except some of

the local regional dress for which the artists had the evidence of their own eyes. They also copied from each other without checking. The availability of such books made familiar certain styles of dress, called Persian or Cypriot, for example, which were nevertheless rendered in a contemporary and familiar graphic convention and figure style. Historical modes were also shown in the same way. Theatrical designers for courtly entertainments could use all these, along with all the allegorical material, and be certain they would be recognized by the cultivated audience, who knew the pictures from which they came.

An aesthetic accord between stage costume and elegant dress was preserved in the entertainments at the court of Louis XIV and eventually at its offshoot, the Académie Royale de la Musique, otherwise known as the Opéra. Louis, of course, had performed the role of Sun King himself, and some of his nobles had also appeared on the stage as mythological characters. It was obviously still appropriate that courtly stage costume, to be worn in formal ballets by an absolute monarch and his courtiers (as well as by professionals for his entertainment), should be kept to a high standard of materials and construction. It was also appropriate to the court of Louis that costume be designed on a rigidly formal plan, with variations provided only by surface decoration, headgear, and hand props. Indeed, for ballet costume this scheme remained in force for two centuries.

But by this time the most serious artistic impulses had ceased to nourish the design of stage dress. To promote an elevated visual perception of clothing, life and art were no longer fruitfully linked by theater. Dress in court theater had developed traditions of its own, which continued to shift in shape according to current fashion but which lost some of its dynamic relation to literary and visual art. This division may have occurred partly because the content of the productions themselves took on stronger artistic validity. Characters in serious opera, for example, had to wear clothes appropriate to the specific quality of opera life. They were no longer pictures or emblems come to life, walking or carried in procession, descending from clouds and expounding their meanings in speeches, or dancing in abstract symbolic configurations. They were instead observed to be leading intense dramatic lives (maybe somewhat artificial), given order and meaning by music. They expressed their feelings and intentions in difficult specialized musical utterances. Similarly, the *ballet d'action,* or dramatic ballet with a story, which came into existence in the eighteenth century, presented characters in whose lives dramatic incidents were not simply mimed or enacted but danced. Clothes for such beings had to be,

as they still are, remote from common experience—including the experience of similar characters in paintings or realistic drama.

Costumes for the courtly type of entertainment—that is, opera and ballet—as these continued to develop, thus went on to have their own rigid conventions quite apart from costume in straight drama or serious comedy and apart from dress in art. Instead of swirling draperies over heroic bare limbs, Classical characters in seventeenth-century opera wore stiff corsets, box-shaped skirts, and heavy plumes; but the scenery—the clouds, mountains, disappearing architectural vistas behind them—was still the same as that in paintings and engravings.

Both Classical and Renaissance treatises on architecture had included programs for stage settings. Vitruvius in Augustan Rome described how they should look (this book was discovered in 1414), and Serlio in Renaissance Italy (1545) did perspective drawings to follow Vitruvius' descriptions. Consequently, later artists and architects were allowed to be serious about scenery for itself alone, and they further established the outdoor scene with buildings or parts of buildings as being suitable to all theater. A bucolic setting with cottages was proper to satyric drama; a street with bourgeois dwellings, taverns, and brothels was proper for comedy; and a prospect of temples, monuments, and palaces was right for tragedy.

What special clothing might be appropriate to the actors and singers inhabiting such milieus seems never to have entered the head of Vitruvius or Serlio, and consequently the question never gained any artistic weight. The problem certainly did have great importance for the Renaissance spectacle, as it had undoubtedly had for the religious theater of ancient Greece, from which Vitruvius had got his ideas of scenery in the first place. It is possible that Vitruvius assumed that satyric, comic, and tragic costume were so well established as visual conventions as not to be worth mentioning. Indeed the ancient dramatic dress, originally evolved for the Greek theater out of the ritual garments for the cult of Dionysus, has as serious an importance as the stage setting. But the later, diffuse development of European theater, even beginning with Rome, brought about an ever-widening division not only between stage costume and stage scenery but between proper "theatrical" costume and proper "dramatic" costume. Later confusion arises from the occasionally combined use of these kinds of stage clothing and from the essential war between them.

Essentially, a theatrical costume is an expansion of the performer's own self, whereas a dramatic costume transforms him completely into a character. The dramatic costume may consist of a mere scarf, hat, or a few patches of makeup, or it can be a complete masked disguise, like the Greek tragic costume; but while the actor wears it he must be acting the part it indicates or the costume will be meaningless or ridiculous. His real self will be mocked by it, and vice versa. In contrast, the theatrical costume does not transform the actor into his character but, rather, it amplifies him and shows him as something else without eliminating him; it may also quite simply embellish him and focus visual attention on him, and have no symbolic significance.

Charles I and Louis XIV, appearing in masques and ballets, were thus recognizable as showing through their clothes, so to speak. The characters they played, and those played by their courtiers, had to be noble or allegorically benign and important. Disruptive, funny, or low-down characters, such as the ones in Ben Jonson's antimasques at the Stuart court, had to be played by professionals who could alter or hide their true selves for dramatic reasons. Following the convention for kings, star performers in later public productions of tragedy and opera continued to be dressed (by designers when productions were subsidized but much more often simply by themselves) in essentially theatrical fashion, eventually with ludicrous effect on the dramatic action.

So much was agreed by certain dramatic critics of the eighteenth century. Operatic and tragic performers had to appear primarily as heroes and heroines—divine, royal, or legendary, according to the program—and thus visually important and beautiful by the old theatrical courtly standards. For operatic spectacles under royal patronage, this injunction meant carefully designed clothing of which the first requirement was extraordinary splendor; characterization was not a requirement at all. For tragedies performed in public theaters, without patronage, the chief actors had to contrive and arrange their own garments out of a well-used wardrobe so as to make themselves as imposing, attractive, and spectacular as they could—and characterization was also not considered, except from time to time by a few imaginative actors, who would become celebrated for creating truly dramatic effects. And if their acting was good, departure from costume convention was considered a success—but not otherwise.

Once serious theater and opera were established as a commercial enterprise, the demands of fashion and vanity were sovereign for most stage dress, just as they were for worldly dress. Primary artistic influence on European stage costume, even at court, was virtually nonexistent for a century

and a half, between the final productions of Inigo Jones for Charles I in the 1630s and the Neo-Classic revival at the end of the eighteenth century. During that time a certain tradition of theatrical costuming evolved that lost contact first with art and eventually with believable fashion.

This tradition originally derived from the early-seventeenth-century designers' need to dress actual monarchs and courtiers for significant appearance on the stage; but it was codified thereafter on the drawing boards of Louis XIV's costume designers for the Opéra (compare IV5, 6). Stage clothes were there concocted by one overworked, skilled decorative artist, with the aid of a couple of master tailors and a roomful of seamstresses, all of whom operated at a great distance from the main artistic currents of the epoch.

Meanwhile theatrical setting became a more and more prestigious endeavor on the part of serious artists and architects. Three generations of the illustrious Galli-Bibiena family were called to cities and courts all over Europe to design theaters and masterful, elegant theatrical settings. So were many other peripatetic scene designers, usually Italian. But not a word about costumes—these would no doubt be appropriately worked out by the clever folk in the local workrooms. Imaginary architectural scenes and landscapes, similar to stage sets but not actually meant for production, were created by Piranesi and a host of Italian and French *vedutisti* in the seventeenth and eighteenth centuries, just for the imaginative pleasure of it. Figures sometimes appeared in these Baroque confections to show scale and the relations between levels and spaces; but they are usually only vaguely characterized, and wear nebulous draperies culled from artistic but emphatically not theatrical convention (IV.2). It often looks as if the scene-struck artist really preferred that no obtrusive living creature might ever have to pollute his vision at all—and certainly not an actor.

Actual stage sets intended for operatic or tragic productions, however, might show real theatrical characters actually inhabiting the scene, wearing properly stiff, decorative creations, sometimes but not always designed by the artist himself (IV.3). Some of the famous Torelli's set designs show figures, but they wear clothes lifted whole from Buontalenti and Primaticcio, in a stage style a century out of date. It seems impossible that he should have intended them to be the actual costume designs for the production. Such set designs were often engraved and published along with the name of the piece and the designer. Also published were theatrical prints of individual actors and actresses and singers and dancers, all dressed in costume. In the titles the name of the character being portrayed

IV. 2 FRANCESCO GALLI-BIBIENA (1659–1739), *A Prison Courtyard*, C. 1720
Visionary set with imaginary dress for imaginary classical figures

IV. 3 FERDINANDO GALLI-BIBIENA (?), Scene from *Talestri, Queen of the Amazons*
(Act I, scene 6), 1760. Real set, with real actors in unclassical theater dress

IV. 4 Norma Shearer in
Marie Antoinette, 1938

was often omitted (at least in the seventeenth century), and only the performer's name appeared—sometimes the engraver's, too—but certainly never the costume designer's.

The hundreds of prints of theatrical performers published in the seventeenth and eighteenth centuries were just like the hundreds of modern publicity stills of movie stars. The clothes they wear in them, so rich and extraordinary, nevertheless make no independent claim; they simply support the actor's sexual charm and personal appeal (IV.4). Even when the clothes in such pictures are labeled as proper to a character (Mrs. Siddons as Lady Macbeth, Beverly Sills as Manon, Elizabeth Taylor as Cleopatra), they still only manage to look generally stagy—feathers and gold trim—whereas the face and figure of the star are instantly recognizable, personally stylized according to the expectations of the admiring public. The costume may have taken months of thought and effort, but in the end the sartorial achievement is subsumed by the performer. This is truly theatrical dress; the effect it creates is inseparable from the effect of the wearer's self.

IV. 5 JEAN BÉRAIN (1640–1711), Two designs

The standard European costume for all kinds of courtly theater—opera, ballet, tragedy—was brought to a high level of formal finish by those Italian and French designers working directly for Louis XIV. It was then later improved on by their followers at other courts and at the French Opéra; and it still has a kind of survival in modern opera and ballet, for which creative designing in traditional modes is still done.

Many gorgeous costumes were done at court for Louis' theatricals in the mid-seventeenth century, but only at the end of it was perfect stylization finally achieved, by Jean G. Bérain. He was a first-class decorative artist with an amazing gift for visual invention within extremely narrow limits; and he did not only costumes but also interior decoration, festival decor, and scenery. He did no royal portraits or heroic frescoes or dramatic altarpieces, nor did he design buildings and landscape gardens; but his artistry was as important to the visual life of Louis XIV's court as Le Brun's and Le Vau's (IV.5). The costume designs he created (by the hundreds, all different and all the same) have a definite relation to contemporaneous French portrait engravings showing aristocrats posing or amusing themselves. It would be difficult to judge whether their garments might actually have been designed by the stage artist or simply ordered from the

IV. 6 INIGO JONES (1573–1652)
Costume design for Charles I
in Jonson's *Salmacida Spolia*, 1640

tailor to resemble his stage clothes—or whether the lesser graphic artist
freely copied Bérain's ideas for his fanciful portrayals of the great at play.

Operatic and dance costume was by this time chiefly designed for pro-
fessional performers. It took its form from the dress of noble life, but only
basically, and quickly developed, as it had begun to do earlier under the
hands of Inigo Jones and Stefano della Bella, into an independent stage
style (IV.6). This style was recognizable as theatrical, neither strictly his-
torical nor strictly fashionable nor, indeed, ever totally bizarre. For both
sexes, all opera and ballet costumes, no matter what the character, encased
the torso closely and had a stiff, bell-shaped skirt—shoe length for women,
thigh length for men. Sleeves were complex, with fluffy or flowing ele-
ments added, and most headdresses had plumes. Footgear for women con-
sisted of heeled shoes and, for men, calf-encasing buskins, greaves, or
boots, also with heels. A trained overskirt might be added for ladies, a
sweeping asymmetrical cloak for either sex. All these skirts, sleeves, and
stiff bodices, whether intended for sylvan nymphs, antique priests, or
tragic queens, were made in many overlapping and embellished layers of
satin and brocade, fringed, tasseled, scalloped, dagged, swagged, and
trimmed with silver and gold. For allegorical characters (Time, Music)

lappets and tassels made of appropriate symbols might be attached (clocks, organ pipes).

There was a commitment in all this theatrical gear to a special surface richness and complexity unlike that of seventeenth-century elegant clothes and also unlike that worn in aristocratic portraits as fanciful costume. In the latter, in contrast to the overburdened formality of stage dress, asymmetry and a stylish flow of fabric made them much more closely resemble the heroic or mythical works of Baroque painters and sculptors; as for formal courtly fashion, its stiff, unified, linear style had trimming subordinate to the basic shape. But theatrical dress consisted essentially of trimmings for the performer's body, rather like festoons or garlands for a banquet table or tasteful funerary drapery for a state coffin.

Along with the influence of Louis XIV's court on all other aspects of noble life in Europe went the influence of French theatrical costume on the theater of other courts. The work of the Venetian designer L. O. Burnacini for Emperor Leopold I at Vienna is perhaps the best, better even than Bérain's. He kept the Bérain formula but applied it with great lightness and freshness of touch in all the inventive possibilities, which took some of the curse off Bérain's rigid program. The stiff, overwrought skirt, plumes, and train of Bérain's heroines, however, became the suitable trappings for all European operatic stars and for the heroines of tragedy, too. Dido and Cleopatra, Medea and Clytemnestra all wore them, with as many jewels as possible and fashionably dressed and plumed hair. Jason and Coriolanus wore the male version, usually with the Classical musculated torso above a stiff knee-length bell skirt, all topped with a flowing curled peruke and a plumed helmet, and everything covered with tassels and lappets. The stiff male skirt, which became standard stage wear for heroes, began as the military skirt of antiquity—the flaps, or *bases,* worn below the cuirass.

The Italian Renaissance attempts at approximation, for art and pageantry, to the look of Classical armor, worn in combination with attractive contemporary shirt sleeves and hairstyle, had inaugurated this conception of heroic masculine dress. It had been progressively more formalized in European pageantry for generations, stiffened and embellished until it came to stand, visually, for stage heroics rather than to resemble at all the form-fitting grace of antique armor (IV.7). The original Renaissance female "classical" dress changed much more flexibly in direct relation to fashion. The theatrical result, by the end of the seventeenth century, was Venus in fantasticated fashionable hoopskirts and Mars in

IV. 7 Attributed to P. LIOR
Costume for a trumpeter, c. 1744

grotesquely stiffened Classical armor. This discrepancy was an essential quality in the look of Baroque stage dress.

Ballet, which in the early eighteenth century was still part of the opera, required the same ornate and cumbersome clothes, since it, too, had developed out of the courtly entertainments in which nobles had performed for one another. They had performed at a fairly short distance from the audience, inside elaborately contrived illusionistic settings with remarkable scenic effects but rather dim lighting. Significant symbols had to be incorporated into a costume that was meant first for display and only secondarily for meaning. Courtiers appearing as heavenly bodies, dancing in a harmony mirroring the universal order, or an absolute monarch dressed as the sun would need costumes of which the first necessity was an extra portion of visual dazzle—not complex dramatic meaning but plain glory.

That the glory of the prince be reflected in the glory of his clothes, that high rank be most properly supported by rich dress, was seen as a moral and political principle in the Renaissance and as a sacred religious one in the Middle Ages. Kings and queens who actually adopted austere clothes were thought of as eccentric rather than superior. "Elegant simplicity," the notion that unassuming costume is the sign of more serious tempera-

ment or more refined aesthetic taste among princes, appeared only during the epoch of Romantic Neo-Classicism. Until then rank was appropriately and honestly laden with its outward sign. It had to produce a visible reminder and symbol of the substance and grandeur of the prince himself and of the state he represented. Princes showed themselves readily to the people, suitably caparisoned; it was a form of satisfying visual propaganda. Aristotle's approval of "magnificence," the liberal and tasteful spending of large sums by the wealthy, permitted, later in the Renaissance, humanist, Classically trained European princes to feel justified in spending lavishly on court fetes as an activity proper to their station and their clothes.

Dressing in extra magnificence expressly for display was thus sanctioned in the Renaissance by the example of those of the highest rank, for whom it was a virtue, as it had already been in the Middle Ages by the processional and pictorial magnificence of the Church. This long, strong European tradition of sumptuous costume worn expressly for show took generations of artistic theatrical reform to modify, even after several monarchs had been overthrown and fashion had elevated simplicity in dress. Actors, singers, and dancers who were professional and plebeian and not at all courtly could still go on availing themselves of this tradition of display, especially when they played noble characters. But it was not always easily done.

Professional performers might be hired to appear at court, where they would wear the confections designed by a Jones or a Bérain to harmonize with court dress and with spectacular scenery; but "in town," appearing at theaters where tickets were sold, they would have to wear what the theater wardrobe provided. If they were stars, they could choose the clothing themselves and augment it as they might—designers, at least of costumes, were not included in the regular budgets of most independent, commercially operated theaters. This, of course, was not true of the royally supported Paris Opéra, where Bérain, Claude Gillot, and other famous decorative artists were employed as official costume designers. There is evidence that unscrupulous singers at the Opéra in the eighteenth century occasionally helped themselves to the glorious costumes of the state-subsidized Opéra wardrobe to wear on provincial tours undertaken for their own profit. Supervision of leading performers in such matters was apparently very difficult to implement.

In England, of course, there had long been a healthy public theater independent of royal patronage, besides the extraordinary productions created for the Stuart court. For such early commercial theaters the wardrobe was contrived, worked out, purchased, or donated piecemeal rather

than designed; and by the late sixteenth century, when public theaters were well launched, unity of visual effects was of interest only in court theatricals. Good acting was the English specialty, whereas spectacle in general, like operatic singing a bit later, was considered an Italian phenomenon. As a serious art, opera was still embryonic and still confined to Italy, and the Italian varieties of visual theatrical effect, such as the proscenium arch and the perspective set, were being used in England, as Stephen Orgel has established, only for private viewing by James I. The public theaters had permanent stages with exterior architectural arrangements as background and only partial attempts at illusion or scenery to indicate location. The thrust stage permitted the action to go on in close proximity to the audience rather than behind a proscenium. Costumes were individual and dramatic according to character.

Tragedies, however, and history plays on such stages demanded suitable garments for kings and queens in lofty and serious circumstances. For at least two hundred years (with time out when the theaters were closed under Cromwell), rich and noble stage garments for aristocrats, regardless of the play's period or country, consisted of castoffs from the actual nobility. The elaborate doublet and cloak worn by the duke of Buckingham in *Richard III* might well have been worn by an actual duke a few months or years previously, and the gold-embroidered silk brocade would be authentic. They would, of course, be seen at fairly close range by the audience and in bright daylight.

For an audience still aware that gold and jewels were not only appropriate but necessary to princes, this authenticity was part of the essence of theater. It is a view quite impossible to modern audiences in the theater—which has become the only place where rulers actually wear gold and silk and diamonds while they are at work ruling, and where it is assumed correctly that the jewels and gold are false. When a modern audience sees Queen Elizabeth I conferring with counselors on the stage (or screen), they know her pearls and gold embroidery are not real. Real queens and counselors no longer wear such things when they confer; they wear tailored suits. In such modern shows, Elizabeth's queenship seems thus—and unfortunately—theatrical, not historical. But when an Elizabethan audience saw Cleopatra on the stage covered in gold embroideries, they were properly moved because the embroideries were real, and they knew their real queen on the real throne also wore real gold. The royalty of stage queens was sartorially convincing to the public only if it had some relation to the common practice of real queens. We try to rely on the willing suspension of disbelief.

Leading ladies and gentlemen of tragedy on the English and European commercial stage went on wearing secondhand finery well into the eighteenth century. This clothing was sometimes only just discarded by its owners; it was purchased by agents, by the actors themselves, sometimes by the manager of the theater, but usually paid for by the management. (Jewels, however, might be lent to actresses by rich female admirers or given by male ones.) In any case, it was a theatrical convention of long standing that gorgeous trappings were proper for leading characters, regardless of characterization.

Vanity, always and still very potent among stage personalities, required further that the latest fashionable standards in coiffure and cosmetics should always enhance the public charms of leading actors of both sexes, regardless of their dramatic circumstances—that is, even if they were playing characters who were poor, rustic, engaged in warfare, or otherwise unfortunate. Male stars wore their fashionable castoffs suitably garnished not only with plumes, wigs, and makeup but with added cloaks, swords, boots, and other attractive accessories. Theatrical criticism in France and England had already begun to ridicule these practices in the late seventeenth century.

The traditional pretentiousness in theatrical clothing for stars of the serious stage was often at odds with the aims of the dramatist and even with the appropriate responses of the audience. Opera and ballet could carry it, and still can; literary, nonmusical drama apparently could not. A tragic heroine pacing back and forth in anguish while a page tried constantly and vainly to manage her train was already a comic spectacle in 1711, according to Addison. She was, however, in some respects the authentic theatrical descendant of James I's queen, Anne of Denmark, appearing in *A Masque of Queenes* in cloth of silver, pearls, and lace, dressed both as an intensified version of herself and as the masque character, each justifying the other. Actresses playing queens, however, were actresses first, whereas real queens had been royal first and last. Actresses were attractive creatures riveting public attention, and tragic heroines a laggard second. Modern descendants of such figures flourish in the movies, where Errol Flynn is himself first and the earl of Essex second; his hair-length and his shoulder-width must be currently attractive both to us and to Bette Davis or we won't believe she would have looked twice at him, even in the sixteenth century. Theatrical and dramatic aims are often thus confounded in the modern historical film.

So theatrical dress, whether designed with great genius and at great expense or pulled together out of a trunk, becomes the attribute of the

wearer. Designers may make him look extraordinary, but while he actually has the clothes on he gets the credit for them (and if he has pulled them out of a trunk, he will deserve it). Theatrical scenery is an entirely different enterprise. Its aesthetic goals may be detached from the demands made by the vanity (or nobility) of individuals, and the set designer may be a true artist. Practical design for stage sets, as for theaters, could legitimately occupy working painters and architects.

Practical design for costumes has always demanded some knowledge of the traditionally minor tailor's art. Despite the general community of craftsmanship that was possible in the Renaissance, when a serious artist might be expected to know how not only a building but also a doublet was constructed, the art of the tailor was submerged under the surface of public artistic achievement. The names of Queen Elizabeth's and Henry VIII's tailors do not resound through history like the names of Holbein and Nicholas Hilliard. But their achievements do vibrate just as much in aesthetic historical consciousness. The clothes worn by those monarchs are as distinctive as their faces—indeed, without the characteristic design of their clothes, their faces would probably be unrecognizable. By the seventeenth century this phenomenon was less obvious. In noble portraiture, dress had become subdued to personality, and expressive artistic drapery or *déshabillé* had become appropriate accompaniments to noble likeness. The Renaissance rows of embroidery and pearls had apparently come to seem more suitable to bourgeois portraiture instead.

Tailoring for kings had been a noble craft in sixteenth-century Europe. Surviving portraiture shows that it demanded a high degree of sophistication and an informed sympathy with educated humanist notions of princely appearance. To make it a reality, idiot handiwork must have been required from dozens of needleworkers, but the actual designers of noble clothes, like the designers of costumes and scenery and the designers of paintings and buildings, must often have been gifted, inspired artists. Renaissance dress was truly artistic in itself, in that it had a visual integrity that connected it with both art and the theater.

Baroque dress, however, was divided up into artistic, theatrical, and fashionable, each distinct. Certain creators of fashionable clothes were well known among the rich and mighty but not considered artists; painters and sculptors draped and accoutered their subjects according to the elastic demands of current artistic convention; and costume designers, where they existed, developed an important decorative manner unique to the theater. By the middle of the seventeenth century the character of Theseus, for example, would appear in quite a different costume, depending

261

on whether he were being represented on the operatic stage, in a fresco with a Classical subject, or as the allegorical disguise added to a duke's portrait. A century before, they might well all have looked the same, as they certainly would have in the fifteenth century.

The specifically theatrical tradition for costume invented in the seventeenth century had courtly roots in art and fashion; but essentially it was personally decorative, and its dramatic meaning, if any, was allusive rather than expressive. It has given subsequent theatrical history one of its most basic concepts of "costume"—that of an outfit that is neither a disguise nor a vehicle of dramatic sense but a special stage suit, instantly recognizable as such, even before its historical or symbolic indications register in the eye of the beholder. Musical-comedy choruses, cabaret show girls, and rock stars perform in such clothes; and so do classical-opera stars.

Such costume idealizes the wearer—it subtly depersonalizes him even while glorifying his person and his personality. It makes an image of him, ready for desire and worship—whatever else he may do, such as dance or sing, or whoever else he may represent, such as Don Juan or Dolly. This kind of dress has a new function now that absolute monarchs have long since ceased to indulge in it: it gives unconditional satisfaction to the public eye. Cher in sequined net and feathers and Mick Jagger in skintight white plastic with glittering nailheads are dressed in stardom, as Louis XIV and Charles I were dressed in kingship. Joan Sutherland in flowing yards of copper-colored silk drapery, her hair in the latest mode—while she is supposedly dressed as a primitive Druid priestess—is really dressing her voice. Such clothing has a purity of appeal and an appropriateness to the stage that no considerations of drama or history can challenge.

There was, of course, an alternative convention in Europe for which the costumes were not artistically designed for display but contrived for meaning. There had always been a great deal of professional theater on a small scale, and this included the famous and enduring Commedia dell'Arte. Shows of all kinds were constantly performed in city streets and town squares or in temporarily rented buildings—and also at court when the performers were invited—for which the costumes were based on entirely different aesthetic and economic principles.

Companies of serious players, of fools, mummers, trick performers, any comedians who made a living on the road in show business, could have no established wardrobe, accumulation of costume materials, staff of tailors, or anything like a designer. The costumes had to serve the needs of characters, not actors. For such purposes visual clarity means more than

beauty, and costumes might be rudimentary as long as they helped show what kind of character was meant and what the audience ought to think of him. For this dramatic purpose masks were, of course, the most essential kind of costume. Changes in speech and action all contributed to the basic message of the unchanging mask, and dress was quite subsidiary to it. In the unfolding of the plot, the character behaves characteristically, and the actor is submerged in him. The ancient Greek popular farce and the Roman Atellan farce were played in character masks with standardized clothes, and the Commedia dell'Arte kept that dramatic tradition alive throughout the eighteenth century.

There was always a great range of dramatic theater, some witty and profound, some religious, and some very low-down and smutty. Costumes for the theater of traveling players were put together, donated, fixed up. School productions of Terence seem to have been done in modern dress. There were companies of fools, with everyone in a fool's hat and other costumes added as needed by the play. There was, as always, pure show business—the theater of pure entertainment. For this there might be very carefully made costumes, but their purpose was to be amusing, not dazzling, and the main quality was a combination of quaint flavor and eye-catching movement.

Gaudily beribboned morris dancers, fools' trappings like tassels, scallops, bells, and motley coloring, first appeared in the fifteenth century as quaint and funny references to the serious fashions of a hundred years earlier. They were seen as "old-timey" and thus a little ridiculous rather than historical, quite proper to fools and jokers and comic dancers. This kind of display costume, expressed in visual folly rather than in magnificence and beauty, has great capacities for survival. It will weather hard times, crude times, and troubled times.

Smutty costume, like the huge, dangling phallus of Greek farce or modern varieties of suggestive nudity, although it may have stronger appeal, is nevertheless liable to suppression if the moral climate changes; and serious magnificence quickly becomes offensive, despite its visual satisfactions, if the political temper is revolutionary or if public finances fail. But costume fun, which can be a little dirty, a little quaint, a little grotesque, like the jester's motley, cap, and bells, is acceptable in most circumstances. The Fool is always famous for steering a perilous, funny course between the too serious and the too risqué, and his type of costume does the same. Some of the chorus costumes for "period" musical comedy do this: *Pippin* is an excellent recent example.

This kind of stage dress, like court-masque costume, is nondramatic, but instead of glorifying the performer, it is intended to catch the eye with bright color and somewhat silly movement all on its own, whatever the wearer does, and to tickle the spectator in a low-keyed general way rather than to make him laugh at anything in particular—or think of anything in particular, either. It appeals to people's combined love and hate of dressing up, the conflicting love of finery and fear of ridicule. Costume foolishness lets the actor make a spectacle of himself, and so it invites the spectator's pleasure both in the act and in not being the one to perform it. It is also easily achieved without much expense.

We have suggested that this kind of stage dress, going back to morris-dance costumes and various fool suits in the Middle Ages, often depends for one of its effects on a kind of amused nostalgia for funny old fashions. The fairly obsolete top hat and tails are a modern version. Once unself-consciously and truly elegant, they had their romantic-comic apotheosis when worn by Fred Astaire; later they seemed suitable for stubble-chinned comic drunks. Overtrimmed, confining, and pretentious nineteenth-century clothing, with tight collars, bustles, and bonnets, is now used for general comic effect in popular art.

Old-time clothes have always had a certain display appeal in a comic vein; their role in the serious romantic evocation of the past, however, is another theme. This was one feature of that special aspect of sixteenth-century art which evoked the conventions of medieval chivalry. Illustrations of poetic works dealing with legendary material in an antique style, such as those of Tasso and Ariosto, or *The Faerie Queene* and the *Roman de la Rose,* made liberal use of elements in hundred-year-old fashions to indicate noble doings in the past; but such pictorial references were never very accurate, only romantically evocative. In the same spirit, early-seventeenth-century painters like Rembrandt might use the dress of a hundred years before, somewhat vaguely indicated, to represent all of history including antiquity (IV.8). In a Dutch or Flemish painting done in 1630, soldiers participating in the Crucifixion might wear Holbein-like Henry VIII clothes from 1520, so that the spectator would know that a long time ago was meant. Northern Europe had a shakier grip on Classical visual formulas than Italy during these early Baroque years; in art, the antique was most easily conveyed simply by the old.

A "those days" effect is a theatrical constant for nondramatic, entertaining romantic-comic costume. (Really serious comic performance, like the action in the comedy of Menander in Greece or Plautus in Rome or of

IV. 8 A. VAN DYCK (1599–1641)
Sir John Suckling. Romantic, oldtime
garb for poet—the dagged edges
indicate the Middle Ages, and the
buskins are Classical.

Molière, Wilde, or Shaw, has usually been presented in its own epoch in
that most subtle kind of costume, modern dress.) Comic physical perfor-
mance of the generally amusing kind has also relied on multiple and ex-
aggerated moving shapes and bright colors ever since the days of ancient
Rome. Such clothing was indeed often included, presumably for dancers,
in the total scheme of a courtly production by the lofty designers of court
theater costume. Inigo Jones, Burnacini, and Bérain all left designs of this
nature—fantastic and a little ridiculous rather than Classically harmoni-
ous or merely ornate. In the same way, simple dramatic costume was not
just the prerogative of traveling players or of impoverished serious pro-
ductions. It was also required, as we have observed, for the characters
played by the professional actors in the Stuart antimasque. Inigo Jones has
numerous simple and effective designs for these costumes, and similar
garments for the straight dramatic characters in opera were also designed
by court designers.

C lassical subject matter had been the main framework of most serious theatrical plots since the Renaissance. The actual Roman comedies of Plautus and Terence survived throughout the Middle Ages, modestly performed in schools, ostentatiously at ducal courts; and dramatic productions on Classical heroic themes were also done in Italy beginning in the fifteenth century as part of solemn entries and festivals. In the Netherlands, secular societies called Chambers of Rhetoric produced poetic and. dramatic contests on specially designed stages, often with Classical themes. Renaissance public festivals with jousting and miming and dancing and buffoonery also included such secular drama with Classical subjects, which were then rarefied and refined into very sophisticated kinds of dramatics by the end of the sixteenth century. These entertainments might be plays for the public in the established London theater or early forms of opera at the Italian ducal courts. From the time the public theaters were founded, Classical subjects were also well established as the proper concern of drama. How were all these various Renaissance actors dressed to show they were meant to be Greek and Roman?

In the fifteenth century in Italy, people who dressed up as the gods and goddesses and heroes of ancient Greece and Rome for public shows wore costumes that were intended to invoke but not to reproduce the look of antiquity, just as similar ones were intended to do in Botticelli's and Mantegna's paintings. Classical dress was indicated chiefly by loose, thin, flowing garments, usually the actual sleeved shirt or chemise of contemporary life. A short, rich tunic might be worn over it or a diagonally or asymmetrically draped mantle of some kind; the asymmetry specifically was perceived as antique in this period of great symmetry of design in dress. The musculated cuirass of Classical armor, with military skirt below, was adapted from the originals and modified for the stage. As usual in theatrical dress, contemporary hairstyles were maintained, and a heightened degree of sexual allure was infused into the costumes, particularly of the Classically dressed women. Their thin drapery, shortened hemlines, and delicate footgear were visually piquant in those well-skirted times. The look of a double skirt—shorter tunic over longer gauzy gown—became standard, and so did some kind of high-waisted, elaborate girdle, which might even outline the breasts and come up over the shoulders.

Actual total nudity was apparently not generally permissible anywhere in Europe. Nude suits of tricot or leather were worn by characters like Adam and Eve or Venus and the Three Graces; and the breasts might occasionally be bared, as they also occasionally were in art. The themes of Classical antiq-

uity, with sartorial convention to match, had thus already become a theatrical commonplace, right along with saintly and biblical legend.

In the north of Europe the same themes came to be adopted, but German and Flemish Renaissance theatrical costume did not try for approximation to real antique clothing. Instead, ancient Greeks might be represented in Byzantine dress—that is, *modern* Greek clothing—or as Orientals with gowns and turbans. Classical heroes might wear medieval armor instead of the antique cuirass. From the late fifteenth century to the end of the sixteenth, the Flemish rhetorical societies met and competed before the public in different towns in dramas usually on religious themes but with Classical admixtures. Although such groups were like guilds, they were a source of competitive civic pride; and their lavish productions, including sumptuous clothes, were paid for by their native towns.

And so rich display in costume, created expressly to illustrate Classical and religious themes on the stage and not just for courtly pomp and splendor, was also a public visual privilege in Renaissance Europe. Not just princes but communities paid handsomely out of public funds to dress their own theatrical productions. Commercial interest did not yet exist to dictate economy of expenditure, even for such nonfestival, nonritual theater of display, and old clothes did not have to represent the proper habit of nobles on the stage. Thus, in the Renaissance, whenever serious costumes were specially designed at all for sacred or pagan shows, they were grandiosely conceived and richly executed, whether at private or civic expense. Dramatic simplicity had no appeal—the gaudier, the better.

What were the settings like? In the outdoor sixteenth-century theater, quite a large permanent façade setting might back up the action, as on the Shakespearean stage and the rhetoricians' stages in Holland. But these settings would also be incorporated piecemeal into the action in small sections, as when characters were revealed on inner stages or spoke from balconies. The chief action was in front of the set, as had been the case since antiquity. Only puppet shows and *tableaux vivants* took place completely inside frames, and these were small. Baroque scenery finally developed the old theatrical impulse to create a significant, living picture—and this time to make use of it for true drama. Action, the essence of drama, had been well presented without overwhelming illusionistic scenic elements, just as it had been well served without carefully designed costumes. The action in theater, which requires no action in Aristotle's sense, is essentially visual: the basic action is the impression of a total image, dramatic in itself, on the consciousness all at once. Special dress and setting are obviously prerequi-

sites, and perhaps primitive ritual magic once depended on both before static works of representational art existed. Theater is engaged in the same activity as visual art in these conditions, and the Renaissance visual imagination seems to have made complete use of this capacity of pictorial art and living theater to overlap and simultaneously to enhance the perception of reality.

The static perspective scenery, on the other hand, worked out by architects, actually did very well as a background for pure drama and became standard. One gets the impression that such early fifteenth- and sixteenth-century designers as Peruzzi and Serlio were interested neither in the possible dramatic content of any actual play nor in the other visual aspects of the performance itself, such as the actors' clothes. Designing the settings—essentially backdrops—was an activity independent of production.

Subjects were limited by the Vitruvian descriptions, and style by correct application of perspective principles. The play could be superimposed on the set afterward; and the court architect would undoubtedly be back at his drawing board during rehearsals, having no further interest in the proceedings. This was not so much design for drama as a step in the developing technique of architectural rendering—and perhaps of pure landscape painting—with the stage used as an excuse.* On the other hand, the scenic devices for *tableaux vivants* and designs for festival architecture incorporated posed and costumed figures; these compositions were truly theatrical—three-dimensional versions of the pictorial drama of Renaissance and medieval art.

Thus by the end of the sixteenth century ambitious dramatic productions in Italy seem to have needed perspective sets behind them. Theater, however, demanded spectacular illusionistic scene changes that would incorporate, not just back up, the movements of costumed figures. Designers of these settings, such as Buontalenti, were closely concerned with the total effect, of which the costumes were a vital part. In 1589 the court entertainment devised at Florence underlined the division between these two kinds of stage presentation. At this date each flourished separately, and the two were often offered alternately in one production when spectacular interludes—*intermezzi*—were produced between the acts of a dramatic comedy.

These *intermezzi* were High Renaissance versions of the earlier street *tableaux vivants,* in which the drama was acknowledged to be conveyed

*The prestigious Renaissance architects who exercised their gifts only on such scenery set a precedent for the subsequent diminution of costume design as a respectable artistic concern.

IV. 9 (left) BERNARDO BUONTALENTI (1536–1608). Designs for the *Intermezzi* of 1589. Compare with the clothed goddesses in Hans Eworth's painting, III. 1

IV. 10 (right) BERNARDO BUONTALENTI. Scenery and costumes for the *Intermezzi* of 1589

through the image. In the fifteenth century the image had been static and explained by a speaker; by the sixteenth century it explained itself in motion and later in song. During these *intermezzi* Buontalenti's "classically" costumed figures and transforming arrangements of clouds, fire, stars, rocks, and seas presented visual dramatics of a most extraordinary sort, with musical and vocal accompaniment and some poetic (not dramatic) dialogue. These elements were superadded to the fairly plain perspective city and landscape backdrop settings of the comedy itself. What the comic actors wore is not recorded, but Buontalenti's sketches for the clothes of the *intermezzi* performers survive in all their pictorial richness, looking like contemporary Mannerist paintings and engravings (IV.9, 10). Such *intermezzi* were thrilling—much more so than the complicated five-act comedies and solemn tragedies, with static sets behind them, into which they were interpolated. In Italy such *intermezzi* provided the material for all the visual aspects of the opera, which was to dominate theatrical invention in the next century.

Visual aptness and unity of set and costume were thus a Renaissance theatrical phenomenon, made possible by the intellectual conception that a coherent image might express a coherent idea. Literary drama was a separate activity. Acting in plays or scenarios was different from creating significant apparitions. The only self-conscious practical synthesis attempted of these elements came about when certain late-sixteenth-century humanists decided to establish a theater based on the principles of the Greek drama. This effort required that they try to re-create Greek music and

Greek scenic effects; but the small group of cultivated Florentines who were attempting this re-creation achieved, in fact, not an authentic revival or a new dramatic theater but an early version of opera.

The Greek stage set had never been entirely forgotten: Kernodle has traced the scenic conventions that governed every kind of performance from antiquity through the Renaissance; but his illustrations show that the settings for drama have much more visual continuity than the costumes seem to have. The clothes are usually uncontrolled mixtures of modern dress, old-timey dress, or fantastically amusing getup. There had apparently never been any attempt to perpetuate the visual costume traditions of the ancient serious dramatic theater. For stylized comedy some of the antique principles of stage dress were continually maintained—but not the visual forms, as they were in settings.

In Greek antiquity the characters of tragic and comic drama had distinctive and highly stylized clothes and masks especially associated with them, just as the European Commedia dell'Arte characters came to do. The clothes hid the sex as well as the identity of the male actor. In the Commedia dell'Arte of the late sixteenth century, when female characters joined the original group of stylized and masked male characters, they wore ordinary contemporary dress and no masks; and by appearing thus, they resembled the women who were additions to the New Comedy in Greece and to the later Roman comedy. The convention of using modern dress for comic drama thus dates from late antiquity, when it was first combined with the mask tradition. But all the earliest Greek comedies were acted by men in masks and a special padded, grotesquely stylized stage dress, a kind of body suit over which were worn other costume elements proper to the character. This kind of costume, though it certainly has a pronounced identifying style, cannot be said to be designed or visually conceived by a stage artist. Acting dress in Greece had had its roots in ancient religion; its look was codified rather than designed.

In England, beginning in 1605, Jonson and Jones devised masques that were visually all spectacle, with just a bit of straight drama as antimasque; and the poetic text was incorporated into the spectacle instead of only into the drama. True opera was the next step; the music, which became the unifying action, could carry not only poetry and spectacle but drama, too. The sublime artifice of using a musical vehicle for propelling the drama justified any degree of theatrical artifice in the sets and costumes—as it still does.

So far, it is clear, any conception of total visual design for the stage was associated with royal or courtly display. Visual harmony for sets and cos-

tumes was the privilege of the courtly stage, and unity of design was lacking in all popular kinds of productions, even in lavish ones. The very concept of design was a sophisticated, educated Classical notion; and the connection between visual order and theoretical order, between visual image and idea, was a Renaissance intellectual proposition. Theater expressing this connection was therefore suitable for educated princes, and so was lavish expenditure on such a theater. By the end of the sixteenth century the visually designed theater had abandoned its vital connection with public art, public life, and the public sense of history in favor of its own private conventions. These conventions had come to be sponsored by the new royal or ducal self-aware theater, supported by its private cash, engaged in studying these monuments of its own magnificence. The public, if it had ever got a chance to see them, would not even have understood the allegories.

Sophisticated visual beauty in the theater, whether publicly festive or privately self-congratulatory, was associated with nonliterary theater. And such theater depended not on crude display but on meaningful arrangements for the eye, trained or not. Literary drama, which flourished in schools or in Chambers of Rhetoric or in professional productions, did not have the illustrative imaginative services of visual designers, even when it had money. Art and drama were not seen to need each other; art and theater were strongly bound.

Unified dramatic simplicity had already become an established feature of the visual arts. The great drama of the Sistine Ceiling, with its austere sets and costumes, was finished by 1512; but no such visionary impulse was at that time put to work for the enhancement of literary drama. Special designs for sets and costumes were instead conceived emblematically, for emblematic theatrical pieces. Real drama used old clothes—preferably sumptuous, of course. Even Leone de' Sommi, who was in charge of theatricals for the duke of Mantua and who published a treatise on stagecraft in 1565, suggested ways of artfully draping rich donated garments, without cutting them, for use in tragedies.

De' Sommi also suggested copying antique models for pastoral plays, and this would mean creating new costumes, based on paintings; his ideas on proper pastoral costume, in fact, read exactly like descriptions of the clothes in Titian's bacchanals. The theatrical producer, like the artist, was using "classical" costume convention adapted to current taste in dress. De' Sommi advocates starching the ladies' dresses so that they puff out around the hips when double-girdled—not exactly a Classical effect—and he says they should be short, to show the ankle. Men should wear animal

skins, diagonally draped. All this is copied not so much from antiquity as from Italian artistic and stage conventions for indicating antiquity.

But pastorals and their special fake-antique clothing were only occasionally produced for the Mantuan court circle. For the more usual comedy and tragedy, a concept of design is conspicuously lacking in de' Sommi's prescriptions for costume. His costumes are intended not for allegorical spectacle but for drama, and he is concerned with ways of differentiating clearly among the characters. The only general visual principle he holds is that everything should be as rich and sumptuous as possible—at court a stage necessity, even for straight drama. Stage servants should definitely wear gold embroidery, just as long as their stage masters obviously wear more of it. Tragedies should be dressed in an old-timey look; comedies, when not in modern dress, in some unspecified quaint and foreign mode. Color is to be used only to differentiate character, not for any dramatic effect. There was no sense of unified visual style for the dramatic stage, the kind of style that was so outstanding in current painting, architecture, and fashion. Visual style in costume was reserved for *intermezzi,* ballets, and the allegorical entertainments that were still punctuating royal entries or ceremonial progresses.

As courtly theater became a more and more private phenomenon, professional theater all over Europe became an institution of considerable importance and prestige. The mid-seventeenth century saw the creation of elaborately decorated and large permanent theaters, with the auditorium arranged in tiers of boxes to accommodate paying customers in great numbers. Court theaters continued to be built as they had been during the sixteenth century to provide seating for a select few, but a large house was a more suitable challenge to the Baroque architectural and decorative imagination. Settings by the members of the Bibiena family seemed to be illusionistic extensions of the theater interior itself, which might also be by a Bibiena. The proscenium became a crucial balance point between real and stage space, and it has remained so ever since (IV.11).

The stage in most European theaters and opera houses gradually became an enlarged and enclosed area, incorporating the action behind the arch into an illusionistic and architectural fantasy, based on both perspective and painterly laws of realistic rendering. Earlier stages had kept the action in front of the scenic effects—whether sets were symbolic, as in Northern Europe, or illusionistic, as in Italy. Although the style depended on the show, earlier medieval scenery had tended to be fragmented, consisting of simple portable constructions indicating the locality (hell, a throne, a mountain), also usable in procession, or perhaps an elaborate ar-

IV. II Interior of Bayreuth Opera House in the eighteenth century. The set echoes the architecture of the house; the proscenium divides the space in half

IV. 12 P. D. OLIVERO
Il Teatro Regio, 1740
Visionary-classical setting,
"theatrical" costume:
the set design echoes
the huge proscenium

273

rangement in a *tableau vivant* that might turn and reveal wonders, or separate "mansions" set up on the platform stages for religious plays. In any case, all these early sets tended to be smaller than life-size in relation to the figures in the action.

The Baroque stage developed the large, enclosing environment for the spectacular action—all taking place inside a large building, which also enclosed an increasingly large auditorium. These big, gorgeous rooms were half audience, half stage (IV.12). It was not, however, the case of a dull, undifferentiated throng watching a glittering show: both halves were in balance. Both were equally well lighted, gorgeously decorated, and beautifully dressed. Stage lighting was ingeniously, if dangerously, complex by this time, consisting of multiple banks of hidden candles and reflectors; but it contended throughout performances with thousands of candles in chandeliers and sconces illuminating the glittering house. Theatrical effects were just as important inside the boxes as on the stage. The tiered horseshoe shape, which became standard for opera houses, provided a way for the audience to see itself as elegantly framed as the actors and as beautifully clothed. The decoration of the proscenium was echoed in the stage decor and in the auditorium.

This balance was a remnant of the Renaissance union of theater and life. But operatic theater was commercial by this time, and so it was also more artistically ambitious. Perfect balance did not exist except visually; the singers were engaged in very serious, taxing, and dedicated effort, and they performed in the service of the composer, not the king. The audience, no longer noble amateurs, were no longer directly addressed by the unfolding drama. They engaged, rather, in conversation with one another.

I n the middle of the eighteenth century, theatrical dress with all its courtly sanctions fell victim to—or received the benefit of—some new concepts of historical accuracy, dramatic truth, and natural beauty. The elaborate clothes of stage kings and queens, ancient or modern, which were almost indistinguishable from the stage clothes of shepherds and shepherdesses or of Turks and Chinese, underwent a perceptual transformation. What had looked generally appropriate began to look generally ridiculous—especially in tragic drama on Classical themes.

When the commercial dramatic theater, with haphazard, though often sumptuous wardrobes, was operating in contrast to courtly display theater,

with its formal decorative costumes, no concept of historical accuracy or natural, expressive simplicity existed for stage clothes. A gaudy, artificial beauty and either a fantastic or an emblematic look of history were expected of costumes for the theater, for all serious drama, for Classical tragedy, and for opera. Real history, along with noble simplicity and natural beauty, had to await its cultural moment. When the moment arrived, such notions were wonderfully apt for use on the visual reform of just those entrenched Classical subjects that had been familiar for so long and that had been figured forth on stage in towering plumes and stiffened brocades for so many generations.

Pompeii and Herculaneum were first excavated in 1738 and continuously thereafter for years. Books of engravings of these discoveries and many other depictions of the art of antiquity were published soon after 1750. Winckelmann, the German aesthetician, published his influential history of antique art in the next decade, with recommendations for imitating it and explanations of its absolute superiority. The look of the noble draped beauty of gods and heroes was revealed again to newly appreciative European eyes. These same eyes soon observed the glaring discrepancy between the garments actually worn in antiquity and those worn by theatrical performers purporting to represent the ancients. Reform was inevitable.

The impulse to revive the authentic look of Greek and Roman antiquity seems to have arisen everywhere in the general aesthetic consciousness of Europe and England at the same time and in the same way for all visual art. Sculpture may best display the Neo-Classic impulse at work, but practical architecture was also a splendid field for the new exercise of basic Classical muscles. Practitioners of architectural fantasy and scene design were, of course, already adept at manipulating Classical elements at will: Baroque taste in architectural themes had been an elaborate modification of Classically minded Renaissance taste. It could easily be modified yet again for Neo-Classic taste, using essentially the same material in radically resimplified forms. The Classical authenticity of structural and decorative motifs themselves had never been totally abandoned—it was their rearrangement, recombinations, and alterations of scale that had constituted the departure from the originals. Practical (rather than pictorial) costume, however, for both stage and society, had entirely altered its basic elements since the first Renaissance revival of antiquity. Theatrical dress had developed so idiosyncratically that its reform was more revolutionary than any comparable changes in theatrical setting.

Antique sartorial effects—clothing arranged in versions of simple dra-

pery—now began to be given a good deal of play in painting, in modish feminine clothing, in sculpture, and in literary description. In the late eighteenth century Classical clothing came to connote virtues of all kinds, including egalitarian opinions in France, purity of feeling in Germany, and clever statesmanship in England. Wisdom, heroism, and sanctity had been pictorially accompanied by draped yard goods anyway, and these connotations were now intensified. But on the stage, Classical dress had an important connotation not possible elsewhere: it was associated with simple truth.

Themes for tragedy, ballet, and opera had in preceding centuries prolif- erated from the basic Classical myths and legends of heroic deeds into endless subsidiary tales concerning the minor characters in the great stories of gods and men. This store of Classical subject matter, accumulat- ing since the early Renaissance, was used by conventional playwrights and librettists, who could either imitate older models or produce new varia- tions. This literary convention had become natural to the theater—and conventional costumes had also come to seem natural. But now, in the eighteenth century, the Classical literary material was suddenly recognized to have an authentic visual counterpart in history. Theatrical responsibil- ity began to demand a combination of the two, in the name of truth and beauty.

This idea flew in the face of theatrical "truth and beauty" in dress, which had its old traditions and retained many of its adherents—the tra- dition of display and visual wonder for its own sake. Neo-Classic ideals invoked the principle of historical accuracy for stage costume for the first time, as a corollary to the more general principle of beautiful proportion and noble grace associated with antique art. Truth in the form of dramatic believability was also invoked for the first time: Greeks and Romans, so familiar on the stage in their hoopskirts, curls, and feathers, came to seem not just funny but false—false to rediscovered notions of aesthetic truth, false to life, and false to history, all at once. At this point, theatrical and dramatic costume had to combine.

In Europe, costume design created specifically for drama seems to have begun with the Romantic–Neo-Classic movement in the late eighteenth century, in connection with the new "sentimental science" of archaeology and with the changing sense of theatrical and pictorial meaning. Not only was the fashion for Baroque pretension and Rococo elaboration on the wane, with a tendency to mock it already noticeable in the world of let- ters, but a new kind of middle-class moral illustration became an artistic mode and seems to have cut across various forms of art. Richardson's

novels were tremendously popular, and so were illustrations for them. Hogarth's engravings were graphic pictorial sermons. Later, in France, Greuze painted theatrical-looking bourgeois or rural scenes infused with moral import.

Classical themes, always ready for any kind of use, were newly illuminated for moral purposes; and the simple, clear Classical visual style was accordingly seen to be a noble vehicle suitable for illustrating scenes of antique virtue. The uncluttered lines and clear colors worn by people in the lately unearthed Pompeiian frescoes looked wholesomely simple. (It did not appear to matter that the actual scenes might be of arcane mysteries, debaucheries, or primitive cruelty.) It was obviously proper that actors representing Classical heroes on the stage should wear the simple robes of authentic virtue and honesty, and not parade the plumes, embroidered silks, and curled wigs that had adorned the persons of dissolute, pleasure-loving kings and their self-congratulatory theatricals. Moreover, theater was now aimed at the public, and the public feels respected when its sense of propriety and sense of reality are honored. And then more tickets get sold. Realistic conviction became a dramatic necessity, perhaps because rigid conventions began to look suspiciously like tyranny.

Writers on the theater began to discuss the question of stage dress from the point of view of verisimilitude. Before 1760 or so, the main point was psychological truth. As early as 1711, Addison had observed in *The Spectator* that though an actor pretends anxiety for "his mistress, his country or his friends, one may see by his action that his greatest concern is to keep the plume of feathers from falling off his head" (IV.13).

An actor-manager named Tate Wilkinson, who in 1790 wrote his memoirs about the London stage at mid-century, describes two stage princesses having a stormy encounter on stage, each with a page scurrying after, minding her train but also, of course, overhearing the dead secrets being imparted by the actresses. The plain lack of sense bothered him, and he offered this example as something standard at the time it happened but ridiculous at the time of writing. He also remarked that stage wardrobes had got more expensive, although they were undoubtedly much more tasteful. Now, though costly, they were all thin material and spangles; in the old days things lasted forever and, though cheaply bought, had a good deal of real gold braid on them. Such old clothes might now seem like ridiculous and fusty trappings; but they had been worn by the real nobility, could be used over and over again without wearing out, and if one were hard up, the real gold could be stripped off and sold for a healthy sum.

IV. 13 James Quin as Coriolanus, 1749. Compare with IV.6

The late-eighteenth-century taste for light and simple clothes, thus re-
flected in theatrical hand-me-downs, superseded the full, heavy garments
of earlier decades; and dress on the stage and in the street more and more
became long on taste and short on yardage, substructure, and trim. Overt
Classical references, such as were later made in ladies' clothing in France,
were not necessarily obvious in this new fashion of English dress. But
modish simplicity of line and texture were a natural aesthetic shift after
decades of hoops and brocade; and the "antique" style was already having
its oblique effect on the fashionable eye, as were new concepts of nature,
fostered by contemporary literature and reflected in art. In all this, the
stage both innovated and lagged behind. In England and France costume
reforms were personal and individual, and not general until the nine-
teenth century. Nevertheless, during the eighteenth century the visual
consciousness of the stage was being raised as fashions in both art and
clothing changed.

In 1758 in France, Diderot wasted no words about the absolute falsity
of all fussy theatrical ostentation in stage dress. First, he said, it was a plain
indication of vanity, all too easily understood by the audience; and sec-

ond, it failed to correspond with the very serious and even brutal circumstances of tragedy—murder, exile, human sacrifice, incest, betrayal. Diderot went on, significantly, to suggest that actors (not designers) visit the picture galleries to find out how to dress for such exalted or horrific situations. He observed that pictorial artists were all dealing better than stage tailors with such dramatic sartorial challenges. As for his remarks on settings, they predictably tended to prescribe simplicity—that is, leaving out picturesque material irrelevant to the play; but here he was addressing the scene designers themselves.

Set designers were already bona fide artists; costumes—if they were not simply pulled out of the theater wardrobe—were being ordered individually from obedient tailors by the actors themselves, like their everyday clothes. And so actors might dress to suit their personal view of their own stage looks and not the look of the stage. For costumes actors tended to stay close to the prevailing fashion so as to be attractively modish, and tailors had an easy time doing what they already knew how to do, with some odd decorative embellishments added; they might well have scratched their heads if required to reproduce the clothes in works of art.

Up to this time, painters and sculptors had been costuming their heroic figures in a Baroque–Neo-Classic mode that could never be translated onto any stage. Whereas Michelangelo's costumes for his figures on the Sistine Ceiling might have been transmuted into practical clothes for tragedy, and Titian's nymphs might come alive on de' Sommi's stage, most legendary and mythological clothes in later Baroque art could not have had any practical existence at all. Gianlorenzo Bernini was a devoted man of the theater, creating and performing in many private comic productions and also designing sets for opera; but serious and practicable stage costume apparently did not interest him, either, although the clothes of his sculptured characters have an extraordinary dramatic life; and in general heroic characters in Baroque art wore garments defying the laws of reason and gravity.

The clothes have their pictorial drama, but they were unconnected with the possibilities of stage use. Clothes clutched or swirling around the body, or held precariously in place by one slender off-balance strap, cannot preserve their effect when interpreted in actual yardage, nor can actors manage them as painted saints and angels seem to do. Classical dress, inflated and distorted by three centuries of conventional reverence, could not be brought to life on the stage until it had once again been entirely rediscovered and reperceived in its original easiness and grace, just as the Renaissance had once perceived it.

Diderot's suggestion that actors should look at paintings expresses the emergent notion that the total stage picture, clothes included, might serve some dramatic function, the way a painting does—to help reveal the truth about life, to express a particular vision of that truth. But that there might be a special artist who would control the look of all the clothes in one play for just such a purpose seems not to have occurred to him, and he continued to attribute sartorial effects, good and bad, to the sensibility of the wearer. Still, the sense of visual style for the stage was strong in France (more so than in England), and the public theater still had connections with courtly diversion and with the most refined forms of national elegance. Intelligent and cultivated men expected a great deal of the theater as an artistic institution.

England's eighteenth-century stage practice was centered more around the popularity of theatrical personalities than around visual or literary consciousness; the theaters themselves were often more rowdy than elegant; yet individual English performers' personal taste in stage dress, during this period of aesthetic restlessness, did begin to show a sense of historical propriety. But in England the sense of history (usually British) was indicated by costume on the stage without much sense of the need for beauty, style, taste, or dramatic truth. In France writers were saying that *art* should come to the aid of costume, and they exhorted actors to see to it. And so individual French actors, when they did choose to appear in simple drapery, usually claimed that artists had advised them. In England, however, antiquarians, not artists, were giving the advice. Of course, theatrical performers were not at all accustomed to taking any advice about dress but preferred, rather, to take credit for its success. It is interesting to speculate how well Vernet succeeded with his costume designs for Voltaire's *L'Orphelin de la Chine* in 1755. Voltaire himself had asked the artist to design them (something somewhat Oriental, you see, etc.), but later we find Mlle. Clairon basking in compliments for her own taste in baring her arms and wearing trousers. How much was Vernet?

It was in France that Classical themes first came to seem properly clad in Greek drapery, but this propriety was aesthetically, not historically, justified. Only later, in 1789, when the celebrated Talma appeared in short hair and bare legs to play a Roman proconsul, did he explain his dress as properly historical rather than more beautiful or more dramatically correct (IV.14). History, now fashionable in itself, could be invoked because French taste had assimilated the Classical look. Excuses for its beauty or dramatic aptness were no longer necessary; it was a stroke of avant-garde chic to wear it on the stage. Yet a certain high-minded attempt to unite

iv. 14 Talma as Proculus in
Voltaire's *Brutus*, 1789

art with stage dress had clearly been going on for a while, focused on the
suitability of Classical costume for tragedy. Not only French writers but
artists themselves advocated it, though originally with little success.

The revival of simple Classical dress on the stage was a patchy and un-
even process. Artists, playwrights, and aestheticians could get nowhere
with the idea unless the actors and actresses willingly collaborated, and
their personal tastes were not always in accord with aesthetic theory. Some
intelligent and enlightened French actresses and actors after the middle of
the century, like the analogously history-minded ones in England who at
the same moment were trying "old Scottish habits" for *Macbeth,* under-
took to appear in dramatically appropriate drapery instead of stiff skirts
and curls. These effects were always sensations. Since they were memora-
ble, however, not as innovations but as attributes of individually excellent
performances, jealousy and disapproval were often the backstage re-
sponses; and so no accord about such changes of style in costume could be
reached among the members of a company.

It is curious to see how the "draperies" adopted by such performers,
however authentic in theory, actually look remarkably like fashionable

IV. 15 Mlle. Raucour as Urphanis, 1773

IV. 16 Mary Ann Yates as Electra, 1777

mid-eighteenth-century clothing, only a bit simpler in cut. The huge hoopskirt may indeed be absent, but the skirt is still quite full and the hair quite high, if not always beplumed. Even a frill or two might appear. These costumes must nevertheless be judged as revolutionary, considering how rigid the conventions had previously been (IV.15, 16). These "classical" clothes from the 1770s actually bear a curious resemblance to the contrived portrait costume of a century earlier. The asymmetrical festoons of gauze and pearls look as if they might come straight out of a Kneller or a Mignard from the Baroque era (see I.51, 52). At that earlier time, of course, ladies were wearing carapacelike costumes on the stage, and loose festoons only in paintings.

All reforms or radical departures from conventional stage dress, whether "classical" or historical, English or French, were in fact publicly associated with star performers, not with plays or pictures. Theoreticians, artists, critics, even playwrights themselves, made a great fuss about costumes, but progress was actually made only when an individual actor tried something for himself. As long as the usual fashion of dress still demanded a good deal of trimming and expanse, most actresses felt more attractive wearing the customary big and bedizened stage dresses. After

all, plumes and diamonds were traditionally the proper accompaniments of stage appearance since time immemorial—and besides, they set one off to such advantage. What matter if Iphigenia never wore them?

Men were just as vain; when the famous Garrick came to Paris (1762–65), he once bravely chose to appear as Othello in Moorish costume instead of the usual modern Venetian general's uniform. He happened to overhear someone backstage say he looked like a little black boy hired to carry Desdemona's train—and so he went back to Venetian uniform. Most actors wore fashionable clothes, cast-off or new-made, as long as they felt at home in them and unlikely to incur ridicule. The costume was automatically read as part of the performance. This is, of course, the secret of all successful stage dress; but ludicrous visual inconsistency may result if each actor dresses himself, since not all actors can successfully visualize their own action in terms of clothing.

Sensible realism in stage costume, apart from that proper to Classical tragedy or past history, was another idea. Plays were being produced in which the main characters were servants or rustics, but starring performers were going right on wearing satin and diamonds to portray them. Again, individuals undertook personal reforms with personal success; but for the legitimate stage, the separate principles of theatrical display dress and dramatic costume were at last revealed to be completely at odds, and in full public view. Serious plays simply could no longer be dressed as if they were seedy remnants of courtly pageants. The public deserved better.

The vanity of actors and actresses is, of course, supported by public response, which is geared to fashionable trends. As soon as silk damask and powdered hair began to look tacky in drawing rooms, and the mode veered toward natural hair and white muslin, actresses could feel sure of admiration if they appeared in Classical dress for tragedy or in simple chintz for bourgeois comedy. By the end of the century the transformation was complete: Talma wearing short hair as a stage Roman was the echo of short-haired pseudo-Romans in the streets of Revolutionary Paris. Classical historical realism for the stage could then be agreed upon as good instead of vainly advocated by aestheticians or taken up by eccentric, self-confident stars. (Talma was in fact a friend of the Revolutionary painter who was creating vivid popular images of noble Republican Romans, Jacques-Louis David, who, he said, "advised" him about his costume.)

Scenery, too, had been progressing, independently as usual, as a form of pictorial art. More and more atmospheric effects were attempted on the English stage by such designers as Capon and de Loutherbourg, in accordance with the rise of Romantic landscape painting and the illustration of

IV. 17 A theater, France, c. 1789. Setting as landscape painting

historical romance (IV.17; contrast with IV.11). But now costumes, having emerged as an artistic issue, could not be left out of the total scheme. The awareness that figurative art could be a publicly accessible arena for feelings and ideas helped to revive the sense of the stage as a living picture. The serious stage could borrow from art, and be newly justified by art's truth-bearing power. Pictures and stage pictures could once more appear to engage in similar enterprises, as they had in the Renaissance.

For two centuries all serious costume design had served a courtly concept of idealized dress, divorced from serious or popular art. But by the beginning of the nineteenth century, when the new Romantic connection between pictorial art and the look of the stage was well established, artists designed costumes as well as sets; and actors, eager to be seen as figures in popular pictures, wore them without a murmur. Stage artists were deliberately serving the public taste and even elevating it, as art was now seen properly to do. A changed respect for people, as well as for pictures, was in the ascendant.

By this time, moreover, art had become an established authority for popularly received costume designs—either antiquities themselves (studied and copied by Mrs. Siddons, for example, with the approval of Sir Joshua Reynolds) or contemporary art in its fashionable aspects, sentimental or sublime, or, of course, the masterpieces of the past.

There were expressions of this new connection between art and costume even within the sacred bastions of the Paris Opéra. Here there was not much scope for the imagination and no question of individual creative effort. Everything had always gone through channels and was hierarchically organized. There was always an official costume designer, one master tailor, two assistants, many skilled hands, a huge workroom, and huger wardrobe. Everything was inventoried, and records were kept of the miles of silk, lace, and gold braid, and the hundreds of artificial roses. There were many abuses, much pilfering, graft, corruption, and bribery. Suppliers overcharged and underdelivered; state money was wasted. Stars wore what they liked, demanded special fabrics and accessories, occasionally tore up expensive costumes when jealous of rivals, besides helping themselves for their own purposes.

In charge of design during the middle decades of the eighteenth century was Boquet, a decorative artist greatly skilled in creating delicate Rococo confections that were firmly based on the stiff and standardized costume shape. Like his predecessors, Boquet turned out endless variations on this theme and worked in a kind of vacuum. He had no connection with set designers, composers, choreographers—or current trends in art. Noverre, the famous ballet innovator, wrote enthusiastically, as everyone else did, about getting rid of hoops and wigs, and about the desirability of dancers' wearing light and filmy clothes; but when he became director of the Paris Opéra Ballet in 1775, he accepted, perhaps because he had to, Boquet's relentlessly elegant designs. Boquet's sketches are of Persians, Indians, Classical gods, Furies, the whole theatrical stable: figure after figure is uniformly sprightly, delicate, and as formal as Bérain's a century earlier (IV.18).

But significant changes were afoot. After Boquet an authentic pair of artists were engaged as costume designers at the Opéra. Berthélémy and Ménageot had been Academicians and had also been trained in Rome, and they were as keenly in touch with popular trends and current aesthetic taste as Boquet was remote from them. Boquet stayed on, actually in charge throughout the Revolution, although nothing survives to show what he produced. But as soon as order was restored, Berthélémy and Ménageot plunged into a sea of togas' and sandals and broadswords, tunics, fillets—the whole "Davidian" property shop. But more significant than the official arrival of Neo-Classic taste is the evidence of a different process for costume design. Boquet had had no academic artistic training; his sketches are stock figures, mannequins wearing fancy dress. But his successors' drawings are dramatic compositions, showing several charac-

IV. 18 LOUIS-RENÉ BOQUET (1717–1814). Costume designs, c. 1750

ters at once in various postures and groupings appropriate to the drama. The clothes themselves are not very inventive (the same old snakes and bat wings, suitably updated, appear on the "Fury"), but the mode of composition, as if the stage were visualized as a painting (by David, of course), is a real innovation (IV.19).

Ménageot's designs for the ballet *Fernand Cortez* (1809) display a real effort, unprecedented for the Opéra, at authentic period costuming. His sixteenth-century Spaniards show the results of real research translated into ballet terms with a minimum of distortion. His Aztecs, however, tend to fall back on standard stage primitive: faintly Egyptian-looking symmetrical tunics with fringes, and stiffly arranged feathers.*

"Oriental" stage costume had long consisted of variations on a few standard elements. Chief of these was the dolman, a long robe with a ladder up the front of horizontal bands or frog fastenings and a sash around the middle. A turban or fantastical version thereof would be worn with

*The fact that actual costume sketches, some quite rough, survive in the Opéra archives is of immense value in studying these changes in the designers' own sense of their work. Many costume plates and engravings exist from other theatrical traditions; but working sketches are rare in any number. They tend to fall on the workroom floor and get stained with glue and dye or are torn, lost, or stolen.

IV. 19 JEAN-SIMON BERTHÉLÉMY (1743–1811), Sketch for *Castor et Pollux*

this, and long hanging sleeves. Variations on this costume date originally from the art and theater of Renaissance Italy, where Eastern clothing had sometimes actually been seen at close range and copied more or less vaguely thereafter for ancient and exotic characters in art and pageantry. Baroque formal costume design and imaginative Baroque art swallowed the formula whole, readapting this generalized "Eastern" dress (loosened or stiffened, according to traditions of art or stage) for all purposes and both sexes. In the eighteenth century a special romantic interest in things Oriental arose along with Classical and medieval preoccupations; and so the conventional "Oriental" dress, by this time universally recognizable, could be painlessly troped into the new kind of "realistic" costume—minus hoopskirt and corset, of course.

The English have been called a nation of antiquarians. It was chiefly on the early-nineteenth-century English stage, even without the state support that permitted such extravagance at the Paris Opéra, that spectacular "historical" effects were produced, and eventually there proved to be real money in it. Scott's novels were very popular, and they

IV. 20 (above) David Garrick
as Macbeth, 1776

IV. 21 (right) J. H. FUSELI
Macbeth and the Armed Head
1774–1779

had a great effect on the theater. By 1830 all the Waverley novels had
been worked up into plays that made money for *their* authors, too, and for
actors and theater managers. Historical settings and trappings had been
part of the original charm of the novels themselves, but it was good box
office to offer them in three dimensions and living color to the eager pub-
lic. The stage itself became a living illustration.

Shakespeare's plays were already being intensively revived, but dress for
these was a trumped-up and only haphazardly historical matter. Artists
were doing much better with visualizing Shakespearean clothes than
actors were in dressing themselves. Costume designers were still lacking in
England, though scene painting was in the hands of experts. Fuseli, that
great illustrator of Shakespeare, was in Rome in the 1770s, when most
Shakespearean heroines were stalking about the London stage in huge
hoops, heroes were in breeches and powder, and all were in obvious need
of his superior eye. The skirts might be draped to seem Classical, and the
men's powdered wigs might be worn with a lace "Vandyke" collar; but
Fuseli, in those same years, was painting dramatic scenes from Shakespeare
as he thought Michelangelo might have done them—even though he was
obsessed with exaggerating the latest erotic mode in dress (IV.20, 21).

So far, theatrical taste was not keeping up. But by 1794, when Kemble
staged *Macbeth,* he was a good deal nearer the mark: "The witches no

IV. 22 J. H. FUSELI (1741–1825), *The Three Witches*

longer wore mittens, plaited caps, red stomachers, ruffs, etc. . . . or any human garb, but appeared as preternatural beings, distinguishable only by the fellness of their purpose and the fatality of their delusions." Writhing snakes and black and gray spirits are mentioned in the caldron scene; it all sounds like a description of Fuseli's *Macbeth* illustrations: "the attempt was to strike the eye with a picture of supernatural power, by such appropriate vestures as marked neither mortal grandeur nor earthly insignificance" (IV.22). Shakespeare illustration was already a vogue in English art, in which stage conventions of setting and grouping were employed, and was becoming a vogue on the stage itself, where pictorial conventions were providing models.

Goethe put on plays for Duke Karl August in Weimar for a quarter of a century, beginning in 1791. He apparently agreed with Diderot that actors should look at paintings and sculpture—but not for the costumes, for the deportment. In explaining his views to Eckermann, Goethe urged the Classical idea that reality was not the point of staging and acting; art makes a controlled representation, not imitation, of life—and so should drama. Acting should be manifestly truthful as art, not as reality—but good art, of course, like the great pictures and statues of the past. Yet de-

spite all these serious ideas, and although he had a permanent subsidized theater and a wardrobe, Goethe had very little to say about stage clothes—how they were to be designed or of what and by whom they were to be made. He apparently took it for granted that his enlightened actors would be responsible for dressing themselves properly, although he himself exercised total artistic sovereignty over all other aspects of his stage. His advice to actors about dress was mostly good sense about color and how not to stick your hand in your coat at rehearsal if you were going to wear armor in performance, and so on.

Nevertheless, the idea of theater as fiction, not much articulated elsewhere, was very important; although the thought was perhaps not realized at Weimar in any elaborate visual effects, it certainly was in London. There, however, it was being called truth, for better box-office appeal. Writing in 1840 in *A Brief View of the English Stage*, H. G. Tomlins said, " 'Correctness of costume' was a phrase invented to excuse pageantry, as was 'accuracy of locality' for spectacle." The public, learning to love pictorial wonders, was becoming accustomed to receiving them under the name of "absolutely authentic historical re-creations."

In the eighteenth century, when costume reform had begun to be discussed and practiced, the idea of historical authenticity had been unwieldy and visually unfocused. Having begun in France with ideologically adopted Classical drapery (a malleable and blurry substance), truth to history was confined to isolated and equally ideological notions in England that, for example, the "ancient Scottish habit" and "old Saxon garb," whatever that was, were obviously more suitable to the fearsome adventures of Macbeth and Lear than gold-laced waistcoats. But without a comprehensive sense of design, few theatrical performers could look straight at the evidence of former fashion in the art of the past, grasp its essential style, take it personally, and so let it transform them. Usually when stars tried historical effects, the result was an adaptation of odds and ends—a collar, a sleeve, a hat—to get the point across. These were dramatic devices, in the ancient tradition of character communication. Many other persons on the stage at the same time would be wearing the standard unhistorical wardrobe. The stylistic beauty of any kind of historical dress was as yet almost entirely unperceived, and certainly uncommunicated to audiences.

In London in 1823 James Robinson Planché, neither philosopher, critic, nor actor but a devoted antiquarian and playwright, actually offered to design, free of charge, a whole set of authentic historical costumes for

Charles Kemble's production of *King John*. Such a combination of truly disinterested aesthetic and theatrical zeal had not yet had any practical expression in dress on the English stage; but by this date the public was ready for "history" and "realism," and so Kemble perceived the pecuniary advantage that might result from the experiment and agreed. Planché was not an artist, but he certainly was an expert; and he went on to write a history of English costume, and books on heraldry and armor. His methodically researched twelfth-century costumes got top billing and publicity, with many authorities listed and explanations printed in the program. The show made a lot of money. It was probably the first and last attempt at a complete look of authenticity on the stage for its own sake.

The success of *King John* made "historical authenticity" a fad, and all spectacular effects thereafter tended to be "historical" and have program notes about their "correctness." This accuracy, when profits and not antiquarian integrity had priority, soon became open to question; but the concept of a historical unity in stage design, encompassing costumes and scenery and giving the effect of a history-painting come to life, had been inaugurated. Historical authenticity in visual terms is a compelling idea; and the public, once convinced it was possible, never ceased to love thinking it was being given a glimpse of the past brought to life. The public was, however, also being trained simultaneously to think of the whole past as spectacular and of all spectacle as authentic.

In an age of narrative history-painting, an accord between stage picture and painted picture could become so complete as to be unnoticeable. "Elizabethan" or "cavalier" or "gothic" costumes created at this time corresponded to those in current historical works of art, not only in sartorial detail but in general pictorial style (IV.23, 24). This correspondence was the more reinforced if paintings illustrating Scott's novels or Shakespeare's plays appeared at the same time as stage productions of them—similarly clad, naturally (IV.25, 26). The public could believe (since they were told so) that the clothes in each were absolutely correct, without "seeing" the current fashion distorting them both. Moreover, they could then turn to works of the past and unconsciously read the details of the costumes in them through the filter of modern taste. This could be true only in an epoch before art-historical discipline and modern art criticism had created and trained the public to assimilate a formalist way of seeing paintings.

In such a view, certain characteristic relationships among lines and shapes and colors can be observed to prevail in certain epochs and be

IV. 23 D. MACLISE
(1806–1870) "Thine Own"
Mezzotint by George Every
from the Maclise paint-
ing, 1859. Artistic mid-
nineteenth-century medieval
dress: full skirt, ermine
trim, earmuff coiffure, crown

IV. 24 Theatrical print, 1830
Actress in mid-nineteenth-
century medieval dress: skirt,
ermine, earmuff hair, crown

IV. 25 (left) JOHN SINGER SARGENT (1856–1925), *Ellen Terry as Lady Macbeth*
Late-nineteenth-century medieval garb for art and stage: knee-length braids,
girdle at hips with front closing, neck brooch, diadem, flowing sleeves

IV. 26 (right) EDMUND BLAIR LEIGHTON (1853–1920), *Lady Godiva,* 1892
(detail). Photogravure from the painting. Late-nineteenth-century medieval garb
for art and stage: braids, girdle, sleeves, brooch, diadem

unique to certain artists. Furthermore, these modes of representation, not
of tailoring, can be seen to create the look of clothes in art and hence in
visual history. The look of the past can be discovered only through its art,
viewed with knowledge that art represents it in its own characteristic
style. Only the style can be reproduced—the actual look of the past, with-
out art, is irrecoverable. It went out with the light of its own eyes and,
like its odors, is gone forever. There is no historically authentic look that
is not the look of an artistic style.

Once the detached perception of style had become a visual habit well entrenched in twentieth-century consciousness, stylistic authenticity became a guiding principle of historical costume. Actors could be deliberately made to look like period works of art come to life, not like a modern fashionable artist's view of a past epoch edited for current taste. Costume designers in the twentieth century, taught perhaps even unconsciously by modern art-historical methods of looking at clothed images in pictures, have been able to create walking Goyas, Cranachs, Pisanellos, and Hogarths, as well as characters in medieval manuscripts, out of modern actors and actresses. Painters have sometimes done the same, attempting somehow to penetrate the mystery of art by reproducing the style of another era or of one of its artists.

Certain early-nineteenth-century German artists, obsessed with the Italian Renaissance, attempted history-painting within the strict limits of *quattrocento* and *cinquecento* style. These Nazarenes, however, like the artists of the Pre-Raphaelite Brotherhood, soon developed their own stylistic flavor, since emulating the spirit, rather than just copying the style, was their primary concern. Pastiche paintings and outright forgeries were also done, just as impassioned style copies had been made by Neo-Classic and Renaissance sculptors of antique models; but this special view did not influence the nineteenth-century stage. German artists sometimes did fanciful scenes of artists' lives, respectfully rendered in the style of the artist's work: *Hugo van der Goes in the Madhouse* and *Frans Floris Going to Church. Raphael and the Fornarina,* by Ingres (French and therefore more famous), is another example. But these are isolated, sophisticated efforts. The main tradition of history-painting demanded that an artist work in his own personally developed style. The costumes were bound to be figured forth in that style, too; and research notwithstanding, they would look—as they looked on the stage—emphatically of their own day.

And on the stage, inevitably that look was the most desirable after all. Kemble and his successors mounted many spectacles in London, and many more were put on in Paris, where actors acted, sang, and danced in nebulously gorgeous but becoming trappings (as the photographs and engravings attest), and programs, often inexcusably, made much of how "correct to the period" the costumes were. Throughout the nineteenth century—as throughout the twentieth, in the movies—what were essentially fashionable clothes were worn, posing as authentic historical dress. So, indeed, were purely fanciful theatrical costumes, designed to augment the beauty, charm, or importance of the wearer, but still in terms of modern taste.

Both these genres of stage costume—modish clothes, somewhat fantastic and emphatic, and modishly conceived fancy dress, somewhat quaint or antique—have their respectable history of satisfying the public eye in their own right, without any excuses. For centuries before the idea of absolutely authentic historical truth captured the public imagination and the box office, these two kinds of dress-ups were the only carefully designed stage costumes people ever saw. They were more beautiful and captivating (and sexy) than ordinary dress, and they were their own justification.

The public still has its pure love of display and luxury and frivolity; but these are frequently offered under false pretenses. And they are accepted, furthermore. In the 1974 film of *The Great Gatsby* the costumes were billed as historically correct, and believed to be so; but in reality they were chic and glossy, with only a few authentic visual references to the style of the 1920s thrust into the foreground of a panorama of currently seductive luxury. We have seen that luxury and fantasy, always pegged to fashion, have been the principal props of theatrical (not dramatic) costume design ever since the Middle Ages. History, in all stage clothes, has always been and still is primarily a matter of signals—except in the works of designers deliberately re-creating images from works of art. Applying accurately to the stage the historical costume data achieved archaeologically, as Planché tried to do, is visually an impossibility. Planché's costumes, as the engravings show, for all his purity of purpose still came out looking like early-nineteenth-century versions of medieval dress—correct in every surface detail but cut and fitted and worn to please the contemporary eye.

Convention is nowhere stronger than on the stage. Without ever dealing with history, costume conventions have perpetuated themselves through centuries of show business. In the movies the most perfect illusions constantly submit to conventional presentation. Costume movies implicitly claim to offer a perfect resurrection of past time, based, of course, on camera perfection: the capacity to record, not represent, the way light strikes objects. In the case of historical costume movies the camera turns on artfully crafted ruffles and armor, as well as on blades of grass and pores in the skin, suggesting that both kinds of phenomena are as authentic as if they appeared in newsreels. But, of course, the style of costume movies is derived, just as the style was derived for history-painting and stage costume in the past century—that is, filtered through current styles in reality.

Sir Laurence Alma-Tadema's paintings from the late nineteenth century show people wearing their carefully researched Roman garb in a "natural"

IV. 27 LAURENCE ALMA-TADEMA
Vain Courtship, 1900
Victorians dressed as Romans

manner (IV.27). People accepted them as truthful reconstructions, and so they were, as far as technical detail could take them. But the figures look like perfect period Victorians dressed as Romans, since their "natural" behavior had just as much period style as clothing or interiors; and so, of course, does the painter's work itself.

The camera seems styleless, however, when dealing with history unless it very carefully refers to the artistic vision of the time in question. The gestures and postures, as well as the clothes and coiffure, of filmed historical characters may seem deceptively more "natural" than painted re-creations. For one thing, they actually move. One is tempted to believe that the mobile, spontaneous behavior (and by extension the period dress) recorded by movie cameras is actually more natural than that rendered by artists like Tadema. But Bette Davis behaved and dressed quite differently in her two versions of Queen Elizabeth, one in 1939 and one in 1955; both were in "authentic" period dress and naturalistically acted, although

neither much resembled the clothes and gestures in Queen Elizabeth's actual portraits (IV.28–31). Each looked correctly dressed and naturally behaved for its own time.

Since stage costumes originally shared in the conventions of art, they shared the same repertoire of costume signals for indicating past time. In a Renaissance pageant or painting, a contemporary scheme always governed the style. Historical details were recognizable in their modern form, not as exact replicas of anything but as standing for something historical. They did not have to look historically authentic, only conventionally so. A shortened flimsy skirt and an overtunic meant a lady was a character from antiquity, even if she looked acutely modern and did not resemble antique statuary at all. Such conventions have their own authority. When art and costume design were divorced, the old costume conventions kept their strength, to the degree that they could sometimes influence art even when art was no longer influencing them. Certain seventeenth- and eighteenth-

IV. 28 Bette Davis as Queen Elizabeth I, 1939. Costume by Orry-Kelly for *The Private Lives of Elizabeth and Essex.* Soft 1930s bodice, hair, pearls, and posture

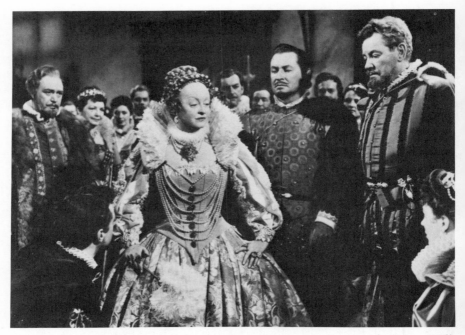

IV. 29 (above) Bette Davis as Queen Elizabeth I, 1955. Costume by Mary Wills for *The Virgin Queen*. Crisp 1950s line, texture, hair, and torso

IV. 30 Glenda Jackson as Queen Elizabeth I, 1971. Costume by Elizabeth Waller for BBC Television's *Elizabeth R.* A close approximation to the original portrait

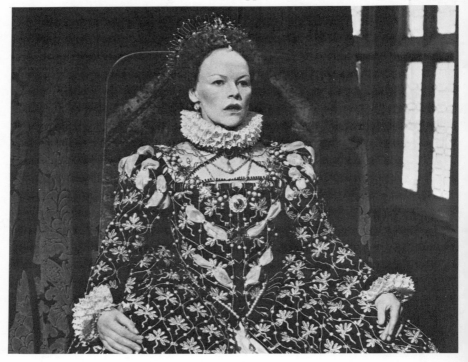

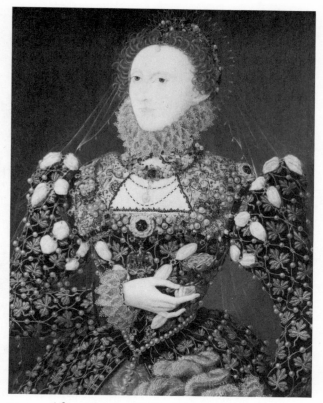

IV. 31 After Nicholas Hilliard (c. 1547–1619)
Elizabeth I, c. 1575

century artists occasionally used the fashion in early-sixteenth-century stage costume to clothe antique characters instead of resorting to the neutral billow of Baroque–Neo-Classic dress (IV.32, 33).

The authority of visual convention is gladly accepted by everyone who goes to the theater. For centuries the public believed that the stage was the home of convention, not illusion; and when illusion was perfected, it quickly became conventionalized. In looking at stage or movie costume, the pleasure of recognition is in the end more satisfying than the pleasure of seeing pure spectacle or of perceiving dramatic logic in stage clothes. That is one reason why the sense of history can be inauthentically but successfully conveyed without seeming ridiculous.

The actor can adopt recognizable signals that do not even have to match each other, let alone harmonize with the rest of the wardrobe. The audience gets the point—and it still does—with the smallest hint. Patchy

IV. 32 FRANCESCO FONTEBASSO (1709-1769)
The Family of Darius before Alexander (detail). Stage dress for painting

or glamorous, authentic or not, a historical costume always looks better to an audience if it resembles other familiar costumes that have always indicated that period in history. So long as Queen Elizabeth's courtiers wear ruffs, it doesn't matter what else they wear. This kind of rule works in modern movies, as it worked in the seventeenth century. These dramatic devices can be very modestly presented or elaborately exaggerated—either way, they carry the same message. But after the success of resurrecting the clothes of the past in complete visual compositions like pictures, the existence of such dramatic conventions for historical meaning was masked.

Token history seemed at odds with the look of total authenticity. But the impulse to conventionalize the signals was still there; and soon certain historically satisfying costume elements, authentic or not, had to appear on certain characters according to precedent. Adrian's *Marie Antoinette* costumes for Irving Thalberg's 1938 film, almost entirely fanciful, look authentic because everyone is wearing a white wig (see IV.44); similarly, the costumes for the 1973 television series *Elizabeth R* with Glenda Jackson, absolutely correct and minutely copied from portraits, look authentic only because everyone is wearing a ruff (see IV.31). Both are assumed to

be authentic because they are on film, lavish, and billed as historical re-creations. It was in the name of historical authenticity—usually taken in vain—that the old institution of theatrical display costume, glittering, fanciful, and purely wonderful, was combined with dramatic costume to convey specific meaning about characters.

Ever since all of this started in the early nineteenth century, the public has had a double historical-costume sense, often overlapping and confounded. Any real public knowledge of authentic historical dress has been invaded and corrupted by stage conventions of such long standing that

IV. 33 G. SERPOTTA
(1656–1732)
Courage, 1714–1717

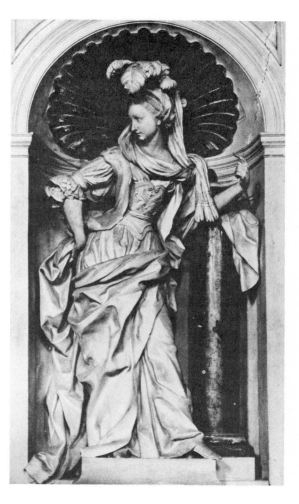

they seem to have the sanction of real history. This has come about because using "correct" historical costume for the stage has been a concept and an institution for so long. Public expectation was originally trained by a seductive combination of promises: first, the lure of re-creating vanished beauty, so important in an increasingly industrialized age; second, and at the same time, the guarantee of a morally responsible truthfulness backing up the gorgeous effects. Sumptuous, cleverly designed, and even very erotic costumes were shown not just to be mindlessly gaudy trappings of self-important, once courtly entertainments, like opera and ballet; not just sexy and pretty and amusing for low-down kinds of shows; but happily appropriate to serious historical drama. History was certainly serious, even tragic, and among the ruling classes it was also authentically gorgeous, without theatrical rhetoric to make it so.

By the mid-nineteenth century royal courts were self-conscious affairs, and clothes covered with gold and jewels were no longer essential public signs of high rank. Kings wore business suits and sportswear in full view of their subjects. Queens could be seen and photographed in sensible traveling costume. Pictures of them wearing such things were even sold in shops, as well as official portraits in regalia. Clearly, the cast-off clothes of dukes no longer looked ducal, nor would they indicate the presence of a duke on the Shakespearean stage. In England the late Romantic history-painters dwelt on meticulously rendered ermine and pearls being worn by the kings of history and on clinging gold-embroidered draperies on Roman empresses. These paintings were successful because a new Romanticizing attention to the sharp contrast between the present prose of clothes and the past poetry of costume was fashionable among lovers of art. Deliberately historical stage costume was successful, too, partly because of the new Romantic sense of a nobly robed and jeweled past, vanished forever, and replaced by modern man, even royal man, in hopelessly drab trousers and elastic-sided boots (IV.34).

The beautiful clothes of the past, "re-created" and worn by living actors and not just figures in pictures, were continuously successful in Shakespearean revivals all during the nineteenth century; and on into the twentieth, the first silent-film versions of Shakespeare were also billed and reviewed as expensively, splendidly, and, of course, "authentically" costumed—so that actors looked exactly as they would have done in, say, sixteenth-century Venice. They look to modern eyes exactly like what they were—actors in 1912.

A new sense of "tawdry magnificence," of "sham finery"—a romance of the very institution of stage glory as opposed to drab reality—confirmed

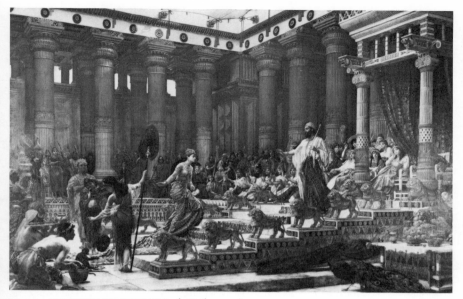

IV. 34 SIR EDWARD POYNTER (1836–1919)
The Visit of the Queen of Sheba to King Solomon, 1890. Vanished pomp

the view that fancy finery is itself stagy. True refined elegance not only was not, but could no longer be, displayed in terms of bright color and feature shiny surfaces, heavy trimming, and expansiveness of cut. After 1914 these were for stage and screen elegance only; they became "theatrical." This view has stayed in force until very recently, when blurring the distinction between clothes and costumes once more became a fashionable game, as it had once been in the Renaissance.

During all those decades of successful historical costuming on the stage, audiences felt confident taking the authenticity on faith. If everything looked simply wonderful, it was presumed to be accurate; the audience could trust the designer for the facts and go back to enjoying the display. But because recognizing signals is the main visual pleasure in theatrical experience, stage conventions for indicating history crept back into "accurate" costume design. Because the public was now buying truth, these conventions were accepted as accurate details. A whole fake history of costume, almost entirely composed of stage conventions, has come to exist, if rather nebulously, in the public awareness.

Of course, the actual history of costume, like any other historical subject, is hard to learn about accurately. For clothes, surviving artifacts offer a great deal of technical but no stylistic information about past usage; doc-

uments yield economic and social information, but all this evidence is not easily available, even for those interested. The history of art—which is generally accessible, even popular—provides the only visual knowledge about the dress of past time offered in its own terms. But these terms are often difficult for most viewers to dissociate from the perception of the whole work of art, of which clothes are only a part. Indeed it is supposed to be a betrayal of the artist to do this, and so truthful historical costume information in pictures—including how it was *seen* as worn—is often easy to ignore in favor of the larger truth of the work of art; historical accuracy of dress instead is assumed to exist in the movies or (earlier) on the stage. The discrepancies between dress in art and its interpretation on the stage often go unnoticed.

Costume signals indicating periods in history are similar to other kinds of isolated stage conventions: they were originally established by association with a popular star and copied by successors and imitators hoping to catch some reflected glory. This way of making an institution out of a single star's stage effect also worked with idiosyncratic styles of rendering certain famous speeches, singing certain famous arias, registering certain emotions in certain scenes. Performers "create" roles, and later performers use those creations as well as the author's to support their interpretations. This works beautifully for costume details, too. When costume was a matter of the actor's personal choice, a successful star could make his costume a part of his success, and later actors could use the same clothes to try for success by contagion. If someone always wore a ruff to mean Elizabethan times with his modern eighteenth-century knee breeches and powdered wig, later actors might feel assured of at least some acceptance simply by doing the same thing. Audiences would catch the auras of success and of the Elizabethan period from the same ruff. This method continued confusingly throughout the "historical authenticity" period, and continues still. Historical dress is made acceptably beautiful by being suitably edited for wear by Sophia Loren or Raquel Welch. Other, less glamorous stars are given similar clothes in later movies, so that the audience finds them vaguely reminiscent of both history and glamorous stars at the same time.

This visual mechanism has a counterpart in unhistorical dress: modern fashion is confirmed and enhanced by the glamour of screen and television stars, under the guise of being ordinary clothes. For modern clothing certain commonly accepted coiffures, ways of opening the collar, choices and combinations of common garments, when worn by the superstars, confirm the acutely contemporary "rightness" of the particular mode—the

IV. 35 Theda Bara as Juliet, 1916
The original Juliet cap

IV. 36 Beverly Bayne as Juliet, 1916
Another original Juliet cap

sense of the *current* historical period, so to speak—and the sense of glamour. The audience achieves a sense of glamour by association, even in wearing the very common mode. Jack Nicholson's watch cap in *One Flew over the Cuckoo's Nest* (1976) is an example. Everyone wore watch caps anyway, but after he wore one in the film, everyone looked like him. It is impossible for *him* to look like "everyone else," just as it is impossible for Bette Davis to look like Queen Elizabeth; the likeness always goes the opposite way.

The so-called Juliet cap was a skullcap of networked gold and pearls, worn with flowing hair first by Theda Bara in a 1916 film version of *Romeo and Juliet* and also by Beverly Bayne in another one the same year (IV.35, 36). In 1921 Silvia Breamer wore the identical cap in a film spoof of *Romeo and Juliet* with Will Rogers. In 1924 Leatrice Joy also wore it as Juliet on film. In 1929 it identified Juliet in a "Pageant of Lovers" in Ziegfeld's *Glorifying the American Girl;* and so Norma Shearer had no other choice but to wear it in 1936, in the film with Leslie Howard (IV.37). Juliet ceased to be identified with that cap only in the 1950s, although she still can be (IV.38).This is an example of dramatic and theatrical conventions combining, both at war with the authentic look of history. The theatrical spirit had originally created a becoming headdress, vaguely "old days," for

305

IV. 37 Norma Shearer, 1936
The most celebrated Juliet cap

IV. 38 Pamela Payton-Wright,
1977. The indispensable Juliet cap

Bara. Borrowing on her success, subsequent versions also identified it with the dramatic character of Juliet, just as Harlequin's suit of multicolored lozenges is identified with him. By Shearer's time the costumes in the 1936 *Romeo and Juliet* were actually quite historically authentic, and designed according to Renaissance pictorial style—but the token Juliet cap had to be added, for dramatic reasons, to an otherwise unified costume

scheme. The Juliet cap thus illegitimately acquired the look of historical authenticity—but only for Juliet. It is not usually worn, authentic or not, by other Italian Renaissance heroines in Shakespeare: Miranda and Isabella and Beatrice never wear it.

Costume designers for the commercial stage or screen must pay attention to what has proved successful. For historical drama they must make use of historical signals to which the public responds, as well as to the demands of current fashion, which continues to include current taste in reality—conventional "natural" behavior and emotional expression that all stage clothing must now encompass. The conscientious study of the past, to determine the combined modes of dress and behavior customary in other days, is profitable to a costume designer only if the actor also undertakes it and the director desires it. Serious research in the history of past art and artifacts is usually a constant study on the part of costume designers, but their creative work must be interpretive. This was obviously just as true in the days of official "authenticity" as it came to be later, when "suggestion" and "flavor" were considered to be the proper characteristics of historical stage dress.

For the legitimate theater in the twentieth century, dramatic considerations outweighed pure display—which was taken over by musical comedy, cabaret, and film. The influence of contemporary art was again, after centuries, perceptible on the stage. The stage again became the acknowledged home of symbol and deliberately adopted convention. And the sense of historical style as perceived through past art also became a dramatic tool for costume designers. Rendering one period in the recognized style of another, for example, became a dramatic device for imposing a certain interpretive decision on a whole production, a way of visually expressing a particular understanding of the play.

Film kept up the old nineteenth-century habits of ostensibly straightforward, historically correct costuming used for the sake of spectacle. Only with very sophisticated cinematography has it been possible for the camera to convey a complete period aspect through the entire visual style of a film. In such a case, a historical costume becomes a matter not of isolated correct detail or general lushness but of the exact angle or texture of the light, the placement of shapes in space, and the combination of tones, all with reference to the representational style of the date. Details of interiors and landscape and architecture harmonize with details of dress, and there seems to be no costuming at all but, rather, clothing as it inevitably must have looked (IV.39–45).

IV. 39　(above) Period costumes from Luchino Visconti's *The Leopard,* 1963

IV. 40　(below) American photographs, early 1860s

IV. 41 Period scene from Luchino Visconti's *The Leopard*, 1963

IV. 42 American popular illustration, 1865

IV. 43 "I Dance Before Them All"
Popular illustration, 1859

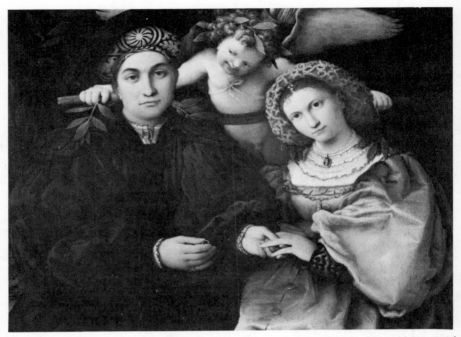

IV. 44 (above) LORENZO LOTTO (c. 1480–after 1556), *Messer Marsilio and His Bride*

IV. 45 (below) Bridal couple from Zeffirelli's *The Taming of the Shrew*, 1966
Correct costumes—with modern hair for stars, authentic hair for the extra

D·R·E·S·S

D ress is a form of visual art, a creation of images with the visible self as its medium. The most important aspect of clothing is the way it looks; all other considerations are occasional and conditional. The way clothes look depends not on how they are designed or made but on how they are perceived; and I have tried to show that the perception of clothing at any epoch is accomplished not so much directly as through a filter of artistic convention. People dress and observe other dressed people with a set of pictures in mind—pictures in a particular style. The style is what combines the clothes and the body into the accepted contemporary look not of chic, not of ideal perfection, but of natural reality.

Like any visual art, the art of dress has its own autonomous history, a self-perpetuating flow of images derived from other images. But any living image of a clothed body derives essentially from a picture or, rather, from an ongoing, known tradition of pictures of clothed bodies, rather than directly out of satisfying a desire for good-looking covering, invented anew in each generation or each decade. And the difference between the way clothes now look (at any given time) and the way they used to look is made most clear to the eye through changes in the style of their pictorial representation—including styles of photography and cinematography. Dressing is always picture making, with reference to actual pictures that indicate how the clothes are to be perceived.

Consequently, the visual demands that govern change in the art of dress have more authority, more consistent and sustained power over all kinds of fashion, than practical and economic demands. Developments in fashion are like changes in pictorial art; in clothes, as in pictures, technical inventions and social change are secondary to visual style, although the former may later be adduced to illuminate the direction taken by the latter. Past fashions are often anecdotally accounted for by the idea that some practical necessity or accident caused an arrangement to be made into a fashion by celebrities or royalty. It is usually more realistic to consider such innovations as beginning with the need for a change of look or a variation of look and then being accomplished and sanctioned by some fashionable person. It is primarily the picture that is in need of modification, at some limit of any fashion. No royal personage or movie star could inaugurate a mode for which no visual desire existed even if a practical need did exist.

It is obvious that certain details of dress have originally been invented for utilitarian purposes. But it is equally obvious that the desire for a satisfying-looking style in dress is stronger than any need for useful arrangements, since the looks of such arrangements have often proved much more enduring than their use. Also, their utility has often been quickly sacrificed to stylistic considerations. The lapels on early military uniforms, for example, which were intended to cross over and keep the chest warm, were speedily atrophied into decorative flaps, worn buttoned open to show the color of the facing. They could still button across, too, but they were never worn so.

In clothing, then, visual need may indeed be stronger than practical need; but the visual elements in a style of dress, like those in an artistic school, naturally have iconographic or symbolic meanings as well as formal properties. The symbolic aspect of dress is what sociological writing about clothing has usually dwelt on, and usually as if the formal aspects were arbitrary and the symbolic ones externally determined. But in fact the shapes, lines, and textures of clothing also fluctuate according to their own formal laws—and often the symbolic meanings attached to these different formal shapes might be equally well expressed by other shapes. However, only certain ones will do at a given moment; these are the ones the eye seems to require.

Expressing female social and sexual freedom in dress, for example, is possible in a number of ways, and it has been accomplished a number of times. The way it is done depends wholly on how the look of the new clothing differs from the way clothing has been looking before. If

women's dress has been cut straight, shapeless, and ankle length, a radical movement toward sexual expression will be manifested by tight stays and long, full, flowing skirts—this happened at the beginning of the fourteenth century. If respectable ordinary women wear tight stays and long trains, radical sexual freedom will be expressed in straight, ankle-length, and shapeless garments—and this happened at the beginning of the twentieth century. The look of freedom for leg movement can be conveyed by adopting trousers, by shortening skirts, or indeed by wearing full, loose, clinging skirts. But if short skirts and trousers are visually unacceptable, clinging skirts will be chosen to convey the message, not the other two. This happened at the beginning of the nineteenth century, and Classical antiquity was invoked to justify it.

It is not enough to say that women adopted short skirts after the First World War because they symbolized sexual freedom and permitted easy movement of the legs, since these practical and symbolic effects could have been accomplished in other ways. Some aesthetic reason, some demand internal to the changing look of women and of clothes over quite a long period, required that legs appear just then. Similarly, it has always been fashionable to copy certain elements of dress that have public timeliness, such as military motifs in wartime or foreign motifs while public attention is focused on the foreigners in question. But fashionable mimicry does not occur unless the look pleases for itself and blends with what already pleases. If Garibaldi's blouse and hat in 1865 and General Eisenhower's jacket in 1945 had not harmonized with the most satisfying shapes in the female dress of their day, they would never have been imitated as elements in modish clothing, no matter how complimentary to those heroes the ladies wished to appear. Nobody copied General Pershing's jacket; it was out of line with the current feminine shape in 1918.

It is common to account for adoptions or sudden changes in fashionable clothing by adducing their meanings alone, rather than by studying their formal, strictly visual properties in the light of previous and concurrent ones, as is usually done in studying changes in styles of art. Blue jeans may express countercultural ideology, but they are worn for their looks. They may also be long-wearing and practical, but they are still worn for their looks. The original meaning naturally supports the look while it is in fashion; it is an extra bonus given away free with the purchase of the garment. In the nineteenth century, city businessmen were wearing a country sportsman's look, overlaid on a vestigial military look—but clothes embodying such meaning carried their significance in suspension, while their formal properties (dull wool fabric, cutaway coattails, crisp

lapels, extra buttons) produced an independent satisfaction. The connotation of soldiering or riding to hounds was not central but peripheral and irrelevant to the pleasure taken in the look. Varieties of "ethnic" look and the look of shabby poverty have been worn, but not because people wished to look like paupers or Ghanaians. When fashionable dress adopts clothing with specific uses or meanings, these usually do not surface at all. The picture the garments make on the body pleases because of its resemblance to a current pictorial ideal of shape, line, trim, texture, and movement. This ideal condenses visually (not ideologically) from the vapor of available meaningful images, in accordance with what the eye wants people to look like. This way of looking may be multiform—but it has a certain harmonizing and unifying visual quality, which will be constantly reinforced by the style of the pictures in which it is represented as natural.

Clothes create at least half the look of any person at any moment. Representational artists, great or popular or both at once, continue to offer images of clothed truth so persuasive that they govern the perception of dress in a whole generation. Advertising, television, movies, all the current vehicles of the human image do this now, and one may imagine how the same process was in effect in earlier times, ever since people saw themselves to be truthfully reflected in church altarpieces, temple sculpture, catacomb frescoes, engravings, cartoons, posters, illustrations, and graffiti.

Before photography or moving pictures, images had to represent movement at chosen fixed moments. A sequence of conventions therefore had to grow up, flourish, and die, and sometimes be resurrected to govern the choice. Visual perception of actual reality, trained by art, would undoubtedly have tended to gloss over all the intervening instants, those transitional movements of bodies and their clothes unrecorded by art, and rest with recognition on those corresponding to the ones made familiar by representation. And those moments, perceived also in the looks of others, must have been reflected in the inward perception of the self. Bodily movement—especially conscious movement but also unconscious action—must always have tended, as it still does, to conform to mental self-images; and these must have been at least partly conceived with the help of external images.

314

These images would have included the looks of other people—parents, friends, the ones one naturally imitated. But these people in turn would unconsciously wear clothes and use gestures in some style approximating to a very generalized "fashion plate." Movements of the head, behavior of the legs, stance, and so on, are not just individually determined but also inwardly conceived as conforming to a general image that everyone agrees is natural and acceptable to look at. This image cannot but include the look of clothes and an accepted sense of how one looks *in* them, even if the person pays very little conscious attention to his wardrobe. He will put his hands in his pockets, cross his legs, rest his arm on the back of a sofa—all "naturally," of course, but in imitation of an acceptable image of a man. A man in the sixteenth century would do it all differently, copying a different image with equally natural gestures in quite different styles. People inwardly model themselves on pictures and on other people, who also look like pictures because they are doing it, too.

It is obviously not for simple reasons that people copy the dress and manners of others whom they admire, but the surface mechanism is purely visual. Important connotations and associations may underlie the look, but the elements of it have no intrinsic meaning. Copying them is an aesthetic act. People choose what they will wear and how they will appear in it working, shopping, sitting on the bus, according to the way it may suggest certain pictures (living, moving, or still) that they feel they wish to resemble. Clothing is felt to be most desirable, and most often spoken of as "comfortable," when it permits this with no steady effort. What it creates, however, is not so much a good physical feeling as a satisfying self-image—gestures and all—needing no demanding adjustments.

During the last half century the media have produced ideal images for millions to follow; but even before, in centuries of rank and class distinction, the mechanism of visualizing the self based on external images must have taken place, and clothing must have been the means of making real the visualization, then as now. Elegant people wished to live up to the exquisitely conceived and executed versions of themselves painted by Van Eyck, Van Dyck, Ingres, Nicholas Hilliard, or John Singer Sargent. But simplified and reduced versions of ideal clothed images also existed in popular art, especially after the invention of printing. Through prints and engravings, people could become accustomed to an accepted, realistic formula for representing clothed persons, of all levels and for all purposes, and identify themselves with it. The purpose was indeed usually not to indicate the mode—although fashion plates per se have existed since the seventeenth century—but to illustrate, advertise, instruct, entertain, as pictures have al-

ways done. The human image, usually wearing clothes, of course, from any given period in the history of such art is recognizable as a reference to a common notion of visual reality and as a stylistic example of its date. A political caricature, for example, or a literary illustration (even with fanciful clothing) will show clothed figures with proportions generally accepted as natural, so as to convey its other, nonsartorial messages most convincingly. But such pictures will betray their date not just because of the general representational style but precisely because of the exact proportions and postures of the clothed bodies, their gestures, and the way of looking in their clothes.

In the early seventeenth century, for example, such figures share in the look of Rubens' fashionable satin-clad beauties even if they represent feather-clad American Indians; the look has nothing to do with the details of period costume. Spectators at that date, accustomed to a common standard of natural looks, would see only the differences between the images of the savage and the lady; from the perspective of history, we first see the similarities. The "savage" woman from South America, dressed in leaves, faithfully represented by a seventeenth-century Flemish artist working *in situ* and intending not to flatter and idealize but to record, will nevertheless show her kinship with a Rubens Venus (V.1, 2; see II.22). The workaday artist's eye, guiding and reflecting the common vision, creates this kinship—apparently unconsciously. For artists, however, the unconsciousness of the eye is a fatuous concept, and what one should observe rather is a conscious reference to the current convention for perceiving and rendering the "natural" figure.

Aside from such things as instructive illustration on the one hand and comic or inflammatory pamphlets on the other, it is chiefly inferior examples of fine art, in indifferent portraiture, genre painting, or religious art, that best reflect the currently acceptable look of the human figure. Great original artists invent what may look like both universal and highly specific original human images, acute instances of vision and insight; but one reason why lesser artists may have been more successful in their day is that they offered undisturbing and palatable versions of human beings, behaving and looking as their audience felt they ought to look in art, in order to reflect the efforts and aspirations and to support the visual beliefs of ordinary living people. Perhaps great artists contribute most to our later sense of the human looks that were generally acceptable in their time in their quick sketches—especially the ones done in preparation for large compositions.

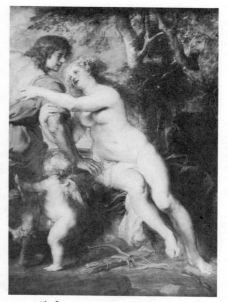

V. 1 (left) ALBERT ECKOUT
Brazilian Indian Woman, 1641
Compare with Rembrandt and Rubens

V. 2 (above) P. P. RUBENS (1577–
1640), *Venus and Adonis* (detail)

Such sketches are graphic shorthand, signatures of an artist's personal figure style, and they lack the self-conscious finality of either finished drawings or those intense sketches done from life with obvious personal attention to living individual models. They are *references* to figures, notes for poses and groupings, generalizations out of the mind's eye. A great artist's perfect mastery over his wrist makes such drawings more telling than similar ones by more awkward practitioners. They will record the bulk of skirts, the bend of necks, the crush of sleeves, and general proportions with total ease. Certain artists have in fact excelled in a suave mastery of this very medium; Constantin Guys, exalted by Baudelaire, is a prime example. Countless commercial illustrators in the twentieth century carry on in this tradition. They capture the current fashion in perceiving the dressed body better even than inspired fashion illustrators (V.3).

Fashion illustration has been a separate branch of art with its own professional status since the late eighteenth century; but it has also developed its own iconography, its own idiosyncratic standard of distortion and styl-

V. 3 C. GUYS (1802–1892)
Taking the Air, c. 1847

ization. Before that time, illustrators such as Wenzel Hollar and indeed the great Dürer and Holbein might do a series of clothed figures deliberately to show off the clothes; but such productions would share in the artist's general representational method. A fashion artist, like a cartoonist, develops his medium only in one direction, and with as much individual flavor as possible. The figures primarily demonstrate a precise mode of graphic stylization—even the clothes are secondary. The fashion artist wishes to produce an attractive image in a pictorial style recognized as conveying modishness in general—he does not create an accurate record of a garment or a social comment.

Other kinds of illustration, like the pictures done for Dickens' novels, will try to capture in the background the standard look of dressed people in ordinary life, so as to convey the main illustrative message more forcefully. Similarly, little drawings illustrating brochures and instruction manuals, for example, represent action with simplified clothed figures and aim to bear the general outlines and proportions of what is acceptable as

natural human appearance. The very distortions will have been designed to look *naturally* ideal, unlike those in fashion drawings. Their clothed looks will have been created to be perceived and appreciated glancingly and obliquely, and accepted as normal. Meanwhile the actual message of the picture may consist in showing the decor of a hotel lobby or the correct method of unfolding a lawn chair. The figures shown in groups in such pictures are usually all within a narrow range of age, height, weight, and general mode of clothing, and individuals are meant to have an average quality—this is their whole function. Figures in many kinds of pictures in the past also had this function if the main theme of the picture permitted them to. If, however, a crowded scene with many different kinds of action *was* the theme, the figures were usually more consciously varied and (as in the case of someone great, like Pieter Brueghel) might have transcendent human appeal; but spectators at a procession, figures in a topographical watercolor, all have the same deliberately neutral flavor. The chief aim is to arouse a pleasing, perhaps amusing, but not uncomfortable sense of identification in the viewer (V.4–6).

Certain successful artists have owed their fame to their skill in crystallizing the image people have of themselves—the visual image that corresponds to their most comfortable form of self-awareness. Such comfort may not be entirely based on self-esteem; it may be self-deprecation or self-mockery. But the most popular pictures of people—ordinary people—offer a combination of specific truth, recognizably reflected, and a high but apparently attainable ideal. The works of Frith make a perfect example in mid-nineteenth-century England and those of Norman Rockwell in mid-twentieth-century America.

The kind of self-image under discussion is not psychological, moral, or social but physical and sartorial, concerned with the look of the body in its garments. The political or social content of figure pictures is naturally often connected to this, and in certain sorts of satirical cartoons or society portraits, it may be expressly conveyed. But there are many pictures carrying serious social or religious messages by means of groupings of figures in which the proportions of the bodies and their clothing are not the point; in which, rather, these are deliberately generalized so as to keep the viewer undistracted from the theme itself. Artists of the stature of Goya or Michelangelo never do this, but many good artists often did (as many still do, mostly in commercial art). From such representations one may learn how bodies in their clothes not only were supposed to look, or were conceived by the privileged vision of artists, but undoubtedly how they actually did look to the eyes of the epoch. When the picture is set in a

V. 4 CLAESZ VISSCHER (1586-1652), *The Sailing Waggon on the Beach* (detail)
Illustration of an event in 1600, published 1612

V. 5 THOMAS ROWLANDSON (1756-1827), *View of Trinity and St. John's College*

V. 6 Topographical
engraving of New York
Hospital (detail)
Putnam's Magazine, 1851

time different from the artist's and the personnel are intended to be residents of, say, ancient Nineveh, wearing vaguely biblical garments remote from modern use, the clothed bodily proportions and gestures identify the actual date. The artist, aiming at the look of universal humanity in bodily style, presents to his audience the assumption that all bodies have always looked like current bodies. In 1860 Gustave Doré gave his nude damned souls the physical tailoring acceptable at his time, and quite different from the kind given by Rogier van der Weyden to his hell-bent wretches in 1440. In such a context this is not idealization but a general reference to current standards, a kind of reduction.

Conventions for pictorial looks and behavior have, of course, been traced, through art, independently of their meaning as reflections of current habit. The iconography of gesture and posture is of obvious importance in mythological and religious works; similarly, clothing for such icons—Jesus' suit, Diana's trappings—must offer familiar references to the eye so as to define their subjects. But a deliberately presented fashion plate has persisted in art, sometimes in the form of a portrait and often, during periods of their vogue, as a figure in a genre scene or in an allegory disguised as a genre scene. The image repeatedly occurs in art of a clothed body that is primarily intended to have no function other than to serve as an example of ideal dressed perfection. Such an image does not always or necessarily show the fashion currently considered perfect for the fashionable class, even if the picture is a portrait of a prince. It may, rather, purport to show the perfect sartorial style appropriate to a different group—or a different time, or a certain role. The perfection will be what the artist and his audience agree on. Clothing being worn, however, is the subject of such pictures.

Chardin, Fragonard, and other eighteenth-century French painters did a number of these, with titles like *The Serving-Maid* (V.7): Liotard's *La Belle Chocolatière* is one of the most famous. A number of English artists of the nineteenth century did similar pictures of perfectly clad female servants. Among straightforward fashion plates reflecting top-level perfection would be many of Terborch's nameless ladies; among oblique fashion plates would be Gainsborough's *Blue Boy* or the portrait of Mme. de Staël as Corinne. Actually, these might better be called costume plates than fashion plates, since Mme. de Staël is wearing the dress out of her own story book, and the Gainsborough boy is in "Vandyke" costume.

This form of vaguely cavalier fancy dress was adopted in England in the eighteenth century for portraits, a kind of homage to the Flemish artist who had done so much to make the English see themselves as elegant in

V. 7 ANDRÉ BOUYS (1656–1740), *La Récureuse*

the previous century (V.8, 9). The same sort of suit is worn by Watteau's dreamy lovers, also as a reference to past modes, this time with a more specific theatrical flavor. It is a pictorial fashion, a perfect visual generalization of the correct romantic attitude to take about old-time clothes. The posture and bodily shape remain modern, and the fashionably old-fashioned dress is modified to suit them. Pictures such as *The Blue Boy* and Watteau's *Le Mezzetin* or *Embarcation for Cythera* provide models for the Romantic-comic stage, fashion plates for ideal fancy dress (V.10).

Paintings that are fashion plates for the clothes of peasants, servants, and beggars have been a feature of romanticizing art since Baroque times. Perfectly idealized servant dress and generalized peasant and farmer costume or tastefully dirty rags have been worn in fashionable paintings ever since a theatrical or romantic view of low life became a proper subject for art (see III.24; VI.34). Italian and Spanish seventeenth-century painters after Caravaggio seem to have started this. Later, Le Nain's cottagers, Velásquez' laborers, and Murillo's urchins are all forerunners of Greuze's

V. 8 (left) THOMAS GAINSBOROUGH (1727-1788), *The Blue Boy*

V. 9 (right) A. DEVIS (1711-87), *James Brydges, 3d Duke of Chandos, in Fancy Dress*

V. 10 J.-A. WATTEAU (1684-1721)
Le Mezzetin

pretty peasants and Hans Thoma's farm boys. This recurrently stylized and emphatic vision of lower-class clothing, just like the one for old-fashioned clothing, has always lent itself smoothly to "realistic" stage convention, and it shows up eventually in the movies. It is a very different way of looking at the dress of the poor from that of Piero della Francesca, Hieronymus Bosch, Goya, or Van Gogh. These and many other artists hold strictly to the poorness of poor clothes; their grace or beauty may be only a property of the picture, not its subject. These are never fashion plates.

The biblical fashion plate is naturally one of the most common, especially when religious art is self-conscious or propagandist. Counter-Reformation paintings in Italy or Nazarene paintings in Germany very pointedly demonstrate the rules for current good manners in holy garb, and modern plaster saints have taken the mode from there, as do the costume designers for modern cinematic biblical epics (see I.62).

Classical fashion plates have perhaps been the most common of all in Western art since the Italian Renaissance, when attempts at indicating the actual clothes of antiquity were first made to harmonize with current vestimentary taste. What the well-dressed nymph is now wearing has been the subject of many pictures ever since and, as always, a steady source of inspiration for the stage, except during the time when stage nymphs (and deities) followed their own special stage fashion.

William Blake, who was the creator of an other-worldly race of humans in a distinctive figure style, produced some female figures indistinguishable from actual fashion plates, gestures and all. This similarity was possible partly because fashion plates, still in their infancy in the late eighteenth century, were usually rendered in a fairly common illustrative style rather than in the well-defined distortions of a special genre, as they later came to be. Blake's *Potiphar's wife* might have come out of a page of Heideloff's *Gallery of Fashion* for 1802 (V.11–14). Each was intended to give the viewer a sense of the normal female body in a set of special circumstances. The dressed body in the fashion plate and the one in the biblical illustration obviously have different meanings, but, coming from different directions, they manage to provide the coordinates for a clear, contemporary image of ordinary clothed female looks. If such different pictures make women look so similar, both must be invoking some common vision, some way all women were seen and saw themselves. Clearly, at this date, all women's clothes clung over breasts that were shallow but perfect and well-separated hemispheres. Hips were narrow, and arms were

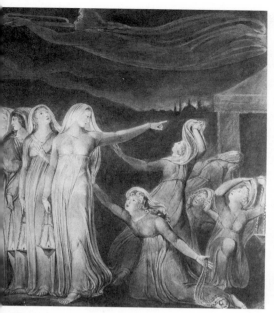

WILLIAM BLAKE (1757–1827)
Wise and Foolish Virgins

WILLIAM BLAKE (1757–1827)
and Potiphar's Wife, c. 1800–10

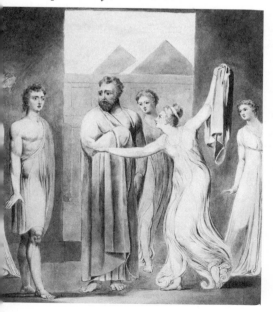

V. 12 Fashion plate of ladies'
morning wear, 1801

V. 14 Fashion plate of ladies'
evening dresses, 1803

very long and mobile under tight sleeves with high armholes, or bare. It may even be argued that, at the time, actual women with short arms, wide hips, and small, pointed breasts were less often noticed and less clearly seen by the collective eye.

This visual process seems to have been continuously in effect in human perception, among people who enjoy making and caring about realistic representations of themselves. Current fashions in the way bodies look wearing garments were (and are) reflected in art because they were selected and seized on as the general truth by contemporary perception. Artists then recorded what both they and their audience agreed was the plain evidence of the senses. Whatever differed from this truth—perhaps to become true at a later date—was simply not recorded, either by artists' hands or by eyes themselves. The exceptions in art were the works of original geniuses at any epoch who, like Michelangelo or even Burne-Jones, could personally invent a figure style that might be heterodox and revolutionary at its time but could change the body consciousness of succeeding generations. Another kind of original, such as Toulouse-Lautrec or Eakins, deliberately chose to copy physical examples from nature that went against common visual expectations—fat women when thin seemed most normal, for example, or thin ones when plumpness seemed natural. Such works of art, which dwelt on neglected aspects of visual truth, had to be accepted (if at all) as revelations. In due course some were hailed as great, others seen as revolting; but apart from such fresh personal visions, most successful serious artists tended to represent human figures as instantly believable—to make them look comfortably, not uncomfortably, "real." This would be true even if the figure composition were heavily indebted to the poses and clothes of the well-known Classical statues and the subject totally mythological. It would be necessary for the success of the picture that the people in it look as members of its contemporary audience also felt *themselves* to look—even if they were temporarily asked to believe that they were observing scenes of myth or history. Ladies of the Second Empire in France, looking at paintings by Gérôme, could observe with recognition and delight that shoulders sloped in ancient Rome just as they did in modern Paris.

When a successful representative artist made images of contemporary life, he offered a reality that was both a model and a copy—a visual convention obeyed in art and life. Well-to-do English people in 1855 saw themselves with satisfaction in Frith's *Derby Day* and *Ramsgate Sands,* and when they dressed and promenaded, they believed themselves (perhaps only semiconsciously) to resemble the people in such pictures. Those who

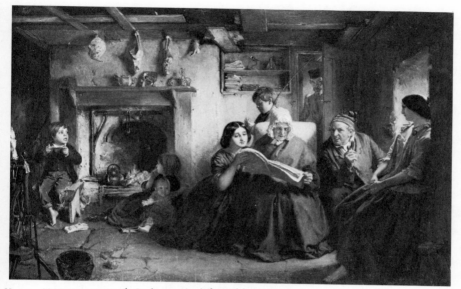

V. 15 THOMAS FAED (1826–1900), *The Soldier's Return*

looked at them walking believed the same thing; and so it became actually true that all women did have smooth, shining hair, long, large eyes, plump cheeks, and a swelling, uniform fullness above the waist. Not only elegant ladies but apparently field laborers and fishermen's wives had them, too (V.15); contemporary pictures of both the urban and rustic poor, whether smooth salon paintings or "accurate" illustrative engravings (for Mayhew's works, for example), demonstrate this kind of selective vision.

When one knows for certain that the artist's intention is specifically *not* to idealize, and yet finds that these physical and sartorial "facts" are the same as those in patently idealized works, one may conclude that they represent not the ideal but the truth for general perception. People believed they looked like the pictures and that their clothes did, too. Now we have the camera and the movie camera to show us the visual facts about ourselves, and changing modes in camera images manifest the same selective eye at work.

The beginnings of photography and cinematography seemed to put an end to the possibility of illusion or edited vision. It seemed that pictures of the rich in their finery, the famous in their distinction, and the beautiful in their nudity were going to be transmuted by photography into an undreamt-of condition of truthfulness, as in "From today

327

painting is dead" and, similarly, "The camera does not lie." Of course, the most powerfully developing impulse of photography soon became the technique of "lying" with the camera—that is, the will to transform it into a creative tool. Once the technical miracle of fixing images on a plate the way the eye does had lost its initial novelty, photography joined the other graphic arts as a means of communication just as flexible and just as subject to stylistic mutation as any other past attempt at two-dimensional representation of three-dimensional reality. In its first half century, photography was in part looked on as a servant of art very like the eye itself—more tractable, if less versatile.

Nineteenth-century artists made constant use of photographs, often treating them as crude or unfinished paintings. Consequently, for general perception, a photograph of a person had more beauty, more complete visual authority, the more it approached the look of a painting—rather than the other way around, as later seemed to be the case. Portrait photographs and "artistic" photographs were arranged to resemble paintings, and paintings were done from photographs. These were often by such brilliant artists as Degas and Manet, who used the camera as if it were an assistant pair of eyes, a sort of apprentice, something that would help do the unmitigated perceiving, the groundwork in preparation for the artist's true transforming view.

Camera vision, however, eventually became the ultimate reference for everyone's sense of visual truth. Even very fashionable people in early candid or unposed pictures from the late 1850s look frumpy, in comparison to carefully edited and touched-up portrait photographs of the same date. Ladies sitting on lawns in crinoline in 1868 or in huge hats and trains in 1898 have a curious lack of linear clarity. Their clothes wrinkle around the body, take up too much room, and spread awkwardly. They have quite a different look from the crisp finesse either of fashion plates, of posed photographs, or of Ingres' or Sargent's portraits (V.16, 17). These were still the *real truth*.

On the other hand, ever since photography acquired its total graphic authority, it is the *painted* portraits of people in modern elegant clothing that have become frumpy-looking, and only photographs are really able to reveal the true essence of mid-twentieth-century chic—especially candid photographs. Pictures of current leaders of fashionable society caught off-guard at parties reveal how elegant female dress has become aesthetically simplified, totally visible and comprehensible in one instant of the camera's flash. Fashion photography has come to ape the look of snapshots, to capture the instantaneity of modern visual taste. Clothes are designed to

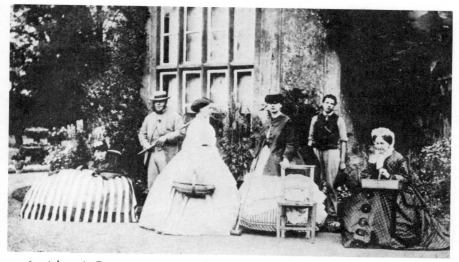

v. 16 (above) Group at a country house, photograph, c. 1862

v. 17 (below) Balloon race at Ranelagh, photograph, July 7, 1906

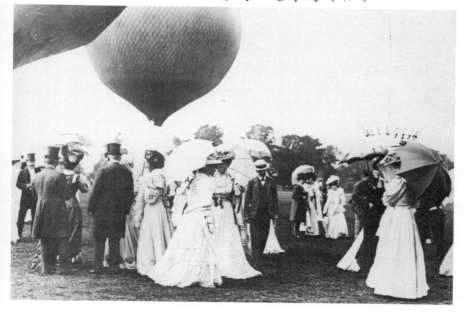

be seen by flashbulb. The first inkling of this phenomenon appears in the work of the young Lartigue and in his subjects.

By the second decade of this century camera vision had become assimilated. It had indeed been consistently bootlegged into visual conscious-

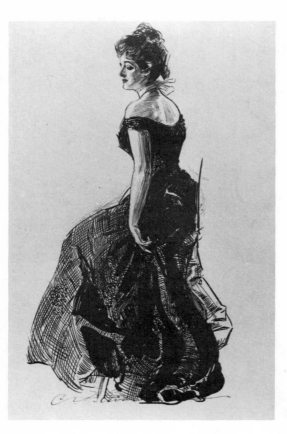

V. 18 CHARLES DANA GIBSON
Drawing, c. 1900

ness by many illustrators who published pen-and-ink copies of photographs without acknowledging their source. Popular graphic art, the mirror of common life, had been thus secretly giving way to camera vision. Formal portraiture and salon painting, besides making use of it, were, of course, simultaneously being exposed to its influence. But for the representation of ideal chic caught unawares, fictions by Charles Dana Gibson were still preferable to the uncertain findings of any camera as the century came to an end. The actual look of clothing while it was in wear was still difficult to keep in perfect order—too difficult to be frozen gracefully by the camera eye under circumstances of chance (V.18).

By about 1912, fashion and photography were beginning to approach each other and combine their interests, as they have done ever since. Lartigue was a vehicle of this impulse then; his unposed pictures of elegant women walking in the park or street show that such moments brought their somewhat bizarre toilettes to a point of visual perfection not possi-

ble in a painter's studio. No painted portraits of elegant women in the clothes of 1914 make them look so perfectly dressed as Lartigue's photographs do. For the first time he captured with a camera the blur of chic—the dash, the vivid, abstract shapes, a face, body, and clothes all perceived as a mysterious, not quite personally identifiable mobile unit. This idealizing perception, working through the camera, was able to elevate the current fashion to the level it aspired to—as the brush of Ingres or Van Dyck had once done. Lartigue's photographs demonstrated not how to study elegance, moreover, as portraits used to do, but how to see it at a glance (V.19).

Fashion drawing changed at this time, too, in the same direction indicated by Lartigue's avant-garde images. Large shapes with clear outlines, quickly grasped visually but not instantly recognizable as human, became the vogue in fashion art. For twenty decades fashion had been ideally represented in sequences of carefully detailed engraving, often accompanied in journals by lengthy description. Clothing was detailed to match the illustrative style: garments had innumerable areas and sections needing em-

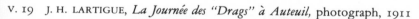

V. 19 J. H. LARTIGUE, *La Journée des "Drags" à Auteuil,* photograph, 1911

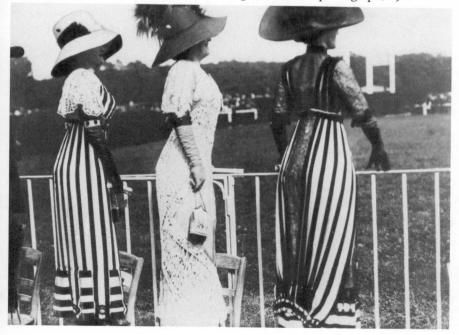

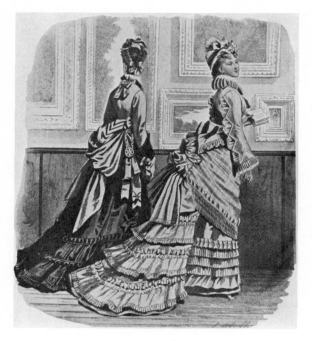

bellishment and elaboration (V.20). The new twentieth-century mode in
fashion copy was suggestive of Imagist poetical prose, as the graphic style
(*post* but probably not *propter* Lartigue) stressed exaggerations of propor-
tion and dashing technique. Thus, at least for fashion, the camera had al-
ready begun to create a mode of abstract art on its own terms; popular
graphics, also for fashion, copied the camera method. The quick im-
pression, the captured instant, was the new test of elegance.

By 1917 women's garments had indeed lost not only their former volu-
minous extensiveness but their quality of being made of many separate
parts, each individually designed and each needing separate, slow appre-
ciation. The new total look, instantaneously perceived, needed unity and
compactness of design. After the First World War women's clothes began
to allow for potential movement and to be clear in shape. They came to be
designed to be seen at their best either in an instant of walking or danc-
ing, conversing or gesturing, or posed as if pausing. Large-scale static elab-
orations of costume, impossible to comprehend except on slow and close
inspection, have since become confined to ceremonial clothing such as
wedding dresses (formally photographed, of course) or to historical cos-
tumes for movies or the opera. Nowadays, costume may be complex when
eyes may dwell on the same static figure during a twenty-minute cere-

mony, or an aria, or a romantic close-up scene. But snapshots of such elaborate garments look bulky and blurry, as candid photos from either 1860 or 1960 attest.

After the public eye had adjusted to camera vision, spontaneity became a new ideal for dress design. By 1914 the gowns for the beauties immortalized in fashionable portraits by Boldini or Helleu with indefinite slapdash strokes of paint or ink were actually being made to look swagged or pinned as if equally haphazardly (V.21). Hair was carefully piled up but as if hastily. Rendering this kind of sloppiness beautiful was quite difficult for artists, even expert ones, and even harder for amateur photographers. Snapshots from this date show a lamentable bunchiness and uneasiness in clothes, the legacy of earlier days, and still not quite firm in the awareness of the camera's compelling glance (V.22). Spontaneity of look but not yet instantaneity of image had been achieved. But Lartigue's productions demonstrate that photography had graduated from the task of slowly re-

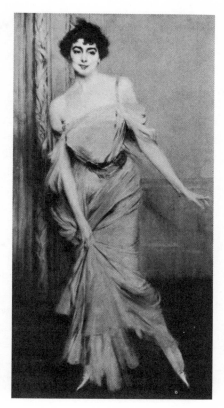

V. 21 GIOVANNI BOLDINI (1845–1931)
Mme. Charles Max

V. 22 Ascot, 1913

cording the complex perfections either of nature or of sartorial skill, as the
eye might do at leisure. It was creating abstract perfections on its own,
even out of clothed female figures; and the look of these was changing,
too, to match the new kind of idealizing eye.

The crisp or sinuous flat patterns of the new illustrative styles—Art
Nouveau, followed by Art Deco—also appeared in the theatrical creations
of Bakst and flowered in the famous dress designs of Paul Poiret. Al-
though Poiret took a great deal of credit for the fashion revolution under
way at his time, the public was largely made aware of it only through the
modishly stylized drawings of Lepape, Iribe, and eventually Dufy, artists
whom Poiret hired to realize his ideas (V.23). The new photography and
the new mode in decorative art were in fact the newly wedded parents of
the new fashions. The clothes Poiret offered looked best either rendered in
the flat areas of color used by his artists or photographed in the abstract
manner of Lartigue. They could be perceived as elegant only by women
who were able to see themselves as visual abstractions. Ladies who still
saw themselves as posed daguerreotypes, detailed engravings, or sketchily

V. 23 GEORGES LEPAPE
Fashion drawing from *Les Choses de Paul Poiret,* 1911

drawn Gibson girls could not feel comfortable in wired pagoda-shaped tunics made of vivid orange silk; people who had absorbed Matisse and Erté, and managed to take them personally, could do so with ease. The fashionable women of more recent days have clearly had no trouble either with flashbulb speed or abstract shape.

For women, strongly stylized coiffures and masklike makeup also required a new kind of visual imagination about the physical self. In Europe since antiquity, cosmetics were traditionally used to improve on nature: makeup was supposed to intend to deceive, to make pink cheeks pinker, lips redder than they naturally were. The results were often in fact quite extreme and abstract, and they never fooled anyone; but writers who attacked cosmetics loved to point this out as if it were a failure of the original purpose. After 1920, however, modern makeup confessed itself to be the kind of paint modern artists were using, not for creating artificial reality but for design. Abstract art and camera vision aided in this new perception of cosmetics as a branch of decorative graphic art (V.24). Red lips, reproduced on film as black, suitably set off by white teeth, with

V. 24 GEORGES LEPAPE
Le Miroir Rouge, fashion
drawing, 1919

matching black outlines and embellishments for eyes, showed how faces, in connection with stylized bodies, could be stylized masks. In some past fashions hair had been treated as if it were fabric—festooned, ruffled, padded. At this point it became more like metal or plastic, to be cut or molded.

The rise of abstract art and decorative design permitted the citizens of Western Europe to accustom their eyes to visions of themselves as shapes. These were naturally not total visions; but they were new possible versions of the dressed self that were steadily seen in popular art and more and more familiar in prestigious painting and sculpture. In many Eastern countries, visual sensibility had been accustomed for centuries to the idea of human looks reduced and abstracted into patterns, as if they were vases or fans. This abstraction occurred not only in art but in direct experience by means of the clothing itself. Figures in Japanese prints show how a robed body may apparently lack all human members or proportions and appear as an arbitrary form. But even an antique Japanese kimono itself, geometrical in shape and embellished from one side to the other with a huge, nonrepeating sequence of plants or fish, for example, takes no ac-

count whatever of the standard equipment of the human body. The robe has its own complete artistic autonomy, as if it were a painted screen; the wearer would have to submit his banal torso, arms, and legs to the superior authority of such a garment (V.25).

Western dress requires the body to give clothes meaning, and Western art had always accommodated itself to this need until the possibilities of abstract vision made themselves available to Western eyes. After that, clothes could aim at an ideal shape of their own, to which a body was truly subordinate—a box, a cylinder, a pyramid—and they could be shown to achieve it in a painting or a fashion illustration (V.26). Actual bodily shapes, always apt for distortion, now had the further task of turning themselves into detached patterns in their own mind's eye. This is harder discipline than corseting and padding. Fashion photography, now advancing in the hands of masters such as Steichen and De Meyer, was able to aid the trend and offer black-and-white compositions of compelling authority—all the stronger because the camera now officially represented truth and such creations could not be considered distorted in the

v. 25 Japanese kimono
with pattern of stream
and wild iris

337

v. 26 (left) JANE RÉGNY, Fashion plate, from *Très Parisien* (Paris), No. I (1926)
v. 27 (right) EDWARD STEICHEN (1819–1972), Fashion photograph, *Vogue,* 1930

same way a drawing could. The ideal simplified shape of a sleek body was now not only indicated by the trend of abstract graphic design but confirmed on film. Since that time, women have had to be slender (V.27).

T here are obvious connections between the new slenderness of body and the entry of women into public life and the professions, and the rise of sports. An active-looking body became requisite for elegance. But utility, which seems as if it ought to have been the reason for the new reduced style in female twentieth-century looks, was not well served by the clothes. Corsets, famous for being discarded, were in fact simply remodeled;

pressure was applied by tough elastic material rather than wholly by steel and canvas. Shoes had higher heels than ever, sheer flesh-colored stockings demanded care and replenishment, hats were still socially necessary and obviously still ornamental and troublesome, fabrics were still fragile. Except for a very brief period in the 1920s, women's dresses contrived to be complex in cut and construction. Old sartorial difficulties—trains and whalebone—were exchanged for new ones: the psychologically taxing problems of looking comfortable and dressing simply while being rather exposed. Bad legs or a bad figure had no hiding place, and the need for a good one was never more obvious.

Comfort, which in clothing is a mental rather than a physical condition, was no more likely to be a matter of course in skimpy clothes than in voluminous ones. The utility of short skirts, for example, is relative. Legs may in fact move quite easily under long skirts if their free action may be allowed to show through and the skirt is wide enough. The wide-striding ladies on Greek vases show how long drapery over the legs permits any kind of movement if the fabric is permitted to cling or slide. The long dresses worn by young women in the 1960s did not hamper them from boarding buses; in the nineteenth century, however, skirts were not only long but modest (which modern long dresses have no stake in being), and they were not supposed to ride up or catch between the legs when their wearers boarded the bus. The Victorian skirt was slowly shortened because its kind of modesty, not its actual length, prohibited action that exposed the legs. The change, like most others, was visual and visually symbolic rather than practical, and skirts had to be seen to rise before they could fall again in a new form.

After the First World War women's legs were supposed to show, to complete the new stripped format of female looks, which included a new look of fashionable immodesty. Decades later, when the point had been made visually, women could wear long skirts again for pleasure, for ease of movement in the newest mode, or to hide their possibly less-than-perfect legs. And, of course, by then, wearing them was optional.

Exposing a woman's legs lays stress on her means of locomotion. In the twentieth century the movement of the whole female body itself, not just that of its garments—its skirt or shawl or train or ruffles—became visually desirable. To judge from art, for centuries women's important bodily gestures had consisted of head and neck movements, some body bending, and a variety of action for the arms. Ever since antiquity their clothes did a lot of their moving for them. Women were rarely seen by artists as awkwardly climbing or actively running or even bracing themselves with

legs apart, as modern fashion models are. In images of workaday life, they might be seen to sweep a floor, carry a bale of hay or a heavy vessel, and lean over to glean in a field or tend a child. In leisured life their hands and arms might employ themselves with details of the costume—to support a shawl or a fold of skirt, to carry a hat—or with discreet gestures. But vigorous action of the legs occurs only in mythological subjects, and (except, as always, in the works of great geniuses) it is very much conventionalized.

Woman's work—domestic, agricultural, or, later, industrial—was often recognized in art to impose backbreaking strain; but it was not seen to make demands on the locomotive functions of the legs and feet. Neither was woman's pleasure. It took modern fashionable amusements to make the public aware of women's legs, and it took photography to catch them in action—to show, as in the famous case of the galloping horse, how they really work. Legs became part of the total visual composition of the female body in its clothes, not just in Classical draperies or in the nude; and their action, not just their shape, similarly became an accustomed fact of visual life (V.28, 29).

Women of leisure had always worn long skirts when taking part in sports, including tennis, which required a good deal of running. But the look of legs in motion did not become interesting or problematic until the widespread use of the bicycle at the end of the nineteenth century. Only then did divided skirts and knickerbockers seem necessary, in order to articulate the legs (although cycling is perfectly easy in skirts); presumably, the look of legs pumping *under* skirts was even less acceptable to modesty than the dreaded trouser. At about the same time, fashionable women began to lift their trained skirts into a bunch with one hand while walking in the street, instead of letting them drag as they had always done before. Skirts, though still stiff and long, were now narrow enough for this; and the modish gesture displayed both feet and ankles in motion, as if by chance (V.30). It was a herald of the new immodesty, a coy lifting of skirts designed to drag, and likewise a herald of the new look of action required for female legs.

It was naturally the movies that confirmed women's visible locomotion. We have already suggested that in a period when people consider themselves and dress themselves as static images, snapshots that freeze action (proving that movement is continuous, not a series of poses) look awkward and ugly until the public learns to dress and move to match them. By 1910 people had become accustomed to the possibility of being frozen in snapshots. Manners were easing, spontaneous clothes and gestures were

V. 28 FRIEDRICH SEIDENSTÜCKER
Untitled photograph, 1930

V. 29 Untitled photograph,
c. 1927

modish, not just for women but for everyone. Life was speeded up by the
motorcar, the dance craze began. Then *moving* pictures became current, in
which the whole phrasing of the new fashion, in clothes and all kinds of
bodily action, could be stylized. Silent film naturally tended toward styl-
ization of gesture, even in realistic drama; and women's clothing worn in
the silent movies corresponded not only to such stylized behavior but also
to the new abstract and reduced mode in dress. Enduring conventions for
the dress of movie characters were established that are still in effect. These
were different from those of the theater; they had to depend on black-
and-white cinematography, and they had to be easily read without color
and in *silent* motion. "Realistic" expression in dress, as well as in emotion,
was reduced to recognizable formulas.

Certain of the early-movie ways of suggesting characterization through
dress have passed completely into the general public consciousness of
clothing as if they were natural laws. A trench coat and a sheathlike, glit-
tering evening dress have continuing visual resonance; they carry sugges-
tions that have less to do with their intrinsic looks than with their movie

V. 30 JEAN BÉRAUD
(1849?–1935)
Une Parisienne, Place de la Concorde, c. 1895

meaning. Screen old ladies in modest circumstances used to wear, and often still wear, a lace collar fastened with a brooch. A certain type of girl wore a beret, another type a hair ribbon, another type marabou—and they were always distinct from one another. These connotations of type carried over into real life, where they came to seem like spontaneous habits, just as cinematic styles of expressing feeling were also to do.

The stylization of everyday dress in film was, and still is, most obvious in fashionable clothes. Gloria Swanson's costumes for her early films were ordered from Paris by De Mille specifically to be exaggerations, not true examples, of the *haute couture.* Elizabeth Taylor's clothes in *Butterfield 8* were similarly exaggerated and not accurately modish. The same has been true in all films of high life, old and new, and the same rules of exaggeration applied, and often still apply, to the movie dress of poverty. It has much in common with Murillo's picturesque beggars.

As the sense of luxury began more and more to depend on the confections of the movie imagination, color drained out of elegance, and was

replaced by the whole black-and-white spectrum. White gold and platinum came into vogue for jewelry and for hair; draped lamé and sequined satin offered rivulets of light to the eye as they flowed and slithered over the shifting flanks and thighs of Garbo, Dietrich, Harlow, and Lombard (V.31, 32). These visions were built on the newly powerful sensuality of colorless texture in motion in which American dreams were now being acted out. For women's clothes, sequins, marabou, white net, and black lace developed a fresh intensity of sexual meaning in the world of colorless fantasy. Innocence, energy, languor, and menace were transmitted through the behavior, movement, and visual feel of fabrics instead of through color; and this condensed range of feminine clothing signals, de-

v. 31 (left) Ina Claire in fur and sequins, fashion photographs, *Vogue,* December 22, 1930. Texture and glitter without color

v. 32 (right) *Lustrous ciré satin,* fashion photograph, *Vogue,* 1930 Allure through shine alone

pendent largely on surface motion, lent itself very well to the new cool, self-sufficient female image.

Black-and-white vision required a certain crispness of shape, texture, and grooming, while fashion in gesture and posture became freer and more expressive. Desirable looks in cosmetics and hair developed a clarity of line and sharpness of contrast as those in clothing did the same. The formulas in movie clothes affected fashion and the whole perception of fashion; when the public adopted details of behavior and clothing from movie stars, they were not actually copying those individuals but referring to their stylistic characteristics and identifying with their qualities of natural behavior. Messages could be exchanged through clothing, based on common cinematic experience. The same became true of gestures—ways of smoking, crossing the legs, shrugging the shoulders, and kissing. Both men and women began to dress and behave and respond to each other as they saw the people in the movies dressing and behaving, who were in turn purporting to represent reality.

Conventional dress and postures representing real life in still art had allowed the transitional stages to be visually ignored. Now convention governed movement, and clothes had to fall in line. The influence of movie clothing on fashion has never been a matter of drab and dowdy people copying the clothes first worn by glamorous movie stars. Movie stars, rather, have always worn, in stylized ways of moving, stylized versions of what has already been established as fashion or custom. They have been "fashion plates" only in that they have exemplified an existing ideal, not set a new one. The copying done by audiences, with the help of clothing manufacturers and merchandisers, has taken the form of references or allusions to those crystallized images. And so again artistic style, when it is the vessel for the acceptable look of reality, becomes natural style.

This is not a process in which contemporary realistic theatrical costume can participate. Since the ascendancy of movies, theater has become increasingly more self-aware as deliberate show business. Modern realism in stage clothing has been merely one of the acceptable modes of costuming a drama. The effects have usually been swallowed whole and not remarked on by audiences, for whom the dramatic action and the actor's clothing are not visually separable. Drama on the stage is confined to one span of time and one place at a time; and the costumes participate in an agreement between actors and audience that visual realism is now irrelevant, though possible, to modern drama. Sets show this concept much more obviously.

Before photojournalism, fashionable lightweight plays were arenas for the display of examples of *haute couture,* worn by famous actresses; and people went to such plays to see clothes, not costumes. Now, famous actresses do not need to wear modish clothes on stage, only in public places where they can be photographed. People may now go to the movies to see clothes, but whatever movie actors and actresses wear on the screen—"realistic," luxurious, or historical—is confirmed in the distinctive movie tradition of stylized reality.

The enormous plurality of dress messages in our time has been made possible not only by the expansion and diversity of the clothing business but also by the availability of so much visual information, both accumulated and newly generated. The connotative power of dress has never been in greater play, because so many different kinds of dress messages now have meaning. Pictorial advertising of clothing alone has made only a small contribution to this effect—such advertising is consciously offered and received, and may be consciously resisted. But the layering of old and new movies in theaters and on television, along with old and new "realistic" television dramas, has expanded consciousness of what the details of clothing can convey. The rate of change in fashion has not actually increased; what has increased is the number of fashions, all of them individually subject to change. Such modifications tend to occur at about the same rate (or range of rates) at which fashion has always altered.

The tyranny of fashion itself has in fact never been stronger than in this period of visual pluralism, although it is now customary to think of the 1970s as an age of freedom from the domination of fashion designers and the fashion business. This particular alleged freedom has indeed followed a period devoted to a different kind of sartorial emancipation, a rejection of social conventions in dress, sparked by the counterculture movement. It is therefore now supposed to be the case that people may dress with a lack of regard not only for the greedy and wicked businessmen of Seventh Avenue but also for the would-be guardians of convention, suitability, and propriety in dress according to age, sex, or occasion. But it is still never possible to "wear anything." The question now is not how to dress suitably for a given event according to certain social rules or how to be in fashion but, rather, what fashion to be in, how to dress so as to indicate that one has the correct perspective on its particular rules.

The test is much more exacting when every tiny choice of texture, color, and shape has a connotation. All methods and degrees of expressing formality and casualness, and all varieties of sexual emphasis, make oblique references to the groups, subgroups, current ideologies, movies,

movements, historical periods, or individuals with which they are associated; everything makes reference to an image. Contemporary eyes are overexposed and overtrained by such images, and everyone is imprisoned in his sartorial choices under their instantaneously classifying scrutiny. Acuity of perception about clothes has sharpened under the stimulation of multiple choice. Distinctions are much finer but just as important as the old large ones, perhaps more so.

Changes that occur in certain fashions affect all the others, so that the meaning of particular garments may change while they themselves remain unchanged. A conservative person might wish to adopt a given element of dress in a conservative version, in order to remain in a satisfying laggard relation to avant-garde versions of the same fashion. But changes will be necessary in order to keep the distance steady as the avant-garde moves ahead—or else the avant-garde may come full circle and overtake from behind, putting the conservative dresser into an uncomfortable condition of modishness.

In simpler days, as literature suggests, disguise was rather easy. When sex, age, and rank were all instantly conveyed through clothes, a fine lady could presumably dress as a barge captain and be taken for a barge captain. One important reason for this was that eyes were as yet untrained by photography, cinematography, and the revelations offered by electric light. It was evidently less easy to recognize distinctions of texture and line among details of gesture and posture. Perhaps people simply saw less clearly before cinematic close-ups and snapshot photography taught everyone to observe each other with sharper eyes than centuries of drawing, painting, and engraving had done. Clothing itself took up more space. It may have needed more study to appreciate its exact design and trim but less time to perceive its overall meaning.

Modern clothes, like facial expressions and body movements, are more exposed and revelatory as they have developed more complex meanings. The modern police who dressed as hippies to entrap drug users and homosexuals were not always very convincing, whereas Conan Doyle's readers had no difficulty believing that Sherlock Holmes could pass himself off as an authentic burglar among burglars. A number of women in fact and fiction are supposed to have served in various armies with their sex undetected. The uniform evidently announced their sex to everyone's satisfaction, as did the boy's clothes in which women were also supposed to have traveled without discovery. In ancient days kings and queens could go slumming undetected, but the modern photographic familiarity of any leader's looks makes this much harder today. And when neither sexual

nor class distinction is well defined by dress, the less well-defined things about clothes and bodies that do distinguish the sexes and classes are automatically more carefully scrutinized.

Classes are now better called groups, and their identifying marks of dress are usually a matter of wide choice. Complete disguise is now perhaps a difficult matter, requiring special talent and special equipment; but dressing to make ambiguous one's exact identity is a very common game. In America the vast clothing business makes possible a great visible diversity of the same kind of garment in each price range: not only is it possible to buy a ninety-nine-cent T-shirt and a twenty-dollar T-shirt that resemble each other closely; it is also possible to buy twenty different pullover short-sleeved shirts, each for five dollars, all of them totally unlike one another in fabric, cut, embellishment, and connotative associations. Identifying oneself through dress has therefore become a matter of appearing as a member of a group that wears certain things and not others in the same price range. Income level, occupation, and background are not so easily detected, especially if any desire exists to keep them undetectable. But taste in T-shirts on any economic level may reveal the other associations one wishes to make or makes unconsciously: suggestions of regional origin, social style, sexual and moral outlook, attitudes toward work, money, leisure, and pleasure, and, above all, the other people one's clothes associate one with.

Most people do care very deeply about the way their clothes look, although they may not care about fashion, do not spend much time shopping, or do not have large wardrobes or much money and leisure. Except in uniform, people must choose their clothes, even if the choice is perpetually and even unthinkingly to reject most of what is available. It is obviously very exacting and almost impossible to look unique in an age of mass production, no matter how diverse the goods. Therefore all choices of clothing, particularly the quick and simple ones, involve allying oneself in the eyes of spectators with others who have made the same kind of choice, usually for the same reason.

If you always buy Brooks Brothers button-down shirts whenever you do buy shirts, if your income permits it, you will be associated with everyone else who does the same, whether that is what you intend or not. Brooks Brothers, of course, makes excellent shirts; but although you may claim this as the motive, the quality of the shirts is actually secondary. Equally beautiful shirts may be found elsewhere, but it takes vigilance, time, energy, and imagination to shop for them and the willingness to take risks. Going once a year to Brooks Brothers usually indicates that in

order to keep shopping easy and safe you associate yourself with other safe, conservative Brooks Brothers shirt wearers and, further, that you do not wish to avoid being associated with them. You are therefore following one kind of fashion very scrupulously, although you may never look at an ad and may think you are immune to the madness of the mode. Brooks Brothers will produce a limited range to choose from, and you will always gladly be clad within those limits. It is possible, however, to admire the cut and quality of Brooks Brothers shirts and still never go near the place, out of fear of the very same associations of safety, conservatism, and exclusivity. It is very common to wish to wear certain things for their intrinsic virtues, their excellence of quality, or their visual and tactile beauty, but to abjure them. They might be physically flattering, but if they are socially damning, they are forbidden.

In America men have been very sensitive for a long time to the associations attached to small details of clothing, because for a century their choices have been limited and subtle. Women, on the other hand, have been supposed to follow fashion, do a lot of shopping, and love finery. But now that finery is out of fashion for so many women, they often show a duller awareness than men of the variety of meaning in nonfinery. When they wear frayed blue jeans and a T-shirt, for example, they are perhaps less conscious that they don't simply look comfortable and casual; primarily, they look like all the other people of their sex and age who wear the same garments, and they only incidentally look casual. For young girls that is, of course, exactly the desired effect. Grown women, however, have long understood the associative variations in finery itself, as well as the technique of staying in control of one's chosen position between what is avant-garde and what is passé. Hemlines for decades were one great test of this technique.

To justify and explain their adoption of various modes of nonfashion, women have often invoked the concept of comfort. This is analogous to the idea of "freedom" invoked by the first short-skirt wearers in the 1920s—it is a case of the practical excuse for an aesthetic impulse. In the 1970s the skirt itself, long an identifying mark of sex, shortened and lengthened and thinned and thickened itself out of its former existence completely. After the mid-twentieth century, skirts, an absolute law for Western women for fifteen centuries, could change further only by becoming optional; some form of trouser became the alternative. This mode had been developing for several decades in a subterranean way, beginning with strong connotations of traditional sexual daring and of modern sporty informality.

Among women, blue jeans were originally worn exclusively by horsy young girls or their grown counterparts. Gradually trousers became more and more commonplace, and as they did they naturally lost the look of daring or emphatic jauntiness. They also lost the avant-garde characteristic of suiting only the very slim—that is, either the rich and elegant or those who resembled men, the "natural" wearers of trousers. In this period energetic and respectable housewives began appearing in television commercials in pants instead of shirtwaist dresses, and ladies over sixty-five began wearing them out to dinner instead of just for gardening. Trousers were transformed from a subfashion into a dominant fashion. The usual reason given was comfort; but the actual reason was visual indigestion from and discontent with the miniskirt, the maxiskirt, and the midiskirt, combined with a general visual acceptance of blue jeans and other trousers on women. Female trousers were by now entrenched in everyone's clothes consciousness, but they began also to connote youth and healthy disregard for the dictates of fashion designers. Most important, they connoted comfort, which is always much more important than providing it.

Jeans worn so tight that the labia majora are clearly molded, and the wearer has to lie down to get the zipper closed, cannot exactly be called physically comfortable; it is the image of comfort that is desirable, the look of wearing something sanctioned by the fashionable ideal of comfort. Trousers are actually no more physically comfortable than skirts, with a few exceptions: for certain activities loose pants are comfortable, and European sailors and Indian and Mexican laborers have worn varieties of them for centuries. But loose, pajamalike, floppy pants are not particularly becoming to women unless the trousers are very carefully designed, and they have been worn by women chiefly in countries where artistic representations of the clothed figure have been stylized—China, for example, and other Eastern countries—or missing altogether, as in the Muslim tradition.

I have attempted to show that dressing is an act usually undertaken with reference to pictures—mental pictures, which are personally edited versions of actual ones. The style in which the image of the clothed figure is rendered—in whatever representational art is most comfortably consumed and absorbed as realistic at a given time—governs the

way we create and perceive our own clothed selves. Such images in art are acceptable as models because they are offered not as models at all but as renderings of the truth. They are followed partly because they purport to follow; they may guide perception because they seem "realistic," like reflections, not interpretations of reality. (Figures in fashion plates, like the bizarre creatures in *Vogue* photographs or in some of the equally bizarre tinted fashion engravings of, say, the 1840s, are always known to be unreal, to represent not an ideal but a grotesque and even undesirable exaggeration, which is nevertheless distorted in desirable directions.) Art thus monitors the perception of clothing, and in a sense it may produce changes in the mode; but it cannot dictate what those changes are. Rather, it is in a way governed by them whenever it reinterprets the clothed image in a new form.

The *shift* in the look of clothing during any period, however, is still primarily based on visual impulse, a response to the pressure of visual need. Consequently, it is still the representational artist—the photographer, illustrator, and moviemaker, the ones who create the visualization—who also engenders the need to change the look. These artists build into their compelling interpretation of the look of the moment the necessity for a different look in the next moment. They do not invent the exact changes, however, only the need for them. Changing fashion is thus perpetually complicated by its own image. It is an essential fact that without the constant reference of its interpretation, fashion could not be perceived. Certain ways of looking could not be seen as more desirable than others, as acceptable or in need of subversion or further exaggeration, without the visual demonstration that pictures provide.

There are different ways of defining fashion, but what is meant here is the whole spectrum of desirable ways of looking at any given time. The scope of what everyone wants to be seen wearing in a given society is what is in fashion; and this includes the *haute couture,* all forms of antifashion and nonfashion, and the garments and accessories of people who claim no interest in fashion—a periodically fashionable attitude in the history of dress. Clothing in the West may no longer be committed to class, but it is still committed to time; and it still manifests itself in complex tailoring, strongly defined shapes and colors, self-conscious borrowings, and reciprocal visual relations with parts of the body. All this has too much instability not to keep shifting, even among people who believe they are ignoring fashion. Apparently fashion is in its nature able to change by itself. What, then, actually creates the changes?

It has been thought that designers dictate to a gullible public. But many expensive and pretentious designers fail where one succeeds, and successful designers also perpetually risk failure in their attempts to seize and direct even a small portion of the public taste in personal looks. The truly successful designer has an instinct for visualizing sharply what is perhaps nebulously and unconsciously desired. Designers, it must be remembered, exist and work on all levels, not just at the top under the limelight. Most cheap blouses and shoes have been specially designed for the mass market, not copied from high-priced versions. Designers of such goods, most of them unknown to the public by name, are the real successes in fashion; but their bad guesses may yet crowd the sale bins and sale racks in all price ranges, examples as much of their aesthetic miscalculation as of errors in purchasing. The public will frequently not buy what is designed expressly for its consumption; but whether they buy or reject, most people shopping for clothes have the sense that the look of the available garments has been created out of the air by some unseen forces—"They" are offering pants with wider legs this year, or shoes with thicker heels.

In the middle of the nineteenth century the French invented, fostered, and spread the idea of the dress designer as an original genius, like a painter—someone totally responsible for his creations. Then, custom-designed clothes were more like paintings, elaborate and full of tiny detail, and were bought by the same clientele. It was possible to think of an elegant female costume, intended for show at a racecourse or in a ballroom, as something similar to a glossy salon painting, suitable for show in a drawing room, and to think of each as properly bought and seen by the haute bourgeoisie. In such works for such clients, whether sartorial or pictorial, the artist's taste and above all his skill were perhaps of more value than his imagination. But in this same country and at this same period, the notion took root of the artist as prophet and hero, subject only to private moral and aesthetic laws.

Art was seen to be engaged in for art's sake, and an artist could be thought to live for art alone, willing to starve to remain exempt from the tyranny of commerce, which might bring pressure to bear on him in matters of aesthetic choice. In late-nineteenth-century France the couturier thus eventually borrowed some of the heroic luster that had come to surround the figure of the independent artist. Great couturiers, artists in a special realm, thereafter also seemed to be above yielding to external pressure, to have a vision unmodifiable by either the demands of clients or

the outrage of the public, and they were thought to lay down the laws of dress.

The great personalities first to be associated with dress designing in nineteenth-century France were indeed artists to a degree to which earlier designers of finery did not aspire, and some of them achieved great fame and considerable aesthetic power during their careers. Centuries of refined civilization in France had fostered a high level of taste in clothes, famous throughout Europe as early as the sixteenth century; and at least since the seventeenth century the names of celebrated tailors and modistes figure in letters and memoirs. Most of these, however, dealt not in the basic creative design of garments but in imaginative trimming, accessories, and choice of fabric. From the time of Louis XIV, the actual *cut* of clothing was extremely standardized and not very subtle, and it changed rather slowly for both sexes. For this kind of construction work, basic technical skill but no artistic talent was required. Creative fashion instead expressed itself on the surface, and there it changed very rapidly, particularly at idle and rich courts, with the aid of certain specialized experts. The Baroque and Rococo spirit of display—theatrical, impressionistic, rhetorical—was a departure from earlier modes of magnificence. In general, charming momentary effects created the look of elegance, as opposed to the stiff, smooth spread of rich texture and the abstract shapes that characterized the mode until the end of the sixteenth century.

Modistes and milliners in eighteenth-century France were specialists in such effects, for the arrangement of which they charged enormous sums. Tailors and dressmakers per se did not invent extraordinary and innovative constructions, and the famous modistes who dealt in accessories were more like stage designers than artists. Their importance to the fashion-absorbed ladies of Versailles, and of other courts imitating Versailles, was enormous; but their status as artists was always metaphorical and their famous "power" completely dependent on the importance of their clients. The arrogance of Rose Bertin, milliner to Marie Antoinette and others, was as well known as her headdresses; but it was the legend of the queen's elegance and extravagance that survived in history, not the works of Bertin. Her contemporary fame was based on ephemera that enhanced the enduring glamour of chief characters but had no independent aesthetic status. Her arrogance and that of many other famous dictatorial modistes of the period probably arose from a keen sense of the modistes' total contingency, also probably combined with an equally keen sense of their real value and unique talents. Rose Bertin and her colleagues remained backstage when their creations went into the ballroom under the spotlight, to

produce the impression (which still lingers) of their clients' taste but not of their own gifts.

It took the rise of the conventional bourgeoisie and of the unconventional artist to create the couturier as dictator. To follow the dictates of Fashion itself was a historically traditional weakness, always traditionally criticized—particularly when the fashion was especially bizarre-looking. But the blame had always been put on the followers. Moreover, the setting of a fashion was never identified with any kind of aesthetic decision on the part of a designer: when artists were called in to design clothes, it was usually fancy dress or theatrical dress, but definitely nonfashionable garments.

In the traditional folklore of the mode, something that becomes a fashion is often thought to have originated as a caprice, usually unselfconscious, on the part of a public figure. Such a personage—a king, an actress—is supposed casually to have designed or devised the new idea only for himself, and certainly with no help from any artisan. Sycophantic courtiers, admirers, and the general public are then supposed, mindlessly and slavishly but cunningly, to follow the example of a free, inventive, and superior spirit. When, as is most common, specific fashions are associated with no known originator, Fashion is supposed to have issued a decree that obedient subjects unquestioningly obeyed, often at the risk of ridicule (or even of losing their immortal souls) and always at great expense to their husbands, lovers, or fathers.

French nineteenth-century *haute couture* was not simply an arrangement whereby very rich women had dresses designed and made especially for them by talented professionals. That was essentially what had been happening for centuries among the rich and mighty, although generations of such gifted tailors lived and worked and died unsung all over the civilized world while their patrons acquired fame for their own taste. The name of a famous artist might occasionally be associated with the design of garments, usually theatrical, but never the name of the tailor. The work of the clothes designer was subsumed in the taste of his patron; and so Queen Elizabeth I is known for the sumptuousness of her clothing, and she herself also gets personal credit for each tiny detail of her dresses. Near satellites and more remote admirers might imitate such glittering figures and have similar garments made, and so fashions were set and followed within a small social sphere.

The main difference between this time-honored system and the Parisian *haute couture* that persists today is that the great French dress designers of the nineteenth century, beginning with Worth, managed to inaugurate

exclusive fashion as a business, which concentrated the value of the commodity in its intrinsic design, not in its association with a great public figure. Dress design became a recognized art, practiced by artists with known names. Moreover, the *grand couturier* created models designed with no particular client in mind. Such models might then be made several times to individual order in the designer's atelier, and the design might also be sold or exported and reproduced elsewhere. It would, however, still bear the designer's name and be protected by copyright. High fashion all over the world then began to be associated with the names of a few Parisian designers rather than with the names of a few great ladies.

Certain famous exceptions to this complete shift of emphasis occurred in the theatrical world, where a singer or an actress would collaborate with a couturier in the creation of her personal looks (the letters exchanged between Réjane and Doucet show how this worked), but the designer's name was as important as the performer's in the public awareness of the results. When the work of the exclusive dress designer went onto the stage as costume, the public got a good view of the highest fashion at the highest prices, and they were told on the program who was responsible. Actresses, enacting dramatic scenes and wearing fabulous designers' garments, could be observed by ordinary people with ease and satisfaction, whereas queens and duchesses were harder to see, more discreetly and boringly behaved, and irksomely superior.

Women, instead of making themselves into images and then having their looks confirmed in an artist's portrait, could have their looks idealized directly by dressmaking artists. In the century after Worth, not just great dressmakers but great *names* proliferated in the *haute couture*. Famous women were known to be dressed by famous designers, who increasingly came to be respected as artists. Their kind of artistic fame was a blend of that attached to a theatrical performer or stage designer, someone who did brilliant but ephemeral work limited to one performance or a limited run of performances, and that of the graphic artist (including the photographer) such as Alphonse Mucha and even Toulouse-Lautrec, whose original work had an unmistakable individual stamp, recognizable in later reproductions. Social changes gradually made both the pictorial and the performing artist socially acceptable; and the dress designer, like the theatrical artist, became a prestigious figure, someone as famous for his personality (eccentric, of course) and his costliness as he was for his productions.

The photographs of Worth in his velvet cap and furred robe are extremely suggestive of the photographs showing Wagner wearing similar getup at about the same period. Over in Bavaria, Wagner was cashing in,

in his own way, on the same Romantic prestige that had been coagulating around the figure of the Artist. He was burdening his royal patron with his personal life and personal expenditures, and fostering his own image as an unanswerable genius, worthy to swallow up a whole state treasury. Such attitudes between patron and artist reverberated all over Europe, and Worth undoubtedly felt the possibilities of such vibrations. Like Wagner's, his creations were more expensive than anyone else's, and the empress Eugénie was his famous chief patroness. His flamboyant and autocratic manner with her and others was as notorious as his huge bills—and both were perpetually redeemed by his undeniable gifts. His own velvet beret looks like Wagner's, and both in fact derive from the version (also worn with a furred gown) in Rembrandt's self-portraits: the crowning insignia of the self-aware, self-created Artistic Figure (V.33–35). The notion thus born of the dress designer as star—perverse, troublesome, expensive, but transcendently and unquestionably talented—has caused modern hostile feeling about fashion to gather around and form the idea of the narcissistic designer as villain and scapegoat.

Before the emergence of designers, fashion used to be thought of as a force that made people do things against all practical or aesthetic reason. Observers of other social forces, however, soon made the connection between the conflict among social classes and the competitive essence of fashionable change. Obviously, if dress expresses status, not only actual rank but also the desire for a change in rank may be safely expressed in clothing, if not in speech or action. If dress also expresses other kinds of classification—age, sex, occupation—obviously a change of clothes can come before or instead of any possible change in circumstance.

Clothes can suggest, persuade, connote, insinuate, or indeed lie, and apply subtle pressure while their wearer is speaking frankly and straightforwardly of other matters. Thus changes in mode have rightly been sensed as subversive. Blame could be and continually was attached to people for seeming to try to be other than they were: richer, higher born, younger, or of another sex, busy if they were idle, idle if they were really workers—and, of course, beautiful if they were really ugly, according to prevailing standards, or ugly if they were beautiful when the mode was bizarre. Baudelaire suggests that this impulse is noble, akin to the entire aspiration of man to transcend nature, to create rather than to accept, and thus to participate in divinity. Most critics of fashion, however, have found the very changeability of modishness terrifying and irrational, even as they may have felt terror at the implications of an underlying motive in the class struggle, the sex war, or the generation gap.

V. 33 Engraving from a photograph of Charles Frederick Worth, c. 1880

V. 34 Photograph of Richard Wagner, c. 1870

V. 35 REMBRANDT VAN RIJN
Self-Portrait, 1640

356

To counteract evil fashion, the ideal of establishing an absolute and unchanging beauty and practicality in the design of dress has repeatedly been conceived. It has also proved consistently elusive, never itself exempt from the fashion in beauty and practicality current at the date of its proposal. Keeping to a steady ideal of beauty, such as maintained itself for long periods in some Eastern countries or in the ancient world, demands the kind of static social situation that has not existed in Western life for hundreds of years. The dynamic quality of Western civilization keeps altering visual perception as it alters other habits. Fear in particular, however, seems to haunt the changeable quality of fashion in dress. There is a persistent fear of its visual subversiveness, its way of signaling upheaval and need for upheaval in the standard of good looks. The upheaval, however slight, seems always to demand some burdensome personal response—even, perhaps, too much effort to ignore it. Fear of fashion has other, more obvious sources in thoughts of ridicule, pecuniary sacrifice, possible discomfort, and uncertainty about personal choices.

Ever since Worth and Poiret, and later Chanel, with their vivid and vocally expressed personal responsibility for their work, much of this fear of fashion has expressed itself as hostility toward designers, accompanied naturally by its counterpart, worship of designers. Myths about the hatred of women expressed by couturiers through the ugly clothes designed for them could be generated first of all only in a situation where people knew who actually did design women's clothes and, second, where the boldest and most innovative designs were created for no particular woman, so that many might desire them because of the designer's prestige and thus play into his treacherous hands. Designers (and not, as formerly, foolish fad followers) could thus be thought of by critics of fashion as entirely responsible for the peculiarities of the mode.

But designers since Worth have *not* had the freedom that their new status as artists seemed to lend them. They are, as he was, in business, and since the end of the nineteenth century the real talent of the dress designer has been not aesthetic but commercial. Since designs must be sold, buyers must be pleased. What is beautiful or becoming to someone in particular is less important than what will sell to many, and successful designers are ones who create what buyers think a number of women will want. Individual clients, as always, have a good deal to say about what they privately order, and designers will adjust their designs for them. But for commercial buyers the thing must look commercially viable in one glance, beautiful or not—and it is often the case that what is really good really sells, and sells best. Figuring out what clothes people will buy, on

357

the basis of what they have or have not bought in the past, is hard but increasingly profitable work, and now it is also known as honorable work, not just the nasty secret of a few name designers. As society becomes more diversified all kinds of commerce have gained and kept a new prestige, and by now the designing, mass production, distribution, and display of clothing is not only an honest business to be in but a glamorous one.

Ostentatious clothes-wearing was always a sign of rank and wealth. Clothes-*manufacturing,* however, was considered a grubby business, engaged in debasing public taste or catering to its vulgarity. By the time of the Second World War the prestige of *haute couture* was very high, but it was a matter kept in the hands of a few designers, a few clients, a few journalists, and a few photographers. The press made much, as it has always done, of the exclusiveness of the whole enterprise and its costliness. Cinema and theater had their own designers of clothing and costumes working in circumstances quite different from those of the *haute couture.* Money and glamour were stressed there, too, but nobody was supposed to feel that really superior beings wore those clothes or designed them; the whole make-believe spirit of stage and screen justified the extravagance and subtly denatured the details of the designers' achievements. Also, no sense of injustice is manifested in Barbra Streisand's wearing sable or Gloria Swanson's wearing diamonds on the screen. On the contrary, they are thus seen to be clothed in proper symbols of the public's affection for them. And given the luck, drive, and talent, it could happen to anyone.

Mass-produced fashion, however, had no prestige. The garment business was huge and profitable, but most of its designers were nameless to the general public, and little glamour attached to any aspect of the process of clothing the nation. Intense and self-conscious clothes-wearing was still something only the rich and famous were supposed to do, as usual; but if they were famous only *because* they were rich (unlike movie stars), their sartorial extravagance gradually produced impatience and disgust. "Rich society ladies" lost any ability to please ordinary people by dazzling them with their clothes. In less than a hundred years, economic and social changes (including wars) caused the rich who wished to be popular to need justifications other than the pleasure of pure spectacle. That, rather, is what the stars are for.

By the late 1970s many rich ladies themselves took up dress designing, this time not only for their own use, as in the days of Catherine de' Medici, but for the general public. The prestige and glamour of the garment business has so increased and overshadowed that of the exclusive *couture* that the two have interpenetrated. Designers of moderately priced ready-

to-wear garments have acquired as much success and celebrity value as the Parisian Kings of Fashion, who in turn have had to disseminate their talents to keep up. Certain clients of the *couture,* no longer satisfied, as in the days of Poiret, to be dressed exquisitely but obviously by someone else, have once again after a hundred years of aesthetic submission taken up the option of creating their own effects. This shift is probably partially in imitation of the nonrich, who made use of that option increasingly during the late 1960s and 1970s as the international sense of fashion became unprecedentedly fluid. Prominent women have learned the facts of the grubby garment trade and have gone into the clothing business, participating in promotion and selling. The hitherto lowly rag trade is now as prestigious as show business and can demand a less exacting degree of training and talent, though just as much in the way of energy and good connections.

Fear of fashion remains, however, in the face of the profitable international fashion business and despite the great diversification in all price ranges of available fashions to adopt. Clearly, in changing Western life the desire to wear things that look a certain way and not another remains constant, with or without advertising, and so does the changeableness of the desire's focus. Change continues to be spurred and led by images in pictures, more and more of which offer themselves to feed the eye and create dissatisfaction. But the fear of fashion is still primarily concentrated on designers and on their publicized performances several times a year. Pride is taken by many in avoiding or ignoring such productions, and in dissociating themselves from the grotesquerie and expensiveness of such garments and the theatricality of the enterprise. What many people sense is that wearing the very latest creations announced in the fashion press and available in shops produces the effect not of elegance but only of modishness. Wearing the latest thing indicates helpless submission to the desire to look fashionable, and this state of mind is distinctly unmodish itself among many groups of people. Queens, first ladies, and important women never admit to such a desire. In interviews with them about their habits of dress, stress is laid on the business of life, the shortness of time; and this attitude implies (right in line with an old tradition) that the expenditure of time and effort on dress is inappropriate for serious folk, especially any intense study of the mode. Admittedly desired looks are those of comfort, straightforward femininity, a working, clear-cut, honest simplicity—but never chic. Sometimes there is a reliance on certain designers, some go to see collections, but most say they hate to shop. This is the acceptable public view of clothes; it is satisfying to hear that High Fashion is suspect

even in high places. The so-called Beautiful People are another story. It is their self-appointed function, while they may also govern or serve the public or take responsibility, specifically to be seriously frivolous—to wear the latest fashions and be photographed in them. The line between professional mannequin and female Beautiful Person is already blurry.

People still like to speak against the phenomenon of fashion while enjoying it at a distance, although the same people are usually participating in it while looking the other way. It is commonly said, "You'll never see me in one of those," and sometimes it is a safe bet. But the miniskirt, for example, initially so offensive, ugly, silly, and awkward in the eyes of many, became in a very few years so standard a visual fact, so much a part of female looks regardless of shape or age, that not wearing it made one look strange. During this short period, the mass media combined to produce a harmonious short-skirted image all women could take personally and could dress themselves to resemble in order to look normal. And so as the general eye adjusts itself, aided by art, private choices automatically adjust to match; the same thing happened with the fashionable length of men's hair. Fashions of this very general kind are usually followed without conscious effort, in response to the need to make the personal image continue to look natural, not modish.

Although such fashions are easily followed, they are nevertheless often deliberately resisted—by people who despise fashion as a vessel of conformity, of copying other people's habits, particularly if it involves changing their own. They tend to forget that their own way of dressing conforms to obsolete fashions, perhaps revolutionary in their day, that have come to have the flavor for them of inviolable personal laws. The slow advance of the masculine mode in the last two hundred years has made men more likely victims than women of this desire to resist fashion, but they also have social and moral tradition behind them in the form of conventional male superiority to female folly. Devotion to fashion in dress was adduced as a natural weakness of women, something they could not help. This view was strengthened in the nineteenth century, when masculine and feminine clothing became so much more different in fabric, trim, and construction. Elegant men's clothing during this time was actually no less complex, demanding, and uncomfortable, but it tended to be more subdued and abstract in the way it looked. Women's clothing was extremely expressive, almost literary, and very deliberately decorative and noticeable. The old fulminations of Isaiah were often quoted down the ages, probably most often in guilty Victorian times:

Moreover the Lord saith, Because the daughters of Zion are haughty, and walk with stretched forth necks and wanton eyes, walking and mincing as they go, and making a tinkling with their feet:

Therefore the Lord will smite with a scab the crown of the head of the daughters of Zion, and the Lord will discover their secret parts.

In that day the Lord will take away the bravery of their tinkling ornaments about their feet, and their cauls, and their round tires like the moon.

The chains, and the bracelets, and the mufflers,

The bonnets, and the ornaments of the legs, and the headbands, and the tablets, and the earrings,

The rings, and nose jewels,

The changeable suits of apparel, and the mantles, and the wimples, and the crisping pins,

The glasses, and the fine linen, and the hoods, and the vails.

And it shall come to pass, that instead of sweet smell there shall be stink; and instead of a girdle a rent; and instead of well set hair baldness; and instead of a stomacher a girding of sackcloth; and burning instead of beauty.

And Isaiah, of course, fails to inveigh against any masculine dandies of his time who might also have worn gold ornaments, elaborately curled hair, perfume and cosmetics, and might perhaps even have minced and stretched their necks.

Men have taken full advantage of their alleged exemption from fashion risk, so well sanctioned for so long. Masculine sartorial vanity has been a kind of secret, an influence largely unacknowledged in literature (except in the exceptional cases of famous dandies or in certain realistic novels) by comparison with the avowed importance of its feminine counterpart. Thousands of works of art display the obvious interest taken by men in the elaborate beauty of their clothes; plenty of actual male concern for fashion shows up constantly in personal memoirs and letters (Samuel Pepys' and Lord Chesterfield's) and in all sorts of descriptive accounts of men by other men. But the following of fashion, the vanity of modishness, was still supposed to be a feminine weakness—possibly a feminine wile, a form of black art.

Modishness as a serious concern was supposed to be a feminine province, even a privilege, linked not only with weakness and fickleness but also somehow with godless and unaccountable female sexual power. In literature devotedly modish women could never be shown to be devotedly virtuous, and truly virtuous women usually dressed unfashionably or at

least nonfashionably (Dorothea Brooke, for example). For men serious-ness about elegance, as opposed to modishness, for centuries had a per-fectly respectable justification in accord with male wisdom, sense of responsibility, steadiness of purpose, even godliness. For men in public life, elegant dress (not just decent clothes) was necessary to sustain rank and dignity. One owed it to one's audience not to masquerade as poor if one were rich, not to violate degree in outward appearance and upset so-cial morality. Proper attention to dress was a sign of self-respect and re-spect for the order of things—Polonius puts it very nicely. It is this originally masculine spirit that is now being expressed by the women in public life who eschew modishness in favor of respectable elegance achieved without too much noticeable effort.

Once social mobility and fashion were set on their common path, sumptuary laws were continually enacted to prohibit the sartorial usurpa-tion of high degree by the lower ranks—but it was always a fruitless ef-fort. Desire for advancement or any other change has always expressed itself in dress when the feeling had no other outlet. Sumptuary laws pro-hibiting the use of silk or fur and gold trim to all but one class were vain attempts to stop what had been inexorably set in motion with the end of feudalism. The ranks and classes may have been generally supposed to be fixed in their orbits; but if confidence in this idea failed, there were no better ways of making it reassuringly clear than by means of clothing. And clothing could become a vehicle of aspiration and heterodox expres-sion, as well as of orthodoxy or tyranny. The ineluctable movement of fashion had its origins as a form of presumption—the desire to imitate and resemble something better, more free, more beautiful and shining, which one could not actually aspire to be.

Fashion as we know it thus began roughly with the rise of towns and the middle class, along with the consolidation of monarchical power. The boundaries between Church, court, and bourgeoisie required more vesti-mentary emphasis as they seemed more subject to threat. Fines were im-posed on wealthy twelfth-century bourgeoises for dressing as richly as noblewomen, but even by the fourteenth century bourgeois ladies were more elegant than princesses. Priests were complained of in the thirteenth century for their rich clothing, and the Fourth Lateran Council (1215) forbade the clergy to wear the colors green and red, brooches, and sleeved copes. Like all such rules, these were made to correct an already wide-spread habit: priests were dressing like knights, and knights and commons alike were scandalized.

Clothes of the Middle Ages all over the Christian world, East and West, show a fairly static simplicity of shape. The sense of clothing that obtained in Europe until the twelfth century certainly allowed a great deal of variation in the length of different garments and the method of adjusting them, but these were mostly utilitarian differences, equally true of rich, poor, or sacerdotal dress. Sumptuous fabrics were worn by the rich, mean ones by the poor; but the cut and fit of clothes were uniformly simple and unsophisticated for all classes and both sexes. Wealth and rank were expressed in the nobility's clothing but no kind of aesthetic or stylistic superiority. Fashion was not really moving.

Once pronounced *formal* elements began to distinguish elegant dress, fashion could become truly competitive, as it has been ever since, in a battle fought chiefly on aesthetic grounds between members of the same class, generation after generation. The participants, however, have always had a keen eye for daring possibilities in the clothes of other classes. The rich twelfth-century bourgeoise needed only to add too wide a band of jeweled embroidery to her simple dress to incur a fine for presumption. But later, as bourgeois power increased and commerce expanded, the intricate cut of sleeves, the artful pleating of skirts, the flattering shape of headdresses, became issues of fashion politics within the bourgeois class itself. Not trim or fabric but basic formal shape became the raw material of fashionable change.

Leisure and culture obviously generate aesthetic invention in dress; and representational art advanced in the same way for the same reasons, so that by the fifteenth century art and elegant clothing were engaged in that symbiotic relation to which so much subsequent sense of past grace is owed. Noblewomen took up the bourgeois challenge and became more elegant to keep their status plainly visible; courtly elegance, both in large countries and in small principalities, developed its own fashionable course, sometimes more sumptuous and dignified by comparison with bourgeois ease and dash, sometimes sophisticated and daring by comparison with bourgeois sobriety.

Antifashion, a recurrent theme in the history of dress, was probably first taken up as a sign of status by the nobility, perhaps originally out of necessity. Impoverished, threadbare noblemen could take pride in their lack of style while middle-class upstarts were deeply considering the cut of their coats. This strain in aristocratic style persists. The essential presumptuousness of fashion—its constant pushiness, its middle-class mobility—is one of the things that make people hate and fear it, especially very

radical and very conservative people. Some variety of antifashion is one natural response. The constant dress-reform movements of the nineteenth century in England and America were attempts, in different modes, to resist and even to abolish fashion, which had become a more and more virulent and noticeable public phenomenon than ever in the uneven but booming expansion of Victorian times. These attempts were also linked to social reform. If elaborate fashion was the outward sign of bourgeois prosperity, antifashion had to be invented as a necessary means of indicating objections to existing social, economic, and sexual standards. Moreover, if these standards themselves could not be so easily altered, the outward aspect of their critics at least could be. The real aesthetic virtue in the current mode, the desired way of looking at the moment, had to be flouted and if possible impugned. This is next to impossible without very heavy ideological weapons; nevertheless, scathing remarks were written in the nineteenth century about the horrors of stovepipe trousers, tall hats, bustles, trains, crinolines, and, of course, tight stays. "Bohemian" garb was affected in France by artists and their friends in the face of bourgeois philistine riches and Second Empire luxury. In England "aesthetic" dress, intending to defy corsets, hoops, and excessive trim, had an underground vogue. These sorts of antifashion, worn in the same spirit as blue jeans, usually lose no time bobbing up in the mainstream of fashion itself, which is always alert for the attractions of the outrageous and usually able to outwit its own avowed enemies by using their weapons against them, at least to start with.

But reform dress (or counterculture dress or antifashion clothes) always begins by looking ugly. It is interesting that very avant-garde fashion also begins by looking ugly; but if it really conforms to emerging visual needs, if it contains the elements that are bound to satisfy the public taste next, it will soon look well and become generally sought after. Counterculture or antifashion garments will catch on for the same reason, not because of the ideological arguments that urge or justify their adoption. If the elements in the antifashion look have been prepared for within fashion itself, it will become the next fashion. Indeed, those who devise antifashion clothing are themselves not exempt from the influence of general taste even as they flout it. They are likely to propose a way for clothes to look that is not really revolutionary but evolutionary and likely to emerge anyway in the normal course of fashion before long.

Naturally, the commitment to change that is the essence of fashion must often rely heavily on the effect of shock. And so while fashion is in process the spirit of antifashion arises repeatedly, to oppose various forms

of aesthetic or commercial tyranny and excess. It appeals to the idea of liberation, especially to the seductive notion of individual free will. Such attacks on the curse of fashion occur successfully in a climate of political revolution, as in recent times and at moments in eighteenth- and nineteenth-century European life when they had ideological material with which to justify their importance. Arbitrary sartorial revolution by itself lacks much scope without such support, since it goes against the true desire of the eye.

Nevertheless, whenever antifashion clothing has made itself noticeable, either by ostentatiously going against the mode or by becoming the uniform of an ideological movement, the impulse within fashion to make capital of what is new and disturbing converts it speedily into fashion. Stella Mary Newton has demonstrated that most reform dress or antifashion dress of the nineteenth century contained the basic visual elements most likely to become the cutting edge of the next change in mode, if they were not indeed already present (perhaps undeveloped) in current style. Even deliberate revolutions in styles of clothing apparently cannot escape the inevitable evolution of visual taste. Those who create antifashion are themselves products of the coercion they wish to ignore.

There is one steady current in the course of fashion that always gains power, whenever it comes to the surface, from its ancient flavor of antifashion. This is the habit of wearing black. The symbolism of black as a color for clothing seems stronger and longer lasting than that of any other color except white—and black maintains its edge because of its standard connotations of the sinister. Black conjures fear of the blind darkness of night and the eternal darkness of death; and in small, carefully flavored doses, such deliberate conjuring is always attractive. For clothing, however, black began in Europe as the straightforward color of death, appropriate for mourning but nothing else. This custom was the legacy of Mediterranean antiquity. Later, when many led the religious life, black seemed appropriately negative for the dress of ascetics and God's ministers; but it was not until the fourteenth century, when European fashion was under way in good earnest, chiefly at the courts of France and Burgundy, that the mordant beauty of black in itself was recognized as a foil for color

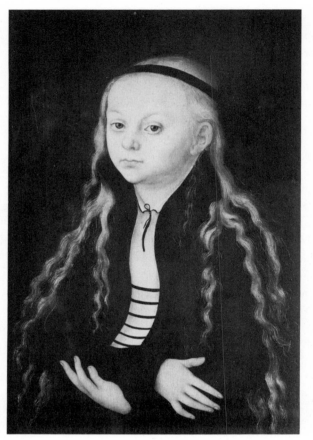

V. 36 LUCAS CRANACH
(1472–1553)
Young Girl in Black

in sartorial schemes. At the same time, it was recognized, at the dawn of the Renaissance, as an enhancement to the individual qualities of the human face.

The interest in visual form in dress that was focusing at this moment in history was thus accompanied by a new awareness of the dramatic possibilities of color, in view of its combined symbolic and optical power. Black enhances infantine rosiness and dignifies aged wrinkles; it glorifies both gold and silver hair, as well as white flesh, whether plump or crumpled. Black clothing can also make the swarthy-faced look interesting when color makes them look bilious, and it makes the black-skinned look both menacing and dignified. It can make the pink-and-white look rather elegantly sinister when color makes them look hopelessly honest and open-hearted. Black can tone down the overblown and create a useful false bloom for the unripe (V.36).

The appreciation and use of this kind of effect require a strong creative impulse in the area of clothing—an impulse that was not very active in Europe in the days when a T-shaped silk robe with gold borders meant rank and wealth, and a T-shaped rough wool robe without borders meant lack of both. But dress did become an art rather than a craft; and the imagination began to operate freely among symbolic shapes and colors, and to use the re-creation of the body through clothing to make suggestions or disguise intentions, to lift or undermine the morale of others. Black was thought of as *suitable* for monks or mourners, but it was not thought particularly *becoming* to either until this process had begun. Black was sad and color happy; the symbolic importance took precedence over aesthetic interest. Once fashion was in motion the symbolism of black could be used with creative perversity for emotional effect.

The blackness of the devil and the blackness of godly renunciation are always played off against each other in the modish use of black for clothes. When Philip the Good, duke of Burgundy, first appeared completely dressed in black among his peacock courtiers, he must have looked both ascetic and satanic, his perfectly cut fashionable garments self-parodied by their color (V.37). Examples of this kind of effect constantly recur in the folklore of costume history. As an enduring illustration, Catherine de' Medici stands out in her black robes among the rainbow-colored company in the Valois Tapestries in the Uffizi Gallery (V.38). Although Catherine's excuse was mourning, strong-minded rulers have often been famous for dressing in black. Catherine's personal style, as well as her piety, undoubtedly dictated her choice.

It was chiefly the Spaniards and finally the Dutch who adopted the general use of chic black, as opposed to its occasional use for effect, after the manner of the fifteenth-century Burgundian and Italian dandies. This use, however, was a departure and a development. Once everybody is in black, there is more possibility of nuance and less crude drama. A general company all in black has abandoned antifashion for conformity; this shift illustrates the triumph of fashion over any counterfashion, the creation of an establishment out of the success of a revolution. And in periods when fashionable scope has thus limited itself, modish innovation must consist in variations of texture, line, and trim, all in the conventional black. Color lies in wait to create the next outrageous revolution. Spanish taste, originating in the Burgundian style that influenced all Europe, and later Dutch taste, in imitation and adaptation of Spanish modes, were both very receptive to the morbid beauty of black; but they stuck to black relieved by a little white around the neck. This compelling style is a special

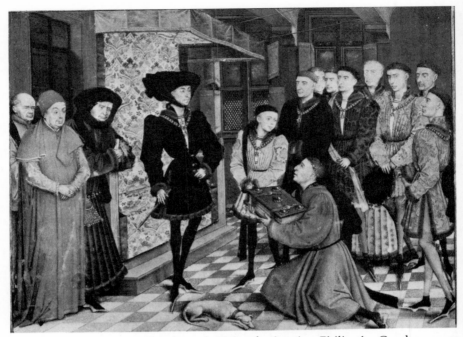

v. 37 Dedication page, *Chroniques de Hainault,* showing Philip the Good, 1447–50

v. 38 *The Polish Ambassadors,* c. 1575 (detail). Tapestry showing Catherine de Medici in black at a court festival

case of black, quite different from total black or black and white in equal areas.

The abstract beauty of the black-and-white combination for clothing has been exploited over and over, even by certain societies in Tierra del Fuego that create the effect with stripes of body paint. Black-and-white ensembles appear frequently in fifteenth-century Franco-Flemish and Italian clothing, and so does black in combination with other colors. Black and white used together have a dramatic beauty without the need of symbolism. In European society, where the symbolism of each is important, they both cancel and support each other. They mean both the same thing and opposite things, and any costume combining them in equal areas has a certain symbolic neutrality. But this is not at all the case when the whole costume is black and only the usual white underlinen is visible according to custom. Showing the edge of the white chemise or the white collar of the shirt was an intrinsic part of the mode in much fifteenth-century costume, and it became an increasingly formalized element of sixteenth-century dress. Thus if a costume was unusual because it was black, but the collar was nevertheless white as usual, the point was sharply made that the wearer was first of all conventionally dressed; and if color was modish, he was also making a subtle antifashion commitment and invoking all that black implies.

Certain monastic orders wore distinctive costume using black and white in equal areas. The Dominican order wore it (black cloak over white tunic) long before society ever took it up, as the Benedictines and Augustinian monks had worn unrelieved black. But the look of a black suit of clothes or dress with white around the neck was first admired and worn as an antifashion fashion in secular life. The effect of black with a white collar became clerical only in the seventeenth century, when various kinds of puritanism were expressed in clothing, and religious dress borrowed backward from fashion the visual power of black with white neckwear. Fifteenth-century elegance for men in particular made much, both in Northern and in Southern Europe, of the arresting look of black clothing with a white collar. Later the great millstone ruff, the elaborate lace collar, and finally clerical bands had their great moments in connection with black clothing.

Black clothes with white around the head is a distinctively female case of the same thing. White silk or linen headgear with dresses of all colors had been worn by European women for centuries; black for the gown was adopted by Renaissance ladies as well as by nuns (see II.18). The self-denying character of the black dress with white coif began to stabilize

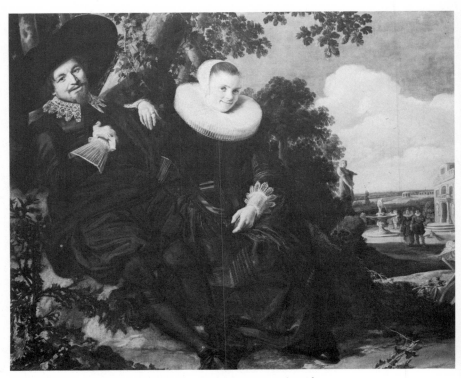

V. 39 FRANS HALS (1581/5–1666), *J. A. Massa and Wife*
Cheerful bourgeois black in Holland

only when fashionable women stopped draping their necks and chins and only nuns and widows in mourning continued. But black clothes with a white headdress, worn with décolletage and a good deal of jewelry, continued to be a distinctive mode for women, as black with a white collar was for men, until the sexes began to share their effects in the late sixteenth century and women could wear the ruff, too, with a hat instead of a coif or veil.

As a theme, black with a touch of white linen infests the secular dress of the sixteenth century and finally takes over in seventeenth-century Holland (V.39). By that time the use of black clothing had become more generally a rich bourgeois fashion rather than the courtly one it had originally been. Pale or gaudy garments in portraits begin to appear more on courtiers, especially in France, England, and Italy, and solid black more on professional men (including the clergy) and the elegant bourgeoisie, especially in Germany, Switzerland, and the Low Countries. This new and gradually established code for black meant that in pale, glittering courtly

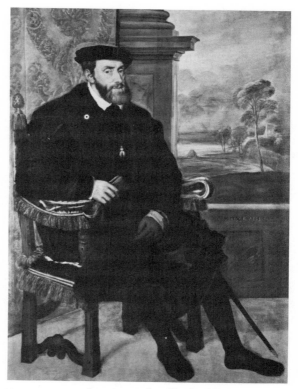

V. 40 TITIAN (1478–1576), *Charles V*, 1548

company, black stood out, as it had originally done in the days of Philip
the Good. Members of the Spanish court and princes and noblemen of the
Holy Roman Empire might wear black in the late sixteenth or early sev-
enteenth century, as Philip II and Charles V did, for somber emphasis
among a colorfully dressed group, just like Catherine de' Medici (V.40).

The bourgeois or professional flavor that black had acquired by then
added the idea of *modesty* to its basic drama: a recurrent, perverse use of
black, which intends to strike a note. In Mannerist and early Baroque
portraits this note was often further insisted upon by the inclusion of
vividly colored draperies to accompany the stark, black-clad figure (see
I.19). These silken surroundings seem to stand for all the other people
who might be in the room wearing brilliant clothes, while the subject
preserves his distinction in his inky cloak. Hamlet, in about 1600, wearing
black mourning in the thick of colorful wedding festivities, is still very
much the glass of fashion, in the most elegant antifashion tradition. El
Greco, Velásquez, and Spanish artists generally, however, tended to keep

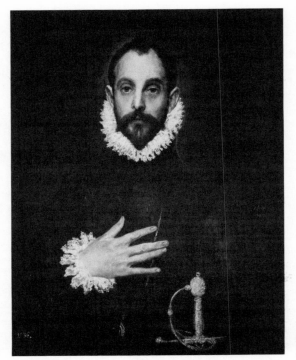

V. 41 EL GRECO (1541–1614)
Portrait of a Man
Black on black in Spain

the somber sartorial note consonant with a dim background, and the seventeenth-century Dutch portraits usually followed that same plan (V.41).

Courtly clothing in the late seventeenth century was increasingly gaudy and colorful, rich in texture, and often carelessly worn. English lords and French courtiers—the men around Charles I and II and Louis XIII and XIV—wore pale colors at the same time that English Puritans, retrograde Spanish noblemen, and Dutch burghers were wearing a good deal of black. The symbolic expressiveness of black clothing had by this time achieved considerable density, but it still had a long way to go. Religious and moral probity, with connotations of intellect and substantial but unfrivolous solvency, was conveyed by the wearing of black in this anticlerical but religious and prosperous age.

In such a context the pallid, bejeweled, and complex fashions of the seventeenth-century French court did not produce the perverse impulse to create a mode for piquant, elegant black except as an accent, in combination with other colors—for gloves, masks, hoods. Even for mourning it was worn in equal areas with white, and the solid color was left to eccentrics like Mme. de Maintenon and various fashionable *abbés*. In the seven-

teenth century black was firmly divided between God (Catholic or Protestant) and Mammon. Abstract visual values no longer governed the use of black, and both erotic frivolity and Romantic satanism were yet to come.

Stylization in dress became even more thoroughly refined in elegant circles during the course of the eighteenth century. Powdered hair and cosmetics, extremely muted colors and delicate trimmings, replaced the cruder, more sumptuous effects of seventeenth-century modish clothing. Cotton fabric, crisp and sprightly, became first available and then fashionable. Black as conventionally modish wear had become passé in England and Holland, and all pretentious European elegance was imitating French taste, with suitable modifications. Black could therefore once again become piquant and arresting without the troubling and heavy connotations of godliness, professionalism, bourgeois solidity, or mourning.

Dramatically frivolous black, suitable for setting off pale skin and powdered hair, began to make its occasional appearance in portraiture fetchingly relieved with pink or pale blue or shiny trim, and obviously no longer encumbered with notions of sobriety and modesty. The Spanish nobility had indeed never ceased to wear black, and they, too, worked it into the erotic drama of eighteenth-century fashion (V.42, 43). This eighteenth-century aesthetic use of black clothing invaded theatrical tradition and thus produced an extra layer of self-conscious reference around its wear in society. Tragedy queens and heroines conventionally appeared on the stage in black velvet but otherwise dressed in the height of the mode with jewels and powder. On stage, such use of the color did not so much express the somberness of tragic themes as it corresponded to the exaggerated effects sought in theatrical action and diction; and so the wearing of black for festive occasions in society could borrow extra dramatic emphasis from theatrical custom. It is from this period, and largely via the stage, that wearing a black dress for elegant occasions acquired the modern rhetorical quality it still retains in fashion.

Although black has obvious appropriateness for mourning and has been frequently used for it since antiquity, it was not always *de rigueur*. Indeed the only generalization possible about mourning costume in European history is that it was different from ordinary dress and usually suggested humility—sometimes not with color at all but by the use of special eye-veiling hoods or enveloping cloaks. White has also been commonly used for mourning, especially for the death of children or the unmarried of both sexes. When mourning or other specifically confining uses of black for clothes are not uppermost among the suggestions conveyed by wear-

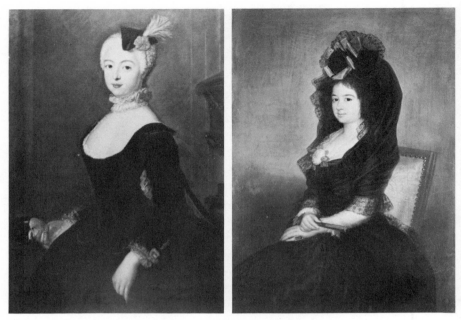

V. 42 (left) *Portrait of a Lady in Fancy Dress with Mask*

V. 43 (right) F. DE GOYA, *Doña Narcisa Barañana de Goicoechea,* C. 1785

ing the color, it obviously can have more aesthetic latitude. Catherine de' Medici's mourning black, like Hamlet's, thus takes on its touch of stylish antifashion, since in sixteenth-century Europe wearing black connoted perverse elegance and the emphasis of individual distinction just as much as ceremonial grief, and mourning itself was not always accomplished in black clothes.

These uses of black, however, are still serious rather than frivolous, in a context of a general seriousness about the function of dress to support rank and express a basic respect for civil and religious institutions. Really frivolous rhetoric enters the spirit of dress when these serious functions of clothes are not exercised directly but merely referred to—exaggerated, mocked, or in some way represented, as if on a stage. This phenomenon occurred especially in the fashion of wearing black clothing during and after the period of literary Romanticism. Rhetorical black invokes the concept of drama itself. It does not simply have the visual property of sharp contrast to other colors, or the antifashion function of distinguishing an individual, or the ritual quality continually associated with

mourning. Rather, in the nineteenth century it *represents* sartorial drama, in an essentially literary spirit. Romantic clothing, like Romantic painting, had strong literary connections.

The most obvious example is the use of black for men's evening dress, when women's was excessively colorful (increasingly so with the development of aniline dyes). Standard black evening clothes only for men were essentially a Romantic literary invention. In other "black spots" in fashion history, such as sixteenth-century Spain, seventeenth-century Holland, and early-sixteenth-century Germany, both sexes took it up. In the first two thirds of the nineteenth century it distinguished men, especially in the evening. By this time the remote male—the "fatal man," as Mario Praz calls him—was a literary role of considerable power over fashionable imagination, beginning somewhere before 1800. "Fatal women" were traditional, and their motives and trappings also traditionally various; the fatal man was rarer, and specifically connected with spiritual unrest and personal solitude. He was a wanderer, somehow in league possibly with the devil but certainly with a kind of dark power that exempted him from the responsibilities of common feeling and experience. He was unhappy; black was his natural color (V.44, 45).

V. 44 (left) E. DELACROIX (1798–1863), *Self-Portrait as Hamlet* (*or Ravenswood*)
Self-conscious romantic masculine black

V. 45 (right) T. GÉRICAULT (1791–1824), *The Artist in His Studio*
The remote black-clad male

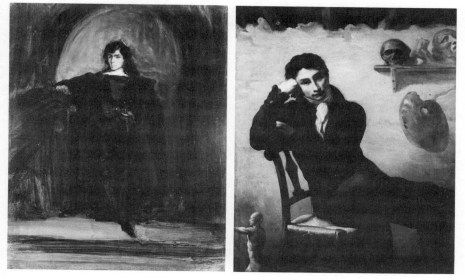

Lord Byron took up this role in real life, as he elaborated on it in verse, although it had already been adumbrated by Ann Radcliffe, M. G. Lewis, Chateaubriand, and others. At the time of Byron's vogue, black evening dress was also established as a "dandy" mode; and the Dandy had manifest links with the fatal man. Brummell and Byron were in obvious imaginative alliance, and have remained allied in everyone's consciousness still. The isolating quality of the new black male clothing, particularly among the ever more simplified and light-colored modes of post-Revolutionary female dress, made subtle mockery of its sacerdotal and monastic use. It emphasized an austere male detachment from female emotive and procreative life (expressed in color and change), especially on ceremonial occasions—evening parties, for example—when the symbolism of dress is always most energetically in play.

This use of black is an example of the specifically male and specifically literary antifashion that became acutely fashionable almost immediately, and institutional thereafter, under Romantic-Dandy influence later in the nineteenth century, on both sides of the English Channel. The diabolic character of black male evening clothes retained its flavor well into the twentieth century, when its customary wear had largely ceased. It is the proper dress of the magician, of Dracula—even in the morning. In the first half of the twentieth century it was the popularly conceived costume of sexual villainy, as the daytime version (black frock coat and striped pants) was the popularly conceived costume of financial and political villainy. Wicked doings were thought of, since Romantic times, as conventionally carried on by black-clad men—originally, perverted priests and monks in cassocks and cowls; later, depraved youths in evening dress; and, finally, bloated capitalists and sneaky politicians in cutaways and top hats. Nasty Dickensian schoolmasters had gone along with the fashion, too.

Black appears as the color suitable to delicious forbidden practice and belief—the courting of death, not the mourning of it—in a great deal of Romantic literature. Poe, Hawthorne, and Baudelaire make much of it; and as a female affectation for elegant dress, besides its self-conscious theatricalism, black clothing had (and still retains) its connotations of fatal sexuality. A lady in black is not only dramatic and dignified but also dangerous. The flavor of danger was absent from the black worn by women before the eighteenth century but never entirely missing from it afterward, even during the most excessive use of black for mourning in the nineteenth century.

Mourning black for women indeed acquired a new literary and Romantic emphasis, as narrative painting from the nineteenth century shows—

an emphasis deriving directly from the satanic and fatal eroticism of black clothing in the early Romantic imagination. A number of European and English paintings take women's mourning black as a sentimental theme with pronounced erotic overtones. Redgrave's *The Poor Teacher* is an example, as are all sorts of paintings with the Young Widow or Orphan as theme or title (V.46–48). The blacker and heavier the mourning, the sexier the effect, worn with grave pallor and shining hair.

At the same time, wearing black as a brilliant *coup de théâtre* in the ballroom was obviously being carried off with similar effect, as can be seen from Ingres' *Madame Moitessier* and Sargent's *Madame X* (V.49, 50). Dashing and slightly masculine riding habits in severe black, complete with top hat and arrogant expression, were another provocative effect in mid-nineteenth-century female fashion—Courbet's lady called *L'Amazone* wears one, and so does the empress Elizabeth of Austria in some of her portraits. So does Lola Montez. All these feminine uses of black were in the original antifashion, rebellious tradition, which seeks to isolate and distinguish the wearer.

True "sober" black, as opposed to all these varieties of "emotional" black, had its own gradual revival. These two aspects of black clothing— the conventionally sober, self-denying black and the dramatic, isolating, and distinguishing black—were supposed to be separate in the nineteenth century. In fact, one grew out of the other, as antifashion black caught on

V. 46 TOM GRAHAM (1840–1906), *The Landing Stage*

V. 47 P. A. FEDOTOV
(1815–1852)
The Little Widow, 1851

V. 48 RICHARD REDGRAVE (1804–1888), *The Poor Teacher,* 1844

V. 49 (left) J. S. SARGENT (1856–1925), *Portrait of Madame X*, 1883
V. 50 (right) J.-A.-D. INGRES (1780–1867), *Madame Moitessier*, 1851

and became an institution. After the middle of the century, domestic servants, shop girls, clerks, and elderly people of straitened means were considered to be most properly dressed in black all the time when publicly on view. But simultaneously, rich and idle men were considered properly dressed in black in the evening, and rich and idle women properly dressed in black for ostentatious mourning or, suitably décolleté, for occasional dramatic evenings.

Such contradictions indicate an entrenched literary and middle-class notion of dress. Meanwhile, professional black for the bench and the clergy, and by extension for the classroom and the consulting room, kept its long-standing use, which had been established in the sixteenth century and which undoubtedly always affected the public consciousness of meaning in black clothes. The bourgeois rich could pretend to a fashionable and aristocratic distinction through self-conscious use of black clothing

and could impose a nonfashionable visual nullity, also through conventional black clothing, on the contingent, the dependent, and the unworldly. For the rich, conspicuously consumed "emotional" black could be of fragile velvet, superfine wool, or silk gauze, and intricately cut and trimmed, sometimes with black glitter. Null black was economical and hard-wearing and did not show stains, and looked it.

The similarity in color, actually full of reciprocally nourishing symbolism, as narrative painters and sentimental writers show, was carefully offset by differences in cut and usage to preserve the artificially separate meanings. If, in 1880, maid and mistress were both dressed in black, or master and butler, the similarity of color was unremarkable to the wearers because two totally differing, significant ways of wearing black were known to be in effect. In 1380 this state of mind would have been impossible; the blackness of everybody's clothes would have meant household mourning. In 1580 it would have been unlikely that both master and servant would be wearing black: an elegant man or woman in black clothes would have had a lackey dressed in color to maintain the superior distinction of his or her blackness.

By the third quarter of the nineteenth century black changed its character for menswear. Having started as a dazzlingly sinister, antifashionable evening mode, it became tamed into daylight respectability and began to share in the flavor of null black—to become clerkly in the shopkeeping sense rather than clerical in the priestly and potentially demonic sense—a Protestant reform of a popish fad, like the Dutch after the Spanish. Alfred de Musset, observing the ever more general blackness of male dress, called it a century in mourning for itself. Female daytime black dress took on the same respectable character. The delicate butterfly colors of Romantic female daytime clothing were largely abandoned, first in favor of vivid and gaudy color at mid-century, then finally for sobriety, with black the most suitable, not just for showy mourning but for dignity, maturity, substance, and probity—all capable of expression at once in terms of a visiting dress, and still imbued with sexual threat—but in a nice way (V.51).

Antifashion black was thus out of luck as an aesthetically rebellious possibility, as it always must be when it takes over fashion itself. Established, prosperous bourgeois taste made black necessary both for the correct quality of dressy sobriety and for self-deprecating subservience. As elegant daytime male dress, in this double-layered spirit, black also separated itself from women and allied itself with the clerical, professional, and commercial aspects of public life. Men in politics and business carried on public affairs in clothes of drab, soberly cut black; heads of state and

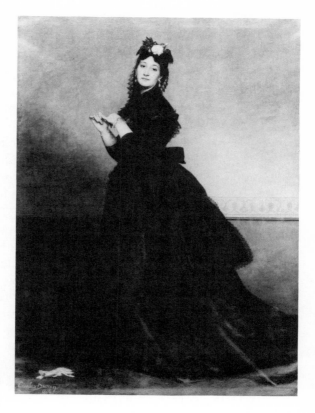

V. 51 C. DURAN
(1838–1917)
Woman with a Glove, 1869
Respectably sexy black

ambassadors likewise publicly wore such aesthetically restricted garments, in contrast to the spectacular dress of medieval statesmen. Female black in these late-nineteenth-century decades still had the option of conscious erotic drama, as evening black for men kept its look of Romantic isolation; but daytime black for all classes and both sexes carried a cumulative weight of deliberate repressiveness. Clothing for leisure and sport, and loungewear, stayed colorful in emphatic counterpoint to the exclusive use of black as a symbolic and formal color, burdened by the accumulated freight of its historical appearances. The beauty of black for itself could not have weight in the design or choices of fabric for golfing, cycling, country walks, or tennis.

Art Nouveau and abstract art, aided by photography, were able to create a new set of visual possibilities for black clothing in the twentieth century that could take new account of its purely visual appeal. At that time, about the end of the First World War, conventional sober black for feminine costume had largely given way to pale colors, as feminine freedom of

self-expression advanced and became a commonplace, along with feminine employment. Black could again rely more on its visual impact than on its symbolic social impact. This time it contributed to the new abstract modes. The Vamp, a faintly ridiculous vestigial form of Fatal Woman, wore black in the fully Romantic tradition; but in this decade it tended to have the bizarre shapes adumbrated by Aubrey Beardsley and refined by Erté. Hollywood Vamp Black was doubtless further inspired as much by the possibilities of black-and-white cinematography as by the convention of the Romantic *femme fatale*. Gloria Swanson, Mae Murray, and Theda Bara could smolder effectively in black on screen, but real-life elegance had a use for it, too. In the period 1900–1920, avant-garde Parisian designers and their elegant customers took up the use of abstract, visually dramatic black. This trend in elegant dress was more an aesthetic response than an antifashion mode—black was used, as it had often been before, to contrast with other colors, but this time under the influence of abstract art and black-and-white photography.

Among so many other reasons for wearing black in the late nineteenth century, widowhood lost some of its visible distinctiveness, just as it had in the seventeenth. In both cases special headgear had to be adopted to indicate the condition of widowhood, just as the hood and *barbe* had been retained for the same identifying purpose in the black-wearing sixteenth century. Black garments were not themselves sufficient. A widow's peak was originally worn by such ladies as Catherine de' Medici and Mary Queen of Scots; it was a vestigial forward extension of the fashionable, off-the-face tiaralike hood of the period—the token remains of the ritual face-covering hood of public mourning, worn since the previous century. The cap with central peak pointing downward over the brow was adopted by Marie de' Medici in the early seventeenth century after the cap itself was no longer generally fashionable except in Holland (V.52). Seventeenth-century ladies continued to wear a veil and black hood fitting closely around the head, often with a pronounced peak, to indicate widowhood; but this hood is not to be confused with the coquettish soft black one often worn informally, as an accent, with a mask.

The general use of black clothing for formal wear in the nineteenth century demanded that widowhood be signalized by such a widow's cap—black with a thick veil and later sometimes white with a veil, in the style adopted and popularized by Queen Victoria. For men there were mourning armbands and crape drapery for the hat. The veil and hat drapery suggested a funeral pall—funerary drapery having been a long-established sign of mourning. The voluminous Renaissance cloaks and

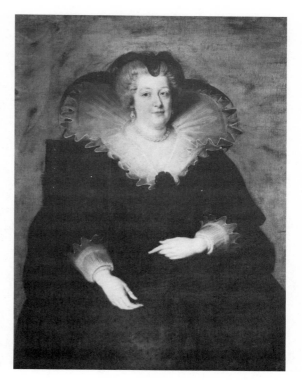

V. 52 P. P. RUBENS
(1577–1640)
Marie de' Medici
The "widow's peak"

concealing hoods for mourners and covering cloths for the bier were thus invoked, and symbolic bits of dull blackness were imposed on conventional costume that might in fact often be black for other reasons.

By the mid-twentieth century black had lost much of its conventional importance for formal day wear and most of its Art Deco impact, and was ready for yet another kind of revolutionary antifashion appeal. Black was obsolescent as a sign of moral respectability and financial solvency, even as a sign of mourning, when ease and physical freedom in dress became the correct fashionable quality to display. Both respectable and dramatic mourning went out of fashion (except for heads of state in the full view of the public) and finally out of use. Black had to wait for another way to become unexpected, antifashionable, and finally chic again.

As the liberated twentieth century progressed maids and waitresses and waiters wore black all the more noticeably, and so black appeared in male evening dress accompanied more and more by a certain amount of self-mockery. Masculine business attire had been slowly emancipated from the sober black cutaway or frock coat of the late nineteenth century and had

included the comfortable lounge suit originally used only for private leisure. Formal black now appeared correct at weddings (because it had been correct morning wear) in fossilized usage, along with the starched collar, ascot, and high hat.

In the United States, such neckwear and headwear, along with the antiquated formality of formal evening dress, created a whole fund of humor focused on such clothing. Jiggs of *Maggie and Jiggs* wore it, and Chaplin's tramp is a profound instance; but there were many jokes about the discomfort of evening shirts and collars, the resemblance between a formally dressed gentleman and a waiter, and the whole institution of evening dress conceived as a torture imposed by pretentious, social-climbing women on their hapless men, in the Maggie and Jiggs tradition. Evening dress was called a "monkey suit" or "soup and fish," and there was a general need to show disrespect and contempt for this particular convention—yet, although popularly ridiculed, it was unquestioningly adhered to, among conventional leisured folk, through the Second World War.

For daytime wear black gradually disappeared for men except among British bankers, civil servants, and businessmen in the City of London. Dandyism had flourished again in England at the turn of the century; this time the black garb of respectability (originally a chic dandy mode) was flouted by Max Beerbohm, Oscar Wilde, and others; and exquisite tailoring in blends of exquisite colors were correct for aristocrats and aesthetes. Chic antifashion had its expression in pale hues and antiquated modes at this point, but the momentum of conventional fashion stayed with black, finally bequeathing it totally to the servant class and orchestra members.

Easy, subtly colored, tweedy garments, sportswear, and the "dinner jacket" (a comfortable compromise with uncomfortable formality) became the new advanced mode for men. The tailcoat was fast losing its chic but not it prestige. The tuxedo, or dinner jacket, had been invented in America in the 1880s, but it became completely acceptable as formal evening wear only well on in this century. At the time of its origins it had required, despite its informal cut, the same starched neckwear worn with everything else; but by the 1930s soft bosoms and collars were acceptable, and even a double-breasted coat without an evening waistcoat. Evening dress, if worn at all, could thus simply be a lounge suit, black by courtesy. The black tailcoated evening costume with starched linen was relegated yet a step further into the realm of the ceremonial, the theatrical, and the ridiculous. At this point masculine black garments as such had no chic at all.

For women in the 1920s and 1930s, however, a new chic antifashion appeared—the famous "little black dress"—allegedly launched by the legendary, innovative designer Gabrielle Chanel. The first adjective signifies the revolutionary character of this mode at a time when either bright, simple sportswear or pale and gauzy beaded wisps were elegant. Fitzgerald mentions Jordan Baker's way of wearing evening gowns as if they were tennis dresses—a style of bearing acutely chic at the time, along with the "debutante slouch"; both vigorous and limply careless indifference were in vogue. Self-effacement and decorum, expressed by a maidlike little black dress, was quite heterodox, a newly outrageous note to strike in the roar of the 1920s. In America the Depression made elegant the "poor look," of which the little black dress was the herald. Black, used as a serious, modest color in conservatively cut daytime dresses suggesting a shop assistant, could, by the 1930s, seem as revolutionary and new as the slapdash, pale, bright, and shapeless dresses of the 1920s had been.

The respectable black of the despised and restrictive nineteenth century had finally been really forgotten; necessary mourning was also forgotten; and the uneasy longing for sobriety that always follows a mad period in fashion produced the new black dress, often worn with a decorous white collar, plain or ruffled. This time it was pointedly a working girl's dress. Its cut and color connoted neither solvency nor perverse clerical diabolism but, rather, the alienation of poverty. The dress was at this stage another manifestation of symbolic significance in black clothing, which had acquired a new layer of meaning to inspire it: it had become the official uniform of underlings. Nineteenth-century black-clad clerks and servants had been effaced by the color while their masters exploited and exercised the effects of its glittering or somber beauty. But when status in fashion was expressed in color and texture, dull black clothes clearly distinguished the waiter and the shop girl. The emergence of the shop girl's simple black dress as a new and somewhat daring mode for leisured women was a striking sign of the spirit of the 1930s. Social consciousness was expressed, as before and since, in clothes of the utmost elegance.

After the French Revolution the avant-garde mode had also taken on the look of poverty. At first, rags and disorder in male dress, along with unkempt hair, were à la mode. Later, for ladies, simply constructed and fastened muslin dresses, worn with perhaps somewhat studied but natural-looking, untidy hair, came into fashion—the customary dress of milliners' assistants and farm girls in the preceding decades. Idealized versions of milkmaids' cotton dresses had already become chic in court circles in

the time of Marie Antoinette; but real simplicity of cut, fit, and trim occurred only after Republican Virtue and Equality were established as the prevailing fashionable flavor to be sought in chic clothing. In the American Depression, fashion co-opted the unassuming waitress' black dress, and by the early 1950s it had become an institution of the American female wardrobe, as emotionally and socially correct as it had been in seventeenth-century Holland. A fairly frivolous book on American fashion published in 1960 has the following in its glossary: *"Basic:* noun, a simple black dress that costs more than $50. *Functional:* adjective, referring to a simple black dress that costs more than $100. *Nothing:* noun, a simple black dress that costs more than $200, as in 'a little Nettie Rosenstein nothing.' *Understated:* A simple black dress that costs more than $300."* The discrepancy between prices and verbal qualifiers shows the well-worn attitude that increased wealth demands increased deprecation of sumptuous clothes—a deprecation pointedly underlined in the wearing of simple black; moreover, now, by a neat doubling of images, simple black had once again come to indicate financial and social substance while at the same time it was being publicly called by workaday and unassuming names.

This state of mind about black had an analogous but later manifestation in masculine dress of the 1950s. Darker and darker gray flannel, narrower and narrower ties, lapels, trousers, and shoulders, became the prosperous American male mode, almost exactly as it had been in the 1870s. Boxy black or nearly black suits, and thin, black knitted ties were soberly proper. European fashion in this period for both sexes was never affected by the need for a conventional black sobriety—perhaps its connections with grim peasant poverty were too strong and too present. European male tailoring kept the nipped waist with sharp lapels and shoulders, and eschewed dark gray flannel. Feminine elegance was colorful and inventive, and usually scorned the safety of black.

The 1960s confirmed what had been a really revolutionary use of black already in underground existence since the late 1940s. This mode, authentically European, was radically antifashion in accordance with the way society usually becomes freshly aware of black clothing. It originated after the Second World War among Parisian Left Bank intellectuals and their followers, and finally flowered in America among the members of the Beat Generation. This mode might be called Student Black or Modern Bohemian Black, perhaps to be read as another aspect of the Dandy-as-Alienated-Artist Black worn by Delacroix and Baudelaire—but now deliberately scruffy rather than romantically somber. Its most important

386

single element was the black turtleneck sweater. This was later combined, by women, with black tights, both of which contributed to a feminine antifashion variant describable as Dancer's Black, which later focused on the black knitted nylon leotard, which was not available to the original creators of this revolutionary mode. Dancer's Black later extended itself to include black skirts, black trousers, and black eye makeup, and owed much to the self-presentational genius of Martha Graham. It has since penetrated the national consciousness as one standard modern way to dress.

For men the black turtleneck did it all. This garment was supposed to indicate the kind of freedom from sartorial convention demanded by deep thought or pure creation (usually poetic)—with overtones, always carried by masculine black clothes, of both doomed wanderings and sacerdotal zeal. There was at this date (circa 1948–50) a good deal of power in the startling look of a tight black sweater rising high around the chin and neck. It threw the face into sharp relief, all the greater for being unrelieved by the customary intervening area of white shirt, so well established as the proper accompaniment to black clothes for men. It looked both austere and (because it was only a sweater) informal, and it made everyone who wore it look peculiarly interesting. After the Second World War it had new connotations (see Jean Gabin and Humphrey Bogart) of seafaring, which suited the new version of the uncommitted, wandering fatal man. This mode had more currency for young women than for men among actual serious students—even the bohemians in the Ivy League stayed with the old tweedy conventions. But in the light of later developments in antifashion, which came to be called counterculture, the high-necked, black-knit Intellectual Mode can be seen as the herald of the most significant changes in popular clothing in the twentieth century (V.53, 54).

Concurrent with this postwar antifashion was a new orthodox and fashionable use of black. Dramatic sportswear and casual clothing for the very young began to be designed with a good deal of black, used alone or with other colors. This development largely reflected the resurgence of Italian taste and design after the war and its influence on international fashion, particularly in the area of sportswear. The international but essentially British ideal for the look of sportswear, which had been standard for so long, was replaced by a more dramatic and abstract ideal with a much broader sense of visual possibility in informal dress. The use of black in this new mode, worked out in canvas or corduroy or one of the new synthetics, meant a new freedom from dark green, dark blue, tartans, tweeds,

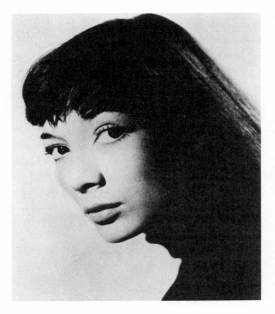

v. 53 Juliette Greco, c. 1950
The Paris chanteuse and friend
of Left Bank intellectuals
in the original female black
turtleneck sweater

and dark brown, which once had seemed the proper informal alternatives to formal black. Black acquired license for truly informal appearances, as garments for sport also ceased to conform universally to the look of blazers, shorts, and slacks, and yachting, hunting, and shooting gear generally, and became truly inventive—eventually overlapping into the area of nonsportswear.

Black in the late twentieth century has lost most of its symbolic significance—partially through the fragmentation and multiplicity of styles in dress but chiefly through the self-consciousness of fashion. Black may no longer appear on the diversely colorful fashion scene to strike a new kind of antifashion note—there is no such single note, since there is no single fashion. All fashion is now aware of its history and of itself as personal, theatrical, or dramatic costume, so that to wear black clothing is to refer to a variety of earlier manifestations of black for clothes—earlier styles, former meanings, obsolete conventions. One may wear a black turtleneck or a black dinner jacket for the same occasion, depending on the part one wishes to play and dress for. Presumably, a black layette might still shock.

It may well be that the recurrent chic of black clothing in European fashion history, followed by its usual subsidence into the sober mode, has art to thank for its persistence. The flowering of black-clad elegance was simultaneous with the rise of portraiture in the fifteenth century, when portrait painting became a method of celebrating the uniqueness of indi-

v. 54 Audrey Hepburn plays
an intellectual in a black
turtleneck sweater in
Funny Face, 1957

viduals. As a corollary to portraiture for this purpose automatically came
an aesthetic elevation of beautiful clothing. Portraits provided a way of
displaying a fashion in a particular instance of highly specific perfection.
The portrait subject, shown as a distinct personality, required his dress to
support this view of him rather than his rank or role. His portrait costume
had to be what he ordinarily or festively wore—not what a ceremonial or
ideal version of him might wear.

In England, at least, debased methods of portraiture did come into
practice by the late seventeenth century, whereby ideal bodies in fantasti-
cal or formalized clothes were added by drapery specialists to facial like-
nesses painted by "face painters," with the result that all subjects look
much alike. The nameless limners of Colonial America also used standard
bodies with vague garments and formal poses, but the main tradition of
portrait painting tried to incorporate some sense of the subject's individ-
ual clothed self into the painting of his likeness. Allegorical effects or in-
signia of rank will not do for the clothes in a personal portrait; the
garments must be subject's, even if the stage props suitable for an ideal-
ized vision of his role or riches are allowed to run riot in his surroundings.

Now, we have seen that black is a beautiful foil for the face—any face. And in the Renaissance, if a man had many suits of which one were black, it seemed quite likely that he would wear the black one for a portrait, so that his face would show up better and his taste in clothes look better for thus enhancing his own looks. The black could also make him look attractive, intelligent, rich, and modest—all or any—and the combination would be in the artist's hands. Black clothing had infinite possibilities in combination with face, pose, background, and embellishments. If he were a learned doctor, such as Erasmus or More, and his professional gown was black anyway, so much the better; his personal qualities could be built all the better into the image of his function and even more prestige accrue to the wearing of black garments—especially if the artist were a genius like Holbein.

A fashion for black-clad portraits would thus confirm and add a dimension to the fashion for black clothing itself. Once the convention of black dress in portraits was established in the canon of art, it could be revived and pictorially invoked at later times, to enhance further or perhaps to inspire the fashion for black clothing as it repeatedly came due again. Sargent, invoking Courbet and Manet, invoking Van Dyck and Velásquez, invoking Bronzino and Titian, could refer to the compelling look of black worn alone, with perhaps a gleam of gold and a streak of discreet white linen—the look not just of distinguished people in black but of great pictures of distinguished people in black. Avedon and other photographers carry on the tradition. Since in general the mode exists only as it is conveyed in the images of the mode, and the fashion is the fashion in images, not in clothes, then without actual visual representations the image has no authority.

M·I·R·R·O·R·S

The most frequently looked-at image of the clothed figure is to be found in the mirror. The glassy surface and empty frame lie in wait for the self-portrait that is to be re-created at each reciprocal view of the artist and his captive subject.

The eye always tends unconsciously to confirm the connection between figures in pictures and the real look of other people. People see clothed bodies around them in terms of the most familiar pictorial images, and thus the picture is the standard by which the direct view is assessed—including the direct view of the self in the mirror. But the only way the personal dressed self can be measured, against other clothed people and against the prevailing acceptable set of pictures, is in the mirror. The mirror is the personal link between the human subject and its representation. Moreover, the mirror gazer may always legitimately hold on to his faith in the mirror's power to reflect objective truth while at the same time he takes advantage of it as a tool for creating satisfactory artistic fictions. The mirror gazer participates (not always consciously) in the imaginative act of making art out of facts: the aim is to mold the reflection into an acceptable picture, instantaneously and repeatedly, with no other means than the eyes themselves.

Now, the mirror has always had a very bad reputation, obviously because of the very power it seems to have of generating, not just reflecting,

an image inside its depths that rather uneasily corresponds to something presented to its surface. Mirrors have afflicted people for millennia with the fear of being either trapped or attacked by something that lives inside the mirror itself and is only released by the viewer's gaze. The "something" is simply the reflection, but this is freighted with the uncanny quality of separate life. And this life, this changed new image, is brought into being by the creative power of the beholder's eye. The mirror is so much like water that it seems to become water, the treacherous haunt of possible death, but even more strongly the burgeoning matrix of all life. Behind the reflecting surface is something waiting to be born.

Myth has made much of still water and its tricky reflecting surface. The story of Narcissus shows that staring at your own reflection means you cannot separate yourself from it; you make it, but then in return it makes you and claims you. Not only did Narcissus reach out to embrace the reflection of his unknowing and innocently beautiful self—it reached out to embrace *him,* he responded, and so he drowned. Narcissus, unlike non-mythological people, was unaware that he saw himself, and he fell in love with something he thought was truly Other, as most do and as he ought to have done. The drowning came not just when the reflection reached out to match his own caress but when he knew it was only himself, and that he had made it up. The danger of the mirror boils down to the risk of letting the infinite and wayward power of the human eye turn on itself and make an uncontrollable, destructive creature out of the self-image.

Most of this activity, in art and myth, refers to the face and not the body. People are most creative when looking just at their faces, and the neck-and-shoulders portrait is the most common private mirror image in bathrooms, bedrooms, vestibules. Modern fear of and fascination with mirrors usually stem from the false idea that it is objective self-knowledge that is given back by the mirror to the self-regarding face. But an actual mirror gazer cannot escape putting self-acceptable expressions and poses into the frame, which are perhaps quite uncharacteristic, rather than attempting to spy on his natural behavior. Far from seeing objectively, the mirror gazer is engaged in creating a posed studio portrait of himself, not even a candid shot. He is without choice in the matter if he meets his own gaze. What he puts into the mirror may be just as self-deludingly ugly as it may be flattering—the impulse is simply creative, not self-congratulatory—but in any case the mirror viewer must, so to speak, always watch himself looking at himself. Under these circumstances the unguarded face is impossible to see, and so to judge; and indeed such a sight is not the usual desire of anyone seeking his reflection. The very act of consulting

the mirror presupposes some will to create an image, to fill the frame deliberately—in fact, to run the risks undertaken by Narcissus. To learn the truth is somehow secondary to creating a truth.

Using mirrors personally for certain kinds of objective evidence is, of course, quite normal. But such use is ordinarily confined to small areas and close-up views: looking only at the eyes, to focus inspection on a network of red veins, or on the lid as a field for cosmetic application: looking at one square inch of chin to check on the advance of a pimple. The mirror is a straightforward, unthreatening speaker of truth on these partial matters, besides being a simple aid to shaving. But looking at the looks is at best an exercise in art, at worst one in self-deception—or at the very worst, perhaps a path to death and damnation. Looking in the mirror is also traditionally supposed to mean looking at something taken for truth that is really false (the mirror is only glass *reflecting* facts); but the falsity in the mirror is somehow felt to be generated out of the viewer's own falsity—of heart, of soul, of intention. In modern demythologized life, the falsity may really be only of the eye as it edits and tailors the image it sees.

Myths have been born of the grudging acknowledgment that it is next to impossible to see the truth by gazing straight at the mirror—especially if the aim is to acquire an objective notion of one's physical looks as they appear to the direct gaze of someone else. The most obvious reason for this impossibility is the phenomenon of left-right reversal. That familiar mirror face, perhaps inwardly worked up and then thought of as the true and safe public mask, is always a hopelessly private fiction: no one sees it but its owner, who thinks it looks like him when actually the public and his intimates see a mirror image of it—the mole on the other cheek, the hair parted on the other side, the rueful smile twisted the other way.

For a true look at the face seen by others, two mirrors are necessary—a state of affairs outside the usual scope of myth but firmly back in the realm of practical truth (VI.1). The indirect doubled image reproduces what another person actually sees, and this cancels the danger and the trap; it becomes like closed-circuit television. But the face looking straight in the single mirror, thinking it sees one thing but really seeing another (its opposite, its shadow), is the conventional image of vanity—the empty condition of self-delusion, of believing the false to be true because one has arranged for gratification instead of seeking for truth.

The image of truth, on the other hand, also often personified as a woman holding a mirror, holds her glass away from herself to reflect the light and the world. Looking for truth in the mirror is successfully done in legend not by looking at the self but only by looking into a mirror as if

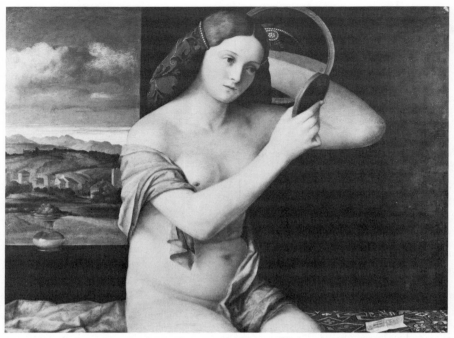

VI. I GIOVANNI BELLINI (1439/40–1516), *Young Woman at Her Toilet,* 1515
Arranging the headdress: simple truth in two mirrors

it were a crystal ball, to see into the past, the future, or a different place. Seeresses who do this also create an image in the glass, but it is truthful through the power of supernatural vision, which is akin to imaginative power. On the other hand, the allegorical figure of Prudence gazing into a looking glass sees only the possible future—and may also, practically speaking, see what is directly behind her, as someone at the wheel of a car may. Some figures of Prudence have a face on the back of the head instead, and sometimes both. The mirror as a practical aid to foresight is the idea here, a guide not to the self but to things as they are or may be, so that action may follow on advance knowledge. Prudence's mirror is a simple defensive weapon, devoid of magic.

People in Renaissance pictures looking in mirrors and being shown their own skull, or perhaps the devil or a monkey, are usually supposed to be looking at their own reflection but seeing falsely, since the true view, visible by artistic license to us but not to them, is that they are distortingly self-absorbed; they cannot see that they may be ugly or ridiculous or even that they will die (VI.2). The mirror here shows the real truth, in contrast to the fiction usually created by the self-regarding eye. Mirrors

may thus be presented in art as useful conveyers of profound truths, but the message is that the image of objective truth in the mirror cannot be simply an optically reflected personal picture—*that* phenomenon implies another kind of truth, the authenticity of artistic creation. The real truth in the mirror itself, such artists seem to say, has to be a condition of man, a state of things, a lesson, or a vision. In Renaissance art, when a mirror is made into a little picture—and in many works of art the picture in the

VI. 2 LAUX FURTENAGEL (b. 1505), *Hans Burgkmair and His Wife,* 1527
Skulls in the mirror are the real truth

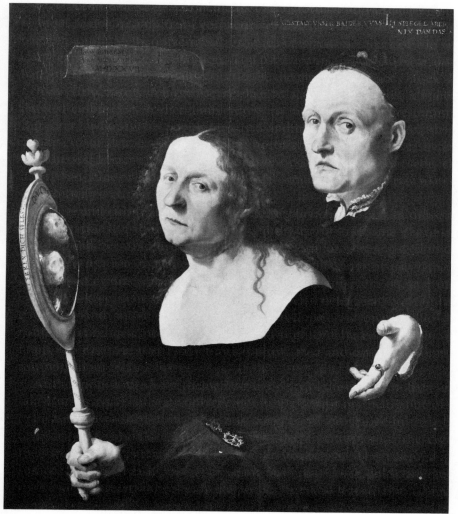

mirror often looks as if it were composed independently of its subject—the image is always a fiction. And it is shown by artists to be the same kind of fiction as the picture in which it appears—a very specially qualified version of natural reality.

The interesting thing about most Renaissance paintings that include mirrors is that the mirror itself is small, and usually shown to reflect only the face. Obviously the mythologically important point about the personal mirror is indeed its usefulness as a key to self-awareness, a usefulness that may be spurned for vanity's sake or welcomed in the name of wisdom but that is best illustrated by the image of the reflected face. Only when a mirror, like a magic crystal, is thought of as giving a vision of another life does it encompass a scene or a whole world—and this does not occur often in pictures, except for the street-reflecting mirrors in Flemish art. Until the late seventeenth century, the face and perhaps the head, neck, and shoulders were the proper scope of the meaningful mirror in art. Such mirrors closely resemble the bust-portraits that also became very important in the same period. Late Renaissance and early Baroque paintings of elaborately nude and bedizened Venuses and Bathshebas and allegories of Vanity show to the viewer their complete collection of visible beauties, but they themselves look only at their faces (VI.3; see I.49; III.48). These are carefully fitted into the mirror frame for us, sometimes in defiance of optical possibility, so we do not mistake what they are looking at. Sometimes they are not looking at themselves but using the mirror to look at us—and then what we see is the same fiction they are looking for: not the ideal face straight on, but its opposite, created like a picture in the transforming glass. It is a face with the treacherous but redoubled power of mirror life, which is the same as the imaginative power of representational art.

A mirror inside such a painting never shows, within its intensified limits, an encapsulated view of the lady's bosom, for example—it is the face, even unadorned, that is selected and seized by the mirror eye. This looks especially strange when the subject of the picture is supposed to be the lady's attention to her toilette, her completed looks. The coiffure, jewelry, and costume are being given a lot of attention, perhaps with the aid of attendants, while the lady looks only into her own eyes or ours. Clearly,

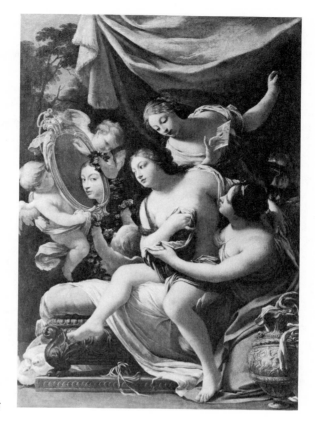

VI. 3 S. VOUET
(1590–1649)
The Toilet of Venus

the mirror is not being used to discover anything about the visible effects of the toilette. Those objective facts are visible to the beholder, whereas the mirror is being asked a personal question—some version of "Who is the fairest one of all?" It is the self confirming itself as a created image. This activity is good for Venus: it redoubles her power over and over, as in the generating of an electric charge; but it is felt to be bad and vain for ordinary people. Beautiful women may look in mirrors but in a sort of ritual manner and only when their beauty is like Venus'—triumphant and truthful in itself. Ordinary women are thought to be in danger of seeing their own faces and out of vanity taking them for Venus'.

Renaissance mirrors were in fact small, usually portable, and somewhat convex, to produce a deliberately reduced image. Reduction of size in itself contributed to a sense of the mythic power of mirrors as vessels of both truth and falsehood, besides being useful for looking chiefly at the face. The little image, just because it is little, cannot be an absolute like-

ness except by some kind of magic. Actual mirror magic is optical. It is, however, analogous to the magic of the pictorial artist, and its use in the history of art seems to follow attitudes about the function of art itself. In the Renaissance, mirrors were used, thought of, and represented as if they were pictures—recognizable images, somewhat reduced in size, of real life, but with special characteristics and controlled messages (see II.25).

The mirror, then, is for seeing the self as a picture, and everyone knows that the artist is responsible for what is in a picture. Dislike and fear of this responsibility give rise to wishful myths about mirrors showing something uncanny, something different, something created by an agency other than the gazing self. Human beings know themselves to be untrustworthy and frail, prone to folly and self-deception, easily tempted and entrapped. If they look for themselves in mirrors, they know they may put unsatisfactory and disheartening pictures there, images of their own failings; or, worse, they secretly know themselves likely to create something in the mirror they will admire too much. Fear of vanity is very deep. Narcissus, loving his own reflection, is safe while he does not know it is his. When he knows he has created the image he loves, he dies. The existence of the myth illustrates how well people understand that a perfectly visible truth can be falsified when the eyes gazing straight at it are blinded by longing for something other than what is there, or by fear of it. The magic mirror, on the other hand, is a comforting, imaginative device whereby the mirror is made to take its own responsibility, create its own picture, and take the gazer off the hook.

It was in late-seventeenth-century Dutch paintings that the mirror was first shown hung on an interior wall, reflecting a random section of a street or room. Such mirrors were like ornamental and unsymbolic pictures, like the still-life paintings similarly hung in similar rooms, with an emphasis on a detached view of visual phenomena. It can, of course, be argued that there is no lack of symbolic meaning in the hanging of these Dutch seventeenth-century mirrors, in reality and especially in art. But in the paintings the medium for such meanings is so emphatically offered in terms of the random arrangements of common existence that the symbolism is obviously intended to be somewhat hermetic and not figured forth clearly, as it is in much Renaissance art, for quick reading and comprehension. After this period large rectangular mirrors were more commonly used in Europe as household decoration, fixed to walls in the reception rooms and not confined to the dressing table. Both the portable convex metal mirror and the small glass hand mirror lost some of their pictorial significance for artists and appear less frequently than before.

Genre scenes became frequent in French and Northern European art in the seventeenth and eighteenth centuries, and mirrors shared in their dispassionate spirit. Sheer visual value—the importance of light and shade, space and movement—came both to enfold and to expand the earlier, more densely packed symbolic baggage carried by mirrors and pictures. They both enlarged. The Baroque sensibility could conceive a sense of mirror and picture as extensions of optical possibility, to show the reflexive power of light making the space seem to open out beyond the frame, inward and outward. The reductive, convex mirror does the opposite: it gathers light and space into itself, and so do the paintings of the fifteenth century and much of the sixteenth. Meaning is similarly gathered *into* the Renaissance mirror and intensified, as it is in Renaissance paintings and in the mirrors inside the paintings. But it is diffused and dilated in Baroque and later mirrors.

Seventeenth-century mirrors are often shown in paintings as catching incomplete aspects of a scene or figures, as if unawares: back views, glancing side views, views from above the head, as in one of Vermeer's paintings (VI.4). Others, as in Metsu's *The Letter,* reflect only a section of floor or window (VI.5). Such mirrors are like the other elements in these paintings: the open doors into rooms beyond, the open windows casting light inward and drawing the gaze outward, the paintings and maps on

VI. 4 JAN VERMEER (1632–1675)
Lady and Gentleman at the Virginals

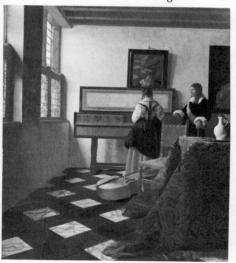

VI. 5 GABRIEL METSU (1629–1667)
The Letter

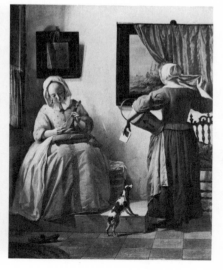

the walls offering dimly glimpsed and half-articulated reflections of this life in other terms. These are not the agents of truth or falsehood, only of neutral illumination, unsought.

There was, in the seventeenth century, no lack of pictorial variations on the old theme of the beautiful woman looking in a mirror. Such a woman, whether she is called so or not, seems always to be an image of Venus, in a dangerous aspect—the one that irresistibly lures men to destruction just by steadily looking in a mirror and perhaps arranging her hair; the Lorelei and the mermaid with comb and glass are versions of her. Rubens and Veronese show her pointedly looking at us; and Velásquez has her pictured gaze completely brooding and ambiguous, with no excuses such as hairdressing presented at all (see I.49). In the same century the opposite theme, showing the mirror confirming and intensifying the power of death, not love, is offered several times by Georges da La Tour in a similar lady-in-the-mirror format. In these paintings she is a variation of the "seeress" theme: she stares not into her own eyes and not at a grim vision conjured in the glass, but at the reflection of a very palpable candle that is sitting on the table, or at a skull (VI.6). These de La Tour paintings, usually intended for repentant Magdalenes, have the curious look of a woman peering at a painted still life. There is something detached about the scene, something that also makes the lady seem to be judging the effect of a mirror placed in the room for the same reasons as the one over Vermeer's virginals—or wondering where to hang it.

A telling painting by Terborch combines this new sense of the open-minded, objective glass with the Venus theme (VI.7). In the traditional Venus-like way, the lady has the mirror held for her by a pretty youth, a version of Eros, and she is also attended by a maid. But she has been distracted from her potent self-portraiture and looks up for a moment. The indifferent mirror nevertheless keeps its eye on her, and we get her unarmed, powerless face reflected for us as neutrally as if it were a vase of flowers or the corner of a bookcase. An eighteenth-century example in a similar spirit catches a serious young writer unawares, in a mirror that seems to stand for the illuminating power of the imagination (VI.8).

Eighteenth-century Rococo mirrors acquired illuminative and decorative functions that have been maintained ever since for the arrangement of pretentious interiors. Baroque notions of pictorial and actual space had permitted mirrors to be further and further enlarged, so as to line whole rooms with framed and decorated reflecting surfaces. They came to be used on ceilings as well as on walls, and (as at Versailles) to create huge

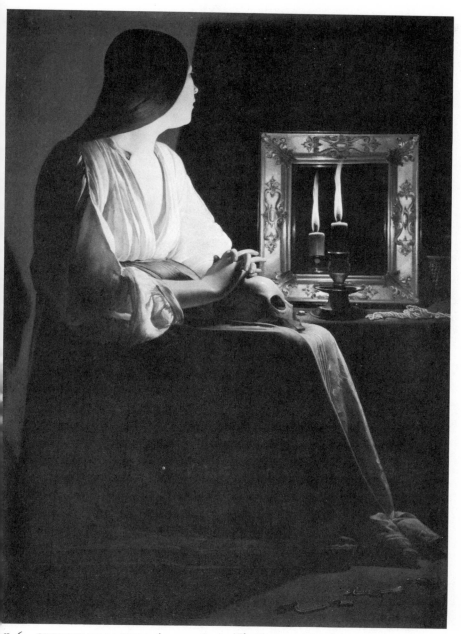

VI. 6 GEORGES DE LA TOUR (1593–1652), *The Penitent Magdalen*

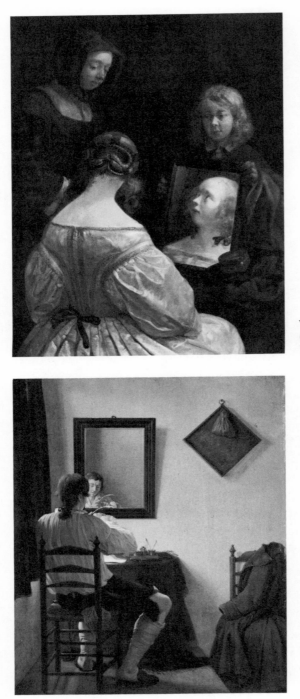

VI. 7 G. TERBORCH
(1617–1681)
Woman at a Mirror

VI. 8 JAN EKELS
(1759–1793)
A Writer Trimming His Pen
An enlightening mirror

redoublings of walls and windows by reproducing them in mirror glass on the opposing wall. Such mirrored paneling reduced the living people themselves moving about in the room to the status of decorative figures. Their reflections were like the ones bounced off the frescoes painted in the alternating panels, or from the tapestries and worked upholstery. These mirrors were obviously not for looking into but for glancing at. Real people appeared massed and grouped as if they were nameless nymphs and minor allegorical figures, invented only for the casual pleasure of the eye and not the enlightenment of the soul. Small mirrored rooms, a favorite indulgence in the eighteenth century, had the same purpose. Bathrooms with mirrored walls reflected multiple nudity as if it were semipornographic decorative art, like Boucher's wall paintings. The decorative mirror repels too close a self-examination, as it repels too intense an eye for pictorial meaning, like its counterpart in mural decoration.

The dispassionate mirror appears appropriately in Impressionist art as a slice of life within a slice of life, another aid in demonstrating the truth of fleeting vision without symbolic or picturesque pretensions. Impressionist painters could also show mirrors helping to diffuse light, as a vehicle of color. But their sense of mirrors as windows on the truth could not have been unaffected by the increasing scope of photography. Because of the possibilities of the camera, the picture showing the subject taken unawares acquired new meaning and new kinds of visual authority. Pictures began to be painted of people engaged in odd, unfocused action, behaving without reference to one another (let alone to the viewer), without expression of face or gesture, and uncoordinated by a gracefully ordered composition (VI.9). Figures might be arbitrarily cut off by the painting's edge at random anatomical points. This new pictorial way of looking at people obviously gave new sanction to the similar way mirrors have of grabbing and framing the untidy vistas of ordinary life; and mirrors, too, are shown doing it in the paintings.

Decorative impersonal mirrors, intended for the optical extension of sumptuous interiors, kept their prestige through all the successive styles of interior opulence current in the late eighteenth and early nineteenth centuries. By the last quarter of the nineteenth century, however, these mirrors had accumulated so many associations with middle-class material indulgence, wealth, and luxury that they ceased to be considered quite so tasteful for refined private dwellings (even vast ones) and now were judged to be more suitable for opera houses and theaters. From there it was only a brief step to flashy restaurants and luxury hotels, and thence to gambling dens and whorehouses. In France, at least, mirrored paneling fi-

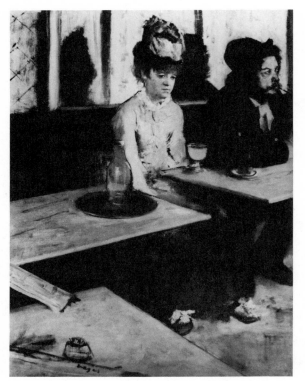

VI. 9 EDGAR DEGAS
(1834–1917)
L'Absinthe (*Au café*)

nally became the characteristic decor of *charcuteries* and *pâtisseries,* those other expensive temples of fleshly lust.

The old, deep-seated fear of the deadly mirror now expressed itself anew as a sense of the wickedness of excessive mirror paneling. Mirror decor was a kind of emblem of physical self-indulgence, pursued in a context of questionable wealth—*nouvelle richesse,* ill-gotten gains, and immoral earnings. A single large mirrored panel over a mantel remained respectable, presumably because it was chiefly engaged in reflecting the bric-a-brac on the chimneypiece. It also served, of course, as a kind of genre painting of a ghostly opposite interior—the looking-glass world. Another socially acceptable mirror was the narrow panel between two windows, a discreet bourgeois remnant of the grand effects at Versailles. Paintings show it, too, catching neutral domestic vistas (see I.60, 61). Respect could thus be paid to the pictorial meaning of mirrors—the overmantel or between-windows mirror is like a painting of a landscape or an interior—but without personal risk. It is not for looking in but for looking at. (If you do look in, you may have to climb in, too, like Alice.) Ingres shows his sub-

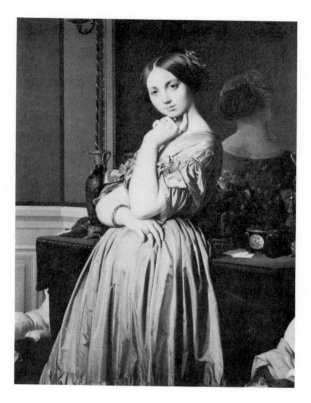

VI. 10 J.-A.-D. INGRES
La Comtesse d'Haussonville,
1845

ject indifferently turning her back on it but just happening to offer us fur-
ther proof of the perfection of her toilette, like a rear view in a fashion
plate (VI.10).

Large-scale mirror decor as a possibility for tasteful interiors had to be
eclipsed before its revival in the present century. The personal mirror,
however, never ceased to flourish, and was framed and placed to match
new concepts of portraiture. Besides the indispensable ladies' toilet-table
mirrors, now cunningly fitted to fold or tilt or both, there was at least one
that was made to attach to the top of a lady's desk, to produce for her own
satisfaction the image of its owner gracefully writing letters. Genre paint-
ings of ladies writing, rendered with a light touch, were common enough
in the eighteenth century, and one can imagine the desire to sit alone at
one's correspondence, able to check constantly on one's resemblance to
certain elegant engravings.

Most significant in the nineteenth century was the full-length mirror
for dressing, used by both sexes. The new invention of a wardrobe with
mirrored doors made private self-contemplation for men into an institu-

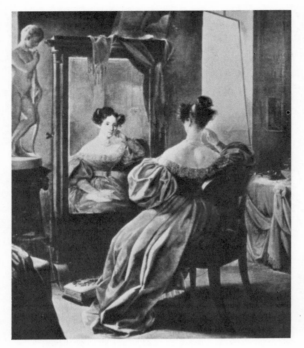

VI. 11 FERDINAND
LUITGENDORF-LEINBURG
(1785–1858)
Lady before the Mirror. The
drapery around the mirror
completes the picture

tion, apparently not an entirely comfortable one. A certain disapproval of this piece of furniture existed, to confront which the dandy Barbey D'Aurevilly said in his own defense, *"C'est comme un grand lac où je vois flotter mes idées avec mon image."* The free-standing full-length cheval glass for women became a nineteenth-century fixture, and for the first time paintings and graphic works showed ladies admiring themselves naked at full length in mirrors; others showed ladies creating full-length clothed self-portraits in them, instead of just head-and-shoulders portraits, in the traditional way (VI.11, 12). Still other satirical pictures appeared showing members of both sexes rehearsing speeches or theatrical scenes before the mirror (VI.13, 14).

The flavor of both the ridiculous and the profane is very strong in all such pictures. The mirror is shown and obviously felt to be both menacing and degrading, and it figures in many other kinds of nineteenth-century paintings that have somewhat obscure but sinister meanings. A large overmantel mirror is witness to the faithless wife's exposure and prostration in Augustus Egg's *Past and Present,* as it also is to the strange scene in Degas' *Le Viol* (VI.15, 16). The huge mirror backing up Holman Hunt's

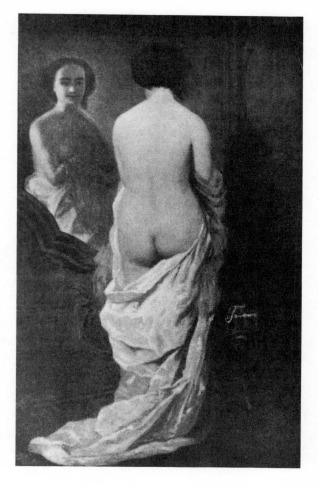

VI. 12 T. COUTURE
(1815–79)
At the Mirror

clandestine lovers in *The Awakening Conscience* (1853) shows us (in mocking reverse) the sunlit world gazed out at by the bemused girl from her imprisoning nest. Half a century later, this mirror is directly echoed in Hunt's fearsome *Lady of Shalott* (1905), in which it again appears (this time obedient to Tennyson's text) backing up a crazed lady, here caught in her hair and her threads, just about to gaze out like the earlier girl, only now to crack the mirror by looking straight at truth (VI.17, 18).

From such works one can see how mirrors seem likely witnesses to the critical moments in moral and sexual life—especially disastrous ones. Ford Madox Brown's unfinished *Take Your Son, Sir!*, a grotesque and brutal picture, has a distorted domestic scene reflected in the halolike convex

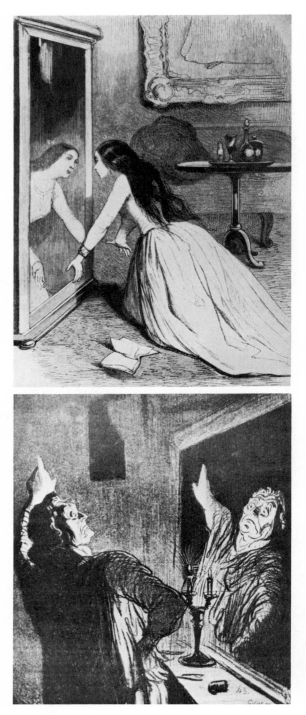

VI. 13 GAVARNI (1804–66).
*"Ah! Seigneur, protégez une
vierge chrétienne."* Woodcut,
c. 1840

VI. 14 H. DAUMIER (1808–79)
*The Actor: "Mon Vieux Talma,
tu peux te fouiller."*
Lithograph

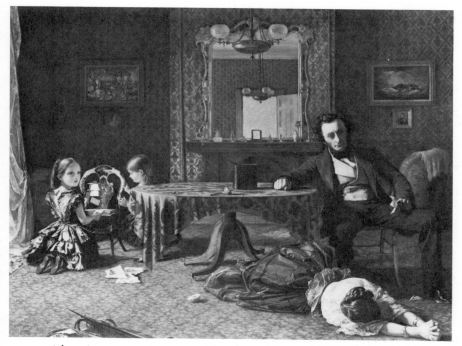

VI. 15 (above) AUGUSTUS LEOPOLD EGG (1816–1863), *Past and Present No. 1*
The mirror as witness

VI. 16 (below) EDGAR DEGAS (1834–1917), *Interior (Le Viol)*, 1875

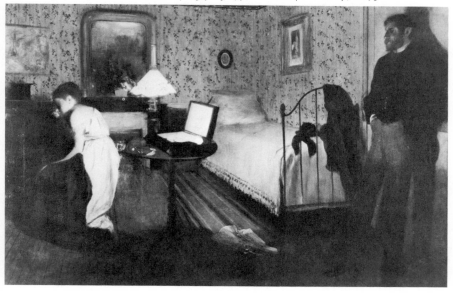

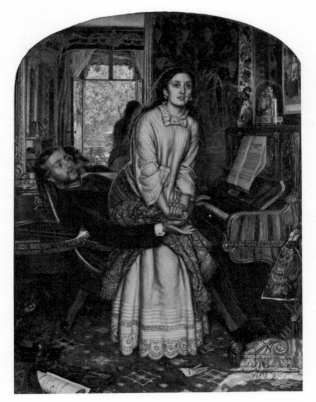

VI. 17 WILLIAM HOLMAN
HUNT, *The Awakening
Conscience,* 1853

mirror behind the grim woman's head as she thrusts the baby forward
(VI.19). In the same vein, but in a wholly different mode, the impersonal
French mirror reflects the backs of the heads of Degas' absinthe drinkers,
Manet's barmaid, or Toulouse-Lautrec's prostitutes, as they gaze unfo-
cusedly at nothing in unemotionally sinful surroundings. This is the
other kind of mirror, which need not bear witness to crisis but can be
trusted to bend just as gleaming an eye on spiritual death as on physical
beauty.

The significance of the mirror has by this time come full circle. In the
seventeenth and eighteenth centuries, when the vessels of symbolic mean-
ing in pictures were altering their style, mirrors had simultaneously
needed to change their focus and back off from too much intensity of
function. New pictorial conventions enabled them to be agents of de-
tachment and finally of mere ornament. But the self-consciousness of
nineteenth-century art drew the mirror back from the neutral spreading of

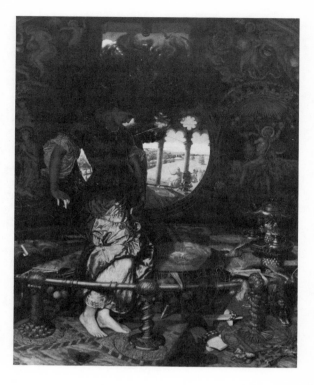

VI. 18 WILLIAM HOLMAN
HUNT, *The Lady of
Shalott*, 1905

light into the orbit of moral concern and visual discovery where it had
begun in the early Renaissance. Nineteenth-century satirical artists took it
up with greater ferocity and scope than ever. The toilette mirror came eas-
ily to hand for satire: Goya's horrid crones staring besottedly into the glass
(¿*Qué Tal?* and *Hasta la Muerte*) are echoed by various ferocious cartoons
in England. One, from 1805, called *The Looking Glass in Disgrace,* shows
an ugly old lady smashing her mirror with curling tongs.

It took the rise of the Dandy and the genius of Daumier to recover the
much-neglected theme of the fool in the looking glass as an emblem of
silly male pride, rather than the usual one of female vanity. G. F. Hart-
laub, in his unique *Zauber des Spiegels,* has one 1590 print of a male mon-
key in a huge ruff holding up a mirror and another of an idiot holding
one with the motto *proditor stultitiae;* but since the time these were done,
Daumier's male politicians and actors gesticulating and emoting before
the mirror are unusual in satirical art, although there were many harsh
pictorial spoofs of dandyism. Of the serious lesson to be learned from the
image of the Man Before the Mirror, only Narcissus survived as an illus-

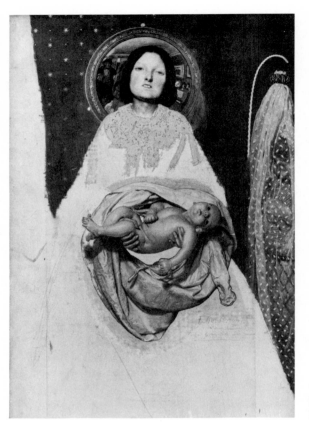

VI. 19 FORD MADOX
BROWN, *"Take Your Son,
Sir!"*, 1856–57

tration, at least into the early seventeenth century, as an example either of
tragic self-knowledge or of erotically potent self-regard, à la Venus. Cara-
vaggio's *Narcissus* is an impassioned example of the latter.

Narcissus himself as a serious subject, interestingly enough, seems to
have escaped the moral intensity of nineteenth-century English painters,
and he also appears only rarely as a generally Neo-Classic phenomenon. It
was an age of heterosexual dandyism, and it may be that a more overtly
expressed homosexual feeling is required in society before Narcissus may
flourish in art. Wilde's Dorian Gray (to whom Lord Henry gives a mir-
ror) is a latter-day Narcissus, a flower of the homoerotic fin-de-siècle atmo-
sphere. Early- and mid-nineteenth-century mirror morality in art, however,
concentrates on women. The later version of Burne-Jones's Pygmalion
kneels before his vitalized creation in the presence of a carefully rendered
convex Renaissance mirror—another background commentary on love,
art, and the soul. The same artist's vision of the confrontation between

Elinor and Fair Rosamund has a whole bouquet of little convex mirrors behind the rivals.

French mirrors in art kept a certain detachment, filtered through realism, satire, and, later, symbolism. The best and one of the only male mirror moralities in contemporary European art is Magritte's *Reproduction interdite,* a portrait in which not only the spectator but the subject himself gazes at a mirror view of the back of his head, which reproduces the direct back view the spectator also has of him (VI.20). This is a comment on the truth and not the falsity of the mirror, a reminder that the mirror really sees only what is actually visible. The man's face may theoretically be on the other side of his head; but what is visible is the back of it, and so that is what the painted mirror must also show. What the man sees does not exist because he is really not a man, only the part of the picture consisting of the back of a head. The mirror is the mirror of a picture, and so it must record only what the picture shows.

The modern mirror meets the eye carrying the accumulated weight of centuries, and film has taken over from painting the task of illustrating

VI. 20 RENÉ MAGRITTE
(1898–1967)
Reproduction interdite

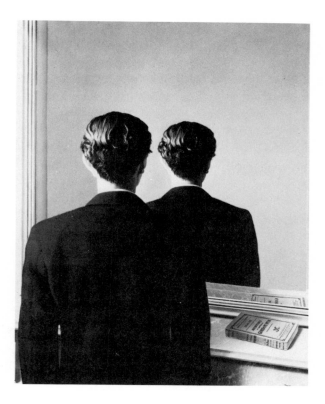

413

the theme of self-knowledge in modern art. In *Orphée,* Cocteau relies both on the banal prevalence of domestic mirrors and on the old legacy of mirror-fear. This modern-dress Orpheus, to his deep amazement, finds the door to hell always open and waiting just inside the frame of the bedroom looking glass. He learns that to summon Death one need only gaze invitingly into the mirror's depths. Anyone can do it (one certainly need not be a poet); Death will walk right into the room through the glass, beautifully groomed, articulate, and ready to pay personal attention. The familiar furniture and wallpaper make this cinematic Death-through-the-mirror scene hair-raisingly immediate.

The personal reflection, however, is now largely merged with the public scene. Despite Cocteau, private mirrors have lost a lot of their uneasy meaning because they have come to share in the common mid-twentieth-century use of reflecting surfaces for all kinds of industrial design, from hubcaps to skyscrapers. Plate glass, both clear and mirrored, now faces out into the street, freely scanning those limitless prospects just as mirror paneling once faced itself indoors, exclusively imprisoning princes and courtiers, or whores and their patrons. Now the mirror turns outward and, with a total flexibility of focus and motion, catches clouds, crowds, horrors, beauties, the distant flow of traffic, or the near individual. And so reflecting glass on city streets all over the world makes constant instant movies out of life in action (VI.21).

Indoors, public and private mirror paneling has lost its connotations of sinful luxury, since it is now indiscriminately applied to the walls of fast-food lunch counters, banks, jewelry shops, supermarkets, shoe-repair and dry-cleaning establishments, elegant hotels and restaurants. Thus the interior mirror also provides dispassionate cinematic shots, and the absence of moral freight is in the jaded eye of the beholder. In private dwellings the chrome toaster so circumspectly reflects domestic bickering that the overmantel mirror loses its old standing as the moral and aesthetic eye of the home. In pictorial art mirrors have their current moral meaning (or lack of meaning) expounded in pictures that expand the convention that art is the mirror of life—that is, the very convention of representation. The mirror as such a commentary on the role of art itself appears with great éclat in Picasso's *Girl before a Mirror,* in which the two images confront each other and interact, each completing the other, the two forming one whole as visual life and visual art do in real experience (VI.22).

Art in the twentieth century shows that the vanity mirror and the wardrobe or closet-door mirror have lost their old significance, their old powers of entrapment and deceit. Self-image-making is the acknowledged

VI. 21 DON EDDY (b. 1944), *New Shoes for H,* 1973–74

activity of us all, and we know we need our private camera and screen for our personal productions. Mirrors are generally represented as impersonally benign enhancers of visual experience, including the visual experience of the personal self. In this very fact, however, is generated our continuing fear. Dread of mirrors may have acquired the quaint flavor of superstition, proper for overt mention only in myths and fairy tales and fantastic stories, with or without modern costumes, but it does remain. We are still ashamed of our self-regarding impulses, our desire to see ourselves face-to-face as pictures, and so to acknowledge that we inwardly see ourselves that way. We are afraid that psychic harm and social censure, if not spiritual damnation, may arise from too much study of the mirror.

It is the restless ghost of centuries of past fear that haunts the most furtive snatchers of intimate personal survey and those who make ritual faces and noises of disgust when first facing their reflection. And yet the ubiquity of mirrored surfaces, their public availability in contemporary

VI. 22 PABLO PICASSO
(1881–1973)
Girl before a Mirror, 1932

life, suggests the idea that making visual fictions out of the self is an activity not only common but quite outside the spiritual and moral dominion. Twentieth-century society requires the theatrical approach to physical looks. The large mirror inside or outside a public building (where it is sometimes simply the window, backed with darkness) seems like an extension of the one in the dancers' classroom, where personal physical images must be constantly checked and measured against the mental picture. The present theatrical attitude to clothing supports this comparison.

The mirror remains a picture, inextricable from the representational style of its moment. What appears there is what pleases most in pictures, and what fails to please in the mirror is either changed by force of visual will or ignored. Looking in the glass ideally gives us an instant portrait in the current style, with clothes, pose, expression, and gesture to match. We may believe that without mirrors we cannot know how we look; but beyond or behind that is the fact that without pictures to begin with, we do not know how we look in mirrors. The filter of art is necessary, and through it we acquire the right perception of all clothed selves; but the mirror connects our own with the others. We may be tall or short or old or young, but what we think we look like must align in some way both

with what others look like and with what contemporary pictures tell us is the truth of looks. In the realm of dress, every man is his own artist, and his creation must be confirmed as a picture, a visual composition. To aid his self-creating eye, ideal pictures and reality meet in the polished glass.

There remains the danger of self-deception, the possibility of failure (common to bad artists) to perceive correctly. Vanity holds sway over corruptible human vision, preventing self-knowledge even in the crudest terms of outward aspect. Creation in the form of fiction is as always easily confounded with lying, and in the visual aspect of self-awareness this seems as difficult to avoid as in the psychological one. Mirrors keep their status as gateways to hell by being possible engines of falsehood and threats to integrity. If the mirror remains the emblem of the soul, it must probably also remain the symbol of spiritual pride.

People look at their clothes in mirrors to see how they fit into the common visual scheme or indeed to make themselves fit in. If the world is a movie, and each single view a still shot, the mirror obligingly absorbs and sends back photographic images, with the pattern of light and shade showing the variations in texture of skin and cloth, the deceptive outline always fattened by possible movement, the random action of fabric and the shift of bone and tendon catching the light. When the usual picture of a person was a tinted steel engraving, with stylized smooth flesh and flattened, motionless details of costume, the mirror undoubtedly provided that, too. If people are perceived as most truthfully seen in head or bust portraits, mirrors will be those. Truly objective vision at any given moment may be the property of God or possibly of the citizens of one age looking at another with privileged historical perspective; but it is not within the scope of mirrors unless they reflect only the stars. In human life the mirror is an aid to art's government of the eye. It is an affirmation of faith in the process of visual representation and of satisfaction in the existence of conventions for it.

Mirrors, of course, do simply reflect. Looking in a mirror could not bring a stylized image of the beholder directly into being without the work being done in advance inside the head. The mirror itself is merely obedient, despite its convenient mythology of independent creative power. Visual expectation is what makes the reflected image take a certain kind of pictorial style when it is perceived. The expectation is engendered by pictures of people that have been made to "look real to their own generation"—Berenson's characterization of the Renaissance artist's task. He was talking about the fifteenth century, but the task has since been taken up in all generations. Serviceable realistic images of the human clothed

figure are apparently perpetually needed and so are perpetually supplied, always according to taste. We have seen how making pictures look real causes reality to look like pictures; but apart from altering the style of actual perception, pictures create a mental image, an expectation of how people should look, which waits behind the eyes to be used, whether on others in the world or on the self in the mirror.

But there is an even more traditional place.

The mirror in which the mental image of the human figure has been constantly required to take shape is the mirror of literature. Now, the "mirrors" of literary convention are usually reflections of being, not seeming. The "mirror of mankind" and *The Mirror for Magistrates* and the creative literary task of holding a "mirror up to nature" have all referred to the concept of reflection, a metaphor based on the optical phenomenon but not the phenomenon itself. On the subject of human life, the representational "mirroring" function of literature has been most valued when it has been less visual than moral, emotional, and spiritual. Descriptions and re-creations in words of how people feel or behave have been most easily remembered and respected, and have been extremely specific and refined from the time of the earliest recorded literature. Delicate shades of shame, modulations of pride, subtle, unconscious forms of boasting, and ways of expressing admiration have been described in Homer's epics and in other antique texts, along with love and grief, giving them universal value in all generations and across huge gulfs of time and social difference. But the most telling visual representations of people in literature (complete figures, not just faces) have been connected first with behavior and the description of action and only secondarily with line and form, color and texture—with the changes in facial expression, the meaningful movements of bodies, and the resultant movements of dress.

Clothes may be universally recognizable when they are simply described as flowing or dragging or muffling or veiling; but upon closer examination, it soon becomes evident that representations of the actual physical look of bodies in their clothes as they might actually appear to the eye have, unlike representations of character and feeling, little specific incisiveness. The evocation of garments in literary art has seemed most realistic when it has been offered in connection with dramatic conditions or actions. Descriptions of

the behavior or state of garments (leaving out how they are made or normally look) may be as universally understandable as that of states of mind; dirtiness, raggedness, heaviness, freshness, a windblown or water-logged condition, may sometimes be the case with all kinds of human dress, as fear may strike all human souls. But how garments are visually designed and how they look when ordinarily worn is the part of the image that is nearly always missing from the literary mirror when it is held directly up to nature.

Color and embellishment and accessories, however, do very well in much literary clothing—deceptively well. Many lines of poetry and descriptive prose have been taken up with what appear to be thorough descriptions of dress but are devoted almost entirely to surface detail. The basic construction and what advertising prose calls the "total look" are left out—the harmonious aspect of the body in its dress, which creates its visual style. The fancy costumes in Renaissance pageants were lengthily described by eyewitnesses who were not engaging in any imaginative effort; these descriptions, too, concentrate entirely on what fabric and what color the clothes are made of, what kind of trimmings are applied to them, and what objects are carried by their wearers; the actual cut and fit of the garments, their shape and outline, along with the general proportions of the body and its posture, and often the specific arrangement of the hair, are missing. All the details are there but not the way it looked.

The reason is obvious. Just as the image in the actual mirror depends on a preexistent pictorial vision, so the mirror of literature depends for its basic representations of personal looks on pictorial expectations. In the mind's eye of both writer and reader already exist the elements of a representational style, a notion of how people "really" appear. What is written need contain only what must be superimposed on such common visual knowledge, to suit the needs of the literary circumstances. Most often for clothing itself, these are the details of fabric, color, and trim or some extraordinary action of the clothes and body. But even with respect to certain normal actions for hands and legs, and certainly for hair and faces, the evocation of a visual image depends on a commonly accepted style of "natural" bodily gesture. This movement is linked with the commonly accepted look of the "natural" body altogether (dressed, of course), and so a reference not only to clothing but even to fundamental bodily movement in literature must ideally depend, for its correct visualization in the reader's imagination, on awareness of the art of its moment.

For meaningful action itself, rather than gesture—action important to

the drama or the conceptual vision of the work, sometimes even the action of clothes (just as for landscape and buildings when they signify in themselves, not in their looks)—the reader's visualization of style may sometimes need to be vague, or it may not even need to occur: the writer himself may not be visualizing. He may be imagining motive, feeling, mood, and he may purposely choose words carefully so as to leave out any suggestion of concrete visual form, so that the reader's inner eye shares the writer's own license for absolute freedom, including the freedom *not* to visualize.

The most sophisticated writers have always kept strict control over visual material; but it has a rather special application in the case of clothes, since characters cannot do without them. A character "brought to life" in a work of fiction is, of course, "embodied" in some way, and that means dressed—nakedness in any art being simply one form of costume. His very being, his lifelikeness, naturally requires some indication of a physical form to convey his inner feeling and outward behavior. But it is customary to make the selfhood of a character (perhaps including his basic facial and bodily qualities) precise and at the same time to keep his clothing visually imprecise, although it is sometimes necessary to make it dramatically cogent. This representational method works if the reader has got the right mental image of how contemporary people look. But a certain amount of equivocation is involved if true representation, or the "mirroring" of real human life, is the aim. Life includes not only the perception of outward physical reality and the inner state of mind but the inward sense of the physical reality of the bodily self—the self-image.

This inward sense is so large and so obvious a part of human life that every age has a kind of agreement about the universality of it, just as if it were like hunger or fear. It is universal, but it obviously varies substantively. It varies according to dress—and, of course, the look of both of them engendered in the mind's eye varies according to images current in visual art, whether the mind's eye is inwardly perceiving the self or monitoring one's perception of others. This important element in life is recognized by certain sorts of writers. In particular it is used by realistic novelists, although not usually for itself alone but because of their commitment to dealing with the significant minutiae of social institutions, of which dress is obviously the most expressive. Balzac is the readiest example. But in a good deal of fiction and poetry, as well as in straight description, the actual look and feel of customary clothing are believed to need very little verbal attention. It seems to be assumed that everyone experiences them in the same way and always has, just as they are assumed to have experienced such things as petty jealousy and frustrated ambition.

Rooms, forests, buildings, objects, streets, and oceans in themselves have no human motivations and principles, to be represented as modified by emotion and circumstance or expressed in action; their physicality is their only quality. Variation in their style or aspect, even when it is not intrinsic but perhaps projected by a character's distorted perception, is their only expressive medium. They have no self-image. Therefore any suggestions about the *look* of scenes or things is a record of some outward perception—the writer's or a character's—and consequently more completely under the writer's control than are his characters themselves, with all their resonant (even if unarticulated) inner dimensions. For the rendering of objects in the external world, the details or lack of them, the variety in the mode of representation, and the vagueness or sharpness of its flavor are part of the literary work's essential quality. Readers will get all they need—that is, they will get exactly what the writer wishes to indicate about the visual qualities of rooms or landscapes, including the degree of their clarity. If the reader wishes to fill in anything else mentally, that may safely be arbitrary, and the style of the additions will be insignificant and irrelevant because the meaning and the author's express intention have been sufficiently established.

In the representation of human beings, however, lack of visual clarity, especially with respect to clothes, means something else and produces a different result. People's important qualities in representational fiction are spiritual or mental, perhaps social or temperamental, even conversational; and as these are felt to approach the universal, the better the fiction is judged to be. Consequently, the style of their dress, their historically determined or specific and stylistically presented way of looking, is assumed to be irrelevant. This is, of course, not assumed to be true of their essential physical characteristics (a plump, sullen face with sharp eyes; a thin, nervous face with twitching nose; an ample, loose-jointed body; a thin, stiff frame), which may always justly be considered the outward and visible signs of inward and spiritual facts, and therefore equally universal. But the inner awareness of physical and spiritual selfhood is simultaneous, and physical selfhood must include clothes, just as it must include sex. It is essential, not peripheral, to someone's life if stays, long, full skirts, and long hair bound up are constant facts of physical existence, or a stiff neckcloth and tight trousers or a short tunic and bare legs. And the way these things look, and are felt to look, is essential to *them*. It is certainly possible not to care how one dresses but impossible to be unaware of the normal look and feel of clothes in one's time. Clothing remains an inescapable visual phenomenon, even for the unconscious inner eye and even for the indifferent outward eye.

In the representation of personal feeling, moral state, or physical action, just as with physical objects or scenery, a writer may anatomize minutely or barely suggest; he truly controls what is given. With the physical self in relation to its dress, however, neither general suggestion nor minute detail in itself can give the truth if it does not take into account the clothes' specific *style* of looks—since for clothing, its style is its essence. There are no universal garments, whereas there may be universal feelings. When a writer refers to clothes only in terms of action, he is leaving out the most important aspect of their reality—not their detailed surface look so much as the sense of their general look. In fiction, however, clothes are generally treated less as visual phenomena and more as aspects of emotion, to be similarly communicated to the reader, often in terms of behavior, and so assumed to be recognized by him as having kinship with his own experience. But they are in fact visual, and the way they look is part of the primary being of the people wearing them. And the sense of clothes, which always varies according to the look of clothes, must actually vary through history much more than the feeling of love or vengefulness or embarrassment or triumph.

The visual character of clothing, then, is perceived inwardly by its wearers and outwardly by observers as part of their identity and normal aspect; and indeed it is something so large in life as to be omitted in writing as unnecessary, like the sense of having a head and two hands. And yet this missing material, this essential quality of dress, creates at least half the physical self. Moreover, in most fiction it is in fact tacitly supplied. It is assumed to be provided by the mental image the writer has and expects the reader to have, which both of them will have acquired through current pictorial style.

All these generalizations refer to representations of the writer's own time for readers of his own time, as well as to the work of writers who represent other times exactly as if they were their own, in all physical and personal particulars. Roman lyric poets, Greek tragic playwrights, Elizabethan dramatists, and certain Victorian novelists usually do the one or the other. When a present-day reader of a Latin poem, a Victorian novel, or an Elizabethan play is visually well educated and has seen a lot of pictures, he will have convenient mental images (perhaps vague but strong) of the look of dress in Roman or Victorian or Elizabethan times to conjure while reading; and so the missing material is supplied, correctly if somewhat nebulously, almost automatically. But if he has never seen any pictures other than those of his own day, he may well get a mental image of people dressed in the clothes of his own time; and if he does, he will have not a universal but a falsely specific notion of the physical selves about which he is reading. Or,

carefully refraining from visualizing, he may think he has grasped some universal truth of clothes—a thing that does not exist.

If a reader visualizes Catullus in trousers and a turtleneck sweater, for example, he might conceivably argue that this does not matter because Catullus' feelings about things other than clothes are so very immediate, and can be felt and recognized by people who *do* wear trousers and turtlenecks. But it remains true that the actual Catullus who wrote those poems had certain feelings about himself and about others that were infused with the sense of physical selves clothed in Roman clothes of the first century B.C.; these were just as important to him in their specific qualities, though perhaps not admittedly, as jealousy and impatience.

Catullus, of course, was not writing novels or plays; his lyrics are of such a taut weave that they permit no interstitial gaps needing visual filler from the reader. He gives what he wants, and there is usually no room for anything else, so that what is transmitted really is universal. Shakespeare, on the other hand, dealing with no less universal material, not only includes vivid description to suit dramatic requirements but suggests much more than he describes. He purposely evokes mental images, admittedly to fill up with language the comparatively arid visual space of his stage; but he also understood people's love of visualization and their habit of self-visualization—their awareness of the way they simultaneously feel and look in their clothes.

Shakespeare's own sense of dress was well founded in the general sense of clothing common at his time, and most of his references to dress appeal to the same sense in his audience—he does not try for nebulous "universal" effects or for exotic and historical flavor. When he has Cleopatra say, "Cut my lace, Charmian, come!" (I.iii) he can instantly convey the humanity of this ancient queen in terms of her inner sense of specific qualities in her clothes—and they are the qualities of Elizabethan clothes. In this scene she is not really fainting; she is pretending to need to have her stays loosened so as to impress Antony with her sudden gust of feeling; she is instinctively using her garments to enhance her effectiveness in the situation and to convey knowledge of her feelings and her self-image—she knows how tight her stays look, even if they really feel quite comfortable. In this line of Cleopatra's, Shakespeare demonstrates his knowledge of this kind of self-awareness and his further knowledge that the universality of clothing is in its very contingency, its constant specific modernity.

Elizabethan actors did actually wear contemporary garments on the stage, especially when they played royal and noble characters; but Shakespeare, rather than glossing over or verbally screening the fact that his antique

Egyptian queen is wearing a modern ruff, corset, and farthingale, insists on it. It is interesting, then, to look at the famous "barge she sat in" description of Cleopatra (II.ii). This passage has much detail conveyed with the aid of metaphor and simile, but Shakespeare is careful to say that Cleopatra's person "beggar'd all description." The fact that "we see the fancy outwork nature" means she is probably not actually nude, even though Enobarbus compares her to images of Venus. There are no clothes in the passage of any specific style or construction—the audience is free to visualize her in another familiar ruff and farthingale, or perhaps in an elaborate court-masque costume such as Shakespeare's audience might have known directly or from an engraving—or, indeed, since he does not prevent it, in modern Hollywood–De Mille Egyptian vamp drapes. Twentieth-century productions of *Antony and Cleopatra* tend to favor the latter form of costuming and simply omit the earlier line about the stay lace, so that Shakespeare's real cleverness about clothes is obscured.

Certain novelists who have dealt with society rather than myth, romance, or emotional drama have nevertheless opted almost wholly out of clothes, relying on other forms of being and seeming to carry the social and personal humanity of their characters. Jane Austen and Henry James both do this, although James is more daring and apt with his occasional references to dress than Austen. He is (perhaps because he writes at the other end of the nineteenth century from Austen) more aware of the importance that qualities of clothing have in the area of sensibility, but he hangs back from indications of specific style. Reticence in the verbal consideration of clothing among writers with such high standards as James's and Austen's may, of course, come from their own very deep acknowledgment of the power of clothing, of its much greater importance than that of other inanimate objects, and perhaps from an unwillingness to deal with that very thing.

On the other hand, knowledge of the social importance of clothes and the consideration of fashion are traditional novelistic concerns and very different matters. They often appear to be the preoccupations of this or that fictional character or even manifestly of the author; but this emphasis can occur without any reference to a general aesthetic or psychological sense of clothing on anybody's part; and the references to clothes themselves are often confined entirely to extraneous detail—ribbons, ruffles, patterns—unfocused finery to convey the notion of frivolity.

Many French novelists (Balzac, Proust, Flaubert) have had an intense concern with dress as an integral part of the self, and therefore even with its actual variable spatial properties in relation to the body. Proust acknowl-

edges that the huge, overladen hats and narrow hobble skirts of women infuse the whole quality of a certain period of time with their depressing difference from the tiny, witty hats and large, complex dresses of earlier days. It is not just the clothes, it is the women themselves who seem different, and so the texture and character of life itself is changed. Writing critically about paintings in which all the figures are clothed in the dress of the remote past, Baudelaire makes explicit the connection between fugitive ephemeral beauty of contemporary clothing and its human universality. He despises the idea that some attempt to represent man in a universally ideal way of dressing and looking could illustrate his most noble self; rather, Baudelaire demonstrates that it is in the very contingent, fleeting look of any current fashion that man shows his aspirations to an ideal, his creative longing—and the representational artist's task should therefore be to "extract from fashion whatever element it may contain of poetry within history, to distill the eternal from the transitory." The writer, no less than the painter, should do this, too.

If the idealizing nature of man is truly expressed in contemporary fashion, then he must also inwardly feel his own aspiring and hopeful self to be naturally expressed in the properties of his ordinary clothes. Since about 1820, men have felt that wearing trousers is natural to them. Theater and art (to Baudelaire's disgust) have tried to make men instead believe that drapery or gowns or nudity are worn by more ideally inspired or more universally human men than trousers are—or, by extension and exaggeration, that men who wear fancy costumes are more romantic and silly than those who wear trousers. Outside of France, most writers representing ordinary life beg the question by leaving the matter out, perhaps with the idea that to fail to particularize means to universalize.

Goethe in *Elective Affinities* (1809) seems at first to be deliberately vague, but later in the book he provides an exception. After a number of references to unspecified "new fashions" and "simple dress," he conveys with one or two small strokes a real sense of how clothes actually did look, so the period quality is naturally and effortlessly conveyed; and he does this by contrasting the look of someone's "modern" dress with that of a costume put on to imitate the clothes in an old painting for a *tableau vivant*. It is a beautiful method of calling attention to the decisive phenomena of fashion—in this case the high "antique" waists of current feminine dress seen in contrast to the low, tight stays of the seventeenth century, and the tight-fitting black suit of a modern man to the gaudy fringes and tassels worn for a biblical scene. This contrast is made without

shifting gears, and we get the specific look of current clothes *and* what makes them different from other clothes. All his earlier vagueness is redeemed.

Writers, of course, can get away with vagueness; painters cannot. Figures in pictures must wear something visually specific, even if it is only the fashionable nude body of the moment. One painter contemporary with Goethe who never took the easy (but tricky) Romantic–Neo-Classic way of depicting symbolic human beings in either "universal" garb or "universal" nudity was Caspar David Friedrich; his most pointedly allegorical paintings of men and women, standing for Manhood and Womanhood and facing all the mysteries of life, nevertheless show the figures in very definitely and crisply cut and fitted modern dress (VI.23). They are therefore, as Baudelaire would have said, by being totally unapologetic sartorially, totally universal. On the other hand, the draped attempts at ideal dress on the part of Benjamin West and other contemporaries strain quite vainly against the compelling fashion of the day, the look of which strikes through all their hopeful universalizations.

The lesson for literature is clear, and a number of Baudelaire's literary compatriots took up the challenge of showing positively that they conceived of clothes as an essential part of universal humanity. It may be that

VI. 23 CASPAR DAVID FRIEDRICH (1774–1840), *Woman in the Morning Sun*

a writer such as Jane Austen understood this, too, and simply took it for granted; if that is so, the contemporary garments in her novels, which she herself hardly ever describes or suggests the look of, must nevertheless be visualized by readers correctly according to pictorial knowledge of her time, or we do her a disservice. Here is an actual mistake in visualization that can be shown to have done some harm: the 1940 film of *Pride and Prejudice* (written 1796–97), starring Greer Garson and Laurence Olivier, was cinematically "visualized" as taking place in about 1835. All the costumes and a good bit of the village scenery were conceived in the 1940 Hollywood notion of a "quaint and old-fashioned" English style, which was fixed roughly at that date. Admittedly, the look was suavely and consistently carried out (barring some of the usual modernization of star makeup and hairdo), but it prompted one reviewer, evidently without his knowing why, to censure the film for being done in too Dickensian a spirit—of being too broad in its humor, too obvious in making its points. The acting in that film was actually extremely sophisticated, but the criticism certainly fits the costumes. The flavor of the novel was belied by dressing it up well over a generation past its time and into the period of Romantic exaggeration in clothing (VI.24).

Although we know the date of composition, there is nothing in the narrative to help us know how anyone is dressed in *Pride and Prejudice;* and this omission might seem to give historic license to the visual imagination. But Austen's characters are very precisely indicated, even if the clothes are not: precisely conceived as to their general look as part of the quality of their personal selves. Austen may not permit herself or her people to speak or even think of these things; but for us to visualize Austen characters in all their qualities, we need the look of the clothing proper to them to be consistent with her precision.

Ibsen's play *A Doll's House* is often costumed as if it took place in 1900 or even later, but it was published in 1879. The state of women's consciousness developed a good deal between those dates, and so did their clothes. To dress this drama up as if it were a late Shaw play, pregnant with the nascent sense of modern female power and independence, is ridiculous. Its action is contemporary with the suicide of Anna Karenina (1876), and it should look so and look as if it felt so, if it is to have its proper impact.

Prose and poetic romance, epic and historical fiction, all have special ways of dealing or not dealing with the representation of dress, and these self-evidently need most to depend on the conventions of past or current visual art. Inferior historical fiction has taken on the same tasks imposed

VI. 24 Scene from *Pride and Prejudice*, 1940

on itself by inferior pictorial art, especially the bad, old historical movies and advertising illustrations—tasks that seem like the careless fulfillment of duty while real attention is paid elsewhere. Certain details of dress that are agreed on through a sort of progressive, reductive vulgarization to be characteristic of certain historical periods must be, as it were, invoked; and then the rest of life may be portrayed in strictly contemporary terms. Readers and viewers must perforce swallow these whole, since they are not assimilable to the texture of the narrative or characterization, as, for example, the rare but telling details in George Eliot's historical novels always are.

One sign of tokenized historical dress in fiction is the use of certain generic old-days terms that have no one specific meaning: "cloak" is the most common, followed closely by "robe," "gown," "mantle," "hood," "veil," and "tunic." These are terms with broad and strong connotative power and virtually no unqualified meanings. They will do for all historical periods before the seventeenth century, when the terms for clothing became more approximate to their later use, for example, "coat" and "waistcoat." "Hose" and "breeches" are also fairly safe and broad historical terms for the clothes of the male leg, since they emphatically indicate

nontrousered times anywhere between 1200 and 1800. And so we get the following kind of thing: "Wiping his palms on his breeches, he flung his cloak over his tunic and mounted his horse" (the horse here is another sartorial detail, as it so often also is in art). Or, "Veiled and holding the robe close about her body, she fled down the stairs, her gown whipping behind her in the wind" (the wind is also sartorial).

Such vignettes will do for about four to six centuries of European life at least, and a good bit of antiquity besides. The terms are romantically dramatic and commit one to nothing; and the reader gets the idea that whenever in history the action is occurring, it is certainly not right now. Insufficient historical flavor would be conveyed by, "Wiping his hands on his pants, he flung his jacket over his shirt," or, "A scarf on her head, and holding the coat close around her body, she fled down the stairs, her skirt whipping behind her in the wind," although all these terms would certainly do just as well for vague historical clothes and better for conveying the sense of immediacy to modern readers. George Eliot deftly solves the problem by referring to historical garments (in *Romola,* for example) by their specific names (*becchetto* and *lucco* instead of "hood" and "gown"), sometimes followed or preceded by a small descriptive phrase, so we get what particular sort of thing the name refers to. The very peculiarity of the name makes the garments seem analogous to the specific ones in the paintings of the time. Such literary clothes thus visually defined are not at all to be grouped with the general historical drag called by the term "robe" or "mantle," which fails to specify style and quality and so fails to convey any real time, place, or feeling.

In sensational historical fiction most readers would probably be just as glad to do without things like "She adjusted her wimple" and stick to the action, which is easier to visualize in personal terms. In advertising art, the models who wear clumsily inept but pointedly historical costume are a little unpalatable and more than a little ridiculous; the flavor of such ads is usually humorous by necessity (VI.25), as, for example, when an awkward wig or a stand-up collar or a bushel of pearls is unabashedly superimposed on the image of a highly contemporary-looking person, to convey highly contemporary meanings. Designers for historical movies have raised their standards and ceased to do this, but the illustrators who do the paperback covers for "gothic" and "historical" romances are still at it (VI.26).

It is significant that the most successful advertising photographs incorporating historical dress are the ones that deliberately imitate actual paintings; ads for the furniture company that show photographic imita-

OSHKOSH TRUNKS

Why we didn't ask this lady to endorse Oshkosh Trunks

VI. 25 (left) Advertisement, 1930. Old-fashioned costume for comic effect

VI. 26 (right) Book cover art for Edwina Marlow, *Dark Drums*
Modern heads and bodies dressed for nineteenth-century colonial Africa

tions of Sargent's *Madame X,* Whistler's mother, and others must reproduce the costume as much as possible in its originally represented context, tone, and form. When literary reconstructions of past times do the same, they have the best chance of success (VI.27). Writers do best when the description of or reference to clothing invokes or re-creates as much as possible the quality of the known pictures of that past time—even if with only the merest suggestions and no details.

In order that a literary image of clothing may conjure a particular historical style or quality, and may evoke a pictorial image that makes it characteristic of the time, it has to be produced as if analogously. Clothes must be made to seem and appear to their wearers in the literary work as they are seen to feel and be perceived in the contemporaneous pictures. Such effects may manifestly be achieved by sensitive writers dealing with their own time, such as Henry James, in whose novels dress is very im-

VI. 27 Advertising
photograph, 1977

Not by bread alone.

portant as a characteristic of personal quality rather than as a matter of social importance, as in Balzac. James's verbal allusions to dress are in fact quite like Sargent's pictorial ones: well-chosen and well-placed fitful gleams with a very precise personal flavor, thrown up against a more generally suggestive and atmospheric background (VI.28). But for historical novelists, the difficulty in perceiving the visual experience of past history through its art makes for difficulty in the believable verbal rendering of one age by someone in another, however strong the will and deep the sympathy.

During the nineteenth century historical fiction and historical painting seemed to have identical goals of fidelity to the multiple material details unearthed by historical research. The novels of Walter Scott and the theatrically produced results of J. R. Planché's researches set the nineteenth century on a parallel and reciprocal course of historical visualization. Passages in novels seem to be describing contemporary historical paintings, and many pictures illustrated historical moments as if they were scenes in novels or operas. The Romantic contemporary mold into which all the antiquarian details were cast was also like an invisible forest in which were carefully planted so many finely drawn, carefully observed, and closely studied trees.

Even when Pre-Raphaelite poets and painters evoked the Middle Ages in a more self-conscious way, they also managed rather to evoke each other, and both convey their own common distinctive spirit without the need of reference to the visual taste of any historical period. Styles of dress

431

VI. 28 JOHN SINGER SARGENT (1856–1925), *Interior in Venice*

of all periods are subsumed and subdued entirely by the unique Pre-Ra-
phaelite visualization of life. Past and present are the same, and neither is
actual, though both are mythified in precise and manifold detail. Never-
theless, the very intensity of the Pre-Raphaelite gaze, as it was directed at
current phenomena, produced historical or legendary human figures sub-
tly betraying the usual look of clothed people at mid-century, even when
they were incorporated into medieval visions with clothes made entirely
out of scholarly research; the swell of hips, the set of shoulders, the pos-
tures of bodies, rhyme with those in pictures of acutely modern life, even
with those in popular engravings and fashion plates (VI.29).

Essentially unromantic historical fiction is undertaken by George Eliot,
whose most important novels take place at least a generation and some-
times two generations earlier than the time at which they were written.
And it is not only the state of commerce, social custom, and religious
commitment she is interested in but the qualities of self. Although she
deals with developments in politics, religion, and the advancement of sci-
ence, as well as with the serious politics of love, family life, and the spir-
itual economies of her characters, George Eliot is no less deeply concerned

432

VI. 29 J. E. MILLAIS
(1829–96), *Mariana*
Inspired by Tennyson's
poem—modern hair and
torso in medieval garb

with clothing, for she knew that the exact characteristics of customary clothing are as essential a part of personality as those of customary speech and opinion. She knew that habits of dress are like habits of thought: they feel natural, even unnoticeable, but they affect the actual quality of personal life while they may themselves seem to be independently changing through history. Eliot therefore took pains to be precise, not just about details of costume, which indicate date, but about the phenomena of personal perception and the aspects of self-awareness that are felt in terms of dress at a particular time in history. Rosamond Vincy's long, serpentine neck, bending, drooping, and turning away, her looped braids and her shoulders sloping under wide embroidered collars, are all characteristic feminine sexual charms of the 1830s—clearly shown in fashion plates— and Eliot incorporates them into Rosamond's own sense of herself. Attractive ladies in 1871 and 1872, the years in which *Middlemarch* was published, deployed their necks, hair, and shoulders in a very different style; and Eliot is careful to dwell on the difference in method rather than on the similarity of purpose and result. She is also good at conveying Lydgate's easy dandyism, another period mode for gentlemen in the 1830s,

when she describes him ordering fine linen shirts, cravats, and handker-chiefs "in sheaves," with no petty thought for bourgeois economy, and always having the right clothes without seeming to think about them.

Eliot clearly rejects the idea that because personal concerns may be uni-versal, it does not matter whether people are wearing trousers or knee breeches when they are thinking and feeling. On the contrary, she seems well aware that such differences are as essential to the inner life as to the outward aspect. The late-eighteenth-century (1799) clothing worn by the rustic characters in *Adam Bede* has its special meaning for each of them as each sees himself at that particular time, when fashion in high places was changing fairly radically and was known to be doing so even in humble ones. Resistance to change and delight in it are given natural expression through the sense of dress in different social contexts. Space is given to who wears mellow black and hair powder, who wears a fashionable blue coat and open shirt, and how this choice defines him for himself, and what people think not just of the new fashion for trousers but of them-selves in relation to trousers; not just how Hetty Sorrel looks at night in her stays and petticoat but how she feels about how she looks, her careful concern about the exact disposition of her tucker, sleeves, and kerchief. Hetty's other expectations are lent an even more precise quality by the precision of these historically determined concerns about her clothes. Eliot evokes, moreover, not the sentimental Victorian view of eigh-teenth-century dress pictorially current in 1860 but the real look of eigh-teenth-century engravings.

In *Adam Bede* George Eliot makes no apologies for her express atten-tion to dress, nor does she in *Romola.* In both novels she is obviously working from historical sources, relying on visual material outside her own direct experience. But in *The Mill on the Floss, Felix Holt,* and *Mid-dlemarch,* all of which are set in about 1830, the time of her own child-hood, her vivid evocations of period costume are rendered in a tone of complex irony. This material comes straight from her personal storehouse of early visual memory. Her use of it discharges all the feelings that ac-companied the original impressions while it also maturely allows for the sense of distance. She invokes the present ridiculousness of past modes as if out of respect for her readers' detachment more than out of any of her own. She speaks of the kinds of bonnets that "were then the fate of women," and she magnificently describes the way a lady sobbing in the transports of deep distress must yet contrive, with a nicely calibrated blend of instinct and calculation, to rush through a narrow door without crushing her wide buckram sleeves. George Eliot must herself have seen it

done in the enormous fashionable sleeves of 1830, when she was an observant eleven-year-old girl. She must in general have seen even then how people imagined themselves in their clothes, precisely even if unconsciously according to the visual requirements imposed by the shape and style of them; and she must have later seen how these, and consequently people's basic self-perceptions, change through time. She never failed to take account of that total physical self-awareness that, to be really universally human, must include the temporal look of clothes. It is the only way of undertaking, when evoking the quality of life in another day, what its representational artists were doing, in pictures, for life in their own time.

Like Jane Austen and George Eliot, Louisa May Alcott was concerned with domestic life. But she was a lesser writer, one perhaps somewhat corrupted by the selling power of sentimentality in her time. To complement this, she had a moral imagination that was vivid only in patches. She used it to capacity in portraying the four sisters in *Little Women,* especially in conveying their own awareness of their several weaknesses and their uneven struggles to overcome them. Like George Eliot, she is fruitfully using emotional material from her own youth, and it is the various moments of youthful personal vexation in *Little Women* that alone can make the work immortal. But some of the material details remain mysterious, particularly the details of dress. So strong, yet so unrealized, was Alcott's vision of how clothes generally looked and felt in her own girlhood that she leaves out all indication of it. She is never, as Eliot always seems to have been, drawing on a store of detached observation about other people's sense of how they looked in their clothes; she is simply remembering her own and relying on her readers to remember theirs, and she is certain of the similarity. The many details of dress in *Little Women* are indeed precise—there are colors, a "real lace frill," and fabrics (one first heard of poplin and merino). Things are referred to as "tight" or "soft" or "simple," and sometimes they fasten with a collar close around the neck. But there is no comprehensive visual clue given of how everything about clothes really *was*—something that James and Proust and George Eliot show can be done in half a sentence.

In this respect the book fails to transcend time, since the author thinks her own consciousness will do for all time in exactly the area where it will not. The bell-shaped fullness of floor-length skirts below a tight waist, for example, a phenomenon that by the 1860s had been common to all civilized Western womanhood for almost half a century, is never once referred to. At least one youthful reader in 1937 therefore thought that a "tight" dress should be visualized as something like what Jean Harlow

might wear—tight all the way down to the knees. On the other hand, the small, detachable surface matters, things about fans and gloves, mustaches and curling irons, just like references to calling cards and other interesting obsolete customs, are all the more instructive in *Little Women* for being unselfconsciously presented. The unconscious omission of any sign of a complete visual conception of clothed looks authenticates all the minutiae.

Like George Eliot, Alcott wrote in middle life about her girlhood; but her writer's sense of dress was entirely subjective and entirely social, moral, and emotional. She apparently had no creative insight about its visual dimension at all. It is rather when she writes out of her penetrating understanding of the anxiety about all the difficult relations between clothes and money that she still strikes a responsive chord in young American female readers.

The interdependence of clothes in Romantic fiction and Romantic art goes deeper than the theatricalized visualization of historic dress. The lack of detachment in Romantic fictions, both pictorial and literary, nourishes an intensity of visual impression, and clothed figures in both arts seem to wear the look of their creators' own time more vividly in the Romantic period than at any other. (I use the term "Romantic" in a rather loose and extended sense to include the century between 1760 and 1860.) In *Vanity Fair* (finished in 1848) Thackeray was dealing with the time of Napoleon's defeat in 1815, and the decade or so following; but all his visualizations of female dress, which survive in his own illustrations for the novel, are completely contemporary—the ladies wear the full skirts and curls and bonnets of the late 1840s—although the gentlemen are dressed at least occasionally in the correct coats and collars of the earlier day. He apparently could not create an image of womanhood that would carry conviction in his own inward ear and eye unless it looked like the real women of his adult experience.

Even a poet's fantastic visions are usually cast in the mold of current form. Coleridge's poem "Christabel" was written between 1797 and 1800, when the Neo-Classic fashion for women was at its height and the female form was generally perceived as William Blake and George Romney saw it (see II.34). "Christabel" is a medieval tale of the supernatural, full of castles, damsels, and palfreys, and peppered with cloaks and mantles; but Geraldine, the malevolent nocturnal apparition, wears a "silken robe of white" with bare neck and arms, like those of a fashion plate (see V.14). Later, in Christabel's chamber, "she unbound/The cincture from beneath her breast" and "behold! her bosom and half her side" are revealed in a

spasm of Neo-Classic eroticism ("a sight to dream of, not to tell!"). In the morning she "tricks her hair in lovely plight," and she is frequently described as "lofty."

With all of this—hair, clothes, bosom, and stature, along with extreme behavior and the girdle beneath the breasts—she is a perfect verbal replica of one of Fuseli's sexy dream-women, dressed in clinging folds with noticeable bust and fantastic coiffure. Christabel herself wears a similar fashion: "her girded vests/Grew tight beneath her heaving breasts." The girdle again is high up under the bust. Much is made throughout this poem of bosom and breast, whether heaving, revealed, or full of accursed magic. The mind's eye of the poet is full of contemporary illustrative style, especially its version of the pale, serpentine, but bosomy female figure then so common in art—and so perfect for his "gothic" poem.

Such an immediacy of visual perception seems to burn through attempts of Romantic pictorial artists to keep the eye cool and detached when its gaze is on the people of historic times, antiquity, or exotic lands—or even on inner visions, as in Blake. It may also illuminate fiction even when the literary artist is not applying his visual sense directly to clothes but cannot help unconsciously communicating the undetached vision with which he actually saw living people, and so visualized his characters. In *Wuthering Heights* clothes are almost unmentioned. But in the reader's imagination they share in the same spirit (though not the same look) as those in the Friedrich paintings: the vehicle, the prose, the mode of presentation, the plot, and the characters may all be nonhistorical, poetic, elemental, tragic—but to the mind's eye of the reader (as undoubtedly to the writer's) the garments are visualized as contemporary.

Emily Brontë (unlike Friedrich) as good as says that she does not consciously mean to create this effect. Her Cathy is supposed to have been born in 1778, and the frame narrative is supposed to begin in 1801. But that is the end of all period reference. Everything else is so piercingly immediate that all the events, which span something like forty years, are easily conjured in the mind as synchronically costumed in the clothes of the late 1840s, when the book was written. Not "period" dress, not elemental drapery, but the clothes of real life—and the real life of Emily Brontë's imagination obviously was "right now," no matter how many dates in the past she sprinkles throughout her text.

It might be argued that Yorkshire rustics would not have changed their style of dress in either fifty years or a hundred and fifty; but the characters she gives us at Thrushcross Grange most certainly would have, in perhaps as many weeks or months. The material possibility of this is not even

VI. 30 Illustration for
Thackeray's *Vanity Fair,*
1847

suggested in the novel. No lace ruffles or powdered wigs are dragged in to back up her avowed chronology, as in popular fiction; nor are such things creatively troped in to the image of the rest of life as one of the reflections of consciousness, as in Flaubert or George Eliot. Emily Brontë may never have given them a conscious passing thought; nevertheless, her inner eye transmits its image directly. The quality of the tale and the diction strongly evokes what C. W. Cunnington calls the "gothic" clothes of the 1840s, as they were drawn or engraved in the sharp and slightly sinister black-and-white graphic style of that epoch (Thackeray himself is a good practitioner of it): everyone of both sexes with long black hair and large eyes, elongated torsos, sharply sloped shoulders; men in boots, their white or swarthy faces smoldering inside the frame of standing collars. Women's dresses might be drab or rich, but they would always have constricted shoulders, a long, pointed bodice, and full, unstiffened, mobile skirts in a bell shape. Hair dropped over ears from a center part. Seriousness and intensity and passion barely contained are well clothed in these garments (VI.30).

Charlotte Brontë's *Jane Eyre* is also supposed to be set at the turn of the century, in the time of Jane Austen's characters, but it also evokes those same Romantic clothes contemporary with its authorship, despite such occasional remarks as "in the mode of those days." In the Brontës' fiction, historical or not, there is no attempt to suggest any historically determined quality of life, as there always is in George Eliot; but there is a much greater personal and emotional engagement with the quality of present life itself, a visual sense that is much keener (though not given much more play) than the one that goes with Jane Austen's style of detachment. The number of bonnets, shawls, boots, and petticoats mentioned is about the same—that is, very few; one cannot learn many more facts about dress from the Brontës' books than from Austen's. But the physicality, indeed the sexuality, of all the Brontë characters is so much stronger that they come more readily to life in the mind's eye in physical terms. And when they do, they are naturally wearing the clothes that most clearly, for the author, invested their vitality as characters—the kind of clothes customarily worn at the date they were so corporeally, so vividly conceived. The Austen characters, though no less vivid, are rather uncorporeal. Their looks elude a mental image, clothes included, and one must make an effort to *see* them, however well Austen lets us know them.

Flaubert, like George Eliot, can infuse character with the phenomena of clothing so that his people demonstrably live and move and have their being not only in the moral and political but also in the physical habitude of their time. He is careful to put in what is usually left out—the actual shape and volume of clothing and the random but familiar details of its behavior: the flapping of a lady's skirt flounces against a man's trouser legs as the two stand together outdoors; the lappets of a woman's cap hanging on either shoulder like the headdress of a sphinx. The cool blond corkscrew curls framing Mme. Dambreuse's taut face in *L'Education sentimentale* are part of her essence, as the dark, pomaded *bandeaux* of her hair are part of Mme. Arnoux'. A crowd of men at an evening party are described as a "mass of black" relieved by the bits of red of chevaliers' ribbons, whereas the women are described not with the primarily emotional response to a fusion of color, glitter, and seminudity usual in such descriptions of ladies at parties, but in precise visual terms of shape and line. Like Eliot, Flaubert in *L'Education sentimentale* is re-creating his own intense perception of the clothes worn in his youth. This aspect of his art manifests what must have been an early nourishment of a critical visual sense—the equivalent, for the visual imagination, of the detached, "realistic" view of emotive behavior. Such similar detachment of visual and

emotional perception was operative in novels like *Madame Bovary,* and produced such a chill in the reader as to create a scandal around the author.

Stendhal, however, remains with great candor and intelligence intensely engaged. His perception and representation of people are direct and sympathetic, always personal; and when he records his visual apprehension of them, it is often translated immediately into comparison with a work of art. If the reader knows the work, this method gives him the correct mental picture; but it is also a way of showing the emotional depth of Stendhal's visual responses. He conjures the memory of feelings and ideas experienced in front of pictures, the ineffaceable impact of the image. As in the Brontë books, the visual strength of this writer's imagination about his characters and his period, the power of his own personal visualization of them, carries over directly to the reader's inner eye and re-creates them, alive and fully clothed. The verbal phenomena with respect to clothing that make Flaubert's descriptive strokes so telling are missing in Stendhal. Even though he is much concerned with dandy attitudes, and thus with English fashion as it affected the rest of Europe, with the effect of all this on actual dress—and also with the Napoleonization of all Europe—he refrains from specific sartorial description. In general, Stendhal's writing offers a keen intellectual and emotional apprehension of dress as part of a state of mind. He takes it very personally; and he seizes on that aspect of his characters' personal life—as he does on love, ambition, anxiety—and includes it among all his other rare illuminations of the interaction of feeling and intelligence, in the face of current events and inward conditions. The psychological penetration in his writings embraces in large measure the psychological importance of clothing—including dandyism—but he makes no actual aesthetic use of the specific *look* of dress. There is no detachment in the workings of his eye, any more than in the workings of his heart. In *Memoirs of Egotism,* Stendhal speaks of wishing not to be himself, of longing to go about being a tall, blond German; he mentions seeing a bad statue of William Tell "in a stone smock." And in *The Charterhouse of Parma* he speaks of a girl succumbing to "the haughty insolence and the huge whiskers" of a certain man, and of a red wig the color of a flaming heart; clothes, personal books, and essential inner qualities of persons (or statues) are inseparable in this kind of comprehensive sensibility.

Such extremely engaged writing requires very little description of dress to transmit a clear image. The visual sense does not lack in Emily or Charlotte Brontë, any more than in Stendhal; rather, it informs life; it is

intense enough not to need purposeful efforts at evoking personal images. It is in a novelist determined to be popular, for example, Richardson, that one can feel both a reliance on and an exaggeration of type for characterization, a lack of literary faith in direct psychological perception, and a consequent dependence on standard popular representations of physical looks. In much popular fiction, this last is often conveyed by elaborate descriptions that are clearly of pictures, not of people. The mental images of the protagonists that are conjured by reading *Clarissa* and *Pamela* are in the style of popular illustrations of the time (Highmore, for example) rather than in the style of the great English artists who used their own eyes, such as Hogarth. They run to sentimental attitudes, very smooth and rosy cheeks, long legs, tiny waists, bright, melting eyes, facial expressions of exaggerated banality, and perfectly fitting and sentimentally behaved clothing (VI.31, 32). There is often much detail of feminine dress. When the novel is sentimental, the visual images in it tend to be picturesque, including the people and their garments and the action of both.

This commonplace correspondence of the popular arts has been brought in this century to final synthesis in the movies; but sentimental and sensational fiction of modern times—stories in women's magazines, paperback detective novels, and so on—are just as aptly illustrated by commercial artists, who often deal in the same kind of modish reduction of the human image as that used by popular artists in the eighteenth century (VI.33). For women (then as now), the form still tends to include full lips, long legs, and small waists, although for men in the twentieth century rugged jaws and crinkly eyes are required instead of receding jaws and liquid eyes, and women must have cheekbones. The image is not so much a contribution by the illustrator in the standard style as it is a collaboration of writer and artist. The characters are obligingly described in looks and physical behavior as if to suit the prevailing pictorial taste; and the heroine's clothes are at least once very satisfyingly detailed, for avid feminine consumption. The usual looks of the main character of each sex strongly resemble those of a fashion plate.

To make this connection even more obvious, clothing is described in set pieces, to allow for which the action stops dead. Richardson uses this device in *Clarissa,* as Erle Stanley Gardner did in numerous detective stories. This literary method is utterly unlike Flaubert's or Eliot's, which can weave carefully chosen elements of clothing into the texture of the narrative and use them to support the action in the revelation of character. And this ability is what makes Flaubert's novels seem best illustrated not by the fashion plates and illustrations of the time but by the works of

441

VI. 31 JOSEPH HIGHMORE (1692–1780), *Pamela Is Married*
Illustration

VI. 32 Illustration for a story in
Peterson's Magazine, 1878

VI. 33 Book cover art for
Barbara Cartland, *Kiss of Silk*

great painters such as Ingres and Courbet, both of whom use dress in the same way Flaubert does. Details are exact and numerous, but they are never there for their own sake; they always serve the total vision, which focuses on the unique distinction of each face and the characteristic posture of the body, neck, and shoulders—that is, on the real person himself, most intensely filling out and being himself *in his own garments*.

Balzac is more interested in society. He concentrates on the social force of clothes, their advertising function. It is Daumier's and Balzac's friend Gavarni, the fashion-illustrator-cum-cartoonist, who best illuminates the visual sense of this novelist (who was also a journalist and a dandy of an exaggerated style). Balzac is perhaps the first writer to take clothes seriously in the modern sociological spirit. He wrote several essays on their importance, especially for the newly founded fluid French bourgeois society of the 1830s; and when he deals with clothes, the control of appearances is his theme: role-playing through dress and manner, even without conscious effort. His provincials make unconscious mistakes and self-conscious choices, betraying their pretensions or ignorance or parsimony; and his urban bohemians, aristocrats, and dandies betray their varieties of aesthetic zeal and sexual and social sophistication through varieties of sartorial choice. There is much careful description of dress in Balzac that manifests a steady awareness of how clothes work rather than how they feel or seem. He demonstrates how clothes make the man, with that ferocity of seriousness that is easily transmuted into irony.

This theme has been the subject of satire for centuries, as it has been an uncomfortable fact of human life. People know that dress can deliberately express perhaps ignoble pretensions to a change of being, but it can also actually succeed so well in pretending that it truly transforms the aspiring pretender into his ideal. This is the opposite of what happens to Cinderella: her rags are supposed to hide but not diminish her loveliness and virtue, which then simply have only to show forth, first in her magic finery and finally at the epiphany of the fitting slipper. She keeps the same self all through her changes of clothes. In real life, however, rags obviously cannot be "seen through" to something lovely underneath because they themselves express and also create a tattered condition of soul. The habit of fine clothes, however, can actually produce a true personal grace. If elegant garments and matching behavior are seriously and devotedly adopted and consciously refined, with applied effort, as in the case of an achieved dandy, they can bring about, through the reformation of personal style, a true refining of the self, however gross its origins and original clothing.

Obviously, spiritual strength and moral excellence, as well as weakness of will and stupidity and depravity, remain quite independent of such

transformations. One's objective moral being may well be unchangeable, and, moreover, it may be consistently expressed, perhaps in speech and action of very base content. Clothing, however, like tone of voice and speed of utterance, conveys other kinds of moral quality—the texture and style and flavor of the self—since it is a necessary form of customary behavior. In a sense, beautiful clothes *are* beautiful manners: if they are consciously adopted and taken seriously and personally, they become part of personal authenticity. One cannot pretend to have good behavior.

Clothes make the man, not because they make up or invent what the man is or dress him up for show but because they actually create his conscious self. You are what you wear—and especially when class structure lacks rigidity. Balzac was one of the first to express this idea at length in narrative without laughing, apologizing, or keeping up the old fiction that natural grace and beauty may function and flourish under the oppressive habits of grimy and awkward and threadbare garments. Clothes unmake the man, too, as everyone secretly knows. Analogues to Cinderella in real life, such as female prisoners, frequently suffer a sad corrosion of spirit if forced into the equivalent of her circumstances and her rags. The Cinderella myth also expresses the dear idea that ugliness and bad behavior cannot be transformed by exquisite finery, whereas Balzac relentlessly demonstrates that they can indeed when the motivation is strong and the method is efficiently studied. A truer-to-life fairy tale—perhaps because it comes from the acute nineteenth-century imagination of Hans Christian Andersen—is the story of the ugly duckling transformed into a swan, achieving beauty through self-knowledge and patience. Had the stepsisters been beautiful and Cinderella ugly, the seventeenth-century Perrault fairy tale would have had all the basic elements of a novel such as *Jane Eyre.*

People seem always actually to know, with a degree of pain that has required the comfort of fairy tales, that when you are dressed in any particular way at all, you are revealed rather than hidden. Yet the dream that clothes are always a kind of disguise has persistently expressed itself in myth and romance. It is a Romantic-pastoral notion that ragged and clumsy clothing can cover an exquisite refinement of soul and person, and that many human roses of both sexes have blushed unseen and wasted

444

their sweetness on rough garments and muddy, heavy shoes. If such folk did exist, such as can be found in Fielding and later in Dickens and in other, lesser writers, they were undoubtedly "unseen" by one another under the blinding pressure of poverty; but they were nevertheless very creatively and inventively "seen" by writers and artists. This literary notion of the beauty of the poor under their rags (especially the young poor) overlaps the pictorial habit of idealizing the rags themselves and creating a sense of the picturesque beauty of poor people—a sense that Ruskin was eventually to repudiate, after being trained to appreciate it along with the picturesque beauty of ruins and natural wilderness. It is pure imaginative power, rather than the force of clear-sighted observation, that could give any real impetus to the idea that grubby rags are the certain signs of basic grace and true beauty (with an assist from the gospels, perhaps), but it is an idea that still has the power to achieve fashionable currency. Even the unflinching gaze turned by eighteenth- and nineteenth-century reformers' eyes on how poverty really makes people look and feel could not expunge from artistic sensibility the pastoral impulse to idealize it. By various means writers and artists, and lately photographers in particular, have continued to foster the old romantic belief in the superior beauty of the ill-clad (VI.34-36).

The other side of this same view—that beautiful clothes are usually certain to be covering essentially ugly people—is also kept alive by such artists as Richard Avedon, despite well-worn knowledge that leisured, well-nourished, and well-groomed people usually look wonderful because they feel self-confident and at ease with their physical selves, and that bad food, cheap clothes, and hard times really make people look dreadful because they feel and generally are at a disadvantage, and it shows. It is, of course, a well-known fact that many poor and badly dressed people are indeed very beautiful and that many of the rich and well-dressed are ugly; but the tendency persists to make moral pictorial capital out of this neutral phenomenon, a tendency with centuries of literary nourishment behind it. It has given rise more than once to a fashion for rags among the rich, a kind of sartorial aspiration in reverse. This recurrent mode reflects not just the actual upheavals of society but the old ideals embodied in Cinderella's story.

A conception of clothes as disguise infuses not only Romantic literature but allegory and the whole vocabulary of metaphor itself. Nothing is more common than the metaphorical mention of clothing, first of all to indicate a simple screen that hides the truth or, more subtly, a distracting display that demands attention but confounds true perception. These notions invoke dress in its erotic function, as something that seems to prom-

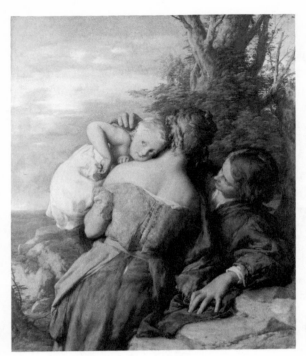

VI. 34 WILLIAM MULREADY
(1786–1863)
The Younger Brother, 1842

VI. 35 JOHN G. BROWN (1831–1913)
"Lazy Bones"

VI. 36 RICHARD AVEDON (b. 1923)
Anna, Palermo 1947

ise something else, a mystery that promotes in the viewer the desire to remove it, get behind it, through it, or under it. The idea that dress hides something is, of course, not false; in the West it usually and most importantly hides the genitals, so as to make them seem more worthy of discovery and consequently to make them into a secret and clothing into a kind of temple veil.

There are, of course, more sophisticated metaphorical uses of clothing. Wordsworth in "Composed upon Westminster Bridge" is describing London:

> This City now doth, like a garment, wear
> The beauty of the morning; silent, bare,
> Ships, towers, domes, theatres, and temples lie
> Open unto the fields, and to the sky. . . .

This "garment" clearly hides nothing, since in the next line the city's beauties (especially those "domes") are "bare." The kind of clothing here instantly evoked without the need for direct reference is the clinging, transparent female dress of the date (1802). No direct reference is made to the city's sex other than the suggestive "lie/Open"; the revealing garment is enough. "Bare," on the face of it, means unpopulated, but its proximity to "garment" gives a vivid image of dress as revelation: we see the city through "the beauty of the morning" it wears, and also because of it.

Besides sexual secrets, clothing also hides the commonness of nakedness; and so, by its variable creative means, it produces the quality of individuality—all the mysteries of uncommonness, all the distinctions of quality and of mode. And here the literary conception of clothing becomes more complex. It has been said that clothes have that same relation to the body that language has to truth or pure thought. That is, they are somehow a necessary form that bodily truth must take in order to be told and understood at all. Although the casting of truth into a specific verbal form may constitute some kind of reduction of it in any given instance, without this process all thought remains formless and unintelligible. So with dress and the body. Moreover, the elements of dress, like those of language, are perpetually flexible, and just as apt to betray and mislead as they are to express and convey—with or without intent. Nevertheless, although clothes may appear to reduce the grand truth of unclad natural humanity simply by being contingent, specific, and intrinsically bound to style, they are recognizably the only thing that gives—has always given—that shapeless and meaningless nakedness its comprehensible form.

447

The neoplatonic Renaissance pictorial allegories that show two kinds of truth (or two kinds of love or two kinds of felicity, worldly and heavenly) frequently use an idealized nude female figure for the higher, abstract principle and an ordinarily dressed female figure for the earthly version. The very quality of the nudity of such an image—Classicized, usually depilated, unrealistically half draped—shows the insufficiency of the idea that the spectacle of ordinary people without clothes offers any satisfaction to a seeker of pure truth. The idealized nudity stands for whatever the abstraction is in its purest intelligibility—ideal, celestial, that which is not perceptible to the senses. The recognizably contemporary clothed figure (dressed, not draped) represents truth in worldly experience (VI.37). A naked figure, aggressively unidealized, could never have the moral weight to balance and oppose such a clothed image. The truth embodied in the existence of temporal clothing creates a sense that its true counterpart is not banal nakedness but an eternal and ideal form of nudity. Nude celestial truth, moreover, is mirrored on earth not by mundane nakedness but by the truth of clothes.

In human life the dressed state, though it may be a lower condition than theoretical ideal nudity, is also the best emblem of corporeal existence. It is the means by which humans acknowledge themselves to transcend their fallen condition and their primitive animal nakedness. Clothes stand for knowledge and language, art and love, time and death—the creative, struggling state of man. While they conceal only his unapplied, unrealized body they reveal all of his and its possibilities. But to do this, they (like language) are condemned to contingency, and consequently the idea of them is something of a thorn and a goad. As a concept, clothing resists clarity, even as fashion defies augury.

As art, dress lacks the possibility of purity. As a straightforward medium for social communication, it is too liable to the unaccountable pretensions of art. Though similar to them all, dress is not exactly like art or theater, not exactly like architecture or furniture, and not exactly like food or sex. Because it is so closely connected to the private self-awareness of every individual and to his social being, its importance is as inescapable as that of sex; but this importance is even more difficult to assimilate emotionally and intellectually than is the power of sex because of the demanding visual dimension of dress. Clothes must look like something, the way pictures must—that is, they must have some sort of looks. They must submit not just to mental and behavioral conventions but to visual ones. The very absence of visual material about clothes in much fiction

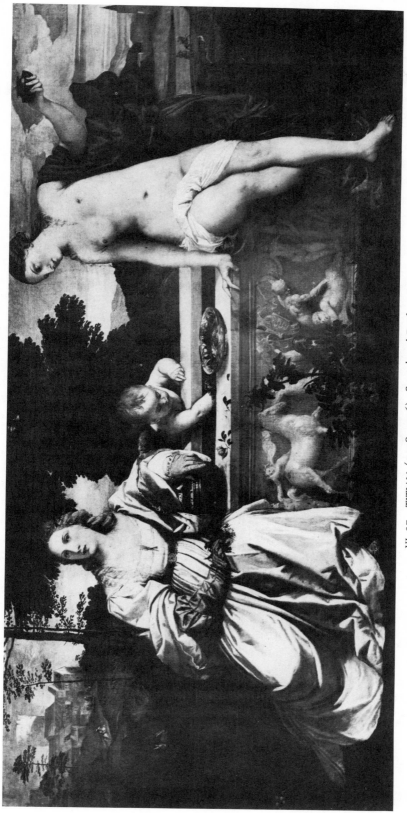

VI. 37 TITIAN (1478–1576), *Sacred and Profane Love*

shows how much easier it would be if clothing had no specific looks, as the emotions, sexuality, and other difficult conditions of being have none.

Indications in literature of the mental indigestibility of clothing as a serious human phenomenon take the form of pointed neglect, ferocious satire, heavy irony (Carlyle's *Sartor Resartus*), and sarcastically exaggerated respect. In their perpetual irksome worldliness, their common visibleness so inescapably attached to every body, ordinary clothes seem to drag at all the lofty aspirations of man and at all his finer feelings. They (like Shelley's "dome of many-coloured glass") seem to interrupt man's relations with the infinite. Worse, they seem to belittle and make ridiculous his deep personal tragedies, his serious love, or even his most rampant and obscene lust. Clothes do this simply by having to look (as against be) a certain way and by being apparently subject to constant change in that way of looking, and then by being nevertheless indispensable to natural human life so as always to require some kind of attention, some kind of choice. Clothes always register. The fiction that they are not important is thus generated out of an inability to deal easily with that intractable importance itself. Serious people, aspirers to unworldliness, devotees of the importance of things-not-seen, are particularly unhappy with the idea of clothes and especially with the phenomenon of fashion—the thing that makes clothes need to change their looks and thus stay persistently worldly. Fashion makes clothing resist any universal idealization of use or aspect.

Despite all ideological attempts to transcend the mode in clothes, it is the lust of the eye for change, the power of the eye to make instant associations, and its need to demand and to create and combine images that hold clothing to the significant and delicate shifts of dynamic visual form. Their looks make clothes incapable of being purely comfortable or useful or even purely beautiful. At any moment, while certain garments are engaged in being those things, they must have a particular visible shape, which must depend on many more variables than comfort or utility or beauty; and so most of their particular shape will be based on aesthetic standards related to the visual customs of that moment.

Pure protection, pure covering, unlike pure nourishment, cannot exist without a visual style. It is no wonder people conceived the idea that Greek drapery—variously arranged lengths of woven cloth—must be the closest thing to it, despite the obvious stylistic variations possible even in that method of dress. Wise men of different kinds (Lord Chesterfield, Sir Thomas More) manage to agree that however spiritual one's preoccupa-

tions, dressing according to current convention is the best plan because attempts at evading the mode are likely to trap one into the unwanted aspect of eccentricity and to produce uncontrolled visual associations in the public mind. For serious men these are just as bad as visible attempts to dress too elegantly. Presumably, only absolute recluses have the option of wearing nothing, or a bath mat, or old newspapers, without the image and its associations registering on the retina of the public eye.

Because they always do have a particular way of looking, and because they are committed to change in form through time, clothes might be easily grouped with the so-called minor arts and be considered along with other objects connected with changing social behavior: china and silver, tables and chairs—or with architecture, the mold of life. But clothes are separated from all other objects by being inseparable from the self. They give a visual aspect to consciousness itself, not to its surroundings. They produce its look as seen from within. Dress has clearly much to do with people's deep theatrical impulses, their desire to be costumed characters, especially because it functions only in wear and in motion, unlike the static objects with which its style may be associated.

Dress has not only no social but also no significant aesthetic existence unless it is actually being worn. Western sartorial relics on display simply do not have the artistic status of antique vases and cabinets. Half their beauty is obviously missing. This is true not just if they are displayed unworn, but always, simply because they are not seen completing the unique and conscious selves of their owners. The absence of the "informing flame," the animating, self-aware inner eye, darkens and deadens all clothing from the past. Concepts of design and feats of workmanship survive, along with indications of social attitudes, economic conditions, and so on. But a vase in a museum has a completeness to offer the eye that a dress never has, though both may be breathtakingly made according to artistic standards of equal altitude.

Clothes do seem to be like costumes, ways of dressing selves in roles for show, and sometimes they are. But this is another insufficient idea, similar to the one that conceives of clothes as masks or disguises showing one thing and hiding another. Clothes cannot be altogether dramatic *or* theatrical because people are not always acting or performing, even though they are always appearing. It is the inner theater that is costumed by the choice in clothes, and this is not always under conscious management. The public may not always be intended, much less able, to get the picture. Control of sensory events is the essence of theater, and a good deal of sig-

nificant dressing is obviously done with a very incomplete knowledge or control of the outward and inward effects.

It is pictorial art that dress most resembles, and to which it is inescapably bound, in its changing vision of what looks natural. In order that the look of the body might always be beautiful, significant, and comprehensible to the eye, ways developed of reshaping and presenting it anew by means of clothing. But in order that this clothed image might in turn be perceived and understood as beautiful, significant, and comprehensible to each succeeding generation of eyes, conventions of representing it realistically were correspondingly developed by visual artists, in all media, from monumental relief sculpture to television. Such clothed images in art could be perceived and accepted as true by hopeful, appreciative, idealistic eyes; and so, remembered and followed by the inner eye, they could finally become "natural," echoed and reexpressed in the sartorial habits of common life as they reflected that image of the inner eye.

The eyes of any epoch in Western civilization have always accepted as truthful the representational effort of its artists. Since antiquity, nature has been the avowed guide of artists, despite the extraordinary variety of methods used to follow her. Nature has, of course, periodically seemed to recede from the aim of art, during epochs of extreme conventionality in picture making, and to be in need of revival under the hand of innovative genius every few generations and in every century. But the underlying theme, even during the sway of mannered or inflexible schools of art, has been truthful representation, in the name of Apelles and all the famous artists of the past who were supposed to have dazzled their public with their true images of visible reality. The audience for art, no less than the artists themselves, have agreed about this assumption; and so the most commonly accepted method by which the clothed image has been purveyed has been considered the most real, in accordance with the ancient and perhaps no longer even conscious assumption that the aim of pictures is to show the truth. Nude images follow the same rule, and the self-perception of the naked body is based on the "natural" pictorial ideal of the moment—which, as we have suggested, is in turn dependent on the dressed image from which the clothes are missing.

When people put clothes on their bodies, they are primarily engaged in making pictures of themselves to suit their own eyes, out of the completed combination of clothing and body. The people who do this most readily are those living in civilizations in which the naturalistic image of man is the cornerstone of art, and the pictures they make when they dress

are directly connected to the pictures they ordinarily see and accept as real. Interesting changes in actual fashions of dress have coincided with vital activity in representational art—in the nineteenth and twentieth centuries no less than in the fifteenth and sixteenth; and this seems to happen even without reference to the profound differences in the fabric of society that divide Western countries and centuries from one another or to technological differences in the substance and production of clothes and pictures. Visual fare must vary, and the looks of people are the staple of the visual diet. This continues to be true, whatever the personal or social messages that clothing offers and whatever need figurative art is currently being enlisted to fill.

At different times and places Western art has come to terms with complete nonobjectivity and abstraction, and with all the nonhuman manifestations in nature, both gross and delicate. But it has never abandoned the human image. After the transmutation of visible nature by art became complicated by the art of photography, it was the latter that took over governing the perception of human looks, in a long-range maneuver made in collusion with traditional pictorial art. Showing how people look has always been the most satisfactory function of the representational artist, whether he is making sensational movies in 1970 or painting devotional altarpieces in 1470. The civilized Western human eye apparently cannot tire of devouring the human image—but to be satisfying in art, that image (even the nude one) requires a conventional way for clothing to look while it is on the body, so that the figure in its garments makes an acceptable visual unit. The eye is eager for human images and even more eager for styles in the human image. Eyes love feasting much more than they ever love reading. They have an instant voracity, when they are trained on the looks of people, that has no time for the discriminative energy needed for decoding and interpreting messages. Those complex signals conveyed directly by dress, of which contemporary Americans have lately become so keenly aware, are not what register first. It is, rather, the impact of the picture that the eye takes and modifies simultaneously into a picture in the style of the moment without any initial interpretation. There is certainly an associative element in this visual process, but it is virtually subliminal. Later, perhaps only a split second later, come the conscious interpretations, the cracking of the codes, and the mental and emotional responses. First comes the picture itself, in its pictorial style.

In Western culture dress has status as a visual art because it abides by the same rules that pictures follow; the look of clothes borrows whole per-

ceptual modes from style in art. The aesthetic alterations within fashion have a visual autonomy that is granted by that of art itself, which in turn is generally granted—despite all its connections with religion, politics, and the wealth of princes or nations. The history of dress or the study of clothes has no real substance other than in *images* of clothes, in which their visual reality truly lives, naturalized, as it were, by the persuasive eye of art.

I DRAPERY

1.1 *Ceres.* Rome, Vatican Museum.

1.2 *Venus.* Rome, Capitoline Museum.

1.3 *Apollo Belvedere.* Rome, Vatican Museum.

1.4 *Meleager.* Rome, Vatican Museum.

1.5 Antonio Canova, *Perseus Holding the Head of Medusa.* New York, The Metropolitan Museum of Art, Fletcher Fund, 1967

1.6 *Running Niobid.* Rome, Vatican Museum.

1.7 *Sophocles.* Rome, Vatican Museum.

1.8 Apollodorus of Phocaea, *Draped Female Figure.* London, British Museum.

1.9 Attributed to the "Orchard Painter," Red-figured Oinochoë: *Conversation Scene.* New York, The Metropolitan Museum of Art, Rogers Fund, 1921.

1.10 *The Woman in Terror* and *The Flagellated Woman and the Bacchante,* frescoes from the Villa of the Mysteries, Pompeii.

1.11 Master of Flémalle, *The Mérode Altarpiece,* central panel. New York, The Cloisters Collection.

1.12 Filippino Lippi, *Tobias and the Angel.* Washington, D.C., National Gallery of Art, Samuel H. Kress Collection, 1939.

1.13 Rogier van der Weyden, *Crucifixion.* Vienna, Kunsthistorisches Museum.

1.14 Mathis Grünewald, *The Small Crucifixion.* Washington, D.C., National Gallery of Art, Samuel H. Kress Collection, 1961.

455

1.15 Albrecht Dürer, *Crucifixion*. Vienna, Albertina.

1.16 Joos van Cleve, *Virgin and Child*. Cambridge, Fitzwilliam Museum.

1.17 Jan van Eyck, *Virgin and Child with Saints and Donor*. New York, copyright The Frick Collection.

1.18 Agnolo Bronzino, *Lodovico Capponi*. New York, copyright The Frick Collection.

1.19 Attributed to Michele Tosini (di Rodolfo), *A Florentine Nobleman*. The St. Louis Art Museum.

1.20 Marcus Gheeraerts, *Lady Mary Scudamore*. London, National Portrait Gallery.

1.21 François Clouet, *Portrait of Pierre Quthe*. Paris, The Louvre. Photo Musées Nationaux.

1.22 Master of Flémalle, *Nativity*. Musée de Dijon.

1.23 Hans Holbein the Younger, *Venus and Amor* (portrait of Magdalena Offenburg). Basel, Kunstmuseum.

1.24 Hans Holbein the Younger, *Sir Thomas More*. New York, copyright The Frick Collection.

1.25 Agnolo Bronzino, *Portrait,* called Eleonora of Toledo. Turin, Galleria Sabauda.

1.26 Abraham Bosse, *Allegory of the Sense of Sight*. Paris, Cabinet des Dessins du Louvre.

1.27 Anonymous, *The Borghese Family in Their Palace of Borgo Pinti, Florence,* c. 1828. Rome, Collection Mario Praz.

1.28 Thomas Cole, *The Course of Empire,* No. 3 (*Consummation*). Courtesy of the New-York Historical Society.

1.29 Thomas Cole, *The Architect's Dream*. Toledo, Ohio, The Toledo Museum of Art, gift of Florence Scott Libbey.

1.30 Agnolo Bronzino, *Portrait of Andrea Doria as Neptune*. Milan, Brera.

1.31 El Greco, *Vincenzo Anastagi*. New York, copyright The Frick Collection.

1.32 Anthony Van Dyck, *James, Seventh Earl of Derby, His Lady and Child*. New York, copyright The Frick Collection.

1.33 Agnolo Bronzino, *Portrait of Stefano Colonna*. Rome, Galleria Nazionale (Barberini).

1.34 Anthony Van Dyck, *La Marchesa Spinola Doria*. Paris, The Louvre. Photo Musées Nationaux.

1.35 El Greco, *Baptism of Christ*. Rome, Galleria Nazionale (Barberini).

1.36 Gianlorenzo Bernini, *Constantine*. Rome, St. Peter's Cathedral.

1.37 Gianlorenzo Bernini, *Louis XIV*. Versailles, Museum. Photo Giraudon.

1.38 Gianlorenzo Bernini, *Fathers of the Church*. Rome, St. Peter's Cathedral.

1.39 François Duquesnoy, *Tomb of Ferdinand van den Eynde*. Rome, Sta. Maria dell'Anima.

1.40 Carlo Saraceni, *Madonna with Saint Anne*. Rome, Galleria Nazionale (Barberini).

1.41 Orazio Gentileschi, *The Annunciation*. Turin, Galleria Sabauda.

1.42 Frans Hals, *Willem van Heythuyzen*. Munich, Alte Pinakothek.

1.43 Frans Hals, *Banquet of Officers of the Civic Guard of Saint George at Haarlem*, 1627. Haarlem, Frans Halsmuseum.

1.44 Anthony Van Dyck, *Portrait of Lady Castlehaven*. Wilton House.

1.45 Guido Reni, *Lot and His Daughters Leaving Sodom*. London, The National Gallery.

1.46 Annibale Carracci, *Madonna and Child with Saint John the Baptist, the Evangelist, and Saint Catherine*. Bologna, Pinacoteca.

1.47 Simone Cantarini, *Rest on the Flight into Egypt*. Milan, Brera.

1.48 Orazio Gentileschi, *Danaë*. The Cleveland Museum of Art, Leonard C. Hanna Jr. Bequest.

1.49 Diego Velásquez, *The Rokeby Venus*. London, The National Gallery.

1.50 Rembrandt van Rijn, *Flora*. New York, The Metropolitan Museum of Art, gift of Archer M. Huntington, 1926.

1.51 Sir Peter Lely, *Portrait of a Lady*. Cambridge, Fitzwilliam Museum.

1.52 Sir Godfrey Kneller, *Lady Diana de Vere, Duchess of St. Albans*. London, Hampton Court Palace. Copyright reserved.

1.53 François Boucher, *La Toilette de Venus*. Stockholm, Nationalmuseum.

1.54 François Boucher, *Madame Boucher*. New York, copyright The Frick Collection.

1.55 J.-B.-S. Chardin, *La Toilette du Matin*. Stockholm, Nationalmuseum.

1.56 Circle of Jacques-Louis David, *Portrait of a Young Woman in White*. Washington, D.C., National Gallery of Art.

1.57 Horatio Greenough, *George Washington*. Washington, D.C., Smithsonian Institution.

1.58 Jacques-Louis David, *The Death of Marat*. Brussels, Musée des Beaux-Arts.

1.59 Jacques-Louis David, *Brutus*. Paris, The Louvre. Photo Musées Nationaux.

1.60 Friedrich Georg Kersting, *Couple by a Window*. Obbach, Sammlung Georg Schäfer.

1.61 Adolph Menzel, *Room Giving on a Balcony*. Berlin, Nationalgalerie.

1.62 Julius Schnorr von Carolsfeld, *Flight into Egypt*. Düsseldorf, Kunstmuseum.

1.63 Edward Burne-Jones, *Love and the Pilgrim*. London, The Tate Gallery.

1.64 Gustave Courbet, *Portrait of Jo (La Belle Irlandaise)*. New York, The Metropolitan Museum of Art, bequest of Mrs. H. O. Havemeyer, 1929; the H. O. Havemeyer Collection.

1.65 Sandro Botticelli, *The Birth of Venus* (detail). Florence, Uffizi.

1.66 Albert Moore, *The Dreamers*. Birmingham, England, reproduced by permission of Birmingham Museums and Art Gallery.

II NUDITY

II.1 Jan Gossaert, *Neptune and Amphitrite*. Berlin, Gemäldegalerie.

II.2 Hiram Powers, *The Greek Slave*. Washington, D.C., Corcoran Gallery of Art, gift of William Wilson Corcoran.

II.3 Francisco de Goya, *The Nude Maja*. Madrid, Museo del Prado.

II.4 Rembrandt van Rijn, *Bathsheba*. Paris, The Louvre.

II.5 Hugo van der Goes, *Adam and Eve*. Vienna, Kunsthistorisches Museum.

II.6 William Bailey, *Reclining Nude*. Kansas City, Sosland Collection.

II.7 Lucas Cranach, *Nymph of the Spring*. New York, The Metropolitan Museum of Art, the Robert Lehman Collection, 1975.

II.8 Albrecht Dürer, *Avaritia*. Vienna, Kunsthistorisches Museum.

II.9 Jacopo Tintoretto, *Susanna*. Washington, D.C., National Gallery of Art, Samuel H. Kress Collection, 1939.

II.10 Agnolo Bronzino, *Venus, Cupid, Folly, and Time*. London, The National Gallery.

II.11 Moretto da Brescia, *Portrait of a Lady in White*. Washington, D.C., National Gallery of Art, Samuel H. Kress Collection.

II.12 Agnolo Bronzino, *Eleonora of Toledo*. London, The Wallace Collection. Copyright reserved.

II.13 Lorenzo Lotto, *Lucretia*. London, The National Gallery.

II.14 *Venetian Courtesan*. From Bertelli, *Diversarum Nationum Habitus*.

II.15 Bernardino Luini, *Venus*. Washington, D.C., National Gallery of Art, Samuel H. Kress Collection, 1939.

II.16 Titian, *Danaë*. Madrid, Museo del Prado.

II.17 Ercole Roberti, *Ginevra Bentivoglio*. Washington, D.C., National Gallery of Art, Samuel H. Kress Collection, 1939.

II.18 Rogier van der Weyden, *Portrait of a Lady*. Washington, D.C., National Gallery of Art, Andrew Mellon Collection, 1937.

II.19 Titian, *Pietro Aretino*. New York, copyright The Frick Collection.

II.20 Hans Holbein, *Henry VIII*. Rome, Galleria Nazionale (Borghese).

II.21 Anthony Van Dyck, *Queen Henrietta Maria with Her Dwarf*. Washington, D.C., National Gallery of Art, Samuel H. Kress Collection, 1952.

II.22 Peter Paul Rubens, *The Three Graces*. Madrid, Museo del Prado.

II.23 Peter Paul Rubens, *"Le Chapeau de Paille."* London, The National Gallery.

II.24 Gerrit van Honthorst, *Pastorale*. Seattle Art Museum, Samuel H. Kress Collection.

II.25 Jan van Eyck, *Giovanni Arnolfini and His Wife*. London, The National Gallery.

II.26 Pol de Limbourg, *The Earthly Paradise*, from *Les Très Riches Heures du Duc de Berry*. Chantilly, Musée Condé. Photo Giraudon.

II.27 Jacob Ochtervelt, *A Musical Party*. London, The National Gallery.

II.28 Nicolas Poussin, *Mars and Venus* (detail). Toledo, Ohio, The Toledo Museum of Art, gift of Edward Drummond Libbey.

II.29 Thomas Gainsborough, *Sarah, Lady Innes.* New York, copyright The Frick Collection.

II.30 Louis-Léopold Boilly, *The Optics Lesson.* Private collection.

II.31 Jean-Honoré Fragonard, *Reverie* (detail). New York, copyright The Frick Collection.

II.32 François Boucher, *Venus Consoling Love.* Washington, D.C., National Gallery of Art.

II.33 Jean-Honoré Fragonard, *The Swing* (detail). London, The Wallace Collection. Copyright reserved.

II.34 George Romney, *Initiation of a Nymph.* Truro, England, Royal Institution of Cornwall.

II.35 William Blake, *Angel Michael Binding the Dragon.* Cambridge, Mass., courtesy of the Fogg Art Museum, Harvard University.

II.36 Sir Joshua Reynolds, *Death of Dido.* Buckingham Palace. Copyright reserved.

II.37 J. H. Fuseli, *The Nightmare.* Frankfort, Goethe Museum.

II.38 Thomas Banks, *Death of Germanicus.* Holkham Hall, The Earl of Leicester.

II.39 J.-A.-D. Ingres, *Madame Vesey and Her Daughter.* Cambridge, Mass., courtesy of the Fogg Art Museum, Harvard University.

II.40 Pierre-Paul Prud'hon, *Venus and Adonis.* London, The Wallace Collection. Copyright reserved.

II.41 John Singleton Copley, *Portrait of Elkanah Watson.* Princeton, N. J., The Art Museum, Princeton University.

II.42 James Barry, *The Death of Wolfe.* St. John, courtesy of The New Brunswick Museum, Webster Collection of Pictorial Canadiana.

II.43 Joseph Wright of Derby, *Sir Brooke Boothby.* London, The Tate Gallery.

II.44 Raphael Mengs, *Parnassus* (detail). Rome, Villa Albani.

II.45 Fashion plate, from *Charis,* Leipzig, 1802. In Margaretta Braun-Ronsdorf, *Mirror of Fashion* (New York: McGraw-Hill, 1964).

II.46 William Blake, *Glad Day.* Washington, D.C., National Gallery of Art.

II.47 Sir Thomas Lawrence, *The Countess of Blessington.* London, The Wallace Collection. Copyright reserved.

II.48 William Etty, *Nymph and Children.* New York, The Metropolitan Museum of Art, gift of Martin Birnbaum, 1959.

II.49 Gustave Courbet, *La Source.* Paris, The Louvre.

II.50 Erotic postcard, 1880. From Cecil St. Laurent, *The History of Ladies' Underwear* (London: Michael Joseph, 1968).

II.51 Erotic photograph, 1880s. From Marcel Bovis and François Jullien, *Nus d'Autrefois* (Paris: Arts et Métiers Graphiques, 1953).

II.52 Edgar Degas, *Après le Bain.* Paris, Collection Durand-Ruel.

II.53 Aristide Maillol, *L'Île de France*. Cambridge, Mass., courtesy of The Fogg Art Museum, Harvard University.

II.54 J. L. Stewart, *Wood Nymphs*. The Detroit Institute of Arts.

II.55 Jean-Léon Gérôme, *Pygmalion and Galatea*. New York, The Metropolitan Museum of Art, gift of Louis C. Raegner, 1927.

II.56 Correggio, *Jupiter and Antiope*. Paris, The Louvre.

II.57 Edgar Degas, *The Client,* an illustration for Maupassant's *La Maison Tellier*. In Robert Melville, *Erotic Art of the West* (New York: G. P. Putnam's Sons, 1973).

II.58 Edward Hopper, *Evening Wind*. New York, Whitney Museum of American Art, bequest of Josephine N. Hopper. Photo Geoffrey Clements.

II.59 Thomas Eakins, *William Rush and His Model*. Honolulu Academy of Arts, gift of Friends of the Academy, 1947.

II.60 J.-A.-D. Ingres, study for *Perseus and Andromeda*. Cambridge, Mass., courtesy of the Fogg Art Museum, Harvard University.

II.61 J.-A.-D. Ingres, study for *Le Bain Turc*. Montauban, Museum.

II.62 Amedeo Modigliani, *Reclining Nude* (*Le Grand nu*). New York, The Museum of Modern Art, Mrs. Simon Guggenheim Fund.

II.63 Albrecht Dürer, *Adam and Eve*. London, British Museum.

II.64 Hans Baldung Grien, *Death and the Maiden*. Basel, Kunstmuseum.

II.65 Pierre-Paul Prud'hon, *Study of a Nude Woman*. The Cleveland Museum of Art, purchased from the J. H. Wade Fund.

II.66 Pisanello, *Luxuria*. Vienna, Albertina.

II.67 Edward Burne-Jones, *The Tree of Forgiveness*. Port Sunlight, Cheshire, reproduced by permission of the trustees of the Lady Lever Art Gallery.

II.68 Corset advertisement. The New York Public Library.

II.69 Fashion photograph. *Vogue,* November 10, 1930, copyright 1930 by The Condé Nast Corporation, Inc.

II.70 Thomas Eakins, *William Rush Carving His Allegorical Figure of the Schuylkill River,* 1877. Philadelphia Museum of Art. Photo A. J. Wyatt, staff photographer.

III UNDRESS

III.1 Hans Eworth, *Queen Elizabeth and Three Goddesses*. London, Buckingham Palace. Copyright reserved.

III.2 Rembrandt van Rijn, *Diana*. Amsterdam, Rijksmuseum.

III.3 Rembrandt van Rijn, *Naked Woman Seated on a Mound*. Amsterdam, Rijksmuseum.

III.4 Jacopo Tintoretto, *Susannah and the Elders*. Vienna, Gemäldegalerie.

III.5 Pierre-Auguste Renoir, *La Baigneuse au griffon*. Sao Paolo, Museum of Art.

III.6 Giorgione, *Sleeping Venus*. Dresden, Staatliche Kunstsammlung.

III.7 Titian, *Venus and the Lute Player*. New York, The Metropolitan Museum of Art, purchase 1936, Munsey Fund.

III.8 Urs Graf, *Soldier and Whore*. Dresden, Lahmann Gallery.

III.9 Édouard Manet, *Olympia*. Paris, Jeu de Paume.

III.10 Gustave Courbet, *Le Sommeil*. Paris, Musée du Petit Palais. Photo Editions J. E. Bulloz.

III.11 Titian, *Venus of Urbino*. Florence, Uffizi.

III.12 Peter Paul Rubens, *Venus and Adonis*. Florence, Uffizi.

III.13 François Boucher, *Diana at the Bath*. Paris, The Louvre.

III.14 Johann Baptist Reiter, *The Sleeping Woman,* 1849. Vienna, Oesterreichische Galerie.

III.15 Rembrandt van Rijn, *Danaë*. Leningrad, Hermitage.

III.16 Gustave Courbet, *The Painter's Studio*. Paris, The Louvre. Photo Musées Nationaux.

III.17 Edward Hopper, *A Nude in Sunlight*. New York, Collection Mr. and Mrs. Albert Hackett.

III.18 Édouard Manet, *Le Déjeuner sur l'herbe*. Paris, Jeu de Paume.

III.19 Sandro Botticelli, *Pietà*. Munich, Alte Pinakothek.

III.20 Sandro Botticelli, *Venus and Mars*. London, The National Gallery.

III.21 Giorgione, *Le Concert champêtre*. Paris, The Louvre. Photo Musées Nationaux.

III.22 Paolo Veronese, *Mars and Venus United by Love*. New York, The Metropolitan Museum of Art, Kennedy Fund, 1910.

III.23 Hans Memling, *Martyrdom of Saint Sebastian*. Brussels, Musée des Beaux-Arts.

III.24 Georges de La Tour, *Saint Sebastian Tended by Saint Irene*. Berlin, Galerie Dahlem.

III.25 Dirk Bouts, *The Martydom of Saint Hippolytus*. Bruges, St. Sauveur Cathedral.

III.26 Rembrandt van Rijn, *Adam and Eve,* 1638. Amsterdam, Rijksmuseum.

III.27 Andrea di Bartolo, *Madonna and Child*. Washington, D.C., National Gallery of Art, Samuel H. Kress Collection.

III.28 Jean Fouquet, *Madonna and Child*. Antwerp, Musée des Beaux-Arts.

III.29 Paionios, *Nike*. Olympia, The Olympia Museum.

III.30 Piero della Francesca, *Baptism of Christ* (detail). London, The National Gallery.

III.31 Giorgione, *Laura*. Vienna, Kunsthistorisches Museum.

III.32 Bartolomeo Veneto, *Portrait of a Lady*. Frankfort, Städelsches Kunstinstitut.

III.33 Giovanni Bellini, *The Feast of the Gods*. Washington, D.C., National Gallery of Art, Widener Collection.

III.34 Rosso Fiorentino, *Moses and the Daughters of Jethro*. Florence, Uffizi.

III.35 Palma Vecchio, *Flora*. London, The National Gallery.

III.36 Titian, *Bacchus and Ariadne*. London, The National Gallery.

IV.13　James Quin as Coriolanus, 1749. London, Victoria and Albert Museum.

IV.14　Talma as Proculus in Voltaire's *Brutus*. From Max von Boehm, *Das Buhnen Kostüm* (Leipzig, 1921).

IV.15　Mlle. Raucour as Urphanis. From Monval, *Costumes de la Comédie Française* (Paris, 1884).

IV.16　Mary Ann Yates as Electra. London, Victoria and Albert Museum.

IV.17　A theater, France. The New York Public Library.

IV.18　Louis-René Boquet, Costume designs. Paris, Archives de l'Opéra.

IV.19　Jean-Simon Barthélémy, Sketch for *Castor et Pollux*. Paris, Archives de l'Opéra.

IV.20　David Garrick as Macbeth. London, Victoria and Albert Museum, Enthoven Collection.

IV.21　J. H. Fuseli, *Macbeth and the Armed Head*. New York, Courtesy of Sotheby-Parke Bernet, Inc.

IV.22　J. H. Fuseli, *The Three Witches*. Zurich, Kunsthaus.

IV.23　Daniel Maclise, "Thine Own," Mezzotint by George Evey from the Maclise painting. In Rodney K. Eugen, *Victorian Engravings* (New York and London, 1975).

IV.24　Theatrical print. The New York Public Library.

IV.25　John Singer Sargent, *Ellen Terry as Lady Macbeth*. London, The Tate Gallery.

IV.26　Edmund Blair Leighton, *Lady Godiva*, photogravure from the painting. From *The Magazine of Art,* reprinted in Rodney K. Eugen, *Victorian Engravings* (New York and London, 1975).

IV.27　Laurence Alma-Tadema, *Vain Courtship*. New York, Collection Mr. Allen Funt.

IV.28　Bette Davis as Queen Elizabeth I. Costume by Orry-Kelly for *The Private Lives of Elizabeth and Essex*. New York, The Museum of Modern Art Film Stills Archives.

IV.29　Bette Davis as Queen Elizabeth I. Costume by Mary Wills for *The Virgin Queen*. New York, The Museum of Modern Art Film Stills Archives.

IV.30　Glenda Jackson as Queen Elizabeth I. Costume by Elizabeth Waller for BBC Television's *Elizabeth R.*

IV.31　After Nicholas Hilliard, *Elizabeth I,* c. 1575. London, National Portrait Gallery.

IV.32　Francesco Fontebasso, *The Family of Darius before Alexander*. Dallas Museum of Fine Arts, Gift of C. Michael Paul, New York.

IV.33　Giacomo Serpotta, *Courage*. Palermo, Oratorio del Rosario.

IV.34　Sir Edward Poynter, *Visit of the Queen of Sheba to King Solomon*. Sydney, Art Gallery of New South Wales.

IV.35　Theda Bara as Juliet. New York, The Bettmann Archive.

IV.36　Beverly Bayne as Juliet. New York, The Museum of Modern Art Film Stills Archive.

V DRESS

465

VI MIRRORS

VI.13 Gavarni (Sulpice Guillaume Chevalier), *"Ah! Seigneur, protégez une vierge chrétienne,"* woodcut.

VI.14 Honoré Daumier, *The Actor: "Mon Vieux Talma, tu peux te fouiller,"* lithograph.

VI.15 Augustus Leopold Egg, *Past and Present No. 1.* London, The Tate Gallery.

VI.16 Edgar Degas, *Interior (Le Viol).* Philadelphia, private collection.

VI.17 William Holman Hunt, *The Awakening Conscience.* London, The Tate Gallery.

VI.18 William Holman Hunt, *The Lady of Shalott.* Hartford, Conn., Courtesy Wadsworth Atheneum, Ella Gallup Sumner and Mary Catlin Sumner Collection.

VI.19 Ford Madox Brown, *"Take Your Son, Sir!"* London, The Tate Gallery.

VI.20 René Magritte, *Reproduction interdite.* Rotterdam, Boymans Museum.

VI.21 Don Eddy, *New Shoes for H.* The Cleveland Museum of Art, purchased with a grant from the National Endowment for the Arts and matched by gifts from members of the Cleveland Society for Contemporary Art.

VI.22 Pablo Picasso, *Girl before a Mirror.* New York, The Museum of Modern Art, gift of Mrs. Simon Guggenheim.

VI.23 Caspar David Friedrich, *Woman in the Morning Sun.* Essen, Museum Folkwang. Photo Liselotte Witzel.

VI.24 Scene from *Pride and Prejudice,* 1940. New York, The Museum of Modern Art Film Stills Archive.

VI.25 Advertisement. *Vogue,* 1930.

VI.26 Book cover for Edwina Marlow, *Dark Drums,* 1977. New York, Warner Books.

VI.27 Advertising photograph, 1977. Courtesy of Selig.

VI.28 John Singer Sargent, *Interior in Venice.* London, Royal Academy of Arts.

VI.29 John Everett Millais, *Mariana.* The Right Honorable Lord Sherfield.

VI.30 Illustration for Thackeray's *Vanity Fair.*

VI.31 Joseph Highmore, *Pamela Is Married,* illustration. London, The Tate Gallery.

VI.32 Popular illustration for a story. *Peterson's Magazine,* 1878.

VI.33 Book cover for Barbara Cartland, *Kiss of Silk.* New York, Pyramid Books.

VI.34 William Mulready, *The Younger Brother.* London, The Tate Gallery.

VI.35 John G. Brown, *"Lazy Bones."* Princeton, N.J., The Art Museum, Princeton University, The Carl Otto von Kienbusch, Jr., Memorial Collection.

VI.36 Richard Avedon, *Anna, Palermo 1947.* New York, courtesy Mr. Avedon.

VI.37 Titian, *Sacred and Profane Love.* Rome, Galleria Nazionale (Borghese).

I DRAPERY

5 *Seventh-century fit:* Early Greek clothes were woven to mold the individual body just as metal helmets were molded to fit each wearer's head.

Antique clothes: Under the elaborately draped garments of Classical and later times, a hidden belt was worn to anchor the loops, swags, and pockets of fabric and to permit the wearer to move freely. See Répond, p. 27.*

6 *Apollo's drapery:* See Hogarth, Chapter XI, "Of Proportion," p. 91.

8 *Fullness:* See Hogarth, Chapter VI, "Of Quantity," p. 35.

Greek drapery styles: Throughout I refer to antique drapery without differentiating among the historical styles, e.g., Severe, Classical, Hellenistic, Archaizing, or Roman. Bieber says that Hellenistic drapery had the greatest effect on Roman art, and hence on all later art.

9 *Stone folds:* See Reynolds, *Discourse X,* p. 182.

30 *Interior drapery:* See Praz, *An Illustrated History of Furnishings from the Renaissance to the 20th Century,* passim. This monumental history comprises many pictures of rooms, often without figures, chosen expressly for their lack of symbolic or rhetorical content. Many are not professional works of art, but simple records. They represent a neutral view of detailed interior settings since the early Renaissance, with a few examples from earlier

* References to specific texts are identified here by the author's last name (Répond, Bolles, Wittkower, etc.). For complete publication facts, please consult the Bibliography, p. 479.

times. They were collected to provide evidence, and the professional artists represented are those committed to precise detail, such as Carpaccio and various Dutch genre painters. Indoor scenes with fanciful or minimal surroundings have been omitted; and so the exact role of real drapery has presumably been reliably recorded in these pictures, however exaggerated its behavior may be in other works of art.

42 *Bernini clothes:* See Wittkower, p. 100.

58 *Portrait drapery:* Walpole's line comes from *Anecdotes of Painting,* quoted in Davenport, p. 597.

64 *Stone clothes:* See Reynolds, *Discourse X,* p. 187.

65 *Neo-Classic fashion:* The draped ladies' dresses were in fact much skimpier and more clinging than real Classical dress, which was fairly voluminous and modest. English male tailored clothing began to run to native materials, such as wool, buckskin, and muslin. Dress for both sexes stressed materials of home manufacture and a "democratic" spirit of simplicity. Lessons in shawl draping were given. See Bolles, *passim.*

66 *Nude statesmen:* In this period, the nudity of a national hero's sculpted body was itself idealized, as if it were a garment of perfect flesh to match his spiritual perfections. See Janson, p. 194. In response to this habit, later in the century, Hawthorne said, ". . . Man is no longer a naked animal; his clothes are as natural to him as his skin, and sculptors have no more right to undress him than to flay him." (*Italian Notebook,* April 22, 1858. From *The Complete Works of Nathaniel Hawthorne,* Vol. X, Cambridge, 1833.)

75 *Venetian angels:* See Ruskin, "St. Mark's Rest," Chapter IV, *Works,* Vol. 24, pp. 249–50.

76 *Natural drapery:* See Ruskin, "Giotto and His Works in Padua," *Works,* Vol. 24, p. 26; and "The Eagle's Nest," Lecture VIII, Vol. 22, p. 219.

 Base drapery: See Ruskin, "Seven Lamps of Architecture," Chapter IV, *Works,* Vol. 8, pp. 150–51.

77 *Inferior stile:* See Reynolds, *Discourse IV,* p. 62.

 Rhead also quotes Flaxman as saying ". . . [drapery] adds to the character of figures and gives additional interest to sentiment and situation."

79 *Beauty:* See Ruskin, *The Stones of Venice,* Vol. 3, Chapter IV, p. 191.

80 See Oscar Wilde, "The Relation of Dress to Art," *The Pall Mall Gazette,* Feb. 28, 1885. Reprinted in Wilde, p. 49.

81 "Drapery" has come to mean a great deal as a literary term. It was often used to refer to women's garments in nineteenth-century novels, even when the clothes in question were elaborate, fitted modern dresses, worn with stays. The romantic flavor of the term added theoretical poetry to the prose of fashion. Similarly, "drapery," indicating fabric veiling hidden beauties was referred to by seventeenth- and eighteenth-century poets when they also meant ordinary garments, viz. Herrick's "Clothes Do but Cheat and Cozen Us," from *Hesperides* (1627–46).

The following quote from *Belinda* by Maria Edgeworth (1801) shows how using the word to mean something good for hiding uncomfortable truths could not serve very well in the period of clinging Neo-Classic fashion in dress: ". . . 'should we find things much improved by tearing away what has been called the decent drapery of life?' 'Drapery—', cried Mrs. Freke, 'whether wet or dry, is the most confoundedly indecent thing in the world.' " No one actually engaged in the practice of moistening dresses to make them cling; but the rumor had great currency even at the time.

An extreme expression of drapery worship might be seen in Christo's *Valley Curtain,* a contemporary work of art consisting of miles of fabric hung on a cable across a valley between two cliffs.

II NUDITY

96 *Fashion in bodies:* Artists, of course, worked from the nude model rather than making up nudes out of their heads. Even so, sketches from life in all periods show the selective vision of the artist's eye, apart from the taste expressed in the choice of models.

100 *The High Renaissance belly:* Nipples locating the breasts were balanced by an emphatic navel punctuating the abdominal swell. Such navels later show insistently but unrealistically through the clothes of hundreds of Mannerist figures, especially those of the School of Fontainebleau.

III UNDRESS

166 *Le Sommeil:* To increase the contemporary eroticism of this image, the foreground figure has been given a body distorted to fit into the clothes of 1865 to 1870. Her breasts form one smooth curve, her waist is high, and her pelvic region is both enlarged and elongated to look as if she had removed a dress with a *polonaise.*

180 *Tempesta:* According to Wind, this image, like certain others in the Renaissance, illustrates the union of opposing forces—the principle of *harmonia est discordia concors.* A number of otherwise mysterious compositions showing one clothed and one unclothed figure illustrate aspects of this theme, representing Pleasure and Virtue, Fortezza and Carità, and so on, in the same spirit as images of Venus and Mars, showing the union of Love and Strife.

Clothes vs. drapery: The use of formal clothing–accessories instead of drapery on the single nude figure is traditionally erotic. Cranach's ladies wearing only jewels and hats are famous for this mode; Donatello's statue of David wearing only a hat and Classical sandals is no less provocative than they.

185 *Drapery with the nude:* The idealizing effect of drapery on the bare body is vividly illustrated by the fact that Lessing, in his famous essay on the

471

Laokoön, writes about the group as if there were no drapery in the composition at all. In fact, a great deal of fabric is massed under Laokoön's body and partially over the bodies of the two sons; but it is somehow invisible to Lessing, who refers to the figures as completely naked. The drapery is there only to testify to the artist's lofty view of nudity, not to represent possible clothing. It is unconsciously accepted by Lessing as an idealizing agency only.

199 *Liberty:* Delacroix' concern to emphasize the goddess's breasts is confirmed by a preparatory drawing showing the breasts strongly outlined and shaded but the rest of the figure only vaguely sketched.

205 *Bare-bosom iconography:* The allegorical figure of Charity, in contrast to many forbidding bare-breasted images, often appears in art baring one or both breasts to suckle multiple infants. Examples of another version, often called "Roman Charity," show a woman suckling an old man in prison. Both express the benign, bare-breasted spirit of selflessness, combined with an unselfconscious eroticism not usually possible to the suckling virgin.

206 *Power through exposure:* Anecdotes exist about famous women subduing their judges, conquerors, or audiences simply by spontaneously exposing their breasts. Phryne, the legendary Alexandrian courtesan, is supposed to have done this in court; Lola Montez at an audience with Ludwig I; Isadora Duncan on stage during a performance.

213 *Stays as aesthetic objects:* See Hogarth, Chapter IX, "Of Composition with the Waving Line," p. 48. Hogarth makes no apology for using an item of underclothing for his example, and displays no coyness or prurience about the object itself.

215 *The male body:* The full articulation of European male anatomy by means of dress seems to have begun with the development of plate armor at the end of the thirteenth century. Quilted doublets with sleeves and skirts were made either to fit under the armor, to replace it, or simply to imitate its look. Later, when male dress had become fully articulated by custom, ceremonial armor imitated clothing. See Davenport, pp. 152–60.

216 *The bare leg:* Androgynous angels could bare their legs in Italian art, along with Classical nymphs. The classical female costume with the slit skirt helps give later angels who wear it a very feminine look.

229 *Dandyism:* The early English variety stressed personal qualities in contrast to birth and breeding, in accordance with new "democratic" views of distinction. Later in France, when ostentatious bourgeois wealth held sway, true dandies felt themselves to be aristocratic, and so they could affect morose, even shabby elegance in dress, along with spiritual and aesthetic isolation. See Chapter V, pp. 349–65. See also Moers, Parts Two and Five.

IV COSTUME

255 *Bérain:* A modern example of Bérain's kind of talent is the ballet-costume designer Karinska. Her endless invention and imaginative use of conven-

tional elements within the limitations of Classical ballet costume are unrivaled, and so is her taste—a gift that contributes greatly to the success of any stage clothing.

271 *De' Sommi:* The treatise on stagecraft may be found in its entirety printed as an appendix to Nicoll's *Development of the Theatre,* p. 270.

275 *The Neo-Classic revival:/*European knowledge of antiquity had, of course, a long history before the excavations at Herculaneum and Pompeii. The effect of those discoveries was so great perhaps because a dissatisfaction with traditional views of the antique already existed, and a corresponding shift in taste was already prepared for.

277 The quote from Addison is from *The Spectator,* No. 42, April 18, 1711; quoted in Nagler, p. 244; the remarks by Tate Wilkinson are on pp. 388–91.

278 Diderot was concerned with and respectful of people's response to theater; he said, *"le public ne sait toujours désirer le vrai. Quand il est dans le faux il peut y rester des siècles entiers; mais il est sensible aux choses naturelles; et lorsqu'il en a reçu l'impression, il ne la perd jamais entièrement."* See Diderot, p. 267. The theater may perpetuate falsehoods, but it must show natural human behavior to be successful.

279 Hazlitt observes: "The extreme simplicity and graceful uniformity of modern dress, however favorable to the arts, has certainly stript Comedy of one of its richest ornaments and most expressive symbols. The sweeping pall and buskin, and nodding plume, were never more serviceable to Tragedy, than the enormous hoops and stiff stays worn by the belles of former days were to the intrigues of Comedy. . . ." He goes on to say that all the former complex clothes gave an agreeable scope to the imagination. He suggests that amorous adventures are more interesting when clothes present a real difficulty . . . "but Nowadays—a woman can be *but undressed!"* "On Modern Comedy," *Morning Chronicle,* Sept. 25, 1813. *Works,* Vol. 14, Page 12–13.

288 *Macbeth:* The Kemble passage is from W. C. Coulton, *The History of the Theatres of London,* London, 1796, II, 136–37; quoted in Nagler, p. 413.

290 *Correct costume:* The Tomlins quote is given in Nicoll, *Nineteenth Century Drama,* p. 41.

Planché: The advertisement for the production of *King John,* in part, reads: ". . . with an attention to Costume never equalled on the English stage. Every character will appear in the precise HABIT of the PERIOD; the whole of the Dresses and Decorations being executed from indisputable authorities, such as: Monumental Effigies, Seals, Illuminated Mss., etc." (Note that Planché does not stoop to secondary sources, such as historical costume books, although later designers did so and advertised that, too.) The costume plates for *King John* were published and sold; the production opened on December 8, 1823. An earlier performance at the same theater the previous May has no word about costumes in the advertisement, but all later performances for two decades used the same copy for the poster.

473

296 *Classical garb on modern people:* Oscar Wilde said, ". . . The costume model is becoming rather wearisome in modern pictures. It is really of very little use to dress up a London girl in Greek draperies and paint her as a goddess. The robe may be the robe of Athens, but the face is usually the face of Brompton." And later: "As a rule, models are absolutely *de notre siècle,* and should be painted as such. Unfortunately they are not, and as a consequence we are shown every year a series of scenes from fancy dress balls which are called historical pictures, but are little more than mediocre representations of modern people masquerading." (From "London Models," *The London Illustrated Magazine,* No. 64 [Jan. 1889]. Reprinted in Wilde, p. 89.) This deplorable effect had already been remarked on by Baudelaire in his "Salon of 1850." See *Art in Paris 1845–1862,* tr. and ed. Jonathan Mayne, London, 1965, p. 174. The same pictorial method has proved very successful in the movies; critics may not like it, but the public apparently does.

V DRESS

312 *Military dress:* A great number of modern garments stemming originally from seventeenth- and eighteenth-century military costume have preserved some of the look but none of the function of its characteristic trim: lapels, cuffs, straps, pocket flaps, extra buttons, buckles, and sometimes rings have become traditional decorative elements in tailored informal clothing for both sexes during two centuries of stylistic modification. Their military connotations were eventually lost, after the early atrophy of their function.

316 *The visual beliefs of ordinary people:* Baudelaire describes the effect of a mental image on personal looks: *"L'idée que l'homme se fait du beau s'imprime dans tout son ajustement, chiffonne ou raidit son habit, arrondit ou aligne son geste et même pénètre, subtilement, à la longue, les traits de son visage. L'homme finit par ressembler à ce qu'il voudrait être."* (From *Le Peintre de La Vie Moderne,* I, "Le Beau, La Mode et Le Bonheur," Pléiade Edition, p. 1153.)

322 *Watteau:* Some of the figures in his works naturally represent actual theatrical performers in costume, but others show pictorially perfected versions of the same mode.

327 *Selective vision:* It should be noted that great, original artists as well as successful popular ones often saw figures through a veil of current sartorial assumption. In Goya's drawings, for example, the women undergo not only violent and strange experiences, but obvious changes in posture and proportion corresponding to changes in the way clothes made women look in the three decades between 1798 and 1828.

340 *Female dress for sport:* Riding habits for women after the First World War began to combine skirt and jodhpurs, the one draped gracefully over the other like an apron, and the combination still designed for riding sidesaddle. The skirt was finally abandoned entirely only in the third decade of the century, and all women rode astride as a matter of course.

347 *Multiple possibilities:* The basis of the current scope of sartorial choice is mass production. The modern art of dress, like that of the camera, depends on *reproducibility* for its vital continuation. Individual artistic creation is founded on it, rather than achieved in spite of it. See Benjamin's essay.

Classes and groups: Michael Harrington, in *The Other America,* says: ". . . Clothes make the poor invisible, too:—it is much easier in the U.S. to be decently dressed than it is to be decently housed, fed, or doctored. . . . The benefits of mass production are spread [most] evenly in this area. . . . It almost seems as if the affluent society had given out costumes to the poor so that they would not offend the rest of society with the sight of rags." (Extract reprinted in Roach and Eicher, p. 163.)

353 *Fashion innovations:* It is clear that the status itself of individuals, like the status of certain groups, can permit them to *affect* changes in fashion. Mayor says that the dominant class dictates the mode, but that class can be the poor or the young—i.e., the relatively powerless. ". . . Thus reforms in dress will come from the same level as reforms in spelling—not from benevolent inventors of Esperanto but from road signs saying *Thru Hiway Slo.*" (Mayor, p. 268.) He also says the rich now preserve the overalls and workshirts of the poor, as peasants used to preserve courtiers' castoffs.

359 *The latest thing:* Many designs are extreme and experimental in their original form, and require modification on the part of later imitators to become, not acceptably toned down, but actually *better* in a more thoroughly evolved version.

362 Hazlitt on fashion: ". . . The secret is, that fashion is imitating in certain things that are in our power and that are nearly indifferent in themselves, those who possess certain other advantages that are not in our power. . . . We think the cut of a coat fine, because it is worn by a man with ten thousand a-year, with a fine house, and a fine carriage: as we cannot get the ten thousand a-year, the house, or the carriage, we get what we can—the cut of the fine gentleman's coat, and thus are in the fashion. . . ." ("Mr. Northcote's Conversations; Conversation the Nineteenth," *The Atlas,* July 5 and 12, and Aug. 9 and 16, 1829. *Works,* Vol. 11, p. 293.)

364 *Reform dress:* In More's *Utopia,* he suggests that work garments be of leather, but that over these everyone should wear a white cape for church and public appearances. Sexes should be distinguished, and the married from the unmarried, but otherwise everyone should wear the same thing and only have one outfit. He did not draw pictures to illustrate his notion of a design for this; but he said it should not be unpleasing to the eye. It sounds rather like costumes for *The Magic Flute.* See *Complete Works of Thomas More,* ed. Edward Surtz and S. H. Hexter, Yale University Press, New Haven, 1965, Vol. 4, p. 127.

370 *Black in the sixteenth century:* In general, Italian and Spanish black was seen by the English as Catholic—demoniacal and Machiavellian. Northern European black, by contrast, was Protestant-Puritanical. Charles V, as

Holy Roman Emperor, seems to combine both in his self-denying but arresting costume.

375 *Romantic black:* Black velvet for *women's* evening dress also began its vogue in the Neo-Classic period, not only as a reference to theatrical practice, but also as a reaction against the recent pale, clinging modes. See Waugh, *Corsets . . . ,* p. 214.

376 *Black for men:* In her Afterword, Moers describes the following line from the Dandy novel *Pelham,* by Edward Bulwer-Lytton (1828), as the single most influential line of prose ever included in a novel: "A white waistcoat with a black coat and trowsers, and a small chain of dead gold, only partially seen, is never within the bann of the learned in such matters." (Popular Library Edition, New York, 1974, p. 174.)

380 Alfred de Musset's remark comes from *La Confession d'un Enfant du Siècle,* 1880, p. 11. Quoted in Moers, p. 143.

385 Hazlitt on democratic fashions: "The ideas of natural equality and the Manchester steam engines together have, like a double battery, levelled the high towers and artificial structures of fashion in dress, and a white muslin gown is now the common costume of the mistress and the maid, instead of their wearing, as heretofore, rich silks and satin or coarse linsey-wolsey. . . ." ("On Fashion"; *Edinburgh Magazine,* Sept. 1818. *Works,* Vol. 17, p. 35.)

386 *"Glossary" terms:* See Merriam, pp. 254–56.

VI MIRRORS

392 *Narcissus:* In his treatise on painting, Alberti says the following: ". . . Narcissus who was changed into a flower, according to the poets, was the inventor of painting. Since painting is already the flower of every art, the story of Narcissus is most to the point. What else can you call painting but a similar embracing with art of what is presented on the surface of the water in the fountain?" (Leon Battista Alberti, *On Painting* [1435], Yale University Press, New Haven, 1956, revised edition, 1966, p. 64.) Later, Alberti suggests correcting paintings by looking at them in mirrors (p. 83).

397 *The Renaissance mirror:* When round, it was a microcosm—a small round image of the large life of the world.

400 *Velásquez: Las Meninas,* the artist's most famous painting with a mirror in it, shows even more markedly that Velásquez had a special interest in the creative function of mirrors—an interest similar to that of the fifteenth-century Flemish painters. The mirror in *Las Meninas* echoes and amplifies the meaning of the one in Van Eyck's portrait of the Arnolfini couple. It shows the reflection of witnesses to the scene itself, who are simultaneously the royal couple of Spain, the subject of the invisible canvas, and ourselves.

404 *The mirror between windows:* This domestic mirror developed in countries where rooms were heated by stoves, not fireplaces. Consequently there would be no mantelpiece for the room-reflecting interior mirror.

406　*The portrait-mirror:* A piece of drapery over the toilet-table mirror or cheval glass could provide the requisite swag of cloth to decorate the self-portrait with traditional elegance. See illustrations I.51 and VI.11.

420　*Art and description:* In the case of Renaissance pageants, writers who wrote, without further details, of someone dressed as "Fame" or "Justice," for example, would be referring to known allegorical pictures, in which the figure's customary style of costume would be included with the identifying trumpet for "Fame" or scales for "Justice." Readers would get the image from knowing the picture.

425　See Baudelaire, p. 12.

　　Disgust: Ruskin was also disgusted: ". . . Thus the idea of a different dress in art and reality, of which that of art is to be the ideal one, perverts taste in dress; and the study of the nude which is rarely seen as much perverts taste in art." ("The Eagles Nest," Lecture VIII, *Works,* Vol. 22, p. 234.)

427　It should be noted that descriptions of dress, besides being about visual details, also follow their own representational conventions according to genre and period. It is the literary convention that is linked to the pictorial one.

443　*Balzac:* Kunzle points out that Balzac shares Baudelaire's view of the dressed woman as the mirror of the perpetual transformation of society. The clothes *are* the woman, in her function as the embodied expression of prevailing modes in thought. Balzac also contributes to the next generation of writers (Zola, for example) the idea that fashion can be studied as a moral index.

448　*Celestial and worldly figures:* In Titian's painting *Sacred and Profane Love* (see illustration VI.37), the drapery of the nude figure flies up unaccountably, buoyed by nothing. This detail, like the similar effects in fifteenth-century Flemish art, emphasizes the figure's spiritual meaning. It further removes her from ordinary nakedness, despite her realistic flesh and hair.

450　*Clothes as interruptions:* Shelley uses dress itself as an apt metaphor: "Few poets of the highest class have chosen to exhibit the beauty of their conceptions in its naked truth and splendour; but it is doubtful whether the alloy of costume, habit, &c., be not necessary to temper this planetary music for mortal ears." (*Defence of Poetry,* 1821.)

　　Clothes as mediation: Domenico Bernini records that his father, Gianlorenzo ". . . called The Most Holy Humanity of Christ 'Sinner's clothing,' whence he was the more confident not to be struck with divine retribution, which, having first to penetrate the garment before wounding him, would have pardoned his sin rather than tear its innocence." (Quoted by Irving Lavin in "Bernini's Death," *The Art Bulletin,* Vol. LIV, no. 2, 1972, p. 160.)

　　In the first metaphor, the dress is worn by the naked "conceptions" to make them comprehensible; in the second, the divinity wears humanity as a veil to protect other people, not to hide himself or reveal himself differently.

451 *Empty clothes:* Thoreau says, "We are amused at beholding the costume of Henry VIII or Queen Elizabeth, as much as if it was that of the King and Queen of the Cannibal Islands. All costume, off a man, is pitiful or grotesque. It is only the serious eye peering from, and the sincere life passed within it, which restrain laughter and consecrate the costume of any people." (*Walden,* I: "Economy.")

Adams, Robert M. *The Roman Stamp: Frame and Façade in Some Forms of Neo-Classicism.* Berkeley, 1974.

Auerbach, Erich. *Mimesis,* tr. Willard R. Trask. Princeton, 1968.

Baldry, A. L. "Treatment of Drapery in Painting." *The Art Journal,* London, 1909. P. 291.

———. "Treatment of Drapery in Sculpture." *The Art Journal,* London, 1909. P. 265.

Ball, Robert Hamilton. *Shakespeare on Silent Film.* New York, 1968.

Barthes, Roland. *Système de la Mode.* Paris, 1967.

———. "The Diseases of Costume." *Partisan Review* (Winter 1967), p. 89.

Baudelaire, Charles. *The Painter of Modern Life and Other Essays,* tr. Jonathan Mayne. London, 1964.

Baxandall, Michael. *Painting and Experience in Fifteenth-Century Italy.* Oxford and New York, 1972.

Bell, Quentin. *On Human Finery* (Rev. Ed.). New York, 1976.

Benjamin, Walter. "The Work of Art in the Age of Mechanical Reproduction." In *Illuminations.* New York, 1968.

Bieber, Margarete. *Griechische Kleidung.* Berlin and Leipzig, 1928.

———. *The History of the Greek and Roman Theater.* Princeton, 1939 and 1961.

———. *The Sculpture of the Hellenistic Age* (Rev. Ed.). New York, 1961.

Birbari, Elizabeth. *Dress in Italian Painting 1460–1500.* London, 1975.

Blunt, Sir Anthony. *Artistic Theory in Italy 1450–1600.* New York, 1962.

Boehn, Max von. *Das Bühnen Kostüm.* Berlin, 1921.

Bolles, Marion P. "Empire Costume: An Expression of the Classical Revival." *Metropolitan Museum of Art Bulletin,* Vol. 2 (Feb. 1974).

Bradley, H. Dennis. *The Eternal Masquerade.* New York, 1923.

Brendel, Otto J. "Erotic Art in the Greco-Roman World." In *Studies in Erotic Art,* New York, 1970.

Bulwer-Lytton, Edward. *Pelham* (1828). New York, 1974.

Burckhardt, Jacob. *The Civilization of the Renaissance in Italy* (1860). Oxford and London, 1945.

Carlyle, Thomas. *Sartor Resartus* (1835). New York, 1887.

Carpenter, Rhys. *Greek Sculpture.* Chicago, 1960.

———. "Who Carved the Hermes of Praxiteles?" *American Journal of Archaeology,* Vol. XXXV (1931), pp. 249–61.

Cheney, Sheldon. *Stage Decoration.* New York, 1928.

Clark, Kenneth. *The Nude: A Study in Ideal Form.* New York, 1956.

Cobban, Alfred, ed. *The Eighteenth Century: Europe in the Age of Enlightenment.* New York, 1969.

Coke, Van Deren. *The Painter and the Photograph.* Albuquerque, 1964.

Collingwood, R. G. *The Principles of Art.* Oxford and New York, 1938.

Cunnington, C. Willett. *Handbook of English Costume in the Nineteenth Century.* London, 1959.

Cunnington, C. Willett and Phillis. *The History of Underclothes.* London, 1951.

Cunnington, Phillis, and Catherine Lucas. *Costume for Births, Marriages and Deaths.* London, 1972.

Davenport, Millia. *The Book of Costume.* New York, 1948. Still the best historical costume book. I have omitted a lengthy bibliography of costume history.

Diderot, Denis. *Discours de la Poésie Dramatique.* (1758). Librairie Larousse.

Dubois, M. J. *Curtains and Draperies, a Survey of the Classic Periods.* London, 1967.

Duer, Janet. "Clothes and the Painter." In *Art and Life,* Vol. II, 1919. P. 159.

Esquire's Encyclopedia of 20th-Century Men's Fashions. New York, 1973.

Ewing, Elizabeth. *Underwear: A History.* New York, 1972.

Fairservis, Walter A., Jr. *Costumes of the East.* Exhibition catalogue. New York, 1971.

Fischer, Carlos. *Les Costumes de l'Opéra.* Paris, 1931.

Flügel, J. C. *The Psychology of Clothes.* London, 1930.

Garrett, Helen T. *Clothes and Character: The Function of Dress in Balzac.* Philadelphia, 1941.

Gerdts, William H. *The Great American Nude.* New York, 1974.

Gernsheim, Alison. *Fashion and Reality 1840–1914.* London, 1963.

Gregor, Joseph (text). *Denkmäler des Theaters: Part I, L. O. Burnacini.* Vienna, 1924.

Gullberg, Elsa, and Paul Aström. *Studies in Mediterranean Archeology,* Vol. XXI. *The Thread of Ariadne: A Study of Ancient Greek Dress.* Göteborg, 1970.

Hartlaub, G. E. *Zauber des Spiegels.* Munich, 1951.

Hanulotte, Edgar, S. J. *La Symbolique du Vêtement Selon la Bible.* Aubier, 1965.

Hazlitt, William, *Complete Works of Hazlitt,* ed. P. P. Howe. London, 1933; New York, 1967.

Heard, Gerald. *Narcissus: An Anatomy of Clothes.* London, 1927.

Hegel, G. W. F. *The Philosophy of Fine Art,* Vol. III, tr. F. P. B. Osmaston. London, 1920. Pp. 116 ff., pp. 160–61.

Hewison, Robert. *John Ruskin: The Argument of the Eye.* Princeton, 1976.

Hiler, Hilaire. *From Nudity to Raiment.* London, 1929.

Hogarth, William. *The Analysis of Beauty,* 1753. Facsimile ed. New York, 1971.

Holland, Vyvyan. *Hand Colored Fashion Plates 1770–1899.* London, 1955.

Huxley, Aldous. "Beauty in 1920." In *On the Margin: Notes and Essays,* London, 1923. Pp. 115–21).

Irwin, David. *English Neoclassical Art.* London, 1966.

Janson, H. W. "The Image of Man in Renaissance Art: From Donatello to Michelangelo" (1966). In *Sixteen Studies,* New York, 1973.

———. "Observations on Nudity in Neo-classical Art" (1967). In *Sixteen Studies,* New York, 1973.

Jullien, Adolphe. *Histoire du Costume au Théâtre.* Paris, 1880.

Kant, Immanuel. *Critique of Judgement,* tr. J. C. Meredith. Oxford and New York, 1952. Pp. 166 ff.

Kaufmann, Edgar, Jr. "Fashion and the Constant Elements of Form." *Arts and Architecture* (July 1954).

Kelly, F. M. "The Iconography of Costume." *Burlington Magazine* (June 1934).

———. "Stage Costume and Historical Accuracy." *Apollo,* Vol. 2 (1925), pp. 86–91.

Kern, Stephen. *Anatomy and Destiny.* Indianapolis and New York, 1975.

Kernodle, George R. *From Art to Theatre: Form and Convention in the Renaissance.* Chicago, 1947.

Komisarjevsky, T. *The Costume of the Theatre.* London, 1931.

König, René. *A La Mode: On the Social Psychology of Fashion,* tr. F. Bradley. New York, 1973.

Kroeber, A. L. *Style and Civilization.* Ithaca, N.Y., 1957.

Kunzle, David. *Fashion and Fetishism.* Unpublished manuscript.

Landres, Yvonne des. *Le Costume, Image de l'Homme.* Paris, 1976.

Latour, Anny. *Kings of Fashion,* tr. Mervyn Savill. London, 1958.

Laver, James. *Costume in the Theatre.* New York, 1964.

———. *Drama, Its Costume and Décor.* London, 1951.

———. *Modesty in Dress.* London, 1969.

Lessing, G. E. *Laokoön* (1766), tr. Edward Allen McCormick. New York, 1962.

Lewis, Ethel. *The Romance of Textiles.* New York, 1937.

Licht, Hans. *Sexual Life in Ancient Greece.* London, 1932.

Linthicum, M. Channing. *Costume in the Drama of Shakespeare and His Contemporaries.* Oxford, 1936; New York, 1972.

Lucie-Smith, Edward. *Eroticism in Western Art.* London, 1972.

Maret, François. *Les Peintres de Nus.* Paris, 1946.

Mayor, A. Hyatt. "Change and Permanence in Men's Clothes." *Metropolitan Museum of Art Bulletin* (May 1950), pp. 263–68.

Mellencamp, Emma H. "A Note on the Costume of Titian's *Flora.*" *Art Bulletin,* Vol. LI, no. 2 (June 1969), p. 174.

Melville, Robert. *Erotic Art of the West.* New York, 1973.

Merriam, Eve. *Figleaf.* New York, 1960.

Migel, Parmenia. *The Ballerinas.* New York, 1972.

Moers, Ellen. *The Dandy.* New York, 1960.

Moore, Doris Langley. *Fashion Through Fashion Plates 1771–1870.* London, 1971.

———. *The Woman in Fashion.* London, 1949.

Morris, William, Collected Works of, Vol. XXII, *The Lesser Arts of Life* (1882). New York, 1966.

Müller, Valentin. "Some Notes on the Drapery of the Hermes." *American Journal of Archaeology,* Vol. XXXV (1931), p. 291–95.

Nagler, A. J. *A Source Book of Theatrical History.* Toronto, 1952; New York, 1959.

Newton, Stella Mary. *Health, Art and Reason.* London, 1974.

———. *Renaissance Theatre Costume and the Sense of the Historic Past.* London, 1975.

Nicoll, Allardyce. *The Development of the Theatre* (fifth ed.). New York, 1966.

———. *A History of Early 19th-Century Drama 1800–1850.* Cambridge, 1930.

———. *A History of Late 18th-Century Drama 1750–1800.* Cambridge, 1937.

———. *Masks, Mimes and Miracles.* London, 1931.

Nicolson, Benedict. *Courbet: The Studio of the Painter.* New York, 1973.

Nochlin, Linda. *Realism.* Baltimore, 1971.

Oenslager, Donald. *Four Centuries of Scenic Invention* (exhibition catalogue). The International Exhibitions Foundation, 1974.

Orgel, Stephen. *The Illusion of Power.* Berkeley, 1975.

Panofsky, Erwin. *Problems in Titian, Mostly Iconographic.* New York, 1969.

———. *Albrecht Dürer.* Princeton, 1948.

Pearce, Stella Mary (Newton). "Costume in Caravaggio's Painting." *Magazine of Art,* Vol. 46 (April 1953), pp. 147–54.

Poiret, Paul. *En Habillant l'Epoque.* Paris, 1930.

Porta, John Baptista. *Natural Magick* (1658). The Collector's Series in Science, Derek J. Price, ed. New York, 1957.

Posner, Donald. *Watteau: A Lady at Her Toilette.* New York, 1973.

Praz, Mario. *An Illustrated History of Furnishings from the Renaissance to the 20th Century.* New York, 1964.

———. *On Neoclassicism.* Evanston, Ill., 1969.

———. *The Romantic Agony.* Oxford, 1951.

Reff, Theodore. *Manet: Olympia.* New York, 1976.

Répond, Jules. *Les Secrets de la Draperie Antique.* Studi di Antichità Cristiana, Pontificio Instituto d'Archeologia Cristiana, Rome, 1931.

Reynolds, Joshua. *Discourses on Art,* ed. Robert R. Wark. New Haven and London, 1975.

Rhead, G. Woolliscroft. *The Treatment of Drapery in Art.* London, 1904.

Ridgway, Brunilde Sismondo. *The Severe Style in Greek Sculpture.* Princeton, N.J., 1970.

Roach, Mary Ellen, and Joanne Eicher, eds. *Dress, Adornment and the Social Order.* New York, 1965.

Roche, Serge, and Pierre Devinoy. *Miroirs, Galeries et Cabinets de Glaces.* Paris, 1956.

Roe, F. Gordon. *The Nude from Cranach to Etty and Beyond.* Leigh-on-Sea, Essex, 1944.

Rosenblum, Robert. *Transformations in Late Eighteenth-Century Art.* Princeton, N.J., 1967.

Ruskin, John. *The Complete Works of John Ruskin,* ed. E. T. Cook and Alexander Wedderburn. London, 1906.
> Vol. 3 *Modern Painters*
> Vol. 8 *Seven Lamps of Architecture*
> Vol. 21 *Instructions in the Practice of Elementary Drawing*
> Vol. 22 *The Eagle's Nest*
> Vol. 23 *Mornings in Florence*
> Vol. 24 *Giotto and his Works in Padua; St. Mark's Rest*

———. *The Stones of Venice.* New York, 1851.

Saisselin, Rémy Q. "From Baudelaire to Christian Dior: The Poetics of Fashion." *Journal of Aesthetics and Art Criticism,* Vol. 18 (Sept. 1959–60), p. 109.

Saxl, Fritz. "Continuity and Variation in the Meaning of Images." In *A Heritage of Images.* London, 1957; Baltimore, 1970.

Scharf, Aaron. *Art and Photography.* Baltimore, 1968.

Schopenhauer. *The World as Will and Representation,* Vol. I, tr. E. F. J. Payne. Indian Hills, Colo., 1958. Pp. 220 ff.

Squire, Geoffrey. *Dress and Society 1560–1970.* New York, 1974.

Stendhal. *Memoirs of Egotism,* tr. Matthew Josephson. New York, 1945.

Stratheon, Andrew and Marilyn. *Self Decoration in Mount Hagen.* Toronto, 1971.

Strong, Roy. *Splendor at Court.* London, 1973.

Taylor, G. Rattray. *Sex in History.* New York, 1954.

Tidworth, Simon. *Theaters.* New York, 1973.

Utter, Robert Palfrey, and Gwendolyn Bridges Needham. *Pamela's Daughters.* New York, 1936; reissued 1972.

Vandenberg, J. H. *The Changing Nature of Man.* New York, 1961.

Veblen, Thorstein. *The Theory of the Leisure Class* (1899). New York, 1934.

Waugh, Norah. *Corsets and Crinolines.* New York, 1954.

———. *The Cut of Men's Clothes 1600-1930.* London, 1964.

———. *The Cut of Women's Clothes 1600-1930.* London, 1968.

Winckelmann, J. J. *Writings on Art,* sel. and ed. David Irwin. London and New York, 1972.

Wilde, Oscar. *Decorative Art in America, a Lecture by Oscar Wilde.* New York, 1906.

Wind, Edgar. *Giorgione's Tempesta.* New York and Oxford, 1969.

———. *Pagan Mysteries in the Renaissance.* New Haven, 1958.

Wittkower, Rudolf. *Art and Architecture in Italy 1600-1750.* Pelican History of Art Series. Baltimore, 1958.

INDEX

England, 60, 62, 70, 118, 122, 131, 228, 258, 259, 260, 270, 275–81 passim, 287, 290, 291, 302, 319, 321, 364, 370, 373, 384, 389, 411
Enlightenment, 213
Erasmus, Desiderius, 390
Erechtheum maidens, 3
Eros, 400
Erotic photograph (1880s), *ill., 134*
Erotic postcard (1900), *ill., 134*
Erté, 335, 382
Estrées, Gabrielle d', 207
Etty, William, 129, 130
Eucharist, 26
Eugénie, Empress, 355
Evening Wind (Hopper), 140, *ill., 140*
Everdingen, C. van, 199
Eworth, Hans, 157

Faerie Queene, The (Spenser), 264
Family of Darius before Alexander, The (Fontebasso), *ill., 300*
Farce, 242, 263
Farthingale, 93; *see also* Bustle; Crinoline; Hoopskirt
Fashion, 17, 85, 90, 96, 185, 312, 313, 314, 331, 334, 344, 346, 350–65 passim, 388, 425, 448, 450; and antifashion, 363, 364, 365, 374, 376, 377, 380, 383, 384, 385, 386; avant-garde, 346, 364, 382, 385; beginnings of, 362; changes in, 350, 355, 357, 359, 364, 453; and couturiers, 351, 353, 354; defined, 350; erotic messages conveyed by, 91; fear of, 357, 359, 363; masculine, 123–24, 208–209, 225–26, 360, 361, 362; mass-produced, 358; resistance to, 360, 364; tyranny of, 345; *see also* Clothing; Drapery; Dress
Fashion photography, 328, 330, 337, *ill., 154, 343*
Fashion plates, 315, 317–18, 321, 322, 324, 337, *ill., 128, 325, 332, 338*
"Fatal man," 375, 376
"Fatal woman," 375, 382
Fathers of the Church (Bernini), *ill., 45*

Feast of the Gods, The (Bellini), 193, *ill., 193*
Felix Holt (Eliot), 434
Female figure, draped (Apollodorus of Phocaea), *ill., 11*
Femme fatale, 375, 382
Fielding, Henry, 445
Fifteenth century, 27, 97, 98, 104, 106, 132, 137, 148, 150, 164, 185, 187, 190, 203, 206, 216, 367, 369, 388, 399, 453; and stage costumes, 241, 242, 262, 266, 267; theater in, 241, 242, 267
Films, *see* Movies
Fiorentino, Rosso, 194
Fitzgerald, F. Scott, 385
Flagellated Woman and the Bacchante (fresco from Villa of the Mysteries at Pompeii), *ill., 14*
Flaubert, Gustave, 424, 438, 439, 440, 441, 443
Flaxman, John, 120
Flemish art, 20, 22, 23, 48, 62, 76, 98, 104, 106, 187, 264, 316, 396
Flight into Egypt (von Carolsfeld), *ill., 71*
Flora (Palma Vecchio), 209, *ill., 195*
Flora (Rembrandt van Rijn), *ill., 56*
Florentine art, 62, 100, 131, 137, 195
Florentine Nobleman, A (Tosini), *ill., 25*
Flynn, Errol, 260
Fontainebleau school of painting, 104
Fool's motley, 263
Fouquet, Jean, 187
Fourteenth century, 132, 211, 215, 362, 365
Fourth Discourse on Art (Reynolds), 77
Fra Angelico, 76
Fragonard, Jean-Honoré, 58, 60, 113, 114, 116, 218, 224, 321
France, 15, 50, 58, 60, 62, 64, 65, 73, 118, 122, 226, 228, 230, 260, 276, 277, 278, 280, 290, 326, 351, 352, 364, 365, 370, 403, 425; *see also* Louis XIV
Francesca, Piero della, 190, 193, 324
French Revolution, 285, 385
Friedrich, Caspar David, 426, 437

493

Mirrors (cont'd.)
403; and left-right reversal phenomenon, 393; "magic," 398; nineteenth-century, 403, 405, 406; in nineteenth-century art, 410–11; personal, 405, 414; public, 414, 416; Renaissance, 397, 398; in Renaissance art, 394, 395, 396, 398, 399, 400, 410, 411, 412; in twentieth-century art, and loss of old significance, 414–15; two, necessary for image of truth, 393, *ill., 394;* at Versailles, 404
Modigliani, Amedeo, 142, 143
Moitessier, Mme., portrait of (Ingres), 377, *ill., 379*
Molière, 265
"Mono-bosom" and "mono-buttock," 152
Montez, Lola, 377
Moore, Albert, 78
More, Thomas, 29, 390, 450, *ill., 30*
Moreau, Gustave, 150
Morris, Jane, 71
Moses and the Daughters of Jethro (Fiorentino), 194, *ill., 194*
Mourning clothes, 373–74, 376, 377, 382–83
Movies, 239, 243, 295, 314, 341–45 passim, 427, 429; costume, 295, 299, 305–306, 307, 427; fashion influenced by, 153–54, 239–40, 344; *see also* Cinematography
Mucha, Alphonse, 354
Munch, Edvard, 150
Murillo, Bartolomé Esteban, 322, 342
Murray, Mae, 382
Musical Party, A (Ochtervelt), *ill., 112*
Musician, The (van der Helst), *ill., 201*
Musidora (Gainsborough), 224, 225, *ill., 224*
Musset, Alfred de, 380
Mycenaean art, 5

Naked Woman Seated on a Mound (Rembrandt van Rijn), 159, *ill., 160*
Nakedness, 158, 159, 175, 185, 447, 448; and cloth, basic appeal in juxtaposition of, 184; nudity distinguished from, 144, 157; transformed into artistic nudity, 169; *see also* Nudity
Napoleon Bonaparte, 65, 436
Narcissus, 234, 392, 393, 398, 411, 412
Narcissus (Caravaggio), 412
Nativity (Master of Flémalle), *ill., 28*
Naturalism, 15, 16, 42, 46
Naturall Magic (Porta), 147
Nature, as guide of artists, 452
Naval uniforms, 228
Nazarenes (painters), 70, 294, 324
Neckerchief, 112, 211
Négligé, 59
Neo-Classicism, 32, 33, 49, 62, 64, 67, 68, 70, 77, 78, 80, 89, 117–23 passim, 126, 127, 128, 199, 205, 211, 225, 227, 251, 258, 275, 276, 285, 412, 436
Neptune and Amphitrite (Gossaert), *ill., 89*
New Shoes for H (Eddy), *ill., 415*
New York Hospital, engraving of (*Putnam's Magazine,* 1851), *ill., 320*
Newton, Stella Mary, 365
Nicholson, Jack, 305
Night (Michelangelo), 148
Nightmare, The (Fuseli), 120, *ill., 121*
Nijinsky, Vaslav, 10
Nike, 12
Nike (Paionios), 189, *ill., 190*
Nineteenth century, 32, 33, 53, 66, 68, 69, 77, 78, 79, 80, 117, 128, 131, 133, 139, 140, 150, 151, 152, 199, 205, 211, 216, 225, 294, 302, 313, 319, 321, 328, 339, 364, 365, 375, 376, 377, 380–85 passim, 412, 431, 453; dress designing in, 351, 352, 353–54; mirrors of, 403, 405, 406, 410–11; and stage costumes, 284, 294, 307; theater in, 287
Niobe, 149
Nipples, in art, 206–207, 211
Nogent, M. de, portrait of (Ingres), *ill., 226*
Noverre, Jean Georges, 285
Nude Maja, The (Goya), 91, 166, *ill., 91*

496